## Contributors

ANITA BROOKNER

MILTON BROWN

SIR HUGH CASSON

RICHARD CORK

DAVID HOCKNEY

JOHN HALE

JOHN JACOB

PENELOPE MASON

GEORGE MELLY

EDWIN MULLINS

DAVID PIPER

ROBERT ROSENBLUM

ALISTAIR SMITH

# GREAT PAINTINGS

## EDITED BY EDWIN MULLINS

**ST. MARTIN'S PRESS**
**NEW YORK**

All rights reserved. For further information write:
St. Martin's Press, Inc., 175 Fifth Ave., New York, N.Y. 10010.

Library of Congress No. 80-54585

First Published in the United States of America in 1981

© The Contributors 1981

Picture research by Diana Souhami
Designed by Paul McAlinden

Printed in Great Britain
ISBN 0-312-34636-0

The BBC2 series *100 Great Paintings* has as Executive Producers
Kenneth Corden and Bill Morton, with Anita Crum as Production
Assistant. Chief Film Editor is Paddy Wilson; Rostrum
Cameraman is Malcolm Kipling, and the Senior Photographer
(Graphic Design Department) is Michael Sanders. The films are
directed by Christopher Jeans, Christopher Martin and Denis
Moriarty. Stills research is by Margaret Mackenzie.

# Contents

Contents

# Editor's Acknowledgements

It is something of a personal article of faith that a good television script, minimally altered, reads better than many literary efforts. It retains the precious freshness of speech, and there is no fat on it. The spoken word has a natural style of its own which the written word frequently lacks. It is not that I have actively discouraged the contributors to this volume from rephrasing what they wrote originally as scripts for the BBC Television series *100 Great Paintings*; nonetheless in every case they have gone along with my wish to perform as little literary surgery as possible, and I am grateful to them all for that trust.

The task of commissioning the original scripts from authors, in some cases tracking them down to remote dens, was scrupulously handled by the Executive Producer of the series, Bill Morton, to whom I extend my deep personal thanks. I could not have found a more sensitive spirit of collaboration than I have enjoyed with him. And this thanks extends to other members of BBC Television who have given their time and enthusiasm unstintingly — Bill Morton's assistant Anita Crum, and numerous film directors, cameramen, sound recordists and lighting engineers with whom I have travelled and worked over the past two years.

My wife, Gillian, helped invaluably to clarify my thoughts when my response to paintings became blurred, as did numerous scholars I have consulted over specific points of interpretation. Finally, the enthusiasm of Stephen Davies, of BBC Publications, fuelled the motors whenever these looked like running dry.

E.M.

# Introduction

This is a book about looking at pictures – individual pictures. Works of art are all too often served as an enormous meal to be consumed at once. Museums, exhibitions, books on art, films on art – with the best of intentions all these tend to induce a kind of visual indigestion by offering more than anyone can possibly take at one sitting. The principal idea of this anthology, and of the television series upon which it is based, is to do the reverse and offer a single dish at a time; in other words to focus sharply on separate masterpieces rather than on a painter's work as a whole or on a period of art as a whole.

My own experience of museums and art galleries is of how hard it can be to linger in front of any single painting for any length of time. You are always on the move. There is far too much to see and the next painting is already beckoning out of the corner of the eye – or the next museum is beckoning or the next city. It is also physically hard: pressure of crowds in tourist cities can reduce the enjoyment of pictures to a glance at familiar artists and familiar masterpieces ('Oh they've got *that* here, have they?') before being jostled past. Sometimes I have found myself spending longer at the postcard stall than in front of the paintings, simply because the conveyor-belt had at last stopped. Museums in the tourist season can be a nightmare!

There are of course the privileged few who actually own a great painting; and these people enjoy an experience generally denied the rest of us of getting to know a picture as intimately as a favourite record played over and over again, or a novel read and reread in quiet and comfort. Once all pictures – or nearly all – were for such people. Fortunately for the rest of us it is no longer so; we enjoy access – often free access – to works of art in quantity which for centuries remained inaccessible. Had we been living two hundred years ago there would have been sadly few pictures to see. Today there are in a sense too many: instead of not enough pictures, now there is not enough time. A book or a record dictate the length of time to be devoted to them. A work of art in a public gallery does not: it often has to be taken in as rapidly as an advertisement on a railway-station escalator.

But only by focusing one's eyes and mind on a single painting for some length of time does a work of art begin to reveal its character and quality. If all of it can be taken in at a glance it is probably a very superficial painting, however dramatic an impact it may make. Time

and again in preparing my own contributions to this book I have found that paintings which I believed I knew well and understood have begun to speak to me in quite new ways. Thoughts lazily half-formed over the years have been sharpened, put to the test and not infrequently reshaped quite radically. It has reminded me that pictures are meant to be thought about as well as seen – perhaps they cannot be seen at all unless they are thought about. Pictures are built up in layers, not just of paint but of meaning.

If lack of time and lack of thought are two enemies of an appreciation of art, so are many of the conventions which govern the way art is displayed and presented to us. I often think that art belongs too much to art historians. Because pictures belong in museums and museums are the workshops of scholars we are encouraged to see paintings in the way scholars find it most useful to arrange them – neatly in periods, in countries, in cultures, like stamps in an album. We are far more accustomed to being conditioned in our ways of seeing works of art than, say, the way we read literature or listen to music: no one polices the method (or non-method) by which we arrange the books on our shelves or the sequence in which we play gramophone records; but in public art galleries pictures are invariably segregated according to rigid art-historical categories, and art books by and large follow the same procedures. I admit that a museum would be chaos if any other system were followed – they have to act as a sort of reference library, after all; nonetheless it is rather like being expected to enjoy flowers as arranged at a garden centre or in a seedsman's catalogue.

It is the privilege of the anthologist to dispense with many of these conventions; and as an alternative way of looking at pictures I have suggested that we try seeing them in terms of the human activities and preoccupations with which they deal – at least as a point of departure. After all, without such human concerns on the part of artists and their patrons there would never have been any art at all, or none to speak of. Painting has never been simply a stylistic exercise, even if style may be the vehicle by which we find access to it.

Pictures exhibit preoccupations which are constant regardless of where or when they were painted, and these constants, I would argue, are more fundamental to the nature of art than diversities of period and style. What is more, these preoccupations are just as true of the art of our own century, however novel and revolutionary much twentieth-century painting may be thought to be. The art of Picasso, to take the most eminent artist of our own century, owes a profound debt to Cézanne in the nineteenth century, to Goya in the eighteenth, Poussin in the seventeenth and Michelangelo in the sixteenth. Comparable historical links relate the work of Matisse, Kokoschka, Rothko, Pollock and many others to forebears far removed in time and style. But because our museums are arranged according to a policy of cultural *apartheid*, which scrupulously divides the art of today from that of yesterday, these links are scarcely ever emphasised or even acknowledged, and here too art scholars must take their share of the blame. Links like these frighten them. An expert on, say, Dutch seventeenth-century painting or Neo-Classicism is likely to feel himself in outer space if asked to

express some appreciation of German Expressionism or Italian Futurism, and the same is just as true the other way round. It ought not to be so, and in a small way I have tried to disturb these self-limiting habits of segregation.

In one respect only has convention been obeyed, although less out of respect than for the sake of keeping this anthology manageable, and this is in tracing the roots of art as we know it in the western world no further back than Duccio. There are no cave paintings, no icons, no examples of Classical Greek or Roman painting: there are on the other hand examples of Chinese and Japanese painting where these seem to offer an extra dimension to the themes chosen.

Certain themes suggested themselves; the only problems were which themes to include and which to leave out, and how to limit the examples in each theme to five. *Adoration, Bathing, The Outdoor Life – Hunting, Cities* and *The Elements* chose themselves; and in Volume Two I shall include, among others, *Love, Grief, Processions, Music, Children, Gardens, Self-Portraits* and *Storytelling*. The theme of *Touch*, in the present volume, may be a less obvious choice, but I have been struck by how many outstanding masterpieces exist which dwell on the almost electric moment of physical contact between one being and another – from Duccio's *The Blind Man* to Rembrandt's *The Jewish Bride* and Picasso's *La Vie*.

The theme of *The Magic of Light* could, of course, embrace all art since without light nothing is visible: but I have concentrated here on a handful of painters who have made fresh discoveries in the way light can be made to enhance a sense of reality (or unreality) on the flat surface of the canvas, from Caravaggio to Rothko.

To label a theme *The Language of Colour* may also seem somewhat all-embracing: again, though, I have chosen a few artists whose use of the colour and texture of paint is a key to their style, as well as exemplifying the general point that the distinctive touch of the artist's brush is the real language of painting.

Finally I want to dispose of any impression that these are somehow supposed to be the world's greatest paintings. Taste is forever changing, and there can never be such a thing as the 'greatest' in art. In fact I have deliberately left out a number of pictures which a referendum on the subject might nominate as 'the greatest': these are pictures so familiar in our own time that they have become, if not exactly clichés, then archetypal images, part of our common currency, whose reality almost lies outside art altogether, in the image as reproduced rather than in the original. I am thinking of Leonardo da Vinci's *Mona Lisa* which is arguably more real on a T-shirt or a calendar or in our minds than in the Louvre; Frans Hals' *The Laughing Cavalier*, Constable's *The Haywain* and Renoir's *La Première Sortie* are among others. By omitting such 'pops' I am certainly not attempting to rule them out as masterpieces. If they were not I doubt if they would have become so popular; but for the present purpose I hope they can be taken as read, and leaving them out has made room for other pictures just as interesting though less widely appreciated.

And appreciation is what it is all about. Art which lies un-appreciated, whether as an investment in a bank-vault or in the basement of a museum, is of no value at all and might as well not exist.

# THE MAGIC OF LIGHT

To the artist light is revelation: it reveals and it transforms. How he sees light is how he sees the world: how he paints light is how he explains to us his vision of that world. Not surprisingly the stages in the development of western painting have often been marked by fresh discoveries in the way light can be expressed. The subject-matter of art may remain the same; the manner in which it is illuminated never does.

Caravaggio, whose *Supper at Emmaus* was painted at the very end of the sixteenth century, employed light as a powerful theatrical device to instil a shock of realism. He highlights gestures, picks out faces and makes dramatic use of still-life objects by means of violent contrast between light and shadow – known as chiaroscuro, literally 'light-dark'. Strong light raises the emotional pitch of the whole scene.

The Spanish artist Zurbarán was a generation younger than Caravaggio, and the dazzling, torchlit effect of his *Still-Life with Lemons, Oranges and a Rose* suggests some debt to the Italian. But probably the debt is less deep than one might suppose: Zurbarán's roots lay deep in the Spanish tradition of dramatic realism, and his employment of light mirrors the zealous intensity of the Spanish religious experience. It may not be obvious that this is a religious painting, but the symbolism attached to each of these still-life objects – ceremonially laid out as if on an altar – suggests that it was almost certainly intended to be.

Pierre Bonnard's *Nude against the Light* was painted in France nearly two hundred years later. Light is now quite distinctly sunlight, and the way Bonnard has painted it clearly owes much to the Impressionists' discovery that all light is colour, even shadow is colour; though to Bonnard it is more than that. Light intoxicates, it casts a spell.

Magritte's *The Empire of Lights*, painted during the 1950s, also treats light as something which casts a spell. Unlike Bonnard he was not remotely interested in analysing the colours of light; Magritte was a Surrealist and what he sought in art was the 'power to surprise and enchant us'. Light is the agent of that surprise – the landscape is night but the sky is day.

Rothko's abstract painting called merely *Red, Black and Brown* was painted within a few years of the Magritte and is light-years away from it. For Rothko light is not an agent of unreason and visual surprise, it is an experience which is awesome, inexplicable and – as many people have found in his pictures – religious, stirring the mind to thoughts of life and death, of shadow and substance.

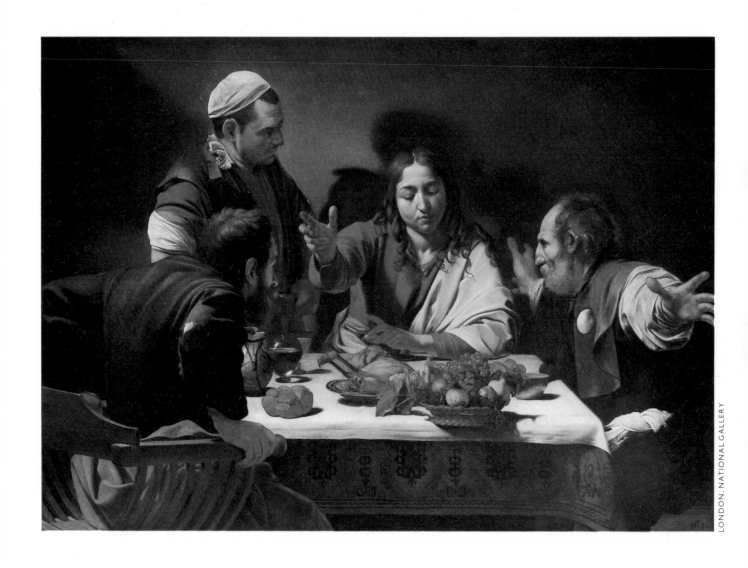

ALISTAIR SMITH

# Caravaggio 1571–1610
# Supper at Emmaus 1596–8

Michelangelo Merisi, called Caravaggio after the little town in north
Italy where he was born, died in 1610, before his fortieth birthday.
An early death was hardly unexpected. All his life he had been in
trouble of one sort or another – permanently involved in lawsuits, in
and out of jail, constantly fighting and brawling. A strain of violence
seems to run through every aspect of his life. Incredible though it
may seem, on one occasion he wounded a man – fatally as it turned
out – in a fight that broke out during a tennis match. It is not clear
from the documents whether they were opponents or partners.

It is no surprise that Caravaggio's paintings reflect something of
the violence of his life; he was a man who infused his art with his
personal experience. This has one particular result: traditional
religious subject-matter is rendered in a completely new way, and in
such a manner that the Church often found it hard to swallow.

His *Supper at Emmaus* is a case in point. It could easily be set in one
of those inns with which Caravaggio was so familiar. The tavern-
keeper tucks his thumbs into his belt pugnaciously, as if about to
take issue with one of his clients, who seems to be holding forth on
some subject or other. One man, startled, throws his arms out in
astonishment. The other starts to rise. The table rocks. A basket of
fruit teeters on the edge, about to plummet to the floor. It could
almost be the start of a brawl, a scuffle in a tavern. But it is nothing so
banal: every object is described with paranormal intensity, every
gesture and expression dramatised. Caravaggio's painting fuses the
natural with the supernatural in such a way that it is difficult to
decide whether this is a tavern interior souped up, or a religious
event in everyday clothing.

In fact the starting-point for the painter is one of the miraculous
appearances that Christ made after the Crucifixion. St Peter and
Cleophas are near a village called Emmaus:

'. . . while they communed together and reasoned, Jesus himself
drew near and went with them. But their eyes were holden that
they should not know him . . . And it came to pass, as he sat at meat
with them, he took bread, and blessed it, and brake and gave it to
them. And their eyes were opened, and they knew him; and he
vanished out of their sight.'

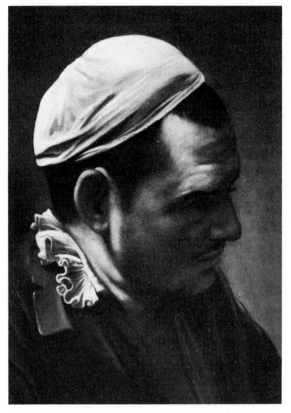

Detail of inn-keeper, *Supper at Emmaus*

13

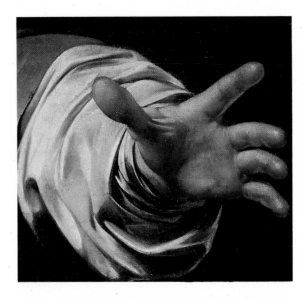

The identity of the man on the right is something of a problem. His name isn't given in the New Testament, and, although there is room for disagreement, he has been thought by Caravaggio scholars, to be St Peter. Seated on the left is Cleophas. The central figure is Christ blessing the bread. He is beardless, which is very unusual in paintings. I wonder if Caravaggio wanted us to think for a moment that he might be one of those women who frequent taverns – the unkempt ringlets, the carefully casual cleavage. Peter looks like a *real* fisherman. Look at his hands: there are callouses like pads on each finger.

It is easy to see that Caravaggio based his characters on real people he knew. It did not matter to him that they did not conform to the usual noble type of model; that was an advantage. They made the old stories look like news. In *The Incredulity of St Thomas* (now destroyed) we see the model for St Peter again, and this could easily be his companion. As for Christ, I wonder if this could be he a couple

*Above* detail of St Peter's hand, *Supper at Emmaus*; *right* Caravaggio, *The Incredulity of St Thomas* (old copy of the lost original); *below* detail of St Peter, *Supper at Emmaus*

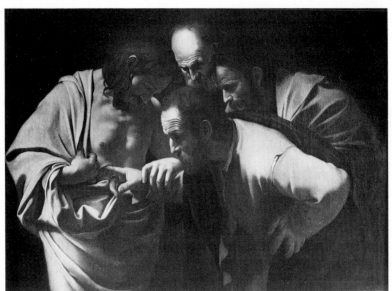

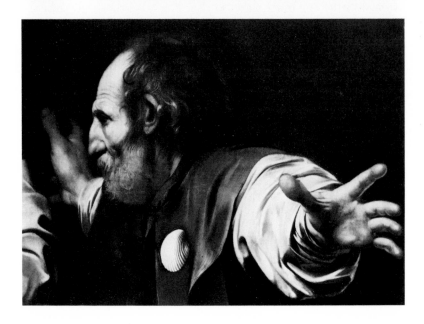

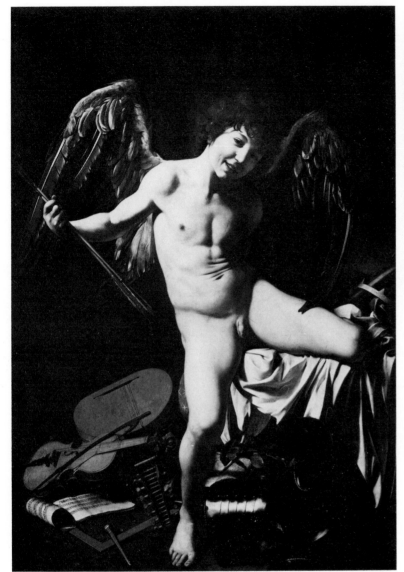

*Left* Caravaggio, *Victorious Love;*
*above* detail of Christ's head, *Supper at Emmaus*

of years earlier and without the wig in *Victorious Love*. In this case, he is a symbol of erotic love, impudent rather than innocent, painted for a rich collector who doted on Caravaggio's realisation of the theme.

Although Caravaggio found favour with a few liberated connoisseurs and intellectuals, in general he was dogged by criticism. It was the realistic aspect of his art which attracted censure. Caravaggio gave his saints dusty feet and workmen's hands; here Cleophas has a hole at his elbow. The Church objected to religion being dressed in rags. More shocking, however, is the characterisation of Christ – a fat youth obviously fed on sweetmeats, the lips gross, his arched eyebrow rather too feminine for a god. It is as if Caravaggio had laid a snare for the spectator, presented him with a problem that is essentially philosophical. If God manifests himself in human form, how can you tell the difference? Small wonder that Peter and Cleophas did not immediately recognise this overblown, effeminate figure.

Nevertheless, Caravaggio answers his own question – spirituality is visible in sudden blinding flashes. Remember that in a moment this

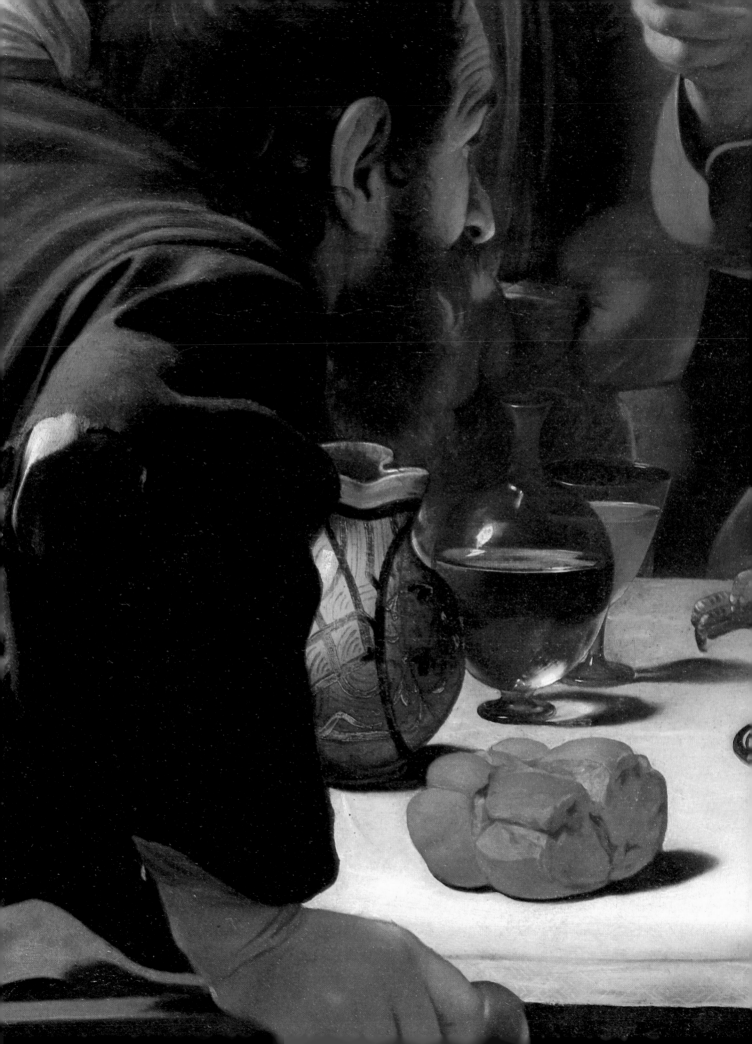

revelation will vanish 'out of their sight'. By its very nature it can exist, within normal human circumstances, only for a moment. Onto his expression of everyday reality Caravaggio has grafted a sense of illumination and awe. How is it done?

Well, first of all take a look at the table. Its cloth is virgin white, unstained, not a crease showing. It and the rich eastern rug beneath it resemble an altar frontal. The food takes on a sacerdotal quality — bread and wine and water. The chicken looks as if it has been stripped and exposed for sacrifice. The fruit — out of season in April — makes explicit reference to the scriptures; the apple of Adam and Eve — rotting; the pomegranate (which usually symbolises Church unity) is here split through the centre. Caravaggio gives all these objects obsessive attention — makes them equal to everything else in the scene. He deliberately gives the tavern a more universal relevance by emphasising the religious quality of the objects on the table. If anything, the food is given an emphasis in excess of the figures. It stands out as if in the beam of a searchlight; the highlights are brighter than on any other object, the shadows darker. The basket casts a shape as menacing as one of the devils of Hieronymus Bosch. It seems to pulse before our eyes, existing almost on its own, separate from the rest of the scene, a still life in its own right.

Unfortunately nothing is known about where this picture was destined to hang, but I think we can be sure that there would have been a real window to the left of it. It was one of Caravaggio's techniques to develop this sort of relationship between real and painted light. There is a modern poem by Thom Gunn about this — 'I see,' he says, 'how shadow in the painting brims with a real shadow.' It must have been difficult, on the original site, to tell which was which. Caravaggio was also fascinated by the foreshortening, the way arms are lost at the expense of hands. It is astonishing how parts of the painting seem to hover without support — heads, hands, St Peter's pilgrim's badge. Having set up a down-to-earth, everyday scene, Caravaggio lends it the most mystical physical circumstances — the natural and the supernatural, the real and the unreal. One might almost say surreal.

More than anything, however, I think of this picture as something of a symbol for Caravaggio's life and personality. Around Christ are gathered men representing the sort of attitudes that Caravaggio's public expressed — suspicion, challenge, outward shock. The painting is, like its painter, somewhat schizoid. Charged with intense emotion, expressing a violent action, it simultaneously possesses a core of spirituality, even austerity. It is the product of a man who swung between two extremes of life, alternating street fights with concentrated work in secluded surroundings. It was Caravaggio's confused life, his familiarity with the tramp as well as the Cardinal, which led him to create his own enigmatic blend of low life and high art.

Detail of Cleophas, *Supper at Emmaus*

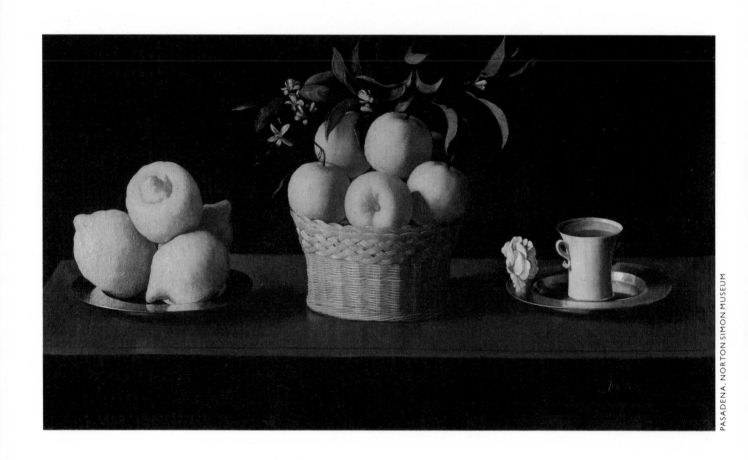

EDWIN MULLINS

# Zurbarán 1598–1664

# Still Life: Lemons, Oranges and a Rose 1633

It is easy to understand why an artist should wish to paint a portrait, or a landscape, or a picture commemorating an event from history or the Bible, and it is easy to understand why an art collector should want to possess any of these.

But why a still-life? Why should it be of interest to anyone to paint a representation of simple objects and foodstuffs of no significance beyond the fact that we use them every day?

Yet every country in the western world has at some time produced artists who have nourished their highest skill on just such apparently humdrum subject-matter. There are as many ways of painting food as there are of cooking it. Consider, for example, a still-life in the Norton Simon Museum in Pasadena, California, by the seventeenth-century Flemish painter Frans Snyders. It is a picture that I can imagine a prosperous greengrocer might have commissioned for his dining-room. Now compare it with another picture which hangs in the same museum in California and was painted at much the same period – in 1633 – but this time in Spain – by Francisco de Zurbarán. The subject is again food (for the most part), yet laid out so sparingly and so precisely that each fruit, each object, takes on a quite new significance. We are no longer being invited to admire the contents of a greengrocer's shop, but to contemplate a kind of altar.

There is no doubt in my mind which of these two still-life paintings is the finer. The Flemish picture is a highly skilful piece of craftsmanship, the sort of brilliantly executed trick which invites us all to clap and that is it. The Zurbarán is a work of art of quite a different order. It has that quality, which all great still-life paintings possess, of supplying to simple daily objects a meaning, a resonance, that in real life such objects do not normally have. It is precisely because they are so commonplace, so familiar to us, that these household items can be made to mean so much. A simple example: a rose in a garden is just a flower, and yet the gift of a single rose is capable of saying more about love than the most passionate speech.

There is a single rose in this picture; just one, laid very delicately on the rim of a pewter plate. Next to it stands a mug full of water – or it may be white wine. In the centre is a finely woven basket containing oranges: sharp Seville oranges (the picture was painted in Seville, where Zurbarán lived most of his life), and the scented

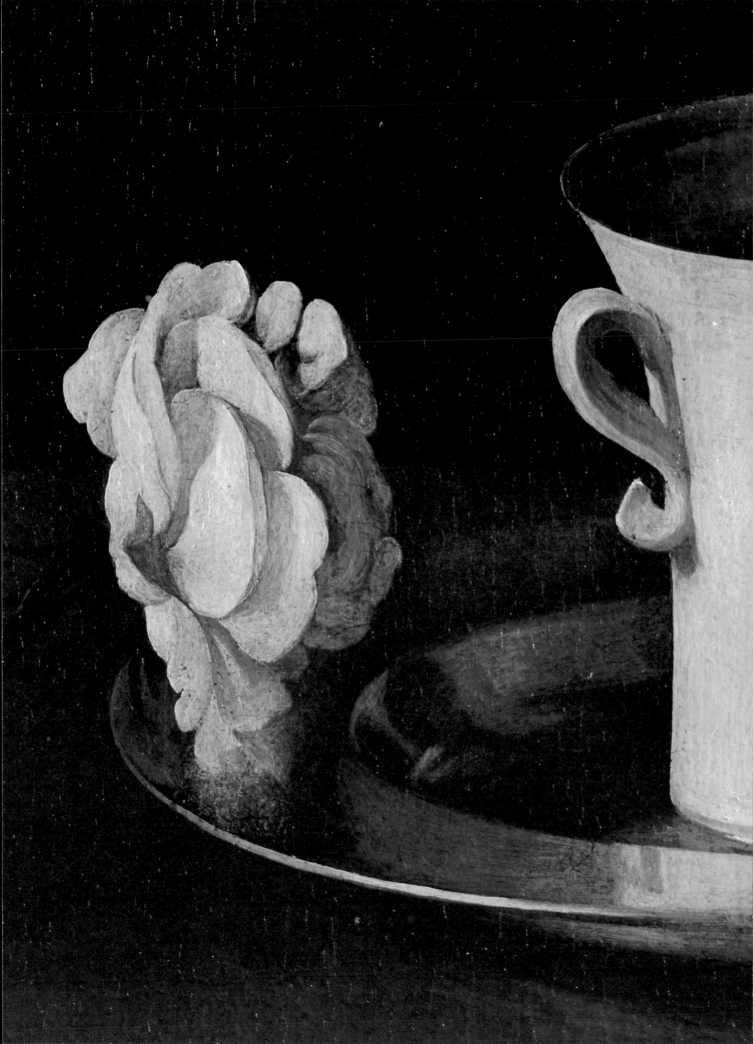

blossom of next year's fruit is in flower at the same time, as happens with orange-trees and gives them their special beauty. On the left, completing the trio of still-life groups, is another pewter plate exactly balancing the one on the right, but this time holding four lemons which reflect in the polished metal and seem to glow in the strong light against the intense blackness of the background. I have said that this is a painting which puts me in mind of an altar – of ritual objects with a powerful symbolic meaning laid out for a Roman Catholic service. I cannot look at this picture without imagining the unseen hand that laid out these objects so meticulously. I want to know why, and I want to know when, because the picture has the feeling of existing outside time: these objects might have been there for ever. There are no marks of decay, there is no movement, no hint of a human presence. They might almost be votive objects set up by the priests of Tutankhamun and brought to light by our torches for the first time in more than 3000 years. They are so real they look unreal. Altogether, this is a painting that impresses me deeply and mystifies me deeply.

For clues I look elsewhere in Zurbarán's vast output, and I find this to be the only still-life he painted – at least the only one we can be sure is his because he signed it. Now, nearly all Zurbarán's work was commissioned by religious orders, and in a painting he did for a monastery in Seville I find an almost identical grouping of plate, cup and rose, with an apple added, set on a similar plain wooden table, except that here the still-life is a detail in a large composition illustrating the miraculous curing of a sick man. It is clearly the sick man's nourishment, but it also seems to play a symbolic role, emphasising the man's simple life and purity of mind.

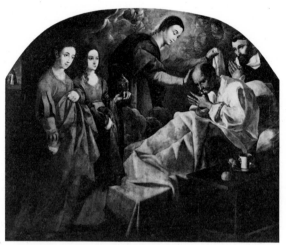

Zurbarán, *The Miraculous Healing of the Blessed Reginald of Orleans*
*Left* detail of above; *opposite* detail of rose and mug of water, *Still Life: Lemons, Oranges and a Rose*

Then in New York, at the Metropolitan Museum, hangs a rather sweet picture by Zurbarán of *The Young Virgin*. Once more the figure is

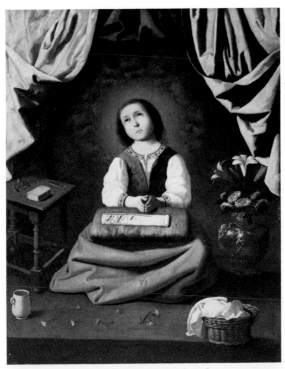

accompanied by tenderly painted objects arranged like offerings to her: a mug, flowers strewn at her feet, her work-basket, roses of love again, lilies – always associated with the Virgin, indeed named after her: 'madonna lilies'.

So lovingly are they painted, these details, that the strength, the meaning even, of the picture seems to reside more in these exquisite details than in the little girl in the centre raising her eyes to heaven.

It is not surprising that when he composed a picture solely of these domestic details and objects Zurbarán created a work of extraordinary power: each object formally arranged, lovingly described, picked out with a light so intense as to be almost eerie. Maybe Zurbarán intended his still-life to be interpreted as a symbolic homage to an absent Virgin: the rose meaning love, water purity, orange and orange-blossom the fruit and flower of chastity. And the lemons – well, some scholars have insisted they are not lemons but citrons, which were used in Easter ceremonies honouring the Virgin; though art scholars are not noted as botanists, and they look very like lemons to me.

Or you can look at it another way: the rose may stand for human love, the cup may hold wine suggesting pleasures of the flesh. Oranges – the flower and the fruit – frequently symbolise carnal love,

and the lemons – well, how breast-like they are!

Does it matter how you read it? Only, I think, in that Zurbarán would have been unlikely to paint it at all if it were a mere decoration, or certainly would not have painted it in this formalised way. What I feel is that if church ritual and symbolism are in your bloodstream – and they were certainly in Zurbarán's – then your imagination feeds on them. Zurbarán's strength as a painter lay in his gift for interpreting human affairs as a kind of ceremonial still-life, so that this painting you might say is the quintessence of his art.

Zurbarán's people are more often than not mere waxwork figures, who supply the human element but have less life in them than the object to which they bend their gaze. In his painting *St Hugo in the Refectory* (Seville Museum) Zurbarán has given the saint exaggerated gestures and facial expression in an attempt to convey a complicated story of a miracle. But he was no story-teller and the beauty of the picture lies in the formal tableau-like arrangement of figures and

*Top* Zurbarán, *The Young Virgin; middle* and *bottom* details of the flowers at her feet and her work basket

objects, and in the wonderfully subtle variations of texture and pale colours in which he had described them. In fact it is another still-life.

Zurbarán, *St Hugo in the Refectory*

The *St Hugo* painting is from late in Zurbarán's life, by which time his stiff manner was already considered old-fashioned. As so often happens, it has taken painters of more recent times to rekindle a feeling for Zurbarán's view of life as something motionless and tactile like the painted surface itself. Cézanne's famous instruction to a sitter comes to my mind, 'Sit like an apple.' Cézanne, too, painted fruit and goblets in such a way that they feel like monuments. So in the present century did Georges Braque. No one questions any longer that great painting can be made out of the humblest ingredients. Zurbarán's still-life is a great painting because it is unforgettable. Having seen it I can never again look at a basket of oranges quite as I did before. There is a magic about this picture which I cannot in the end explain, and perhaps should not, but be content to say that its magic is what makes it unforgettable.

EDWIN MULLINS

# Bonnard 1867–1947

# Nude Against the Light 1908

Such a painting is enough to make any man envious of great artists: they can spend their lives admiring the women they love, paint them over and over again, and grow rich doing nothing else.

You can equally say that the woman in this painting hardly exists in her own right at all; that far from being a woman the painter loves she is nothing more than a reflecting surface, and what really interests the artist is the hypnotic quality of light. But, however you choose to look at it, this is a very hedonistic picture and a very personal picture. The artist was Pierre Bonnard and he painted it in Paris some seventy years ago, at much the same time as Picasso – also in Paris – was painting the most revolutionary picture of its time, *Les Demoiselles d'Avignon.* So Bonnard was certainly not part of any new avant-garde: he was still working in the shadow of the French Impressionists, and still seems to be concerned with painting as an expression simply of enjoyment. I say 'seems to be' deliberately, because the question is, enjoyment of what? Is this a picture about sex? Is it about something more ill-defined – like femininity? Is it about the pleasure the artist takes in domestic life, as a kind of cocoon in which people keep warm and contented without doing much beyond eating, resting and taking baths? Or is it about sunlight? I think it is about all these things.

Bonnard painted this woman for more than forty years, and in his paintings she never grows old. Her name was Marthe. He lived with her, rather late in life he married her, and he never got over her death in 1940. Bonnard met her in Paris when he was twenty-seven. She was sixteen and working in a shop making funeral wreaths out of artificial flowers.

She appears in his work quite early; and the passion he felt for her is marvellously expressed in a series of illustrations he did – commissioned by his dealer Vollard – for a book of erotic verse by the artist's friend Paul Verlaine. The book is *Parallèlement,* published in 1900. The poems themselves are as steamy as a Turkish bath, but Bonnard's drawings have a light touch, a kind of wit, which was to remain a characteristic of his work all his life. There is nothing debauched about his drawings: their sexuality is frank and tender.

The same goes for one of Bonnard's earliest paintings of Marthe entitled *L'Indolente* done about the same time as the Verlaine

Bonnard, *L'Indolente*

illustrations. It has the trappings of debauchery in deference to fashionable Left-Bank Bohemia: the rumpled bed, the sprawl of the girl under a lingering wisp of bedclothes, the toe playfully crooked against her thigh, the cascade of hair, the cat – hardly visible now that the picture has darkened – rubbing itself against her neck, even the suggestion of auto-eroticism. There is also a man's pipe on the side-table discreetly acknowledging the presence of her lover, who of course is Bonnard himself. For all this it is not a pornographic picture: it is a deeply loving painting about sexual passion. It is Bonnard saying: 'This is the girl I desire.'

Looking again at *Nude against the Light*, painted eight years later, the contrast comes as a surprise. It is quite obvious now that this is not an erotic painting, and that sexual passion has cooled in those eight years, or at least it is no longer what primarily concerns him as a

painter. Marthe is self-absorbed as she was before, but now her thoughts seem to dwell not on giving herself to Bonnard, but to the bath-tub, or the mirror, or her scent spray, or to the sunlight. Most of all to the sunlight.

The subject of the picture is not their relationship any longer. She is depersonalising that relationship by turning her back on him to face the sun; and he is depersonalising her by describing her principally as a surface caressed by light and shadow. The furniture records the same shift of interest. Here is a middle-class domestic setting, and what absorbs Bonnard about it is a series of colour-patterns – the carpet, the sofa, the wall-paper, and the flimsy lace curtains; whereas in the earlier picture the furniture was simply a bed of love, and there was virtually no colour at all.

If one looks at how Bonnard painted Marthe over a much broader span of time, forty years, one sees how this process of deper-sonalisation is taken to an extreme. Bonnard painted *Nude in Yellow* when he was over seventy and Marthe more than sixty. It is forty years since he painted her sprawled on a bed. Now she has become a golden daydream of youthfulness. Only her shoes suggest that she is really here in the flesh at all.

It is often said about Bonnard that his discovery of the Mediterranean accounts for the brightening of his palette. I find this a facile explanation – a woman does not as far as I know suddenly turn a vivid golden-yellow just by stepping into the Mediterranean sunlight. Bonnard's colours became what you might call *interior* colours: they were in his mind's eye. What he saw physically in front of him was a mere starting-point, the beginning of a journey into himself. He painted what he felt was right, not what he saw, as the Impressionists did. There is a daring and a freedom about his colours which the Impressionists rarely attempted. He said himself 'Il faut mentir' – a painter must lie.

But what kind of lie? What did he mean? I think he meant that to a painter nothing is èver as it seems. Light is not something which merely illuminates what is before our eyes, as the Impressionists believed. Light is an intoxicant which, if we take enough of it, begins to create in the mind's eye a quite new reality, one which pays no more than lip-service to the objective world around us. It is like the effect of a drug. Or like a composer hearing, let us say, the song of a bird, which sets his imagination to work on sounds that finally bear no resemblance whatever to a bird.

Except that with Bonnard it is colours, not sounds. Other French painters, drunk on colour, like Moreau and Redon, often chose to dispense with objective reality altogether and painted their dreams. Bonnard was not like that. He remained firmly rooted in his domestic environment: none the less he found in this environment any number of aids to what he called the 'lie', and *Nude against the Light* is among the first pictures in which he began to exploit them.

First, he has painted Marthe *against* the light; and as everyone knows if you try to identify things against the sun all kinds of strange effects interfere, and you end up with spots before the eyes. This is a painting, you might say, about spots before the eyes. Then there is the mirror: another trick, another lie. Mirrors distort, throw back

images, suggest perspectives that are not really there, show you what you cannot otherwise see. The frontal view of Marthe seen in the mirror is quite different in tone from the Marthe we see standing before us. There is just a residual hint of the voyeurism Bonnard indulged in eight years earlier in *L'Indolente*: even the position of her hand is virtually a mirror-image of the former pose, though now one suspects she is anointing her breast with toilet-water, not caressing her own body. And there is the bath-tub, the water in it just catching the light, so that it has become another window, another mirror, another distortion. Marthe was a fanatic about hygiene, and seems to have spent half her day in and out of the tub.

Then came the day when the Bonnards could afford a real bathroom with hot running water. Marthe spent even more time soaking herself, and in that almost prosaic way of his Bonnard made use of this fetish of Marthe's to produce a series of studies of her, among them, *The Bath* (London, Tate Gallery) and *Nude in the Bath* (Paris, Petit Palais). Water is liquid light, its surface another mirror. It becomes a rainbow of ephemeral colours, until the body in the water is almost lost and the face lost altogether. Marthe, nearly sixty by the time he painted *Nude in the Bath*, is a young water sprite Bonnard sees fleetingly in his mind. He is dazzled by the patterns and the colours that seem to float before him like painted screens. We are about as far as could be from the flesh-vision of the young Marthe.

Between these two extremes is the *Nude against the Light*: one of the greatest pictures of Bonnard, and one in which she is looking, in more senses than one, both ways. She is still to Bonnard the beautiful young Marthe he desires; though into her room and over her body has begun to creep a spell of light which will keep her for ever young, and ever further from what she really is. She is there, real enough still, yet can we be quite sure whether the surface of her body is skin or a shadow in the sunlight? In this picture Bonnard's two realities meet.

Bonnard, *Nude in Yellow*

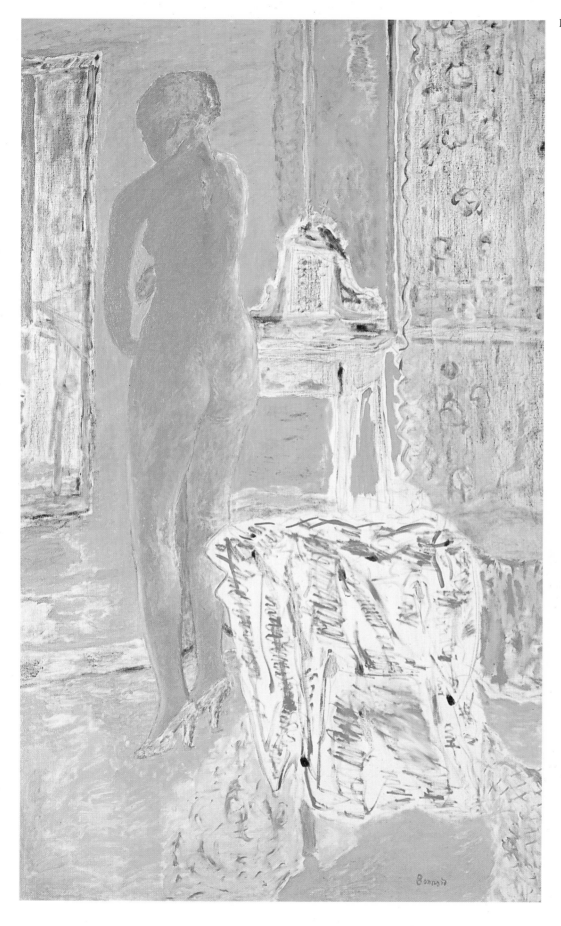

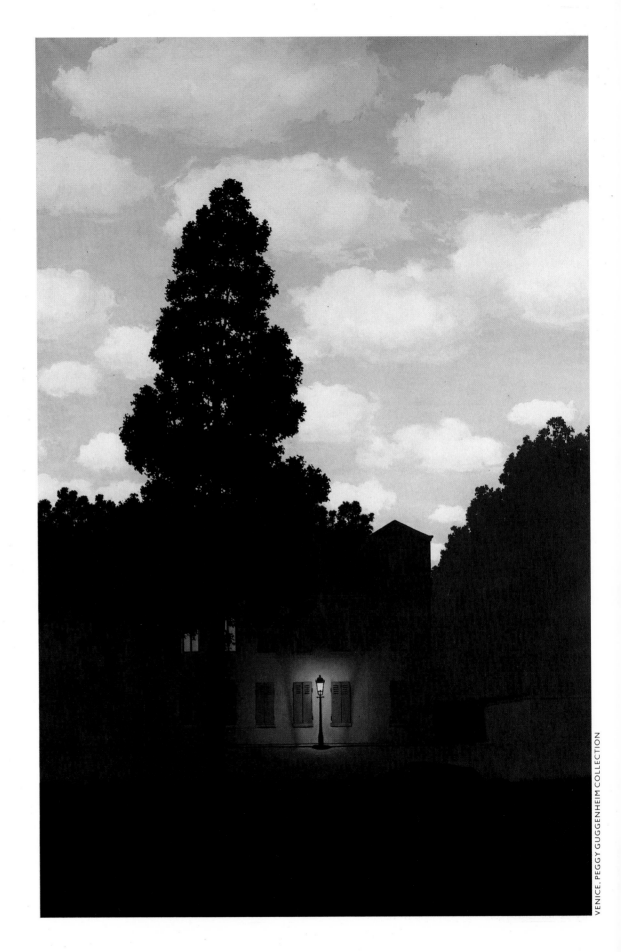

GEORGE MELLY

# Magritte 1898–1967
# The Empire of Lights 1954

'What is represented in *The Empire of Lights*,' explained Magritte, 'is the ideas I arrived at, that is, a night-time landscape and a sky such as we see during the day. The landscape evokes night and the sky evokes day. I find this evocation of day and night is endowed with the power to surprise and enchant us. I call this power poetry.'

Magritte was not a painter to squander a successful idea. He painted several versions of *The Empire of Lights* during the late '40s and '50s, some showing a whole suburb, others a small block of houses or a single building. Even so, as is usual with him, there is one canvas which realises the concept with the greatest intensity and conviction, and for me it is this picture, painted in 1954, now in the collection of the late Miss Peggy Guggenheim in Venice.

In some versions the day-sky could be read as a sky at dusk. Most of us have observed those evenings when light lingers in a quarter of the heavens long after it has deserted the urban landscape; an effect accentuated if the street-lamps, controlled by a time-switch un-affected by the vagaries of the advent of true night, are already gleaming. In other versions the contrast is too abrupt. The sky is a day-sky all right, but the night-scape looks like a flat of theatrical scenery propped up in front of it. In the Guggenheim version the balance is even, the fusion complete. The sky is day. The landscape night. An impossibility in reality is presented with convincing deadpan realism. That 'power to surprise and enchant us' which Magritte calls poetry is present at full strength.

Long before he came to paint *The Empire of Lights* a preoccupation with light and darkness had obsessed him. From his beginnings as a painter he frequently tested one against the other. As early as 1928 he painted a petit-bourgeois living-room evenly lit, next to an inexplic-able black void; a disturbing image in no way diminished by the rather limited technical means at his disposal in those years.

In the same period he placed a lit street-lamp in the middle of a very similar room, thereby disorientating our set notion of interior and exterior, room and street, a confusion reinforced by the presence of one of his ubiquitous bowler-hatted men apparently out taking a stroll. This picture always springs to mind when I hear a Londoner say of some object, 'We got one indoors.'

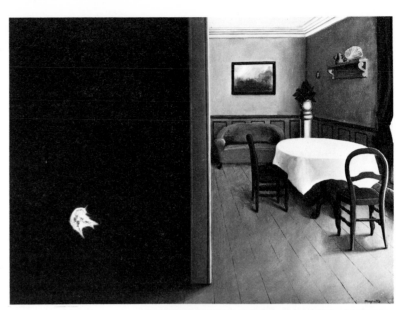

*Right* Magritte, *The Voice of Silence*;
*below* Magritte, *The Ignorant Fairy*

Another, and much later, approach to the problem was a picture in which he tried to show us a candle which produced an aura of darkness rather than light. It was an interesting idea but it didn't

32

seem to work, and as far as I know it is a one-off version, usually a sign that Magritte too was unconvinced by its realisation.

But the picture closest to *The Empire of Lights* is a masterpiece painted in 1963. It is called *The Field-Glass* (*La Lunette d'Approche*). Here the windows seem to look out on to a blue sky with white clouds and yet, as the frames are very slightly ajar, we see that outside it is pitch dark.

I have followed through this series of pictures to illustrate how Magritte, during a long career, returned at intervals to certain preoccupations, of which light or its absence was just one. Indeed he himself objected to his work being considered chronologically instead of thematically and would at times, in the hope of confusing future pedants, deliberately date his pictures incorrectly.

There is, however, a watershed in his work. In 1930 he awoke in a room which he knew to contain a bird in a cage, but imagined momentarily that, instead of a bird, the cage enclosed a large egg. Up until then, with a few possibly accidental exceptions, he had relied on the effect of bringing together incongruous objects in unlikely confrontation; a means of evoking poetry he had learned from Chirico. The egg in its cage suggested a new approach altogether, a resolution which was the equivalent of a visual pun. It is as if in his early paintings he had showed us those separate elements necessary for a chemical experiment. With the caged egg as catalyst he was able to produce an entirely new alloy.

The living-room threatened by darkness or illuminated by a street-lamp belong to the pre-egg period. The window looking out on to the day but opening on to the night, *The Empire of Lights* itself, have resolved the problem of depicting light and darkness simultaneously, and with extraordinary elegance.

It is perhaps useful to say that even if Magritte had conceived *The Empire of Lights* in his early days, it is unlikely that he would have been able to realise it convincingly. While he was immensely gifted in respect to poetic ideas, his technique initially was, to put it kindly, decidedly limited. His early pictures are almost naïve in execution, and the astonishing events he visualised seem to take place on a narrow stage, against a backdrop. By working regular hours almost every day of his life, he became a master. This is not to imply that his early pictures are less interesting – his poetic imagination was working at full throttle – but simply that he would have found it impossible to execute a picture which depends for its effect on an ability to manipulate tone and space with such precision.

Where of course the use of light in this picture differs so radically from painters like Turner or Monet is that Magritte was in no way seduced by the fleeting effects of light on other subjects, whether a ship at sea or a haystack. Light in most of his paintings is a way of illuminating as aptly as possible the problem he sets before us, and in those pictures where light itself *is* the problem he treats it as objectively as the bowler hat or the pipe. Magritte was an illusionist and, like any conjuror, first showed us the properties he intended to use in deceiving and convincing us; holding up the box to prove it was empty, tapping the egg with his wand before transforming it into a full-grown dove.

He knew perfectly well that the sky is not a solid blue sheet, that its blueness is an illusion produced by the effect of light passing through space, but this didn't inhibit him from chopping it up into cubes as if it were blue cheese, and emphasising the disquieting effect by allowing his clouds to pass behind or in front of the cubes or even through them like a letter through a letter-flap. Yet such an enterprise is no more illogical than covering a flat surface with blue pigment to represent light traversing the ether. What Magritte did was to challenge unceasingly our acceptance of reality and the laws which govern it. 'He has approached painting,' wrote André Breton, the leader of the Surrealist Group, 'in the spirit of the object lesson.'

If he was uninterested in visual representation for its own sake he was equally hostile to the principal dogma of twentieth-century painting, the open acknowledgement of the two-dimensional limitation of the canvas; the picture as its own subject. This led to the repeated parrot cry that he was a literary painter, 'literary' being for many years the dirtiest word in the art critics' vocabulary. In fact his images, his poetry were essentially visual images, visual poetry. To read 'a suburban landscape by night under a day sky' is in no way as convincing as its visual realisation in *The Empire of Lights*. The magic lies in seeing it 'before our very eyes'.

What was Magritte's object? It was certainly not symbolic and he became very irritated when accused of symbolism. 'Nothing is symbolic,' he liked to say, 'except of course symbols.' He was equally aggravated when it was suggested that he was the heir of Bosch or Bruegel, especially on the grounds of their shared Flemish origin.

Yet I do believe that in Magritte's temperament there was a balance between a love of mystery and that ability to keep one's feet on the ground which is a characteristic of the Flemish old masters. In Gerard David or Dieric Bouts there is something of the same matter-of-fact presentation of the extraordinary that one finds in Magritte. It is true that their miracles were painted for an age of faith, but seem all the more convincing for taking place in the midst of everyday life. Magritte, who acknowledged neither God nor master, painted his secular miracles to call reality into question, to recharge the ordinary with mystery, by presenting poetic alternatives. Once he has shown us that stones can seem to float or a tuba burst into flames, then a stone rooted to the earth or a tuba on a bandstand become equally unlikely and extraordinary.

It is, however, absurd to deny Magritte's aesthetic qualities, incidental as they are to his main preoccupations. *The Empire of Lights* is realised with a tender and seductive dexterity but its primary object is beyond his patiently acquired skill. This too places him closer to the old masters. Aestheticism for its own sake is a modern preoccupation.

'If I believe this evocation has such poetic power,' he wrote, 'it is because, among other reasons, I have always felt the greatest interest in night and in day, yet without ever having preferred one or the other. This great personal interest in night and day is a feeling of admiration and astonishment.'

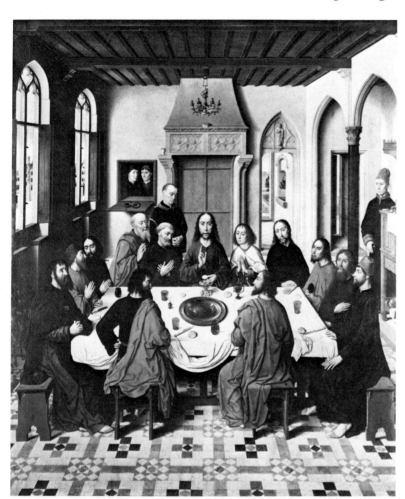

Dieric Bouts, *The Last Supper*
(central panel of the polyptych)

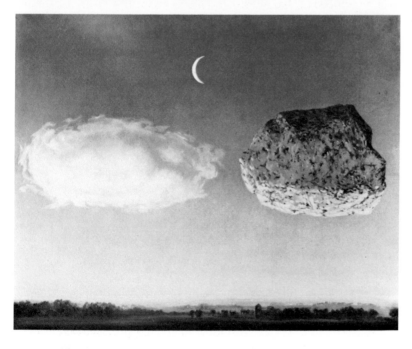

Magritte, *The Battle of Argonne*

ROBERT ROSENBLUM

# **Rothko** 1903–70

# **Red, Brown and Black** 1958

When people make fun of paintings they often explain more about them than they do when they try to praise them. Someone I know who thought that Mark Rothko's paintings were silly, empty and overestimated said that they looked like 'Buddhist television sets'. But in meaning to dismiss as sheer nonsense an abstract painting like this one at the Museum of Modern Art in New York, he may have put his finger on just why so many spectators trouble to look at Rothko and are even strangely moved by his work.

Like a television set Rothko's painting first offers a squarish field of somewhat blurry shiftings of dark and light. And like a filmy screen, not yet in focus, the painting also gives us a sense of something that may change before our eyes, becoming sharper or clearer, closer or further away, or perhaps vanishing entirely. And still more, the painting asks us to look at it in an attentive, expectant way, as if we were going to watch something happen. But the Buddhist part of the quip also tells us that whatever is going to happen is no ordinary television story about our here-and-now world. Although this particular picture was painted in 1958, and in New York City, it depicts no event, no scene, no people or objects of that time and place. Where, in fact, are we? The world Rothko imagines takes us light-years away from our daily environment. What has happened to the twentieth century?

Already in the 1940s, in the midst of the grimmest war in modern history, Rothko, with a fervent group of middle-aged artists working in New York, tried to turn the clock so far backwards that we might be witnessing a prehistoric world of the most primal creatures, of the most elemental nature. In a picture from these years, one of 1944, with the descriptive title *Slow Swirl at the Edge of the Sea*, we can just make out two humanoid beings who stand like totems on what seems to be the water's edge. They look like biological fantasies, with male and female sexual distinctions that conjure up not only a kind of mythic Adam and Eve, but some microscopic adventure in cell division, as if we were being taken back to the very origins of life. The atmosphere in which these creatures exist also takes us back to primeval roots. A shore-line below, a hazy expanse above, some watery ripples; all of these evoke a strange environment of earth and sea, of heat, light and air.

37

But soon Rothko rejected even these references to the particulars of biology or of nature. By the late 1940s these specific clues have been dissolved in patches of glowing light that take us back to an even more primitive sense of the beginning of the world. And by 1950 even these irregularities are stilled. The format is now of the utmost quiet and simplicity, as if everything had been annihilated and we were on the awesome brink of something or nothing.

Rothko was not alone in this pictorial adventure of pulverising the material world. His artistic allies in New York had moved in a similar direction. Jackson Pollock, for instance, had also painted pictures in the mid-1940s that plunge us back to mythical and biological origins; and by the late 1940s he too created a universe of paint that dissolves such creatures and leaves us before something as overwhelming as the Milky Way or a galactic explosion.

Jackson Pollock, *The She-Wolf*

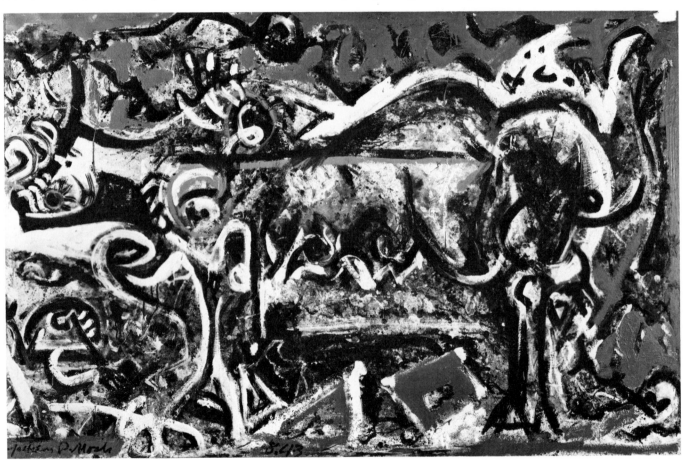

Even more extreme, the painter Barnett Newman could also destroy all of matter, leaving us before a boundless void, disturbed only by paths of energy that have left marks like jet-streams. In all of these works the feelings generated are extreme ones, like those attending an apocalypse or perhaps the Book of Genesis: of a world, that is, which has been destroyed but that might begin again. These are feelings many shared after 1945, when the terror of the atom bomb had halted World War II and cast the most fearful shadows over the destiny of our planet.

Rothko's paintings often belong to this world of cosmic ultimates. In the picture at the Museum of Modern Art we may feel that the

38

images are as yet unformed, as if they might eventually congeal into lucid rectangles of hard and solid blocks that will set the laws of gravity into motion for the first time; or that contrariwise they might disappear like puffs of smoke and leave us with a total void. Even the colours and the darks and lights seem unstable, sometimes merging into the background, sometimes detaching themselves from it.

Yet in all this quietly shifting movement there is something still and solemn about the structure, something that can verge on the hypnotic. The three zones of the softest, duskiest black, brown and grey seem to have been hovering over an invisible horizon for all time. They take their places in dense tiers like the elementary building blocks of some primitive architecture like Stonehenge. And in this stark disposition of horizontal expanses that seem natural in character, Rothko's paintings often recall a long tradition of

Rothko, *Untitled 1956*

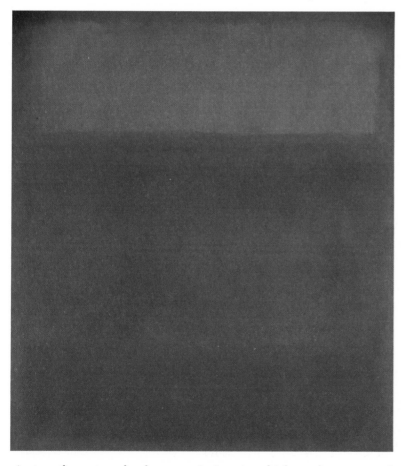

nineteenth-century landscape painting, in which earth, water and sky, colour and light fuse in a quiet continuous glow.

Although Rothko's paintings may at first seem blankly simple, their austere format was subjected by their inventor to an astonishing range of variations. Often Rothko explores colours of such blazing intensity that we almost feel the light and heat of the sun recreated. But more often the mood evoked is sombre and dark, of a kind of renunciation, especially toward the conclusion of a life that was ended in 1970 by his own hand.

No wonder many spectators have found in Rothko's work a twentieth-century equivalent of a modern religious art, of a kind of

painting that creates a mood of solemnity and contemplation. It was an ambition, in fact, that Rothko actually realised at the end of his life in a non-denominational chapel in Houston, Texas, where eight walls, like those of a medieval baptistery, create a kind of secular shrine where a group of eight of his darkest pictures hang. For many visitors, of all faiths or of no faith, these paintings can ask more questions about life and death, about shadow and substance, than the conventional religious art of our time.

# THE LANGUAGE
# OF COLOUR

Whatever distinguishes a great painting from a mediocre one is likely to be very little to do with the subject: some of the world's finest pictures treat thoroughly banal themes, while many a tremendous subject has resulted in a painted nonsense. It is a matter of style, of *how* it is painted. An artist's style is so much more than technique: technique is the syntax and grammar of art and any competent imitator may copy it. But how an artist uses colour and line is as personal as how a poet uses words. It is inimitable, the unique conjunction of one man's eye, brain and hand.

There are probably more dull paintings on classical and biblical subjects than on any other, it being easier to conceal smallness of talent behind resounding themes than behind humble ones. What lifts Poussin's *The Adoration of the Golden Calf* far above the ordinary is the way the artist has composed a large cast of figures so that we appear to be watching the climax of a classical drama, with colour used throughout to bring that drama to life.

From a little later in the seventeenth century, Vermeer's *The Artist in his Studio* could hardly be more different. The scene is intimate, not dramatic at all, and the colours are cool instead of fiery – muted yellows, blues, greys, black, with just the occasional gleam of gold. This is a mysterious picture, of an artist at work in his studio with a model posing apparently as Fame, holding a book and a trumpet. We do not know why Vermeer painted it, nor who is the artist sitting there. But as with the Poussin much of the quality of the picture resides in the extraordinary harmony and rightness of its colours.

There follows a jump of more than two centuries to Gauguin's *The Day of the God*. With the passage of Romanticism and more recently Impressionism, the emotive power of colour was by now more openly explored. Gauguin's painting is less to do with life in Tahiti, its supposed subject, than with an imagined tropical paradise in which figures are quite artificially arranged to create a sense of harmony with nature (surprisingly like Poussin), and all colours are deliberately heightened to raise the emotional pitch.

The influence of Gauguin's exotic colour on European painting early this century was nowhere stronger than on the group of young painters in Munich who included the Russian expatriate Kandinsky. The very title *Improvisation 6* indicates Kandinsky's desire to free painting from having to describe recognisable images in nature. This view that paint has a language all of its own, and the act of painting a life of its own, found its most powerful advocate in the American Jackson Pollock in his 'drip' pictures of the 1940s and 50s. *Autumn Rhythm* may appear to defy all the traditional values of art, in that it has no subject at all. But then neither does a piece of orchestral music. Pollock compels us to rethink what we expect art to be, and what it is that the language of paint is supposed to communicate.

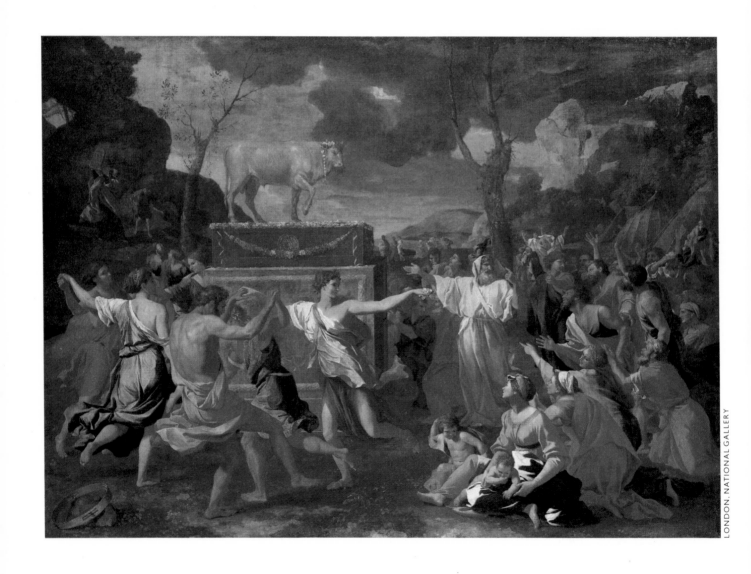

42

EDWIN MULLINS

# Poussin 1594–1665

# The Adoration of the Golden Calf 1633–6

The perfect setting for this painting by Nicolas Poussin might have been the drawing-room of some notable scholar of Classics overlooking the Ancient Forum in Rome about three hundred years ago. The National Gallery in London has done its best with a few Roman stage-props: a marble head of Hercules, a frieze of draped figures – accessories from Rome's imperial past of the kind which would have caught Poussin's eye when he took his stroll through the city every morning, and which became the models for his way of seeing life and his way of painting it. Poussin was a Roman by adoption: born in France, he lived in Rome with only one short interlude from the age of thirty until his death forty years later in 1665.

The English painter Sir Joshua Reynolds said of him:

'Poussin lived and conversed with the ancient statues so long that he may be said to have been better acquainted with them than with the people who were about him.'

How true that is of this painting: I recognise these people to be men and women but they are not on my planet, and I have little idea what goes on in their minds. Their reality is not the reality of life but of art: the world they inhabit is ruled by laws of harmony which in our world operate only within the ballet or the theatre. In fact what we are looking at *is* a kind of theatre; it is a sumptuous production with magnificent lighting effects and a huge cast, and the subject of this stately drama is not classical at all, neither Greek nor Roman, but the Old Testament story from the Book of Exodus of the *Adoration of the Golden Calf*.

Moses has brought the Children of Israel out of Egypt towards the Promised Land. While he is on Mount Sinai receiving the Tablets of the Law the people have turned away from Jehovah and asked Moses' brother Aaron, their high priest, to fashion them a golden idol. He does so, then builds an altar before it and – in Chapter 32 verse 5 – proclaims a feast-day to the new god. The white figure of Aaron is picked out near the centre of the picture gesturing towards the altar and leading the gestures of his followers. Meanwhile Moses returns with Joshua from Mount Sinai carrying the Tablets of the Law – the Ten Commandments; as verse 19 describes this moment: '. . . as soon as he came nigh unto the camp . . . he saw the calf and the

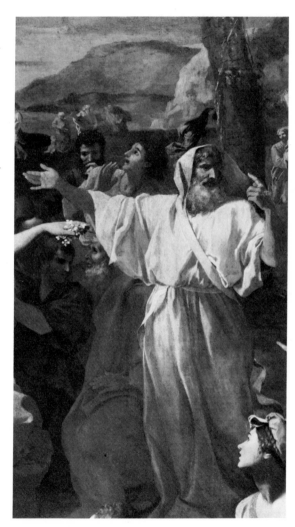

Detail of Aaron, *The Adoration of the Golden Calf*

43

dancing: and Moses' anger waxed hot, and he cast the tablets out of his hands, and brake them beneath the mount.' This dramatic intervention Poussin has relegated to a background detail, but in such a way that the figure of the angry Moses is raised above the crowd of Israelites giving a second meaning to their display of hands and excited faces. They are gesturing in delighted amazement at their new golden god; at the same time there is the suggestion of incipient horror and panic as they notice Moses and realise what they have done.

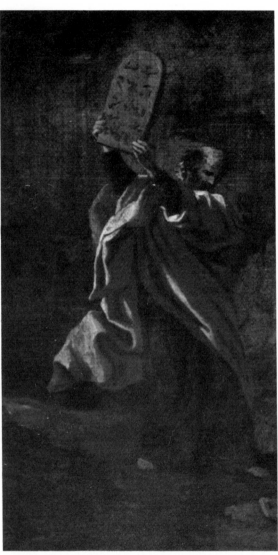

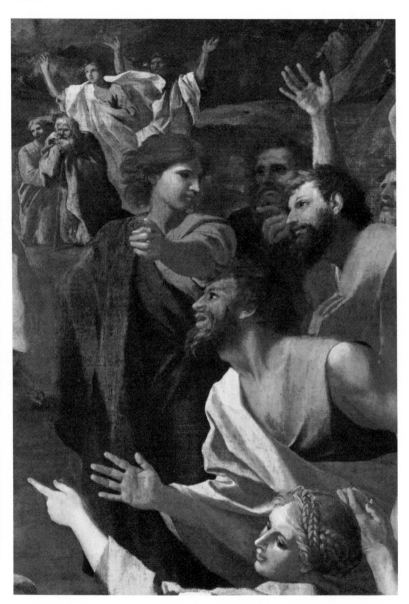

Details of *above* Moses, *right* the Israelites, *opposite* mother with child: *The Adoration of the Golden Calf*

This note of fear is exemplified by the anxious gesture of the mother clutching at her child in the foreground. It is echoed by the blasted trees whose branches mimic the raised arms beneath them; and it is echoed too by an apocalyptic sky. The Pillar of Cloud guiding the Children of Israel has taken on a look of menace, and its surrounding blaze seems to hint at the terrible punishment to come when Moses is to allow the tribe of Levi to butcher 3000 guilty Israelites.

Colour plays a major dramatic role in the painting, the role that in a film would be carried by deafening sound-effects and in an opera by a crashing aria. The whole picture is keyed to the colours of passion and the colours of fire, as if the scene were caught in the glare of this tremendous sky. Reds, yellows, orange and gold: burning colours. Colours that are melting in the heat.

So composed a painter, Poussin. So restrained apparently. Not at all! What he has given us is a textbook classical drama obeying all the rules of ancient Greek tragedy as defined by the philosopher Aristotle. Unity of time and place. Events arousing pity and fear. Narrative sustained by a chorus (here it is a group of dancing figures). Violent action taking place off-stage (Moses breaking the tablets in the background). For Poussin was a contemporary of the great French classical dramatists Corneille and Racine and in this picture we might be looking at a scene of one of their tragedies.

Classical drama is as different from Shakespearian drama as Poussin's paintings are from those of his contemporary, Rubens. Rubens' own account of Moses summoning the Israelites was painted at much the same time as Poussin's *Golden Calf*, in the 1630s: but what a different view of dramatic action. With Rubens the dramatic agent is always the human body. It is a physical drama: bodies writhe, muscles ripple. Everything with Rubens is in the drawing. With Poussin it's in the colour. The figures themselves are statuesque as if they were classical actors. Even the dancers are frozen in motion. There is a profound difference in style between the Baroque Rubens and the Classical Poussin. Also a difference in method: Rubens worked from living models, Poussin from wax models. He would make these about four inches high and arrange them on a kind of miniature stage to get the groupings he wanted and the most desirable effects of light – which incidentally must be why the figures here are illuminated by stage-lighting from behind us, though the source of light within the painting is in the far background.

Poussin would then make larger models and clothe them with moist linen of different colours; and only now would the painter take over from the choreographer. Several pictures might emerge from the same stock of figures. The dancing group in the *Golden Calf* is obviously drawn from the same cast of little wax models as the dancers in *Bacchanalian Revel* also in the National Gallery. There, the graceful girl in blue is almost a mirror-image of the central figure in the *Golden Calf*, only now Poussin has draped her in white to balance the other central figure of Aaron.

How meticulously planned: it is like some obsessive general planning battles with toy soldiers. The miracle of Poussin is that his pictures should come to life at all; and again it is this blaze of colour which warms so much cold wax to life. Not the figures only but the entire painting is enflamed with life to the very horizon. The sky, this golden beast, these crippled trees, and the enclosing rocks – dark against light facing light against dark: everything is designed to heighten this tremendous moment of psychological tension when collective ecstasy is on the point of turning into collective fear.

This is a supreme dramatic achievement, a pulling together of all the elements within the painting, everything singing in tune. It is

Detail of the dancers,
*The Adoration of the Golden Calf*

47

*Above* Poussin, *Bacchanalian Revel*;
*right* detail of the dancers, *The Adoration of the
Golden Calf*

Poussin's supreme gift, which he never lost. Later in life his stage opens out, or rather the broad expanse of nature becomes his stage. There is less of the classical dramatist, more of Shakespeare, about *Landscape with a Snake* – the Shakespeare of *The Tempest* and *A*

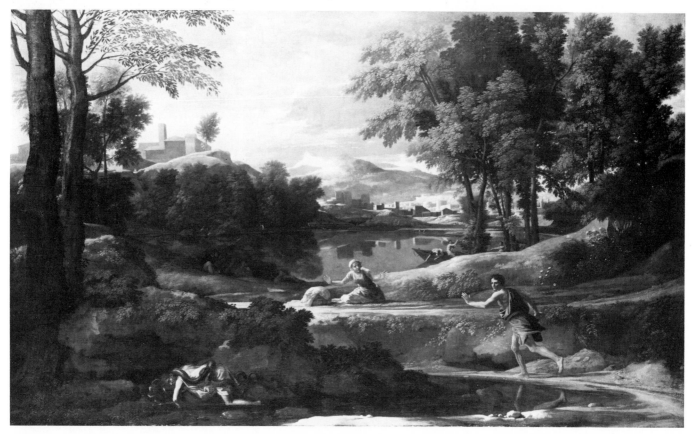

Poussin, *Landscape with a Snake*

*Winter's Tale* with nature the haunting and controlling influence upon man's affairs. And again as in the *Golden Calf* here is a moment of fear: the discovery of a man horribly strangled by a serpent sets off a chain of human reactions. Very soon we know that the account of death will reach the boatmen who are still peacefully unaware, and the town still bathed in sunlight beyond. The news will travel like the dark shadow in which half the picture is already plunged.

Everything in *Landscape with a Snake* is keyed to the colours of damp and chill, where in the *Golden Calf* it is the colours of heat. In both paintings there is the same synthesis of nature and human action, colour and human mood. Exterior with interior, everything in tune. It is hard to believe it was set off by run-of-the-mill Roman sculpture and miniature wax models dressed in coloured linen. Can there be a better illustration of creative genius than this process of transformation: a phoenix from the ashes? He is a painter's painter, Poussin, and maybe it requires something creative in us, the spectators, to appreciate the reality in him.

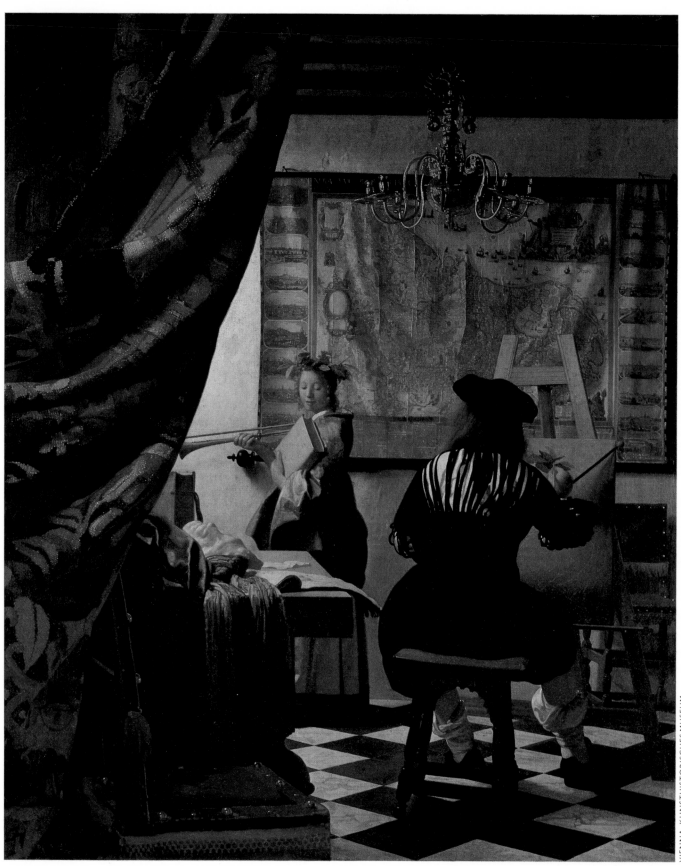

50

DAVID PIPER

# Vermeer 1632–75
# The Artist in his Studio c. 1670

If you could get round to the front of this picture – which alas you never will be able to – you might be confronted by something pretty smart. Punk almost, perhaps. Or not. But anyway you might find out who the man is, which has been the subject of argument. It has been suggested it is a self-portrait of the painter who painted this picture – Jan Vermeer of Delft. If so, it was done with the aid of mirrors, so that he could see himself from the back. Vermeer surely did use mirrors sometimes, and perhaps even in this, but I doubt myself whether the figure is intended for himself. For me, the impression is of a young man, sitting there painting. But everyone agrees that, though the date of this painting is arguable, it must be late in Vermeer's career – perhaps about 1670. On the other hand, Vermeer was only forty-three when he died five years on from that, in 1675: young, at least by our reckoning.

Anyway, the picture is infused with Vermeer's presence – or the perfection of his lack of presence. Kenneth Clark, talking about this picture, noted that no painter 'had so fine a sense of withdrawal'. It is one of the jewels of the Kunsthistorisches Museum in Vienna: Vermeer's *Artist in his Studio*. It has not always been here. It was used to settle a posthumous debt with his mother-in-law, after he died in 1675. Then it vanished from sight, and was only reidentified as a Vermeer in 1860. In the last war there occurred a bizarre interlude in its history: it was sequestered from an Austrian private collection to adorn Hitler's rooms at Berchtesgaden. From that horrid context it was liberated in 1945 to find its rightful home back in Vienna.

It is a picture of a painter painting a picture. You see him from behind, almost looking over his shoulder. An odd shape: curvy, low black shoes on the chequered black and white marble floor; long white boot hose gone floppy halfway down his calves and showing the red stockings underneath; vast, bulbous black breeches planted solidly on the stool. A *very* fanciful jacket or doublet, close round his middle like a wide black cummerbund, but then shredded to black ribbons over a white shirt; long brown hair, fluffy as if fresh from the drier; soft, round black cap perched on top. Vermeer stands off, stands clear, distances the world he paints from anything so trivial as the artist's own presence – one reason why I myself do not consider that black and white back to be Vermeer's own.

51

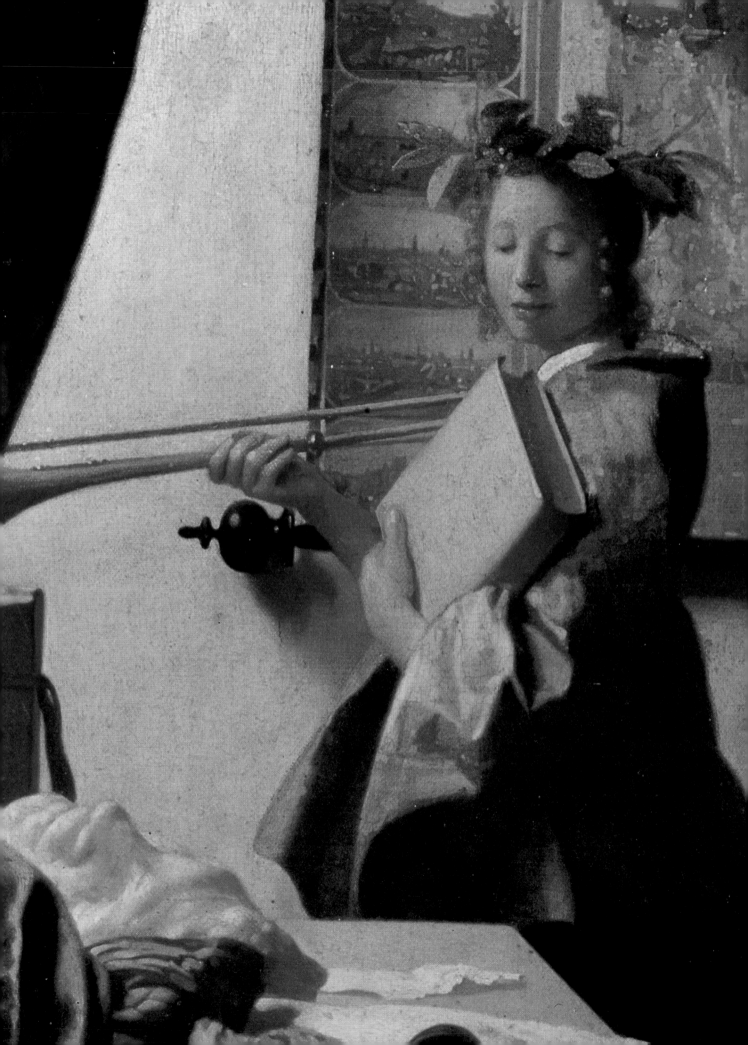

The presence that *is* Vermeer's own is the gentle but all-revealing light that suffuses the painting, and that infallible certainty about the relationship of one object with another, in that cool key of colour – the muted yellows, blues, glint of gold, greys, anchored on black. And that silence. The painter's brush – and how minute it is – may make the faintest sound when he looks down to his canvas, but none yet.

And this brings me to his model – the girl standing over by the wall, and the elaborate map hanging on it. She has a beautiful blue drapery about her, an opalescent silky blue, its tones shifting like those of the calm shallows of a summer-afternoon sea. She holds a rather large yellow book in the crook of one arm; in her other hand she holds a trumpet. Her light brown hair is crowned with what seems to be laurel, though the leaves are mostly blue. A chemical change over 300 years may be responsible for that, the yellow bleaching out of the original green to leave blue. This girl is generally identified as posing in the traditional allegorical image of Fame. Or alternatively, of the Muse of History, which is much the same thing, History being the medium in which Fame is perpetuated.

So the painter painting her would be painting an allegorical subject-picture, though on his blank canvas he has only got as far as indicating very broadly the outlines of her figure, and is starting in on detail, by working on the laurel leaves that crown her head. Incidentally, they too are blue. But it is all a bit odd. The model seems singularly reserved, shy almost, out of character as Fame. Fame was saluted quite frequently by Vermeer's baroque contemporaries, normally as would seem to befit her role, in fairly exultant form, and blasting away all but audibly – as in *An Allegory of Fame* by Valerio Castello, an Italian painter about 1650, whose ceiling fresco in the Palazzo Reale at Genoa shows the lady as tremendously airborne.

That of course is in the full-blooded vein of the Italian seventeenth century, very different from the tranquil domestic subjects of the Dutch tradition in which Vermeer was working. But Vermeer, like many of his compatriots and not only those whose style reflected predominantly an Italian influence, was also far from immune to the temptation of enriching with allegorical colour and allusions his apparently banal domesticities – banal only of course as far as the subject-matter is concerned. An example is Vermeer's *Woman Weighing Pearls*, now in Washington. Here there is surely a variation on the *Vanitas* theme, a comment on the seductive delight of the riches and pleasures of the flesh, contrasted with the ominous threat of the Last Judgement as represented by the picture on the wall behind the girl.

Once, and apparently at about the same time as he painted *The Artist in his Studio*, Vermeer attempted a whole-hearted out-and-out allegorical treatment. This was the *Allegory of the New Testament* now in New York. The imagery in this follows the directions for the subject given in the standard work on emblems and devices, the *Iconology* compiled by the Italian Ripa in the sixteenth century and known throughout Europe. I doubt though if it is many people's favourite Vermeer, for all the brilliance of its handling. The action seems to contradict the setting – that very rhetorical lady – you may

*Opposite* detail of the artist's model, *The Artist in his Studio; below* Vermeer, *Woman Weighing Pearls*

53

think she doth protest too much – and all the symbolic paraphernalia, but set in a Dutch interior, a quite everyday if fairly rich one, apart from the trappings. It all adds up to a vision that is not very convincing: incongruous, almost rather absurd.

*The Artist in his Studio* has much the same rich carpet-curtain, seen close to your eye and so a little blurred in focus, and drawn back as if it were a stage curtain, and there is much the same basic interior beyond, and a strong allegorical element. The whole impression is, however, very different. In fact it is probably rather earlier than the *Allegory of Faith*, yet it could almost be a reconsideration of method in the light of its admitted failure, almost a critique. Almost an engagingly modest statement of the unsuitability of high-flown allegorical rhetoric for this artist's particular serenity of vision. Fame turns out to be a young and pretty but quite ordinary Dutch girl. Her

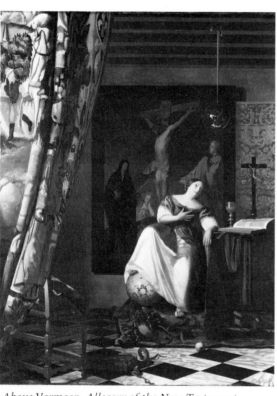

*Above* Vermeer, *Allegory of the New Testament* (or *Allegory of Faith*); *right* and *opposite* details of tapestry curtain, *The Artist in his Studio*

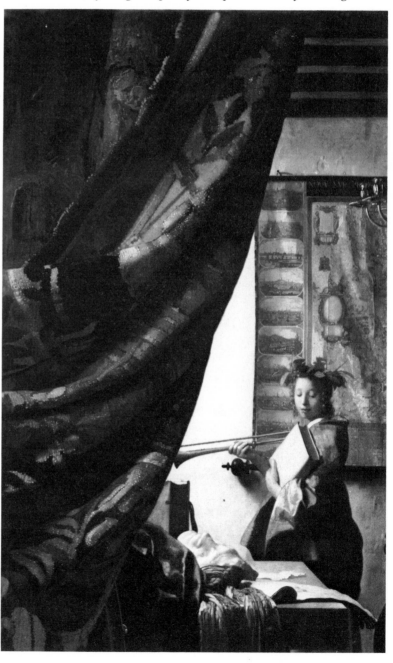

eyes are cast down, bashful; her grasp of the trumpet is far from professional, and you may justifiably doubt that, if challenged, she could manage to extract a single note from it. Very soon the great book will become intolerably heavy, begin to slip: she will need a rest.

The *Artist in his Studio*, according to Vermeer's widow, was titled *De Schilderkonst*, 'The Art of Painting'; and it is no doubt as much an allegory as the New York religious painting. But in spite of its accumulation of accessories – the books, the rich stuffs, the plaster cast on the table, the girl's decking with trumpet, book and laurel – it is, as composition, most beautifully resolved, in the endlessly fascinating way the space, the depth, of that room is articulated by the horizontals of chair, table map and ceiling rafters; by the complementary diagonals of the draped curtain, the chequered floor,

all centred by what is an almost mathematical triangle, formed by the figure of the artist with his easel, the girl, and at the apex, the sparkle of the chandelier. Mysterious hints remain unsolved in the subject-matter. Who *is* the artist sitting there? Is there an implicit ironical comment on the nature of fame? Why does the map show Holland as it was under the old and hated Spanish and Catholic domination instead of in its triumphant Protestant independence? Vermeer was a Catholic, but we are not much the wiser. The real mystery, endlessly unresolved, endlessly entrancing, is the power of Vermeer's infallible sense of cool colour, harmony, his ability to create space flooded with light.

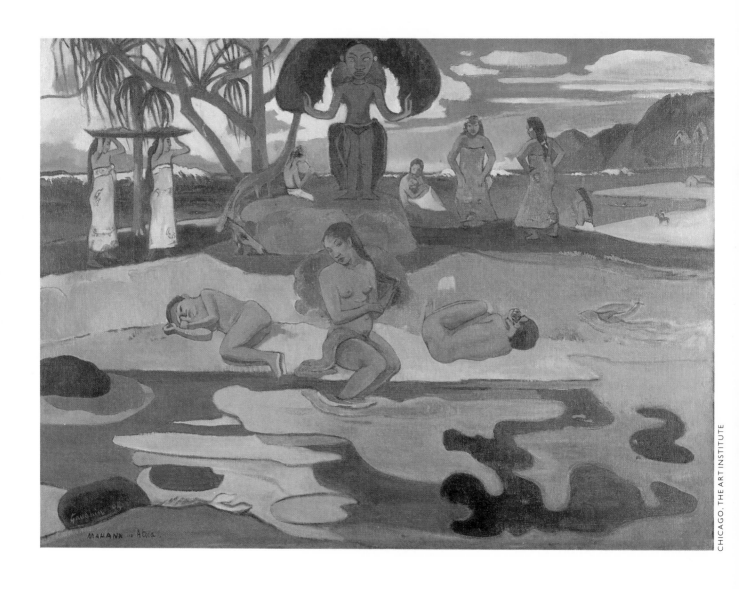

# Gauguin 1848–1903
# The Day of the God 1894

What is implicit in Gauguin's paintings is often more interesting than what is explicit. Take, for example, the area in the foreground of *The Day of the God*: cover over the rest of the picture and allow your eyes to wander back and forth across these strange coloured patterns that are supposed to be reflections in the water, but which very soon take on a strange and rather exciting life of their own. Seeing them out of context, you might accept them as the work of an abstract artist of our own day. The man who painted them in 1894 did more, in my view, than any other artist to demonstrate that colour itself is a kind of language. Colours can strike an emotional response in us just by what they are, and by the shapes and rhythms they describe.

The painting is one of those inspired by the years Gauguin spent in Tahiti. The Gauguin legend often obscures the fact that he was not trying to paint life in the Pacific Islands as he found it. 'With me,' he wrote, 'everything springs from my mad imagination . . . .' This picture was actually painted in Paris between two prolonged stays in Tahiti, and it is a fabrication. He painted it – so to speak – from his guts: Gauguin in fact used the phrase 'the mysterious midriff of the mind' to describe where the experience of an artist should be located; and these luxurious colour-rhythms in the foreground of *The Day of the God* have no firm basis in anything he actually saw.

What Gauguin wanted was to evoke a kind of paradise. He held the view, shared by nineteenth-century writers like Baudelaire and Robert Louis Stevenson, that such a paradise had once existed, had been trampled upon by Western civilisation, and could now be detected – just a shadow of it – only in very primitive societies. This of course is where Gauguin the artist and Gauguin the legend are peculiarly hard to unravel, because Gauguin *did* abandon the career of a Paris stockbroker and go and live the primitive life in the Pacific Islands. What is more, he furthered his own legend by writing idyllic accounts of that life (in *Noa Noa*) as if it were the Garden of Eden – which we know from his actual letters it certainly was not.

In Tahiti Gauguin did find Paradise, but it was in his imagination; and we have to see this painting as something spun out of that imagination. For instance, the Tahitians apparently never carved huge idols like this one. The god is Taaroa, the supreme deity of the islanders – a Zeus figure, father of the gods – and Gauguin has pieced

Gauguin, *Noa Noa*, illustration from page 4 of the manuscript

57

Gauguin, *Under the Pandanus*

Poussin, *The Andrians*

together a deity out of Buddhas which he had seen in European museums and Easter Island figures he had read about. And since there were no such idols in Tahiti, the two girls bearing baskets of offerings to the god must also be invented – or at least adapted. Village girls carrying home food have been transformed into figures from classical Greek mythology, in this case: they are *canephoroi*, basket-carriers who once carried fruit to the Greek feast of Demeter.

The tree in the background – a pandanus tree – is another adaptation. This time it is from a picture he had himself painted three years earlier when he was in Tahiti. He has virtually copied it. And these figures on the shore: no three figures ever composed themselves quite as geometrically as this. The naked girl with her feet in the water poses so exactly in front of the statue of the god as though by his command. The sleeping children are curled womblike one this way, one that, each arranged beneath a pair of standing figures as if the presiding god were a divine gym-master positioning his class in some disciplined exercise. No, life is not like this. Tahiti was never like this, and no Tahitian would have recognised it as true. Only a man steeped in European culture would have painted like this at all.

The more I look at this painting by Gauguin the more I think of that most classical of French masters, Nicolas Poussin, in the seventeenth century, whose works – like *The Andrians* – hung in the Louvre in Paris for all budding artists to admire and emulate. With Poussin art had reached a kind of perfect artificiality. Figures from a mythological past arrange themselves gracefully as if by some supreme law, engaging themselves in sweet pleasures in harmony with their surroundings, and engaging our emotions by means of the colours they wear, which are as rich and pure as music.

I doubt if anyone in late nineteenth-century France would have understood such a comparison, and neither, I feel sure, would Gauguin. And yet both artists were concerned with idealising a myth that was remote in time and place. The difference was that Poussin's myth was Greek and therefore generally acceptable because it was *our* civilisation, whereas Gauguin's was alien and considered savage. A case of naked European chauvinism.

Gauguin himself believed that by turning his back on Europe he was turning his back on European classical painting: all that Greek stuff. In fact I believe he gave it a new lease of life, a blood transfusion. By the late nineteenth century, there was nothing much left to do with those themes of Greek gods and heroes who had inspired Raphael, Titian and Poussin to such noble efforts of the imagination. Mythological painting was now moribund. So was religious painting. The world of the imagination had shrunk. There was only the world about us. Realism. Impressionism. The street. The café. The countryside. Where could a painter locate again that underground river of human invention? Where was the new mythology?

The answer – and it seems to me to be among the most crucial discoveries in modern art, and indeed in modern thinking – was the subconscious: dreams, daydreams, the inner eye. Douanier Rousseau hit on this discovery while venturing no further than the Paris zoo. Gauguin crossed half the world to make the same discovery. It was

not the physical journey that mattered, it was the journey into what Gauguin described as that 'mysterious midriff of the mind'.

No one in the 1890s could have foreseen where this exploration into the subconscious might lead, but it is probably the single most revitalising force in modern painting, and it travels like a troubled spirit through the work of the Surrealists – Max Ernst above all. It

inhabits the dismembered victims of Picasso's great anti-war painting, *Guernica* (page 204). It haunts the doomed features of Edvard Munch's citizen's of Oslo, their interior hell projected on the sky like a curse of nature. Munch painted *Anxiety* in the same year, as it happens, as Gauguin painted *The Day of the God*: 1894. Almost certainly they never knew each other. Both simultaneously hit upon that emotional language of colour and rhythm in which the subconscious manifests itself in painting most readily.

But how peaceful, how gentle Gauguin seems after the turmoils of Expressionism and Surrealism. What a quiet, idyllic picture this is. Classical – I use the word again. Whatever emotions are stirred by these vibrant colours and swirling forms are also controlled by the harmony of the figures and by the inner peace they exude. Gauguin in his paintings created a mythology of tropical paradise which cruelly eluded him in his life. Perhaps that is why he created it in pictures. This is one of those paintings that makes me understand why it is sometimes tormented men who need to make art – and why we, when tormented, may find peace by reflecting on it.

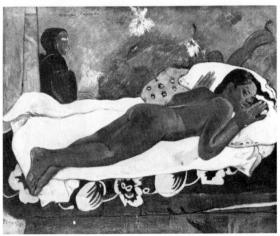

*Top* Gauguin, *Nevermore*;
*above* Gauguin, *Spirit of the Dead Watching*

59

RICHARD CORK

# Kandinsky 1866–1944
# Improvisation 6 1909

In the early years of the twentieth century, when Kandinsky decided on this painting's enigmatic name, most artists still gave their pictures recognisable titles. They supplied precise information about their subjects, revealing the sitter in a portrait or the location of a landscape. And viewers, who might otherwise have been uncertain about the artist's intentions, were reassured. Even if the work of art was puzzling, its title helped spectators to sort out exactly what they were looking at.

But Kandinsky provides no such comfort. In the full knowledge that most people would be bewildered by a painting of two featureless figures in surroundings impossible to identify, he chose a name which offered them little assistance. Indeed, by calling his picture *Improvisation 6*, Kandinsky actually discouraged us from hunting around the canvas in search of a representational scene. Not only does the word 'improvisation' imply that he sat down in front of his easel and extemporised a purely imaginative theme. The number 6 also indicates that this painting belongs to a series of almost musical variations, and that the artist need be no more reliant on a description of visible reality than the composer.

As it happens, the musical analogy was quite deliberate. A fervent admirer of Wagner and friend of Schoenberg, Kandinsky envied music its ability to go beyond the reproduction of nature and uncover what he called the 'inner life'. In his book *Concerning the Spiritual in Art*, which he started around the time *Improvisation 6* was painted, he claimed that all the arts 'are drawing together' and 'finding in Music the best teacher'. Kandinsky hoped that onlookers would approach his work in the same way that they listened to a concert, treating his forms and colours as musical notes rather than a mirror of outward appearances.

Even so, *Concerning the Spiritual in Art* doesn't simply publish the banns of a marriage between music and painting. Right through this book, which had a widespread influence on abstract artists after its appearance in 1912, Kandinsky argues with all the zeal of an evangelical preacher for disclosing 'the internal truth of art'. Convinced that a great spiritual reawakening was imminent, he thought artists would be the first to hear the voice of 'the invisible Moses' and spearhead a revival of divine values. Everything

obstructing the development of this inner need was 'sinful'; everything promoting it was 'sacred'. The entire book is charged with Kandinsky's mystical conviction that the painter, like a medium at a séance, might bring an audience into direct contact with the 'soul' of humanity.

Nowadays, of course, all this elevated talk about the inner spirit sounds far-fetched to everyone except the believer. The upsurge of enthusiasm for the doctrines of the Russian Orthodox Church, to which Kandinsky belonged, never happened. And he eventually witnessed the advent of a godless communist revolution in his own country. But if his religious hopes now seem increasingly remote, Kandinsky's other perceptions of the changes modern life was undergoing still retain their relevance. He studied law and economics before committing himself to art at a relatively late age, and his keen interest in science alerted him to the full significance of recent developments in experimental physics. Suddenly, the entire universe was seen to be in a state of flux, and the dependability of science itself called into question. Einstein and Freud both confirmed the doubts in Kandinsky's mind, and helped him reach the gradual conclusion that art should not try to depict the external face of reality any longer. *Improvisation 6* is among the first of his paintings to reveal a radical new priority, burrowing beneath the façade of things and unearthing deeper forces at work in the world.

It may seem a paradox that the latest discoveries of science should have confirmed Kandinsky in his religious beliefs. But he did feel that the shattering of old scientific certainties about the reality in front of our eyes justified his interest in mysticism, and his Russian origins spurred him on. The bold, almost heraldic colours used in *Improvisation 6* owe a debt to the Russian folk decorations he saw during an early expedition to the province of Vologda. The raw vitality of this peasant art, and the flat, jewel-like colours found in icon painting, both helped his move away from naturalism towards a more abstract approach. He once described his *Improvisation* series as 'a largely unconscious, spontaneous expression of inner character, the non-material nature'. And his Russian roots helped him to break with the representational tradition of European painting at a time when most other artists still shied away from abstraction.

But Germany was an important influence too. In 1896, when the 30-year-old Kandinsky decided to devote himself to art, he left Russia and moved to Munich. It was a far more lively centre for artists, and he was fired by the work of painter-friends like Jawlensky, Franz Marc and Gabriele Münter to push his ideas as far as they could go. The old Russian fairy-tales and legends which people his early work merge with German medieval fables as Kandinsky settled in his adopted land. And the countryside around the isolated village of Murnau in Upper Bavaria, where he and Münter bought a house in 1909 and lived for most of the year, helped him achieve a new uninhibited violence of colour. Soon, in the Murnau landscapes, his external response to the scenery around him was replaced by an internal exploration of his own subconscious. Traces of the mountainous Bavarian terrain can still be seen in *Improvisation 6*, but they are now impossible to pinpoint with any certainty. Someone later

subtitled the painting 'African', as if to suggest it was a souvenir of his visit to Tunis in 1904. But the truth is that no such setting can be identified here. This picture takes us out of the visible world and into a startling alternative – the one Kandinsky inhabited in his own mind.

Everything is shifting and ambiguous in this visionary place. Although the two figures in the foreground are comparatively clear, Kandinsky ensures that the strong contours which define them, and the exclamatory colours within those outlines, are emphasised in their own right as well. They blend with the other, more abstract elements in the picture to such an extent that it becomes misleading to talk of a 'foreground' at all. Conventional perspective gives way to an altogether more malleable space, which bends, twists, swells and flattens like the space in our dreams. Just as we think that a fixed position has been established, from which to gauge the distance between objects and judge their relative sizes, all our speculations are confounded by a cloud as heavy as a boulder, or a hilltop which might be a man. Is the large white structure on the left a wall or an entrance, a solid or a vacuum? We don't know, and Kandinsky won't tell us. He wants to emphasise the mystery of the so-called 'real' world we usually take for granted.

*Improvisation 6* conveys this strangeness principally through colour. It is a brilliantly orchestrated painting, and all the colours are allowed to detach themselves from the things they describe in order to carry a more forceful impact. Kandinsky believed that colour and form were the two main 'weapons' of painting, but in *Improvisation 6* colour achieves the more complete independence. Throughout his book *Concerning the Spiritual in Art* he stressed the 'psychic effect of colour', and explained how it can deliver a direct shock to the spectator. Warm red, for instance, which plays a prominent role in this painting, was cherished by Kandinsky for causing 'a sensation analogous to that caused by flame'. And he valued keen lemon yellow

because it 'hurts the eye'. But he also knew how to temper these aggressive colours, and make them doubly effective, by contrasting them with a pacifier like green, which he described as 'the "bourgeoisie" – self-satisfied, immovable, narrow'. Every hue had a very precise effect in Kandinsky's view, and he uses them so vividly in *Improvisation 6* that they seem to leap out of the picture towards the onlooker. This painting makes us aware of the marvellous eloquence of colour, its ability to invade our emotions almost irrespective of the scene it represents.

Almost, but not quite. Kandinsky, who was soon to become one of the first abstract painters in our century, was nevertheless acutely aware of the dangers which abstraction could lead to. In his book he warned artists – rightly, as it turned out – not to become so arbitrary in their use of colour that nothing but pure patterning results. He was also concerned that any painter who excluded 'the human element' might 'weaken his power of expression'. Both these pitfalls were uppermost in his mind when he painted *Improvisation 6*, which bears out his belief that 'purely abstract forms are beyond the reach of the artist at present; they are too indefinite for him'. A couple of years later he was to change his mind, but *Improvisation 6* holds the rival demands of representation and abstraction in skilful balance. It is a pivotal work, moving with such sureness from the principal figures to less easily readable areas that they all appear at one with each other. Kandinsky is here on the edge of his long voyage into the abstract workings of his own psyche, and in *Improvisation 6* he

Kandinsky, *Couple on Horseback*

Kandinsky, *Colourful Life*

almost seems to be pausing – looking back to earlier paintings where figures and landscapes are both clearly visible and at the same time looking forward to later canvases in the *Improvisation* series, where all descriptive props have been swept away by the irresistible flood welling up from his released subconscious.

But it would be a mistake to regard *Improvisation 6* simply as a halfway house between two phases of Kandinsky's work. The figures in this painting are not merely vague embodiments of the artist's mental state, preparing themselves like travellers for the next stage of their journey towards the non-representational territory depicted above them in the painting. They are substantial *dramatis personae* in their own right, performing a set of actions according to the meaning Kandinsky wanted his picture to convey. In other works of the period, like *All Saints' Day* or *Last Judgement*, he disclosed his religious preoccupations through the use of explicit titles, proving beyond doubt how central a role Christianity played in his subject-matter. The name *Improvisation 6* refuses to offer any such clue about the picture's theme, of course, but its strong narrative content

Kandinsky, *Improvisation 31, Sea Battle*

cannot be avoided for long. And I would suggest that the story it tells, probably the most crucial and affirmative to be found in the Bible, deals with the self-same spiritual rebirth Kandinsky anticipated

66

Kandinsky, *All Saints' Day II*

throughout his contemporary writings.

Like all Christians, he must have attached particular importance to the resurrection story, and even after his move to Europe he never failed to attend Easter services in a Russian church. So it's hardly fanciful to suggest that the huge red block held by the figure on the right, whose head is crowned by a burnished halo, might be the stone rolled away from Christ's tomb. And the figure on the left, clutching a long stretch of blue drapery, may equally well be the man in the 'long white garment' whom St Mark claims was inside the empty sepulchre. The references to Easter, when Christ rose from the dead leaving only his linen clothes behind, seem to me feasible. I can't prove them conclusively, and Kandinsky wouldn't have wanted me to. Nor would he have wished me to over-stress the undoubted resemblance *Improvisation 6* bears to the Russian icon tradition, which treated the same subject with a comparable disregard for naturalism and a similar fondness of exuberant colours. But he did give this painting such a passionate, festive character that it reinforces the optimistic meaning of the resurrection.

Although we may not be able to share Kandinsky's religious fervour, then, it is difficult not to be affected by joyfulness of *Improvisation 6*. 'We are on the threshold of the art of the future', he wrote in 1910, filled with eagerness about the range of possibilities which adventurous painters were about to explore. Many of those possibilities have since been tried and found wanting. But it's worth looking back at *Improvisation 6* in order to realise, all over again, how exciting the rebirth of art must once have seemed. Now that the century Kandinsky ushered in with such energy is fast approaching its winter, the resilient sense of hope in *Improvisation 6* could prove more salutary than ever.

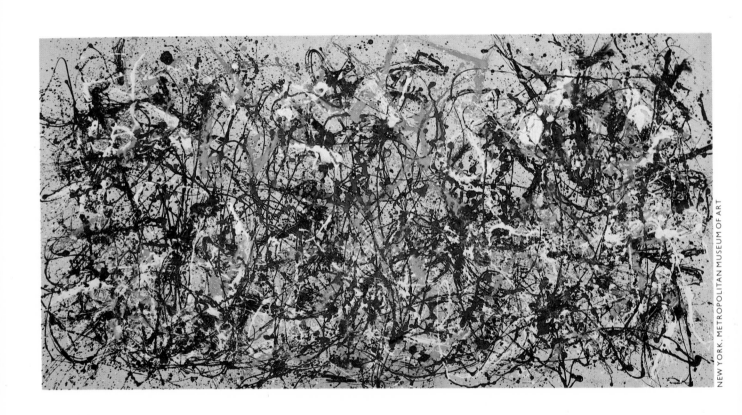

MILTON BROWN

# Jackson Pollock 1912–56
# Autumn Rhythm 1950

*Autumn Rhythm* by Jackson Pollock is probably the most puzzling work in this entire series of Great Paintings. It goes further than any other toward denying the traditional values we have come to accept in art. It has no recognisable subject, nor has it any recognisable or suggested forms, but more than that, it seems to lack any indication of skill. It looks literally like a pot of paint flung at a canvas, if not in the face of the public. And the public appears to have sensed the nature of Pollock's attack on the citadels of art. The label of 'Jack the Dripper' was no doubt inspired by ridicule, but it also reflects a certain unease in the face of implied violence. In *Autumn Rhythm*, which was in effect painted by throwing, spattering and dripping pigment on a canvas, chance or accident were postulated as art, as radical a stance as any taken up to that point in art history.

Pollock's antecedents are quite clear and admitted, though somewhat surprising. In the early 1930s he came as a young man to New York from California to study with Thomas Hart Benton, the western regionalist painter of the American scene, who introduced him to the art of El Greco. Benton was then painting murals and, through him, Pollock met the Mexican revolutionary muralists Clemente Orozco and David Siqueiros, active in New York at that time. Their expressionist intensity and commitment to a public art reinforced his own passionate attitudes. Like many others during the Depression he had his try at social themes and found them unsatisfying. He was one of a group of artists in New York seeking some universal truth in the chaos of the time. Pollock found his in the Jungian collective unconscious.

His early works in this vein were influenced by Surrealism – by painters like Picasso and Miró. The turgidity of paint, colour and symbols in these pictures was a reflection of his own psychic conflicts, his anxiety, rage and violence. The Pollock of those years was a dealer in magic and spells, in rituals and secret signs, purportedly dredged up out of his unconscious.

But it was through the Surrealist involvement with automatism, undirected, free associative drawing, that Pollock, around 1946, liberated himself from the hieroglyphics of the unconscious and transformed his art into a kind of ritual procèdure. Although Pollock

69

Pollock, *Going West*

is reputed to have been inarticulate, he seems to have been very clear about what he was doing. In 1947, he wrote:

'My painting does not come from the easel. I hardly ever stretch my canvas before painting. I prefer to tack the unstretched canvas to the hard wall or the floor. I need the resistance of a hard surface. On the floor I am more at ease. I feel nearer, more a part of the painting, since this way I can walk around it, work from the four sides and literally be *in* the painting. This is akin to the method of the Indian sand painters of the West.

'I continue to get further away from the usual painter's tools such as easel, palette, brushes and so forth. I prefer sticks, trowels, knives, and dripping fluid paint or a heavy impasto with sand, broken glass and other foreign matter added.

'When I am *in* my painting I am not aware of what I am doing. It is only after a sort of 'get acquainted' period that I see what I have been about. I have no fears about making changes, destroying the image, and so forth, because the painting has a life of its own. I try to let it come through. It is only when I lose contact with the painting that the result is a mess. Otherwise there is pure harmony, an easy give and take, and the painting comes out well.'

In these drip paintings, Pollock surrendered a large measure of

conscious control. He transformed the wrist and arm action of the brush stroke into an extension of bodily movement, almost a ritual dance. This method of painting creates what appears to be a chance configuration of a more or less linear network. For Pollock, this configuration was not accidental, but the result of a process, linking the picture or object with the painter or agent and the psyche or source.

Thus the label 'Action Painting', in which the picture is not preconceived, but the product of just such an uninhibited inter-action. The term 'Abstract Expressionism' was also used to describe the work of Pollock and others moving in a similar direction. But it is more specifically historical, tying this movement to such earlier manifestations of Expressionism, as, for instance, van Gogh, empha-sising emotional response rather than rationality — and back to the Romantics who also found the truth closer to the heart than the head. Abstract Expressionism is a more modern extension of this attitude, trusting the unconscious, the scientific replacement for the soul, above the conscious mind. In the end it really does not matter how valid all this is, but Pollock believed it and that belief somehow set him free. The tortured obscurantism of his earlier work suddenly opened up into lyrical grandeur.

To see *Autumn Rhythm* in the framework of more traditional values, one must step back out of one's prejudices and examine the painting freshly. To begin with, it is a very large and strikingly decorative picture. The colour scheme is rather chic but simple, which is perhaps its ultimate limitation — a sand-coloured back-ground upon which black, white, a light cocoa and an elegant slate blue have been applied. Despite its total abstraction, *Autumn Rhythm*, like other paintings of this period after Pollock settled in Easthampton, Long Island, reflects aspects of the seashore environ-ment, though never actually suggesting landscape. The drip paintings originally were simply numbered, but in some cases the visual associations evoked were so strong, that some were given more descriptive, naturalistic or poetic titles. *Autumn Rhythm* was originally *Number 30*.

Pollock's application of pigment transformed painting into drawing and, at the same time, as one critic noted, liberated drawing from its function in defining form. The drawing became a kind of calligraphy. Metaphorically, Pollock had created a new aesthetic language, although no one else has ever been able to use it.

Aside from the drip technique, perhaps the most obvious feature of the paintings of this period is their all-over pattern, an apparent regularity and repetition of form, that has led to their characteri-sation as wallpaper or marblisation. There is no single focus of attention, but an equal distribution of formal elements over the entire surface. It has even been incorrectly alleged that Pollock cut pieces out of large canvases to make smaller ones. In fact, the composition is rather tightly contained within the frame and, though border elements may project beyond, there is a palpable interior tension that draws the web away from the edges.

The layers of spatter, drip and swinging lines create a complex spacial movement in and out of depth, which is perhaps best

Pollock, *Number 1, 1948*

described as a galaxy of forms within an infinite firmament, shifting in relation to the observer. One can be encompassed by the galaxy from close up or view it like the Milky Way from a distance. In this connection, the role of scale becomes crucial, for Pollock has not only gone from easel to mural size, but created a scale which absorbs the viewer.

Pollock spearheaded a new movement in American art, in art in general. He opened the way for a new generation of painters by liberating himself from certain restraints of the past, by redefining creativity on a more personal and interior level, and, on the other hand, forcing the work itself into a more public role. Pollock's influence has been extensive and profound, but his art remains inimitable, the expression of a unique artistic personality.

# ADORATION

Unless it was a royal portrait, the most prestigious commission an artist could receive (at least until the eighteenth century) was to paint an altarpiece for some important and well-endowed church. This means that a great many of the finest pictures we have were painted for a congregation on its knees. They were a point of focus of the act of worship: they made accessible and familiar those figures whom the Christian faith required people to adore.

In general these were from the Bible – Christ and the Virgin Mary pre-eminently, then the apostles, and finally a wider circle of saints and martyrs. But before long shrewd politicians became adept at associating with such luminaries in a picture in order to deflect some of this glory upon themselves. A substantial payment to a church or religious foundation and, in the guise of humble donor, a nobleman could mingle with whom he pleased. It was too good a chance to miss. *The Madonna with Chancellor Rolin* is just such a painting, from early fifteenth-century Flanders, and Rolin was doubly shrewd in selecting the outstanding artist of his day in Northern Europe, Jan van Eyck.

The monumental austerity of Piero della Francesca's *Resurrection* could not possibly have admitted the intrusion of any figure so venal as a donor. Here only the sleeping soldiers witness the most triumphant miracle of Christianity. The painting was commissioned by Piero's home town of San Sepolcro, in Central Italy, and here the painting remains – once covered with whitewash, so it is said, and damaged by years of neglect, yet still among the most majestic works in all European art.

If Piero's masterpiece inspires awe, Botticelli's *Birth of Venus* is a painting to fall in love with. Everything in the picture enshrines the beauty of the goddess of love: roses fall around her like offerings, the wind plays with her golden hair, waves carry her gently towards us. We wait for her, as we have been waiting for her for five hundred years, ever since one of the Medici family in Florence commissioned the artist to paint her – not of course for any church but for his personal pleasure.

There can be no question whose pleasure was being gratified in Rigaud's grandiloquent *Portrait of Louis XIV,* of about 1700. It is a study of unashamed self-aggrandisement – the Sun-King in majesty – which would look absurd had the sitter exhibited the slightest self-doubt or self-ridicule. But it rises as effortlessly above absurdity as Tiepolo's glorious ceiling painting for a Venetian palazzo, some forty years later, *The Triumph of Virtue.*

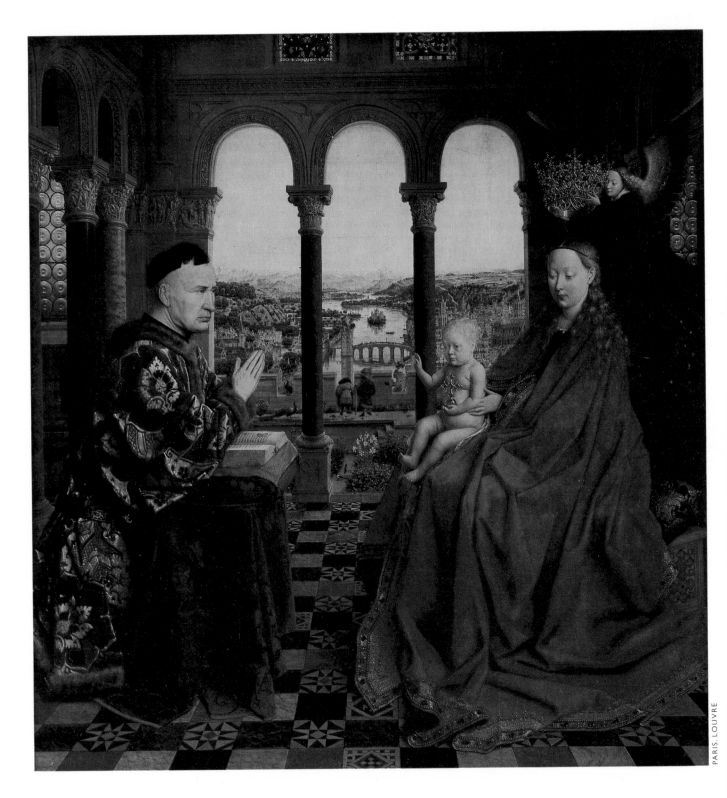

74

JOHN HALE

# Jan van Eyck d. 1441

# The Madonna with Chancellor Rolin 1434

However passionately you believe in monarchy, however closely you want to associate yourself with the Queen, would you commission a picture like this? Probably not. Yet this is how Nicholas Rolin, in 1434, pushed his way into the presence of the Virgin, Queen of Queens, Queen of Heaven.

This placid but extraordinary scene was painted by Jan van Eyck. He was a Burgundian, and Burgundy then comprised not only the great wine-producing province of France but much of modern Belgium and Holland, as well; it included centres of trade and industry like Brussels and Ghent – and Bruges, which was then larger than London and more prosperous than Paris. Its duke, Philip the Good, was the wealthiest ruler in Europe and a generous patron of writers and artists. He employed Jan van Eyck, paid him well, and valued his intelligence enough to send him on a number of diplomatic errands. So Jan was close to the mood and interests of the most glamorous and chivalrous court in the West, an educated and travelled man, an intellectual as well as an artist.

The Duke's chief civil servant and right-hand man in all affairs of state was his chancellor, Nicholas Rolin. Rolin was fifty-eight when Jan brought him here; calculating, determined, tough, very wealthy, loathed by those jealous of his influence, as intent on the courtly wheeling and dealing of the moment as on getting an equivalent position in the court of eternity – the errand which brings him here. But *where* is he? Has the Virgin, as in a vision, come down to him? Or has he, as in a meditation, gone up to her?

They are in an airy, but solid, meticulously realistic hall of state. And it is surely hers. Her throne is permanent, of inlaid marble; his *prie-dieu* is portable, carried with him in his thoughts. And the artist has anyway made it clear that such a room could not possibly have existed on earth. That quatrefoil decoration at the base of the column is Gothic, but the arches springing from the top of the column are rounded, Romanesque: an earlier style. It is topsy-turvy. Here is a clue to the sophisticated observer – and this was painted by a sophisticated artist for a sophisticated member of a sophisticated court – to adjust his eyes to the court of Heaven.

And it is very likely that while Jan was painting this scene he had one specific aspect of Heaven in mind, the new Jerusalem as

described in the Bible in the Revelation of St John the Divine. St John stressed (as Jan does with his columns) its wealth of precious stones. Then there are tiny biblical stories on the capitals, but the room is otherwise quite secular in its architecture: John had written of the city, 'I saw no temple therein.' And John described it as having 'a wall great and high' – and there it is, a battlemented parapet beyond a garden planted with the red roses of Christ's blood and the white lilies of the Virgin's purity.

Most unusually, both mother and child are shown with the attributes of political power. She is being crowned, he holds an orb – and his expression, as he blesses Rolin, has a somewhat unchildlike 'it's up to you' expression. Now St John had written of a New Heaven

Details of *below* Nicholas Rolin, *right* the Infant, *opposite* the Virgin crowned by an angel: *The Madonna with Chancellor Rolin*

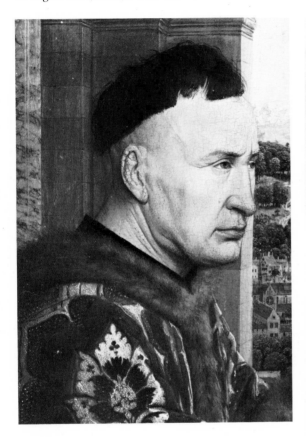

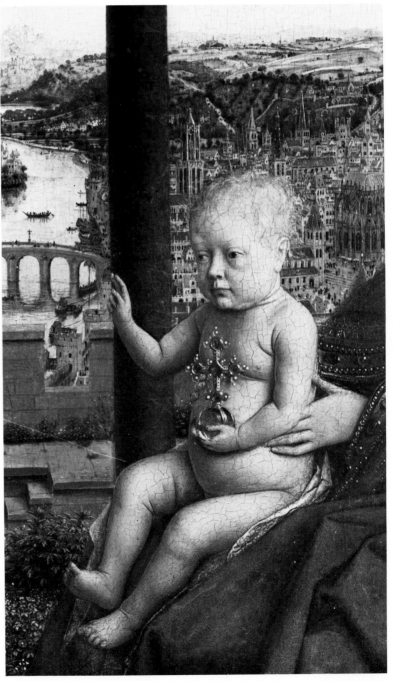

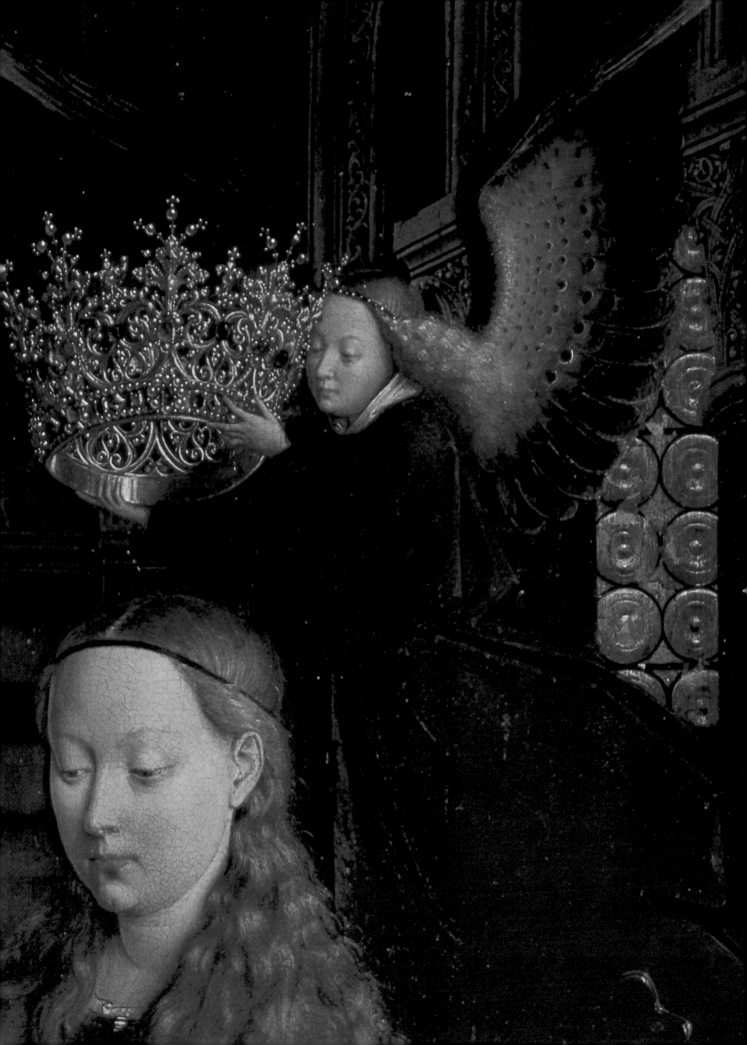

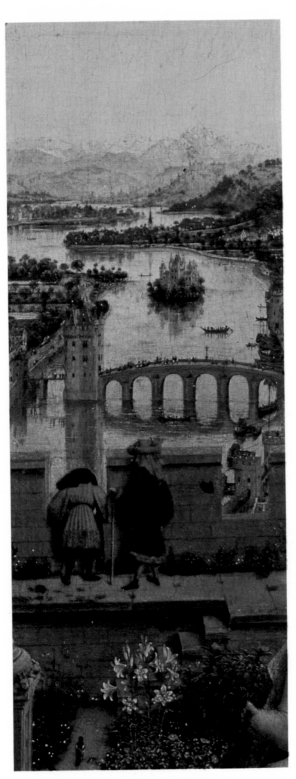

Detail of two men from central arch,
*The Madonna with Chancellor Rolin*

(the New Jerusalem) and a New Earth, both ruled, of course, by Christ. Of all rulers in Europe, the Duke of Burgundy was the most eager to lead a crusade to free the earthly Jerusalem from the infidel and thus extend the empire of Christ on earth. And if the crusade materialised (in fact, it didn't), it would be Rolin's responsibility to organise Burgundy's part of it. Prompted by the eager, imperial little boy, Rolin is probably thinking about this – and about the enhanced chance it would bring him of getting up here permanently.

In all this Jan must have been following his patron's instructions. But the background was *his* and the view beyond the trinity of arches, one of the most amazing ever painted, was also *his* view of worship and salvation.

Far below the parapet, the river divides a fortified city, on the right, from its suburb, on the left. They are connected by a bridge, defended by a tower. Tiny people, minuscule but sufficient nudges of the finest of brushes, cross the bridge, and more of them appear in the streets and square of the suburb. This, behind the brooding, but very much of-*this*-world, presence of Rolin, has only one church: just about right, given the low density of the housing.

The city – behind the Virgin – is in total contrast. The houses are swamped by churches. Thanks to the minute precision of Jan's brush you can count ten of them, culminating in the vast cathedral (though it is less than an inch high) next to her shoulder. In an earlier picture Jan had shown the Virgin filling a church like a holy giantess: she was as necessary to prayer as her son was to salvation. So the city is Jan's 'Virginopolis': his personal homage to the girl deity who must fill men's prayers before they can rise to heaven. Meanwhile the boats discharge at the quayside or ply across the river.

Such unnatural clarity in the description of individual things had something in common with the detailed profusion that was characteristic of Burgundian culture, from poems and chronicles to banquets and processions. It also had the backing of a philosophy which taught that only individual objects were knowable: concepts and generalisations linking them *might* be true but could not be proved. So the surest way to praise God aright was to reproduce with the greatest exactitude the objects He had created or given man the aptitude to make. To these currents of thought Jan added a personal fervour which led him to experiment with an oil technique that could give brilliance and exactness to each individual chimney or jewel or flower.

And this brings us to the two anonymous men at the painting's centre. They look a bit like dwarfs, but it is clear that the standing man is of normal height because he is exactly the same height as the parapet. Standing against the wall, he cannot see the view. Perhaps he is actually blind; he seems quite young, yet he is holding a stick. He appears to be listening to his companion who is leaning well forward to look down at the river.

It cannot be an accident that the exact centre of this scrupulously thought-out work lies between the clump of lilies and these unimpressive little figures. What is more, though our interest *across* the painting depends on the interplay between the massive, intent presences of Rolin and the Virgin and Child, our interest *into* the

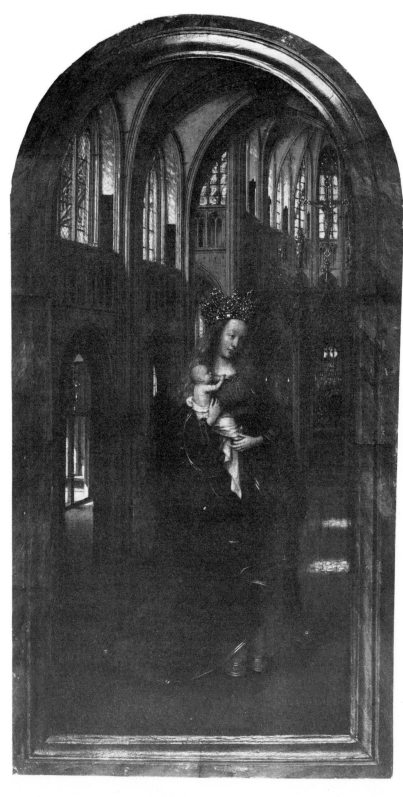

Van Eyck, *The Madonna in the Church*

picture is rushed up the unbroken row of tiles towards *them*. Is it too far-fetched to interpret the one who leans over the battlement of the New Jerusalem, in order to see God's creation with all the freshness imparted to it by the creator, as the painter himself? And the one who cannot see, as representing those of us who must rely on an artist's eye to imagine both heaven and earth aright?

79

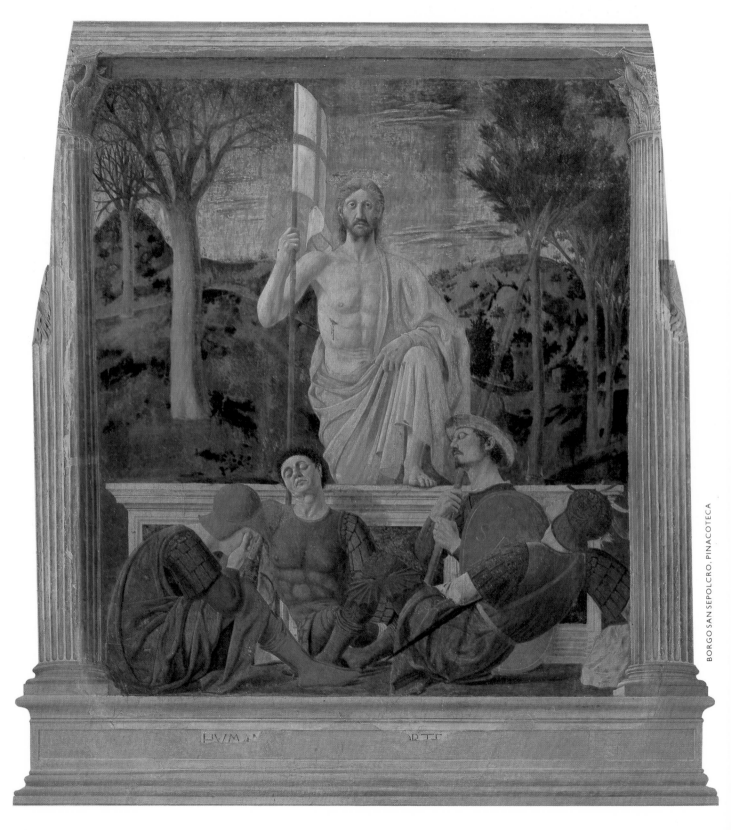

DAVID PIPER

# Piero della Francesca *c.* 1415–92
# The Resurrection *c.* 1460

The little town of Borgo San Sepolcro was Piero della Francesca's home town. Here he was born somewhere about 1415; here he died in 1492. Here the town still is, tucked in against the lower slopes of the Apennines on the borders of Umbria and Tuscany. It has grown of course since Piero was here five hundred years ago. Then it looked more like the town Piero painted in his *Baptism of Christ* in the National Gallery: a miniature, sunbleached, towery town below brown hills. It probably is Borgo San Sepolcro. Just a detail, though hit off with exact visual accuracy as crisp as a staccato on a piano: a detail glimpsed between the pale body of Christ and the pale trunk of a tree. It looks quite at home there.

The town's towers almost all fell to an earthquake in the eighteenth century. The town now nourishes and is nourished by a macaroni factory. The *Palazzo dei Conservatori*, or *Pretorio*, the central civic building, the one that Piero knew – that though is still there, somewhat altered no doubt, but still there and now named the *Palazzo Municipale*. It houses the local art gallery and in it are still several paintings by the town's greatest son, one of the noblest painters ever born, Piero della Francesca.

Among them is the great polyptych of the *Misericordia*, the traditional image of the Virgin of Mercy, sheltering mankind within the sanctuary of her extended mantle. A *Crucifixion*, monumentally impassive, echoes surely something of Masaccio's crucifixion, now in Naples, of half a century earlier, yet already old fashioned in its use of a plain gold background. But here and in the other figures, the earliest certain work we know by Piero, there is already that monumental density, that colossal stillness. And a brooding sense of mystery reminiscent of nothing in Christian art so much as of the impassive serenity, the inscrutable benevolence with which the art of the East, of Buddhism, manages to convey sensual felicity in images of ascetic austerity.

The fresco of Piero's *Resurrection* has always been here. The historian Vasari recorded it as here about a century later, noting also that it was 'considered the best work Piero did either in Borgo or anywhere else'. Later, its prestige faded. At some point, it is said, it was actually shifted within the building; even covered with whitewash. Quite how it could have been moved is not clear. It is

Della Francesca, *La Madonna della Misericordia*

painted in fresco – that is, direct on to the plaster while the plaster was still wet. So the image is part and parcel of the plaster, inseparable from it, and so naturally would tend to disintegrate if detached from its supporting wall. Anyway, it has suffered damage through the centuries, though the total impact is still breathtaking.

Piero originally set his composition within a painted surround simulating a stone base or plinth at the bottom, with a fluted Corinthian column flanking each side, an architrave at the top. This framework is the most damaged bit, and in part rather inefficiently restored. In fact, when the picture is reproduced, it tends to get left out altogether. But it is important. For one thing, its perspective makes it clear that we are meant to be looking up at the picture from below, as does the drawing of the four figures sprawled in front of the sepulchre. So that, even if it has been moved, it has always been meant to be seen from below. The effect, this setting of the scene in an architectural proscenium, is to distance you as you look at it. It sets what is happening in the picture at a remove, in a different space, as does a window, and perhaps in a different scheme of things, a different order of reality, as a window does not, but a stage of course can.

And what is going on is very much of a different order of reality, the greatest, most triumphant miracle of all Christianity. Christ rises from the dead: the proof that death is not the end. The message is stupendous, the way it happens so mysterious that the Gospels do not describe it. There was the Crucifixion; the Entombment. But then, darkness and silence, until the angels shine about the already empty tomb, and the Risen Christ appears elsewhere to the disciples on the third day.

The illustrators of the Middle Ages tended to treat the act of resurrection symbolically. Attempts to render literally the actual rising out of the grave come only later and not all that often. The challenge is, to put it mildly, daunting. For the citizens of San Sepolcro, the town named after the Holy Sepulchre, it was, though, an imperative choice, and they were the ones who presumably commissioned it from Piero, most scholars think somewhere about 1460.

Nearest to us are the four guards, in the disarray of sleep. They are skewed in discomfort, as soldiers from time immemorial tend to be if asleep when they are supposed not to be. The second from the left, with his head tilted back, its foreshortening a superb display of perspective draughtsmanship, is said to be a self-portrait of Piero. Not impossibly. Then the one clutching a spear or lance, identifiable in the onlooker's mind with the weapon that pierced Christ's side two days before. On the right, the fourth. How he is propped up I am not quite clear, but he seems to me to be on the point of pulling himself up, but still disbelieving in his sleep what a flicker of his opening eyes has told him is happening above. According to Matthew, the guards about the tomb were set there to confound the prophecy of the resurrection. But in Christian illustrations of the theme their presence could also serve to answer Jewish accusations that resurrection had never taken place, but that the body had been removed surreptitiously in the night by the disciples. So that one at

least of the guards is usually characterised as witness to the event – that is, awake or awakening and seeing what is happening.

The guards are solidly drawn, in strong colour: purplish-russet, bronze, turquoise, a touch of scarlet. They form a sort of broken calix, collapsed outwards. From its centre, on to the rim of the opened sarcophagus, Christ resurrects: solid, his torso firm as ivory, marked by the lance wound but immaculate of trace of scourge or thorns. Over his left shoulder and about his legs, the shroud has become a ceremonial drapery, as if a classical toga, but of a very pale, very delicate, rose pink. He stands, foursquare. His left foot is raised on the sarcophagus edge. A banner is in his right hand. The head looks out over you, yet into you.

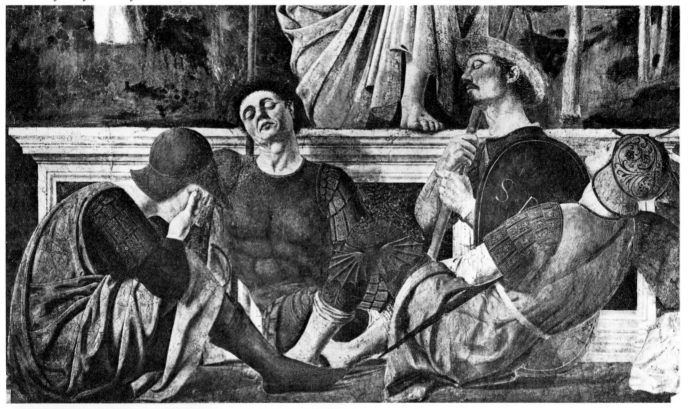

*Above* detail of the four guards and *below* possible self-portrait of Piero della Francesca, *The Resurrection*

83

Lacking any gospel account, as they did, artists could of course interpret the resurrection in different ways, and so they did. They could show Christ standing within the tomb, or in front of it, or above it and so on. Later, as in Tintoretto, virtually being exploded from it. But it seems to me the most effective pose is as Piero has it.

Tintoretto, *The Resurrection*

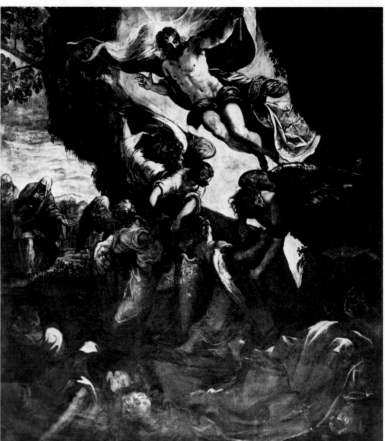

He was not the first to use this exact pose. The idea could have come from a Sienese altarpiece that he would have known in the Cathedral at San Sepolcro, just across the way from where he was to paint his fresco. In style though, that would have been archaic to Piero's Florentine trained eyes. In Florence, where he had worked earlier, he would have seen a *Resurrection* by Andrea del Castagno that is much closer to his own, though Castagno showed Christ with both feet planted on the edge of the sarcophagus. Otherwise, the constituent elements are there: the banner; the guards (though one there, behind the tomb, is astounded and very much awake). Yet in comparison, Castagno's version is strangely lightweight, belonging, as Coleridge might have judged, to the realm of fancy rather than that of inspired imagination. Christ seems an almost beardless, vain young athlete, raising his hands in victory; the supernatural has to be emphasised by a rather busy angel overhead, on which more trouble seems to have been taken than on any other figure. It is, though, generally thought to be earlier than Piero's: about 1447.

From about the same time as Piero's comes a little painting, a *predella* panel for a big triptych, by Mantegna. The three main panels of the triptych are still at Verona, but this little panel got away and is now in France, at Tours. Though probably mostly shop-work, it is

Castagno, *The Resurrection*

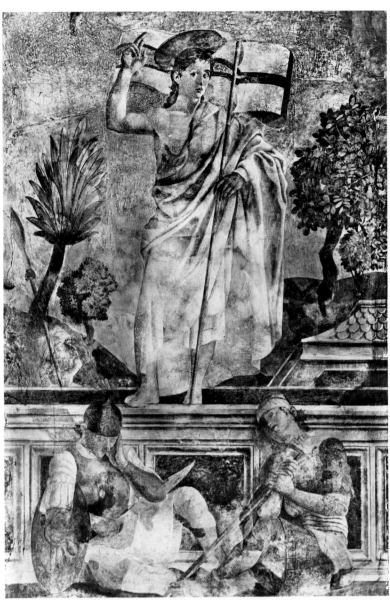

Mantegna *The Resurrection*

Detail of Christ's head
from della Francesca's *The Resurrection*

striking for its similarities with Piero's version, but still more so for its dissimilarities. That usually most austere of painters, Mantegna, seems almost to have cocooned Christ's body in fluffy angels' wings, a memory, perhaps, of the traditional device of the Mandorla. But Piero could achieve his effects without such a device.

But Piero's vision, in its brooding intensity, does seem to echo other older traditions. The head seems nearer to the Byzantine conception of Christ than to a Renaissance one: not just in the style of the hair and beard, but in the authority of those dark eyes, that almost blank, yet loaded, stare from the whites of the eyes under the clear curve of the upper lids. This is the Christ who, crucified, descended into hell, and there broke the locks of hell and released the tormented souls within; the Risen Christ, awakening but still stunned; one who has seen everything, has died, yet has survived. Something of this is in the face of Christ as the Byzantine mosaicists saw him, huge and presiding, the Pantokrator in judgement presiding from the gold heavens of great basilicas like Santa Sophia at Istanbul.

Yet the body of Piero's Christ is more that of a Hellenistic Greek god, as if to incorporate in the Christian god all superseded pagan deities. The stance is the immemorial one of the triumphant victor, but here the defeated enemy on which that foot is so solidly planted is not human or animal, but the grave, Death itself vanquished. And in the world over which he here presides, time has lost its tyranny. The sleeping guards are in Roman armour. The landscape rising beyond is that of the lower slopes of the Apennines, as it was in the fifteenth century, as it can be today. But magically the bare trees of winter on the left yield to the rebirth of spring on the right.

This is not in any way a comfortable picture. I do not sense compassion in that gaze, rather an austere confirmation of endurance, of ultimate survival, but surely no promise of bland bliss. Yet it is an immensely exalting image; the Resurrection raises *us* up too. Something of this is due to Piero's use of perspective. There's a dual viewing point. The soldiers and the sepulchre, as we noted, are seen from below, but Christ is seen from a higher point, level with his own body. Thus his body is even more the upright from which all else depends.

Piero was arch-theorist and arch-technician of the newly discovered mathematics of perspective. He wrote books about them. This painting is structured with almost architectural logic and precision, solid as the façade of a great church. But Piero was also obsessed with light, and with the forms that the limpid Italian light begets on glowing colour, clear and all but shadowless.

As exemplars of that, he had had in Florence the work of Fra Angelico, of Domenico Veneziano. In Florence too he had seen the formidable revelation of monumentality in Masaccio's frescoes. Yet his own monumental stillness seems to go back, too, to Rome, even to classical Greece. It was in all these terms that he saw the great themes of Christianity, and never more perfectly, more awesomely, than in this affirmation of the Risen Christ, this fusion of abstract design with the physical world, where the supernatural informs the natural with such incontrovertible majesty.

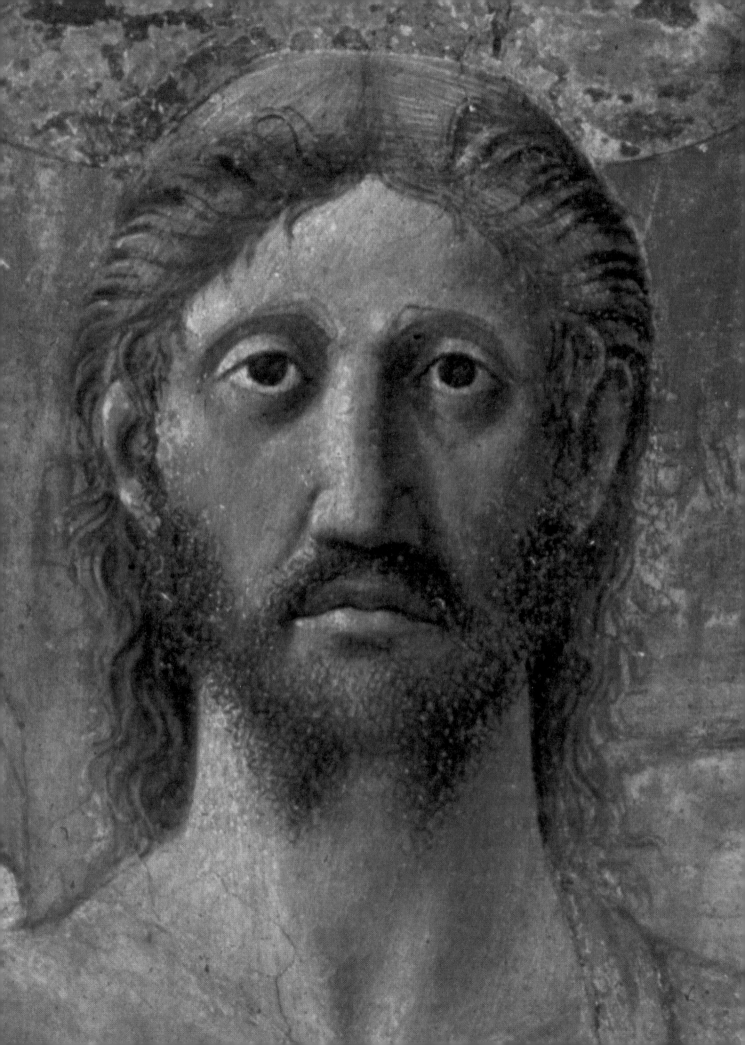

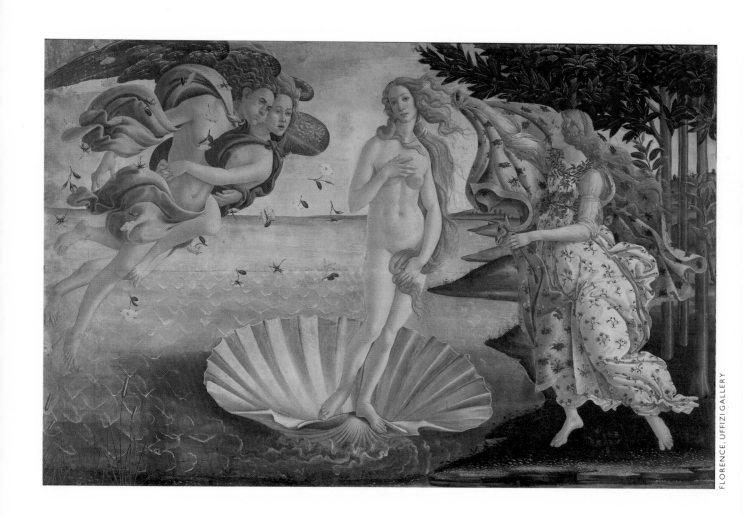

EDWIN MULLINS

# Botticelli c. 1445–1510
# The Birth of Venus 1478–87

At a rough count the equivalent of the entire adult population of the United States has come to the Uffizi Gallery in Florence since the end of World War II, to pay homage to one painting above all others. The picture is Botticelli's *The Birth of Venus*, painted just about 500 years ago in Florence for a member of its most powerful family, who were bankers – the Medicis.

I cannot help feeling that a person who has never at some moment in his life fallen in love with this picture has missed one of the overwhelming experiences which art can offer. I fell in love with it at seventeen and, if anything, am even more in love with it now. Coming face to face with it again after all the postcard reproductions and coffee-table books and images on T-shirts, the first surprise is how large it is: almost ten feet across. Venus is near-enough lifesize. And the second surprise, considering it is one of the best-known pictures in the world, is how very private it is and how mysterious. It's bewitching.

And yet for more than 300 years after his death Botticelli was scarcely regarded as an important painter at all. As recently as the 1890s the most revered critic of the day, Bernard Berenson, began his essay on Botticelli with these words: 'Never pretty, scarcely ever charming or even attractive; rarely correct in drawing; and seldom satisfactory in colour.' Remarks that take my breath away! Botticelli's popular appeal is quite new.

The picture illustrates an ancient Greek myth that Venus, or Aphrodite, was born from the foam of the sea. Botticelli shows her riding naked on a scallop-shell (which is her own symbol, in Latin *venera*, the Venus-shell). She is being blown gently towards the shore, amid a cascade of pink roses, by two entwined figures who represent the winds. As she approaches the world of men Venus already grows modest of her beauty and her nakedness in anticipation of people's eyes, our eyes; and her attendant, who is decked out in garlands and more pink roses, waits for the goddess, holding out a gown to throw about her as she steps ashore.

Now, in fifteenth-century Italy most commissions of this sort were for devotional pictures destined for churches. To commission large pictures on pagan themes was novel in Florence, and Botticelli's *Primavera* had been among the earliest. It was not a case of lip-

smacking hedonism bursting out when a picture was intended for a private dwelling and not a church: rather, it reflected a new and distinctly sober interest among educated Florentines in the classical world of Greece and Rome – the Renaissance as we know it. No longer was the ancient world of myth viewed as pagan, but as a Golden Age in which our own civilisation was born.

An enlightened young Florentine like Pierfrancesco de' Medici, who commissioned the *Primavera* and *The Birth of Venus*, would have been thoroughly schooled in Greek myth and Greek philosophy, particularly that of Plato. Venus was not simply a pagan love-goddess; she embodied much that the Renaissance stood for, sailing into the lives of men as a kind of saviour. She was Truth, she was Humanity, she was Divine Beauty revealed. Now, I doubt whether Botticelli himself had more than the skimpiest understanding of Plato, or of any other Greek writer. Imagine, today, a body of Cambridge philosophers approaching a leading painter with a

Botticelli, *Primavera*

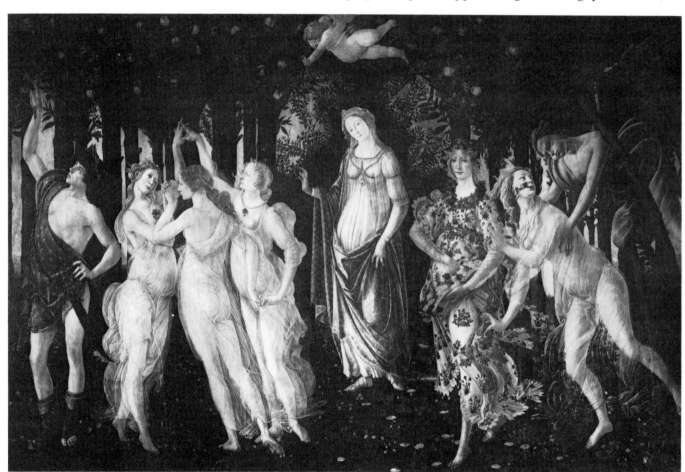

commission to illustrate, say, the writings of Wittgenstein. The painter, if he had any sense, would take the money, grasp a few essentials and go off and do what *he* wanted to do. And this, I suggest, is precisely what Botticelli did. There is no attempt in this painting to describe the world of antiquity: what Botticelli does is to evoke the enchantment which the classical world must have held for those discovering it for the first time. It unlocks his imagination. All around Botticelli painters in Florence were discovering how to copy

nature: they went out and examined animals and plants, they studied human anatomy, they worked out mathematical laws of perspective. The Renaissance spirit fed on facts, on discovery. Copernicus was already born; so was Luther. Columbus was already a sea-captain. A son of one of the Florentine families for whom Botticelli worked would soon give his name to two continents – Amerigo Vespucci. America! And yet Botticelli turned his back on this brave new world. He preferred to be enchanted by nature, rather than to measure it. Leonardo da Vinci, his contemporary, grumbled that Botticelli made 'very dull landscapes'. One can see what he means. You could hardly go for a walk in this picture. The soil is so unreal the attendant's feet scarcely touch it. These are not real waves. Kenneth Clark has pointed out that Venus herself is quite off-balance. Her weight could never be supported on that foot. She would fall down – if she were real. She is an antique statue pretending to be alive. Yet she *is* alive: how very alive.

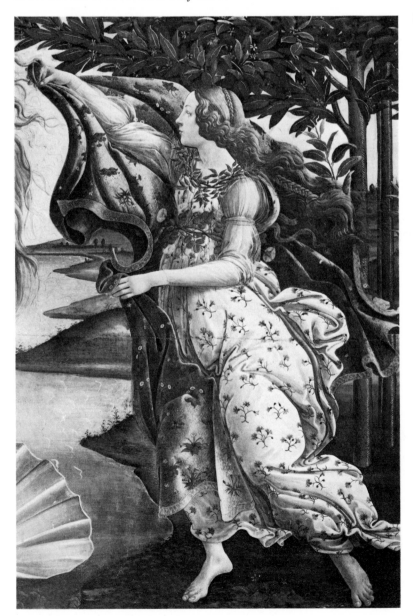

Detail of attendant, *The Birth of Venus*

Maybe there was a model in Florence who looked like this and maybe Botticelli was in love with her. There is a legend, largely unfounded, that she is Simonetta, the beautiful mistress of another of the Medicis, Giuliano. I doubt it. To me she seems like a personification of beauty: Botticelli's ideal, rather than a real person.

She recurs over and over again in his paintings. In the *Virgin and Child* in the National Gallery, London, she is the tender young Madonna – painted by assistants but the drawing is unmistakably Botticelli's. She is melancholic again as the *Madonna with the Pomegranate* in the Uffizi. She is mischievous as Flora in the *Primavera*. And she is stern in the painting of *Venus and Mars* (National Gallery, London). In *The Birth of Venus* she manages to possess all these characteristics, and to be even more beautiful. She seems closest here to Botticelli's ideal.

*Right* detail of Flora, *Primavera*;
*below* Botticelli, *Venus and Mars*;
*opposite* detail of Venus, *The Birth of Venus*

In fact everything in the painting enshrines her beauty. The two figures of the winds waft her to the shore, but their breath is made visible so that it seems to caress her skin and play with her golden hair – not just a figure of speech either: Botticelli has used gold paint. Roses fall around her like love-offerings. The attendant figure on the shore holds a gown that billows out in the same breeze, and is finely embroidered with more flowers to be worthy of the goddess who will wear it. If you think of the physical, rumbustious figures of Venus painted by Titian or Rubens, Botticelli's vision of her is almost disembodied. She is a figure in a daydream. Even the colours, which Berenson found so unsatisfactory, are suitably fragile. Strong primary colours would have broken the spell.

We are a long way from a mere illustration of Plato's philosophy, and a long way from the natural world about us; even a long way from a straightforward account of a beautiful woman. What Botticelli has done is to abstract from his observations of the living world a language of rhythmic patterns – like the fluttering of garments or hair, or the movement of waves; and it is this most delicate sensitivity to pattern which enables him, in so much of his work, to choreograph a story, tell it in the form of a ballet.

This genius of Botticelli remained unappreciated so long as lifelike reality was the ideal of art. But in this century such an ideal has largely collapsed, and other values have come to the fore, in particular the value placed on truth to experience, to how an artist feels. One of Picasso's finest etchings in his Vollard suite is an almost

*Below* detail of the Three Graces, *Primavera*; *left* Picasso, *Vollard Suite xxxiv*: Sculptor and Statue of Three Female Dancers; *opposite* detail of gilded rose, *The Birth of Venus*

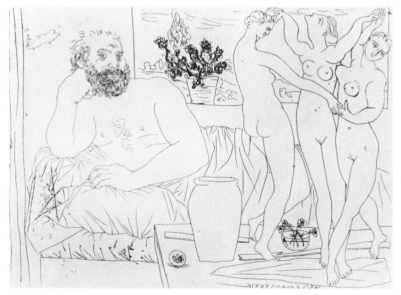

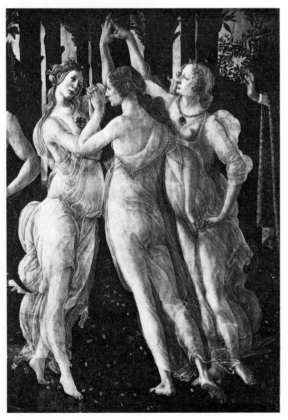

literal tribute to Botticelli, whose grasp of this truth to experience was prophetic. *The Dance* by Matisse is another kind of tribute to him.

It may sound strange to look upon Botticelli as a precursor of modernism: nonetheless it seems to me one of the exciting things about the art of our own century that it should enable us to enjoy even so famous a painting as this one with refreshed eyes.

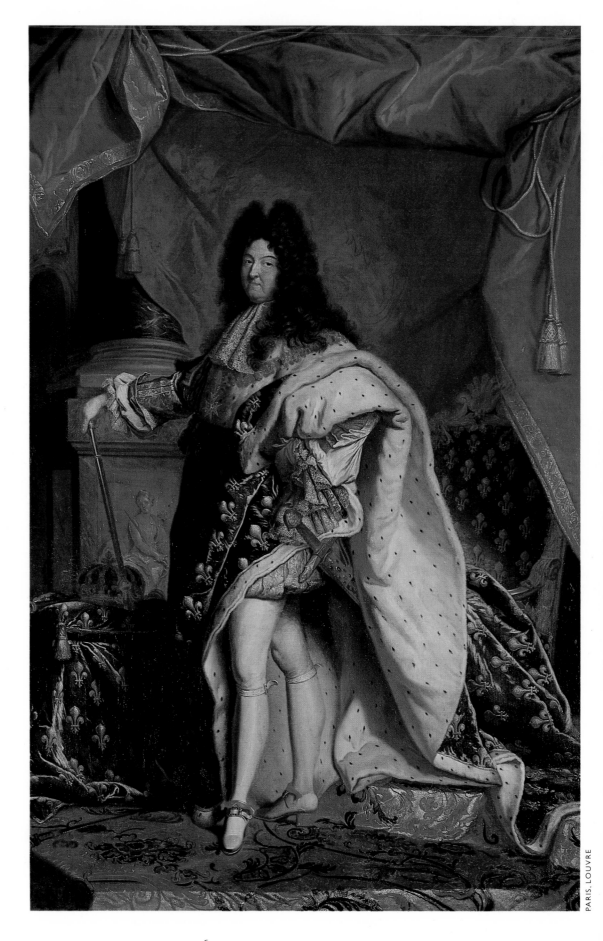

ANITA BROOKNER

# Rigaud 1659–1743
# Portrait of Louis XIV 1681

'Will it be believed? He was also by disposition good and just! God had sufficiently gifted him to enable him to be a good king; perhaps even a tolerably great king.'

These prophetic words were written by Saint-Simon, who arrived at the court of Versailles in 1691, ten years before this portrait of Louis XIV was painted by Rigaud. Saint-Simon was pretty wary of the king and hardly lavish in his praise, but this pronouncement seems heartfelt enough. And in the eighteenth century Voltaire was to look back on what he considered to be a golden age in French history and to say, 'Nature herself seemed to take a delight in producing at this moment in France men of the first rank in every art, and in bringing together at Versailles the most handsome and well-favoured men and women that ever graced a court. Above all his courtiers Louis rose supreme by grace of his figure and the majestic nobility of his countenance. The sound of his voice, at once dignified and charming, won the hearts of those whom his presence had intimidated. His bearing was such as befitted himself and his rank alone, and would have been ridiculous in any other. The awe which he inspired in those who spoke with him secretly flattered the consciousness of his own superiority. The old officer who became confused and faltered in his speech when asking a favour, finally breaking off with, ''Sire, I have never trembled thus before your enemies'', had no difficulty in obtaining what he asked.'

Such sentiments are impossible today, and merely listening to them may make people angry. Yet we still speak of the age of Louis XIV as one of the high points in European civilisation, and we are not likely to forget the experience of wandering through the rooms and gardens of Louis' most outstanding creation: Versailles.

By 1682 there were 36,000 workmen at Versailles. To his grandson, Philip V of Spain, Louis remarked, 'There are few more innocent amusements than hunting and the pleasures of a country house, provided you do not spend too much on it.' To his great-grandson, who was to become Louis XV, he confessed that he *had* spent too much on Versailles, a sentiment with which the revolutionary mobs were to be in total agreement. Today, in this age of architectural shame, we must be grateful for every penny he lavished on his beloved palace and its gardens. We must agree, with Saint-Simon and

Detail of the crown, the sceptre and the king's hand,
*Portrait of Louis XIV*

Voltaire, that there really was something rather extraordinary about Louis XIV.

Here he is, as painted by Rigaud, in his coronation robes. He is sixty-two years old and he has been king of France for fifty-seven years. He has another fourteen to go. This phenomenon easily dominates the emblems of royalty grouped discreetly to his right : the crown, the sceptre, and the hand of justice. The order of the *Saint-Esprit* round his neck is no more prominent than the figure of justice with the sword and scales on the base of the column. Any amusement provoked by the ridiculous padded breeches and high-heeled shoes is instantly quelled by the cynicism of that gaze : here is a man who knew exactly what his courtiers thought of him because he opened their letters to find out.

*Below* van Dyck, *Charles I; bottom* Rigaud, *Louis XV*

In this confrontation between the painter and his model it is the model who wins. So great a sitter would douse any idiosyncrasies that Rigaud might have thought of introducing, and for a court painter, which is what he was, Rigaud was capable of very independent tastes. Many of his less dominating, wigged and armoured sitters are adorned with surprising bursts of drapery in glorious colours of hyacinth, scarlet, and bronze. And into the framework of his airtight portrait compositions comes the heavy ripple of drapery and curtain, agitated by a theatrical tempest somewhere offstage.

The painter, Hyacinthe Rigaud, was not only a public servant who sensed the drama of public occasions; he was a connoisseur both of people and of pictures, probably in that order. One of the few facts we know about him is that he owned eight works by van Dyck and seven by Rembrandt, and this monumental, quintessential, and indeed archetypal portrait of Louis XIV is in fact an adaptation of another portrait of another king: van Dyck's *Charles I of England*. With rather more subtle flattery van Dyck showed the tiny and sensitive Charles I as just another English country gentleman, although his pearl earrings and satin doublet hint at his almost feminine fastidiousness. Yet van Dyck succeeds in conveying nonchalance, an aristocratic English quality not much prized by the French who preferred precision.

If Charles I might be mistaken by the uninitiated for a gentleman out hunting, Louis XIV, who in fact did hunt twice a week, is nothing less than an anointed monarch. We do not need any symbols to explain this to us, and indeed there is something unnecessary about all those lilies of France on the mantle, the throne, the stool, and the cushion. Instead of symbolism, Rigaud has rightly given us profusion: that vast heavy curve of ermine, those great tassels, that slow-moving curtain in the king's favourite colour, brown. Is it absurd? Far from it. It is rather moving. This strong but ageing man, striking a pose for his clever court painter, knows that his subjects are sick and tired of him. The news of his death in 1715 was to be greeted with relief at Versailles and with joy in Paris. And when Rigaud set to, in 1730, to paint the new anointed monarch, Louis XV, he proceeded with that briskness and energy that are said to have characterised the end of an era at Versailles. Draperies flutter, coronation robes swing aside, gilded ropes are slung round columns.

99

Detail, *Portrait of Louis XIV*

Yet the effect is less, particularly when we return to Louis XIV. Patient, knowing, haughty, and impassive, the king – for I think we must acknowledge that he is *the* king – gazes down at us. Apart from that beautiful bronze drapery – the element in which the tastes of the king and his painter come together – this is not a picture likely to be relished by the connoisseur of painting for its own sake. Like most portraits of kings, and more than most, it is an icon – that is to say a symbolic, almost sacred image. If you like you could say the artist has put his subject on a pedestal. But the fact that Rigaud has somehow preserved his own dignity, together with that of the king, is a considerable achievement. And in a sense both painter and subject are holding powers in reserve, so that the more obvious majesty of this particular symbol is enhanced.

# Tiepolo 1696–1770
# The Triumph of Virtue and Nobility over Ignorance c. 1745

This painting is a wonderful absurdity; and to appreciate the full wonder of it, and the full absurdity, you really have to imagine that you are standing within a magnificent palace in Venice and gazing upwards at it high above you on the ceiling.

The artist is Giambattista Tiepolo, who came from Venice; he painted it in the 1740s, and what made him the most sought-after painter of his day was a gift for decorating the mansions of the rich with gorgeous fairy-tales, like this one. These fairy-tales reflected his patrons' taste for pleasure and for seeking flight from humdrum reality on earth. Not a promising area for a serious artist, but, my goodness, how miraculously he did it!

Tiepolo's genius was to be able to transform a plaster ceiling into an imaginary heaven – the kind of heaven which men of wealth and privilege felt entitled to look forward to, where all is light and love and ease. Tiepolo offered his patrons a roof of boundless space, and that space filled Tiepolo's own imagination like a sail. His figures command the sky as naturally as the patrons themselves commanded the affairs of men on earth: here above their heads was a heavenly mirror of their own worldly authority.

This particular extravaganza is called *The Triumph of Virtue and Nobility over Ignorance*, an excessively heavy title for so buoyant a picture, you may say. 'The Triumph of Pleasure' would have been more apt, and certainly this must have been the message to those who gazed up at it on the ceiling of the Palazzo Manin, in Venice. Well, it was long ago removed from there, and today the picture hangs – appropriately – in a museum created by one of the wealthiest art collectors of our own day, Mr Norton Simon, at Pasadena, California.

I cannot help feeling that only a man from Venice could have created so airy a fantasy, and could have done it so successfully, because Venice itself is a city which does not appear to be earthed; it is built on water, and what earth is there is insubstantial. We love Venice – as I love Tiepolo – because it does not seem to be anchored to this world. In Tiepolo's day it was doubly insubstantial in that the Venetian Republic was on its last legs: in half a century Napoleon would swamp it. So is it surprising that the Venetian imagination looked away from reality and had its head in the clouds? Indeed, clouds are the only support the heavens can provide for these figures.

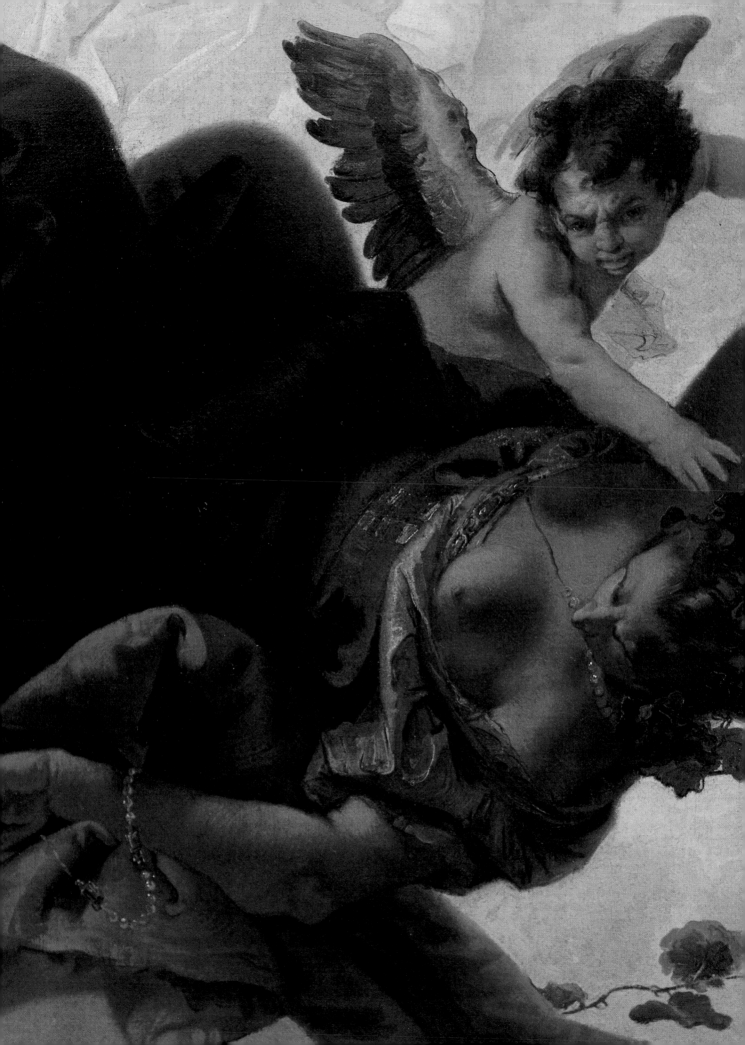

By an outrageous bluff Virtue and Nobility defy gravity with only one pair of feeble wings and a few billowing robes between them, as if it were the most natural thing in the world to hang suspended weightless above us. And because Tiepolo was a great artist we in turn suspend our disbelief. Even the falling figure of Ignorance is scarcely tumbling to earth with a crash, merely toppled as if she has slipped momentarily on a cloud. In fact if you weren't told you'd be unlikely to see her as representing anything bad at all. She wears fine robes, she reclines as elegantly as Virtue and with a bare foot and bare breasts, she crooks her fingers no less fetchingly. A few bats may supply a hint, and her dark skin, Venetians being presumably not immune to racism. But that is all.

So – Ignorance, Virtue, Nobility: where is the meaning behind these high-sounding moral labels, and are they not merely another bluff? I think so. With Tiepolo moral considerations scarcely come into it. He is not a moralist, he is an entertainer. He provides wit, and delight. This is luxurious stagecraft, theatre, the theatre of the sky. And like most theatre, the work of Tiepolo demands a certain distance between ourselves and the action on stage. The credibility of the performance depends on our not being too close; and painting ceilings and other inaccessible places guaranteed Tiepolo this essential distance. It helps to see his work in the extravagant context it was designed for, such as the ballroom ceiling of the Villa Pisani at Strà, near Venice. The light, almost frivolous architecture in the Rococo style is incomplete, it seems to me, without the paintings of Tiepolo and the music of his Venetian contemporary, Vivaldi. Or the Royal Residence at Würzburg in Germany where Tiepolo decorated the Great Hall, and produced a flamboyant vision of Olympus for the ceiling of the Grand Staircase. Think of climbing up to bed under such a canopy of Glory: no wonder the aristocracy of Europe could not grasp that their rule might ever end; and no wonder Tiepolo was called upon to embellish the royal palaces of six nations.

What Tiepolo is habitually glorifying is Love; or, rather, women as objects of love or incarnations of love. They are all goddesses of love in one guise or another, it doesn't matter what they are called. The most glorious of them is Venus herself, in another ceiling painting from a palace in Venice and now in the National Gallery, London: *An Allegory of Venus and Time*. What a goddess for a noble family of a dying republic to dream about!

Tiepolo would have done well in Hollywood had he lived two hundred years later; and the fact that in Pasadena we are only a few miles from Hollywood is again appropriate, because these fantasy goddesses of Tiepolo belong as little to daily life as did the film-stars of vintage Hollywood. Their realm is glamour, and glamour is something that requires to be set above us, the audience, in just the way Tiepolo set his goddesses literally above us. They are stars set among the stars; except that for Tiepolo it is never night, and the radiance of full sunlight always shines upon them.

In the Pasadena picture the figure of Virtue even wears a sun emblazoned on her breast – a sun with the face of a child, a ridiculous convention when you come to think of it, but then you are not supposed to think of it. You accept such conventions as show-

Detail of the falling figure of Ignorance, *The Triumph of Virtue*

Tiepolo, *An Allegory of Venus and Time*

business, just as you accept that most absurd of all conventions, angelic cherubs, known as *putti*, cavorting round the heavens as if the sky were their playground, sometimes playing suggestively beneath billowing skirts, sometimes stumbling in tears against a nasty black cloud, sometimes naughtily flying away out of the picture altogether. No, we are not supposed to think rationally about these absurdities, but to enjoy them as movie-goers used to enjoy Shirley Temple.

And to enjoy, too, the marvellous orchestration of colours which Tiepolo achieves: daring colours – a border of pink on a golden robe, next to darker pink set against flaming scarlet. What couturier would have dared put that lot together? Then, by contrast to these colours in full sunlight, the sombre tones of the falling figure of Ignorance, her dusky skin next to deep indigo and russet, set against a spray of

scarlet flowers: dark flesh against white cloud, pale against dark. Tiepolo was a master at all this, just as he was a master draughtsman: none of these absurd conventions would carry conviction unless each figure, each limb and gesture were brilliantly drawn – which they are. Sophia Loren and Elizabeth Taylor could not look more lifelike on the screen, or more desirable, than these goddesses who patrol the sensuous horizons of our dreams.

In Tiepolo an aristocratic society saw its dreams of glamour and of immortality mirrored in the heavens. Towards the end of his life Tiepolo was summoned to Madrid to carry out the last of his commissions for European royalty, for the king of Spain. And here in

Detail of Virtue and Nobility,
*The Triumph of Virtue*

Spain Tiepolo died, in 1770, at the age of seventy-four. Within a few decades many of the noble families he had worked for saw those dreams of immortality come tumbling down. The French Revolution sent shock-waves across Europe which sank the Venetian Republic and sent the Spanish royal family and many others into exile.

A young Spaniard who witnessed that change and recorded it was Goya. He must have seen Tiepolo's work in Madrid and may even have met him. He was twenty-four when Tiepolo died, and he lived and worked right through this era of revolution, beginning in a gracious mood of calm before the storm with designs for royal tapestries, but ending by painting a darker, stinking world such as Tiepolo and his patrons would not have recognised. Goya, too, was a decorator of houses, but when he came to paint the walls of his own house outside Madrid it was not love-goddesses in the sky he chose to

Goya, *Fight with Clubs*

paint, it was ruffians sinking down and down in the mud, driven insane by a rotten world and fighting a sordid battle, as though after them the human race would be extinguished like the dinosaurs.

Tiepolo's paintings are the end of a mighty tradition of Italian art. Having taken to the air there was nowhere further for it to go, just as there was nowhere to go for the society Tiepolo served. Tiepolo spun glamorous fairy-tales for a doomed aristocracy, but so delectably did he spin them that their appeal has long outlived the society for which they were created.

# THE ELEMENTS

Earth, Air, Fire, Water: one or more of the elements is of course present in all art. But there are painters – and by no means Romantic painters only – whose particular concern is to suggest that by some superior power the elements govern and guide the fortunes of man; or that they echo man's condition; or at least that they offer to his sight evidence of sublime forces at work capable of arousing his passions and stirring his imagination.

The Japanese painter Sōtatsu is little known in the West, though some of his finest work is in our public collections. With heavy-handed misunderstanding it has frequently been termed 'decorative art' rather than 'fine art', and so unjustly overlooked. Sōtatsu worked in the early seventeenth century during the closing period of Japan's feudal age, and among his most successful achievements are his painted screens, *Waves at Matsushima* being a pair of them. They are now in Washington but were originally painted for an élite clientèle of wealthy merchants in the ancient city of Kyoto. These patrons were in a sense Japan's Medicis, just as Kyoto was Japan's Florence; and the art that flourished there shows an attachment to the legends of Japan's past comparable to the rebirth of our own classical past which we call the Renaissance. Sōtatsu's screens are directly related to one of these Japanese legends.

Turner painted two pictures of *The Burning of the Houses of Parliament,* and both of them are now in the United States. It was an event he witnessed in 1834, hurrying there with his sketchbook and water-colours to record his instant impressions of the disaster, which he afterwards used as working studies for the finished oils.

The combination of fire and water always excited Turner's imagination, and later in the nineteenth century it was also a source of inspiration to the American painter Whistler. *Nocturne in Black and Gold: The Falling Rocket* was the subject of a famous lawsuit brought by the artist against the critic John Ruskin who had accused him of 'flinging a pot of paint in the public's face'. Whistler was awarded damages of one farthing!

After Water and Fire – Earth. The central preoccupation of Cézanne's *The Montagne Sainte-Victoire from the Bibémus Quarry* is the structure and physical presence of rocks. It is the most purely physical of all the paintings Cézanne undertook of the mountain which presides over his native city of Aix-en-Provence and over the art of the painter's last years. Finally – Air. Kokoschka's *The Tempest* was painted in 1914 in the aftermath of a tempestuous love-affair with Alma Mahler, widow of the composer Gustav Mahler. The storm is both external and internal, and the painting remains among the most eloquent accounts of emotional disturbance in twentieth-century art.

# Sōtatsu fl. 1624–43

# Waves at Matsushima c. 1630

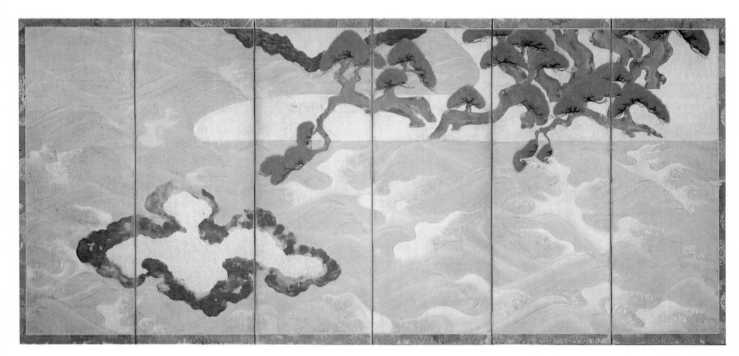

What a gorgeous pair of paintings are these *Waves at Matsushima* by the Japanese artist Sōtatsu. They were executed as folding screens intended to mark off a small area of space within a larger room. How incredible it must have been to kneel on a cushion on the floor and become enveloped in a world of green and brown rocks, gold clouds, white-capped waves and silver-shored islands.

At first glance the eye is captivated by the oddly shaped rocks, rich in browns, greens and blues which seem to blend into each other. The thin clouds and the churning water below have been turned to gold as if by the setting sun. To the left, even the sandy beaches with their gnarled pine-trees have been transformed by the moment; and below, forecasting the dusk, the waters around a sandbar have begun to darken. Truly this is a gorgeous world, but is it a real one or even an ideal one? The longer we look at these two screens, the more disturbing they become. After gazing at the storm-tossed waves, we turn in relief to the solid gold clouds above, but even they cause us doubts. Are they clouds, or are they spits of land? One moment we are certain, the next moment confused and disorientated.

The name *Waves at Matsushima* was not applied to these screens

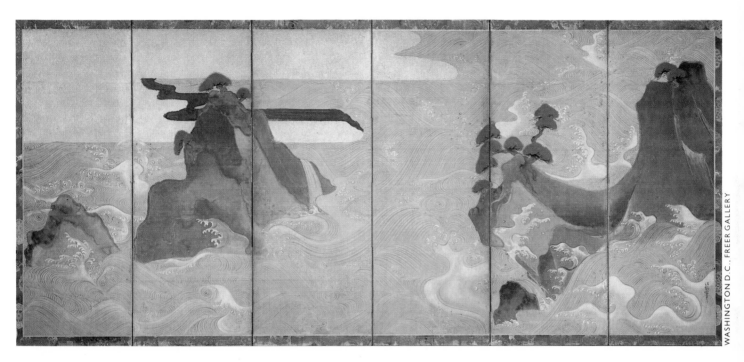

until rather recently – about a century ago. Matsushima is a very beautiful bay, dotted with pine-topped, rocky islands, in northern Japan near the city of Sendai. So picturesque is the scenery there that the Japanese today count it as one of the three most beautiful natural landscapes in their country. However, Sōtatsu and the clientèle for whom he painted lived in the ancient capital of Kyoto many miles to the south-west, and, given the difficulties of travel in the early 1600s, probably knew little if anything about the place. Furthermore, Sōtatsu was not interested in drawing from nature. Instead, he concentrated on such decorative motifs as lotus blossoms, deer and water birds painted in gold and silver or in monochrome ink, and on figural designs in vivid colours, depicting scenes from the great classics of Japanese literature – particularly the *Tales of Ise*, a compilation of poems with prose introductions centring on the Casanova-like figure of Ariwara no Narihira.

Given the range of Sōtatsu's painterly interests, it is likely that the so-called Matsushima screens draw upon a landscape motif more familiar to his patrons, the rocks at Futamigaura, the seaport near the great Shinto shrines at Ise; and that they depict an episode from the

*Tales of Ise*. It could be a portrayal of the feelings of Narihira, in exile from Kyoto, as he paused during his journey along the shore to look at the waters of Ise Bay and to think of the loved ones he had left behind. But if Sōtatsu intended to paint a narrative scene and not a natural landscape, why are there no figures? Why is no story being told?

Sōtatsu illustrated many episodes from the *Tales of Ise*, in some cases detailing the narrative in a straightforward manner, in others making a more elliptical reference to the story. An exquisite album leaf in the Yamato Bunkakan in Nara, Japan, shows Sōtatsu in his most direct story-telling mood. A man is depicted carrying a woman on his back in the dead of night, picking his way through tall grasses and across shallow streams. From the inscription above we know that this is the 'Akutagawa' episode from the *Tales of Ise*. Narihira fell in love with and abducted the future empress, then still a very young woman. As they passed the Akutagawa river, the lady caught sight of a drop of dew, but was too young to know that it would vanish in a moment at the first rays of the sun. The narrative is complete. We understand that the man and woman are in love, the man impetuous, the woman young and acquiescent. She has not learned at first hand of the transitory quality of love, of high position, of life itself.

A more complex and less easily identifiable depiction of the same story appears on a fan pasted on a screen owned by the Japanese imperial family. The fan, because of its curving shape, lends itself to a more dramatic rendering of the narrative. In the extreme right corner we see a man asleep under the eaves of a house and to the left, hovering menacingly over the roof, is a demon. According to the story, after our hero Narihira and his young love passed the Akutagawa River, they were caught in a thunderstorm. They sought shelter in an empty house, the man spending the night on guard outside, the woman sleeping securely indoors. When Narihira called to his love the next morning, she was nowhere to be found. Perhaps the thunder demon had eaten her up. More probably relatives

*Opposite* detail of Narihira carrying the future empress in his back, Sōtatsu, *Tales of Ise*

Sōtatsu, fan-painting, *Tales of Ise*

Detail of last panel from first (right) screen,
*Waves at Matsushima*

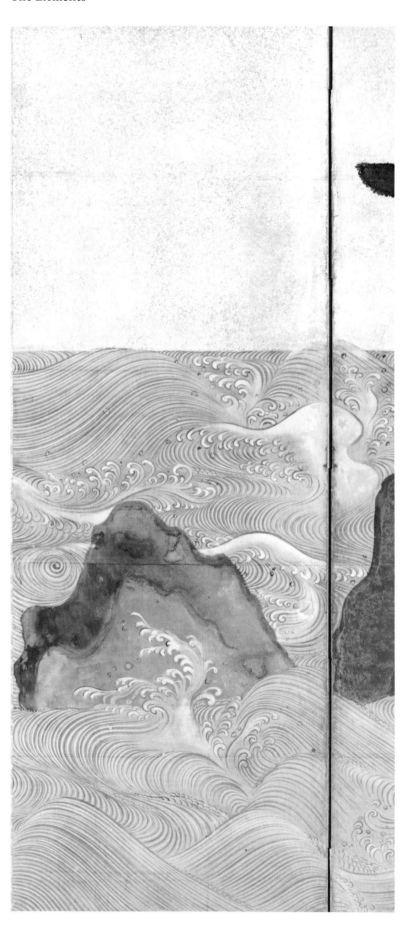

concerned for her reputation had found her and spirited her away.

In the fan painting only the barest details of the story are shown and there is no accompanying text. The man is a minuscule image to the right of the painting, and the woman does not appear at all. The greatest amount of space on the fan surface is devoted to the brown roof of the abandoned house and the demon who grins maliciously as he climbs upward through the air. Yet, in spite of the abbreviated nature of the narrative, the townsmen and courtiers for whom Sōtatsu was painting were so familiar with the *Tales of Ise*, that they could recognise this single episode at a glance.

Thus Sōtatsu was able, in the Matsushima screens, to move a step beyond mere representation to the creation of a visual metaphor for the images Narihira saw and the emotions he felt as he gazed at Ise Bay. Sōtatsu's patrons, recognising the rocks of Futamigaura, would immediately call to mind Narihira's journey along that shore; and, supposing their hero's exile to be the result of his headstrong and imprudent abduction of the empress-to-be, the preceding episode in the tale, would be deeply moved by the gravity of his situation and the sadness of his poem:

How poignant now
my longing for what lies behind.
Enviable indeed
the returning waves.

The screens begin to the right with a richly coloured rocky outcropping of the coastline, surrounded by raging, white-capped water. To the left, a golden cloud appears and then a group of rocks capped by green pine-trees. This rich seascape seems completely true to natural forms, except for one detail: the layer of water which projects to the left behind the rocks and between the two layers of gold clouds. It is as if the man in his loneliness and longing for a moment lost touch with reality. In an eyeblink normal relationships are restored, and in the last panel the gold clouds are clouds again, the water bubbles and boils believably around a single pointed rock.

In the left screen, perception has been completely distorted. Gold clouds have become the shore from which pine-trees grow. In the midst of the white-capped water, two golden islands ringed with silver and black beaches appear devoid of vegetation. Throughout, the waves continue to well up, crest, and roll down only to rise again, flowing inexorably back toward Kyoto.

In the Matsushima screens Sōtatsu has taken the illustration of a specific poem a step beyond the work of previous artists. In earlier paintings of scenes from classical literature, the natural world was used to mirror the emotions of the characters, but the characters were always depicted. In these two paintings, Sōtatsu has penetrated beyond the bland words of the poem, beyond the conventions of earlier painters to Narihira's psychological state, alone, in exile on the beach at Futamigaura, staring at the water and longing to return to his home, his friends, the known world from which he has been expelled. The Matsushima screens are magnificent in their own right, but when viewed so they become an awesome metaphor for deeply felt emotions and a remarkable innovation in Japanese painting.

Detail from second screen, *Waves at Matsushima*

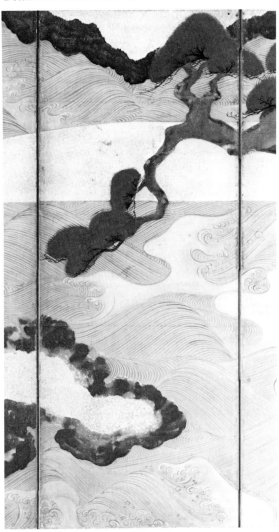

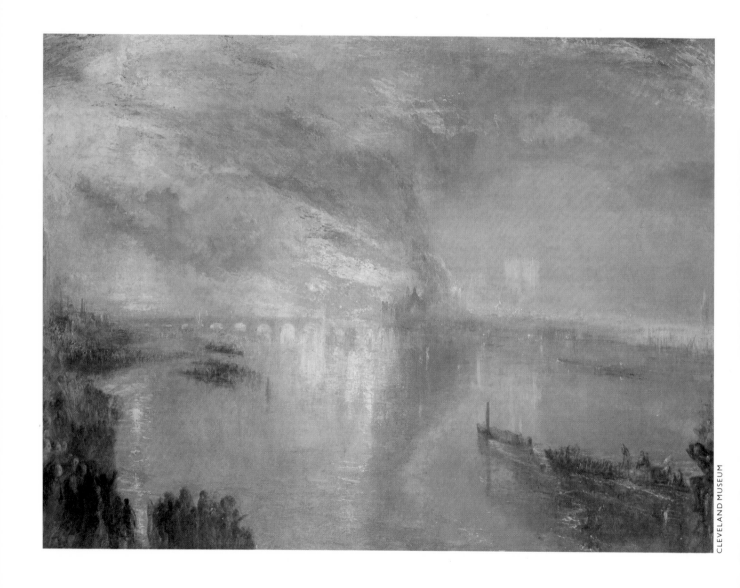

116

# Turner 1775–1851

# The Burning of the Houses of Parliament 1834–5

At 4.30 pm on Thursday 13 October 1834 two visitors were being conducted round the old Palace of Westminster by the Deputy Housekeeper Mrs Wright. One of them complained to her of the heat: he could feel it, he said, through his boots. She told him not to worry. Two hours later the whole place was ablaze, 'affording a spectacle', says a contemporary record, 'of not inferior interest.'

Crowds quickly packed the foreshore and Westminster Bridge. Soldiers were called out. The Prime Minister – Lord Melbourne – arrived to take charge, but by daybreak only Westminster Hall survived among the ruins. Two distinguished witnesses – unknown to each other – watched the tragedy. They were Charles Barry, the architect who was to build the present Houses of Parliament to replace the one destroyed (itself a masterpiece, and certainly one of the best loved buildings in the world), and Joseph Mallord William Turner, arguably England's greatest painter, who was to produce this masterpiece.

He was nearly sixty, and at the height of his powers. The subject was one after his own heart; an imagery of crisis and violence, seen against a background of social upheaval, to be recorded in that fusing whirlwind of light and colour by which of late he had become obsessed.

As soon as he heard of the conflagration, Turner hurried to the scene with his sketchbook. That sketchbook (the size of a paperback – his favourite size) can be seen today in the British Museum. It contains nine water-colours over pencilled notes: two of them were done so quickly one after the other that they blotted the opposite pages. Like most of his fellow artists Turner regarded water-colours like these as working studies for larger and more finished paintings. But by now he was beginning to exploit in oil painting the qualities he had discovered with water-colour – its tension, its luminosity, its airiness, the capacity of the image to 'breathe' as it were upon the paper.

Back home from the scene Turner worked hurriedly on two large compositions, each from a different viewpoint. One of them was exhibited in 1835 in the British Institution and now hangs in the Philadelphia Museum of Art; and this one in the Cleveland Museum of Art which was exhibited also in 1835, at the Royal Academy in

Turner, *The Burning of the Houses of Parliament* (Philadelphia Museum)

London. Turner at this time was beginning more and more to turn away from traditional classical compositions and mythological and Biblical subjects to contemporary subjects like railway trains and shipwrecks. And his passions, fired by a trip to Italy and exposure to its light, were turning to colour experiment or to natural cataclysms in which all the elements are fused in spiralling, convulsive compositions of movement and light.

Not surprisingly the art establishment was as baffled by these works, which were indeed a hundred years ahead of their time, as it was by Turner himself. Many artists and critics (Ruskin's youthful defence of Turner's talents lay several years ahead) believed him to be on the decline, to be senile, even mad. They couldn't make his pictures out. They couldn't make *him* out, and he didn't help them. He had always been solitary, reticent (even furtive) about his private life: he always kept two addresses going, and he found in his work a refuge from a violent childhood (his mother went insane) and a substitute for the domestic peace he was never to enjoy. He was an obsessive worker: his days were dizzy with it. In a short trip to Rome he completed nearly two thousand sketches and paintings, and even on the day of his death a canvas stood ready primed by his bedside. As a result he had only a few close friends – perhaps because, like

Turner, *The Fighting Téméraire*

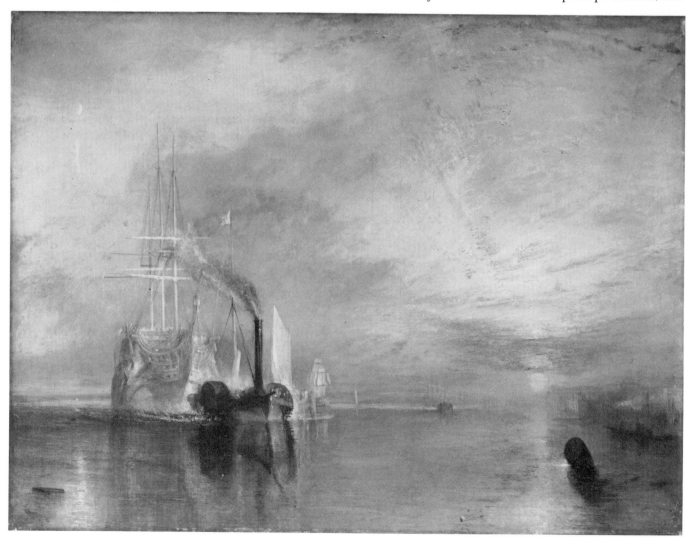

many great artists, he grudged the time and energy spent on being or even looking agreeable. Throughout his life by all accounts his appearance was slipshod, his dress careless, his speech awkward, his manners gauche. No matter, his eye was pin-sharp as a poacher's, his visual memory as unbeatable as his vision and skill.

The period of this picture – the period of his alleged decline – saw the creation of some of his greatest masterpieces such as *Staffa, Fingal's Cave* (1832), *Yacht Approaching Coast* (1835), *Norham Castle, Sunrise* (1835). All of these met with mixed reception, as did *The Burning of the Houses of Parliament* and its companion picture. *The Spectator* praised the purity, the transparency and harmony of the colour, but said (with some truth) that it looked more like day than night and that the people were badly drawn. *The Times* made the same point. *The Athenaeum* magazine called it a 'splendid impossibility . . . truth has been sacrificed for effect, which however is in part magnificent'. *The Literary Gazette* perceptively remarked that it contained more vision and poetry than nature. Turner though sensitive to criticism reacted to such comments not by retreating but by advancing – and the next twenty years were to see his finest achievements: *Fire at Sea* (Tate), *The Fighting Téméraire* and *Rain, Steam and Speed* (both National Gallery).

*Below* Turner, *A Fire at Sea*; *bottom* Turner, *Rain, Steam and Speed*

Detail of the Cleveland *Burning of the Houses of Parliament*

But that lifelong frenzy of eye and hand had begun to take its toll. By 1845 he was drinking too much and his health was failing. He went to Margate to stay with his old mistress/housekeeper Mrs Boothby, returning to London to die at his home in Chelsea on 19 December 1851. Before the burial in St Paul's Cathedral his coffin stood beneath a leaking skylight in the middle of his dingy gallery in Harley Street, watched over only by his pictures that blazed unseen beneath their dustsheets. He left a fortune and his lifeworks (literally thousands of them) to the nation, with his condition that they were to be housed together in one place. The will was contested, the condition has not been kept, and although the nation accepted the pictures, for nearly a century it treated them hardly better than Turner did himself. Most of them however have now found honoured homes – including this one, surely one of his greatest.

Fire and water, smoke and light were to him irresistible – symbols of the destruction of human powers by natural elements. Colour, movement, light all became one. 'Indistinctness', he once said to a complaining client, 'is my forte.' What an understatement for a vision so poetic, for a skill so magical, for a spirit so ultimately invincible . . . for this celebration of an occasion when the picture becomes the man.

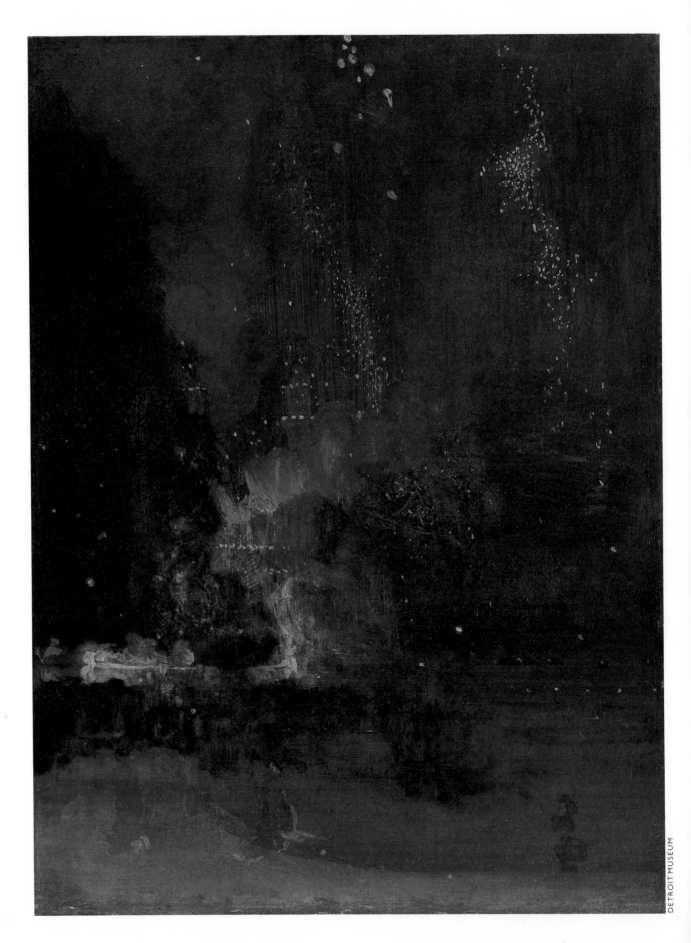

MILTON BROWN

# Whistler 1834–1903

# Nocturne in Black and Gold: The Falling Rocket 1877

The Grosvenor Gallery exhibition in the spring of 1877 is said to have sparked Gilbert and Sullivan's parody of the Aesthetic Movement, the operetta *Patience*. Among the artists included in the exhibition, though they cannot be thought of as constituting a movement or even a congenial group, were such luminaries as Alma-Tadema, Burne-Jones, Holman Hunt, Lord Leighton, Millais, Poynter, Watts, and the American expatriate painter, James Abbot McNeil Whistler. From among the Whistler pictures, John Ruskin, Slade Professor of Art at Oxford and the most influential and authoritative critic in the English-speaking world, singled out the *Nocturne in Black and Gold: The Falling Rocket* for attack. He wrote: 'I have seen, and heard, much of cockney impudence before now, but never expected to hear a coxcomb ask two hundred guineas for flinging a pot of paint in the public's face.'

Whistler, who did not take criticism lightly, especially such demeaning criticism and from so formidable a source, sued for libel. Ruskin was experiencing the first of a series of mental disorders and the trial was not held until November of 1878. For the first time, in English legal history at least, a court was asked to adjudicate in a matter of aesthetics, and there is no question that an English judge and jury of the late nineteenth century were not really equipped to cope with the situation.

The status of the principals turned the trial into a public event, and the action of the participants was often so foolish, befuddled, or obtuse as to turn the proceedings into something of a circus. Still, the trial had historic significance. The drama of the courtroom, though it should never have taken place there, was symbolic of the struggle of the rebel artist against the academic institution. And it was Whistler who had set that stage. But his legal victory and judgement for one farthing and no costs was a disaster. His reputation was badly damaged, his patrons vanished, his creditors swarmed, and he was forced into bankruptcy. The British art world did not forgive the Butterfly, as Whistler signed himself, for challenging – and rather brilliantly – the authority, standards and manners it lived by.

Why did this picture arouse such controversy, such venomous, even hysterical, attack? After one hundred years it may still be a bit difficult to make out in detail, but it would hardly disturb the

Details of *right* exploding rockets and *opposite* middle distance: *The Falling Rocket*

average museum visitor who would probably see it as an impression of a fireworks display. And that is exactly what it was intended to be. Whistler has recorded the memory of such an event at Cremorne Gardens, an entertainment park along the Thames in Chelsea, which was popular in the '70s. Cremorne Gardens was somewhat less fashionable than the earlier Vauxhall Gardens, but it attracted large and lively crowds and Whistler, who was then engrossed in his night pieces, or nocturnes, found the artificial light and fireworks displays fascinating.

What we see in the painting is a vaguely defined night scene in the park: a mass of trees silhouetted on the left, a few figures discernible in the foreground, perhaps on a path and on the green to the right, merging in the middle distance with a crowd, which may be looking back toward the brightly illuminated area from which the fireworks were being launched. The sky is spattered with varicoloured lights of exploded rockets cascading down to earth in random patterns. There is a clearly Japanese quality to the disposition of forms within the composition and it is, perhaps, no accident that fireworks and night scenes were popular subjects among such Japanese print masters as Hiroshige and Hokusai.

Most importantly, the aesthetic signature of Whistler's style – the search for the subtlest nuances of colour, for evanescent form, for that mysterious boundary between the known and the unknown – is stronger and more consistent here than in any of his other nocturnes. The most delicate veils of pigment form exquisite harmonies as

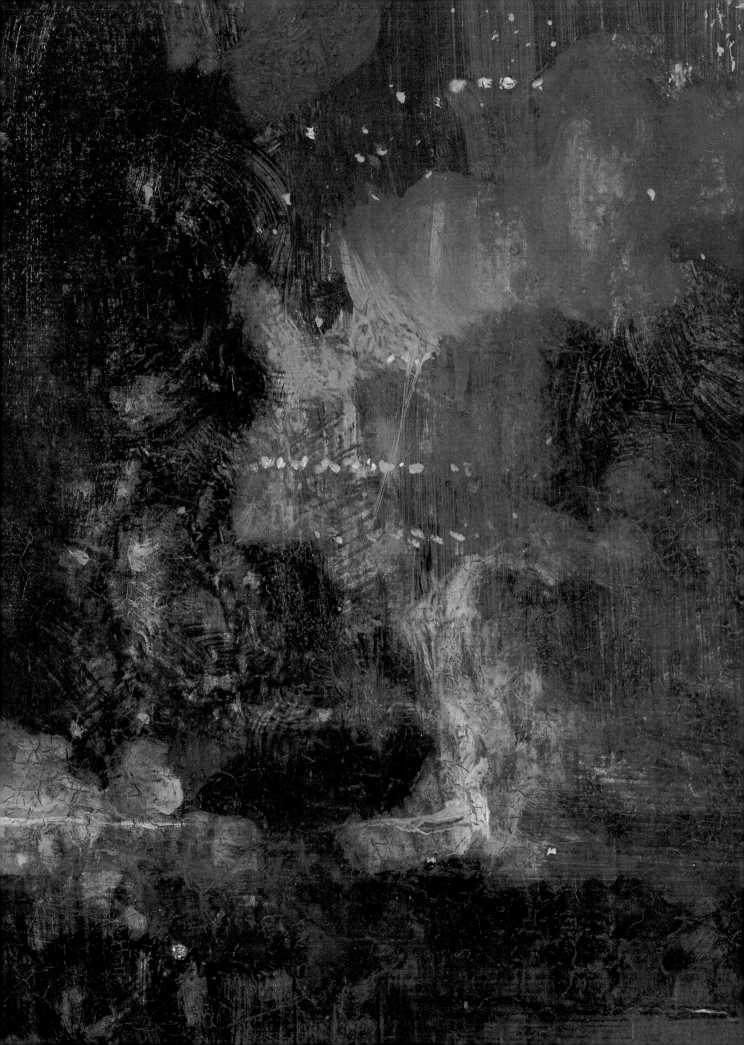

they drift like mists and disappear. Even Sir Edward Burne-Jones testifying against Whistler admitted that the colour of the *Nocturne* was beautiful and that Whistler had an unrivalled sense of atmosphere. Whistler had begun his career as a realist and an Impressionist, but by the '70s he was beyond that, quite independently, somewhere within the orbit of Symbolism.

Whistler's love-hate relationship with England and the English has always remained enigmatic. He was possibly the only truly cosmopolitan artist of his time. Born in the United States, reared as a child in Russia, trained as an artist in France, he decided to settle in London, which was certainly not the artistic centre of Europe nor the most permissive place, socially and aesthetically. He rubbed the English the wrong way. Bohemian, arrogant, a bit of a braggart, and a poseur, he delighted in unsettling the pomposity of what he called 'the tradesmen'. He was in fact something of a coxcomb, a jester. But behind it all was a serious and hard-working artist of remarkable talent and sensitivity. He was truly hurt when Ruskin, the court, and the public did not understand and appreciate his art, were incapable of judging his merit and honouring his achievement. They were incapable of doing so simply because they expected quite other things from art.

Both Burne-Jones and William Powell Frith, painter of the popular *Derby Day*, who testified against Whistler, accepted certain standards in art as they did in morals, and these were beyond question. A work of art, for instance, had to have a subject or a theme, tell a story, describe an event, or express an emotion. Then, the forms in a work of art should be recognisable and convincing, taken from nature. And, finally, it had to have what the English academicians of those days called 'finish'. It had to be worked to a level of completeness that would demonstrate the talent and training of the artist, or in sum his skill, and in addition, hard work. Burne-Jones said at the trial, 'I think that nothing but perfect finish ought to be allowed by artists.'

*The Falling Rocket* fulfilled none of these criteria. Whistler was one of the very first artists to insist that subject-matter in art is irrelevant. An artist might go to nature for inspiration, but to copy or imitate was not the artist's function; a picture was finished when it embodied the artist's conception. For Whistler the artist was a creator, not an imitator, a story-teller or a craftsman. In titling his pictures nocturnes, symphonies, harmonies or arrangements he was asserting what for him was an essential link between painting and music. In his own words, 'As music is the poetry of sound, so is painting the poetry of sight, and subject-matter has nothing to do with harmony of sound or colour'. And in explaining to the court why he had used the term nocturne, Whistler said, 'I have perhaps meant rather to indicate an artistic interest alone in my work, divesting the picture from any outside sort of interest which might have been otherwise attached to it. It is an arrangement of line, form and colour first . . . . Among my works are some night pieces, and I have chosen the word nocturne because it generalises and simplifies the whole set of them.' A quite logical explanation, and, for our time at least, not very difficult to understand and accept. For much of what Whistler battled for in his day has become the dogma of our own.

Whistler, *The Thames in Ice*

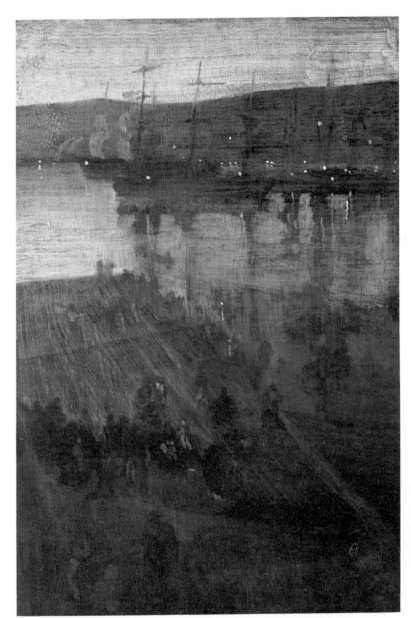

*Left* Whistler, *Neptune*; *below* Whistler *Nocturne in Blue and Gold: Old Battersea Bridge*

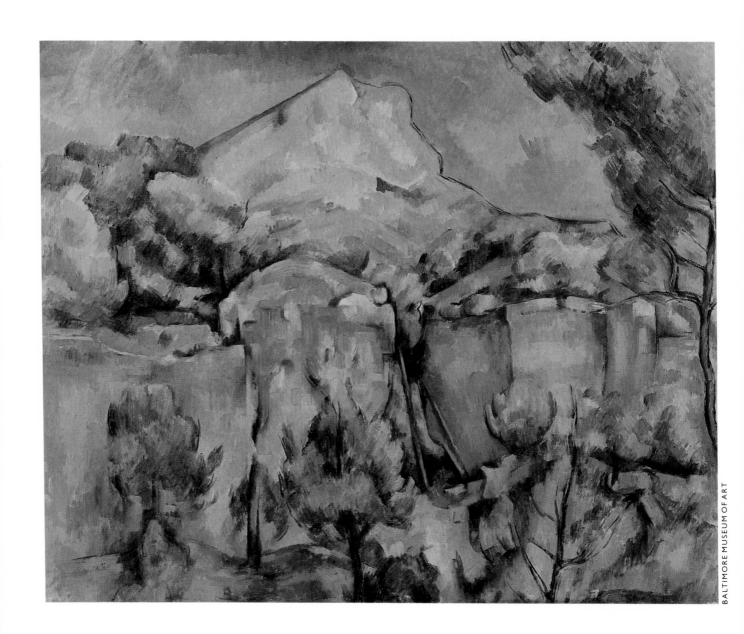

128

EDWIN MULLINS

# Cézanne 1839–1906

# The Montagne Sainte-Victoire from the Bibémus Quarry 1897

Towards the end of his life Paul Cézanne wrote, 'Were it not that I am deeply in love with the landscape of my country, I should not be here.' What Cézanne meant by 'his country' was Provence, the south-eastern region of France near the Mediterranean, and in particular that part of Provence round the city of Aix where he was born and where, in 1906, he died. Cézanne was a lonely man, an unhappy man except when he was painting, and increasingly with age he seems to have transferred to inanimate objects the kind of intimate feelings a less isolated artist might have expressed towards people. Human beings are displaced by objects, or they become objects. He was a wonderful painter of things, whether tiny or (as here) monumental.

This picture in the Baltimore Museum is one of no fewer than sixty studies – oils and water-colours – of the Montagne Sainte-Victoire which Cézanne made during the last twenty years of his life. The mountain presides over the city of Aix, and it presided over Cézanne. He was obsessed with it as though it were an extension of himself, a mirror which reflected his vision of the world and his soul. Cézanne's obsession with the Montagne Sainte-Victoire is not in fact unlike other painters' obsessions with self-portraiture – Rembrandt and van Gogh who painted their own faces in the mirror over and over again with such intensity, such devoted inquiry, documenting the lines of experience and the passage of time. In a way Cézanne did this too. In Cézanne's world of objects the mountain became a point of emotional focus to him, a living presence which echoed his lonely passions and echoed his development as an artist.

In his letters Cézanne constantly stresses the personal and emotional content of his work; and when you look at a painting such as this one it is not hard to feel that the shimmer of light playing across the surface is more than a mere optical effect; it is also a controlled emotional throb. Without this personal note – this rhythmic beat of the heart – Cézanne's paintings would lack the quality which makes them so moving: they would be wooden, like the work of so many of his imitators.

Of all Cézanne's versions of the Montagne Sainte-Victoire this one is the most physical. It is set in a disused quarry where Cézanne had a hut for his painting things and where he would return day after day

Cézanne, *Rocky Ridge above le Château Noir*
(watercolour and pencil)

to make studies of rock-shapes, and of how trees force their way out
of fissures and crevices. He loved this secret relationship with
elemental forces close at hand, just as he loved the blazing contrast in
full sunlight between pine-trees and orange rock.

Both green and orange are intensified, if you look closely, by the
way Cézanne has built up each section in a sequence of colour-
patches, each ranging systematically from light to dark and vice
versa. Cézanne is doing with colour what Italian Renaissance masters
like Leonardo da Vinci did with black and white to produce the effect
of rounded three-dimensional form. When you stand back the
surface appears to quiver in a heat-haze, creating the sensation of
varying depth.

Yet there is no perspective as such in this picture, there are no lines
leading the eye into the distance, and when you look above this
broken wall of rock and take in the landscape and mountain, it is
quite a shock to feel how close – almost menacingly close – the
mountain stands. It is thrust right in your face. The great flank of the
mountain appears flat, as though cut out with scissors, and yet the
same sensation of varying depth is set up by these painstaking
sequences of light to dark and back again. He said he felt he was
'creating forms by means of his brush'. *Creating* forms, note, not
copying them.

When people say, as they have been saying for eighty years, that
Cézanne was the father of modern painting, this is really what they
mean. They mean that Cézanne evolved a way of suggesting depth
and volume without resorting to tricks of perspective. The twentieth
century has had an obsession with flatness and this is a flat picture
first, not an illusion of reality. This way Cubism lies, of course, and a
great deal of abstract painting which came out of Cubism.

Cézanne painted the Baltimore picture round about the autumn of
1897, when he was nearing sixty. It was not the first time he had
made the Montagne Sainte-Victoire the centrepiece of a picture.
More than ten years earlier he had painted it as a far landmark in a
classical vista such as Claude or Poussin could have painted, full of
space and air, and framed by a pine-tree .which might have been

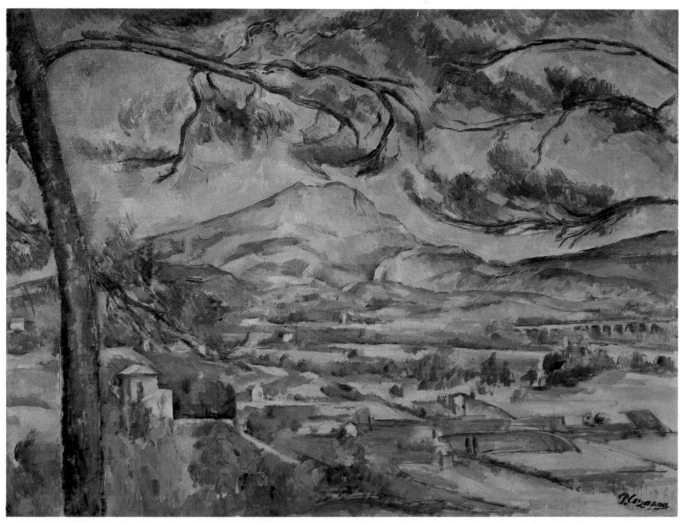

Cézanne, *La Montagne Sainte-Victoire*
(Courtauld Institute)

grown specially for us to measure the rolling distance between here and the horizon. But in the passage of ten years all that wide open space has closed up, all the pictorial details have gone, all suggestion that man inhabits a pleasant land. The landscape now looks rough to the touch, and the mountain itself, from being a serene eminence, has become an object hacked out of the dry earth.

Then, from this point of closest contact, Cézanne moved away again. Or, rather, he moved away from a concern with the tangible reality of landscape to a concern for the intangible – in other words, light. Was it possible to express a sensation of space by means of colour alone? Cézanne's solution was to use oil-paint rather like water-colour, allowing colours to float like transparent veils. He also began to paint more and more rapidly, or apparently so, giving an impression of urgency lest the sensation vanish. The mountain was always new, in every season, every light, every mood of the artist. 'I feel myself washed', Cézanne wrote, 'by all the colours of infinity. I become one with my painting. We live in a rainbow chaos. I stand in front of my subject, lose myself in it. . . The sun, like a distant friend, secretly warms my idleness and makes it fruitful. We germinate.'

Cézanne's impact on modern painting has been so momentous that we have done our best to drown his achievement in critical analysis. We have stressed his method rather than his inspiration. Yet when I

look at these paintings of the Montagne Sainte-Victoire I wonder whether anywhere in art could be found a clearer triumph of inspiration over theory. Each version is built up within a restricted range of colours, like a composer writing a sonata in a selected key – one in dark blues and greys (the Ford picture), another in blues, greens and buffs (the Annenberg picture), another (the Basle picture) in similar tones but moving between more dramatic extremes of black for the foreground vegetation, to a slab of white for the peak.

In the Beyeler picture the peak is left virtually blank. It exists only in the mind's eye. I'm reminded of how Cézanne, when he painted a portrait, would leave the features till last. This is an unfinished version: indeed most of these late pictures are unfinished, but this one more than the others, and it shows Cézanne's way of working particularly clearly, building up colours as if he is erecting fences, territorial boundaries which define areas of perception. The order in which he painted these last studies of the mountain is irrelevant because he worked on several simultaneously over a period of years. In all probability the one now in the Pushkin Museum, Moscow, is

Cézanne, *La Montagne Saint-Victoire*
(Cleveland Museum)

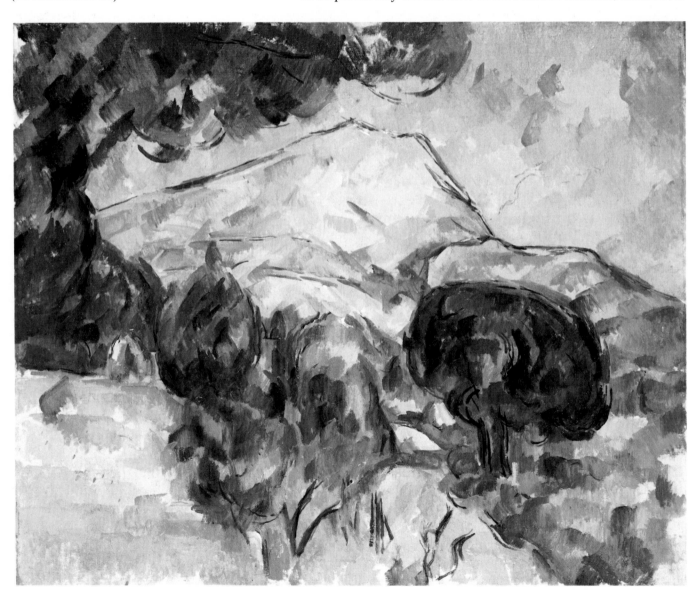

132

the final one, done in the year of his death, 1906; it is also the one least concerned with topographical detail.

So what was Cézanne moving towards? Supposing he had lived to be eighty instead of sixty-seven? One would love to know. Only three years after his death Picasso was painting landscapes at Horta in his early Cubist style which derives directly from Cézanne – but from a much earlier Cézanne. In these last paintings of the Montagne Sainte-Victoire Cézanne had already moved away from 'pure painting'. Yet they are not abstract: it is impossible to use that word about Cézanne. He points a way he would surely never himself have taken.

One of Cézanne's greatest followers, Fernand Léger, expressed what we may all feel when he said, 'I often wonder what would have become of modern painting without Cézanne.' Yes, it *is* impossible to imagine modern painting without him. He was its prophet. At the same time this ever-changing vision of a mountain is an achievement so personal, and so unique, that I cannot help feeling it passes modern art by, like a ghost. It is something alone, like the mountain, like Cézanne himself. Prophets tend to remain solitary people.

Cézanne, *La Montagne Sainte-Victoire* (Basle, Kunstmuseum)

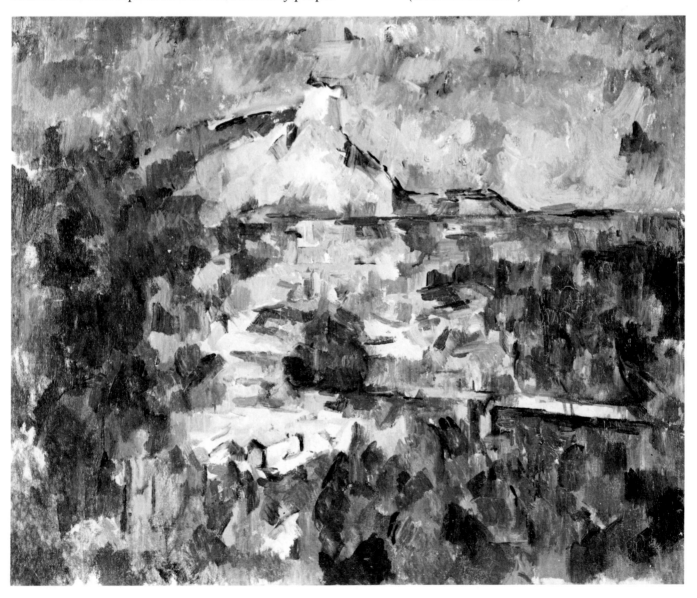

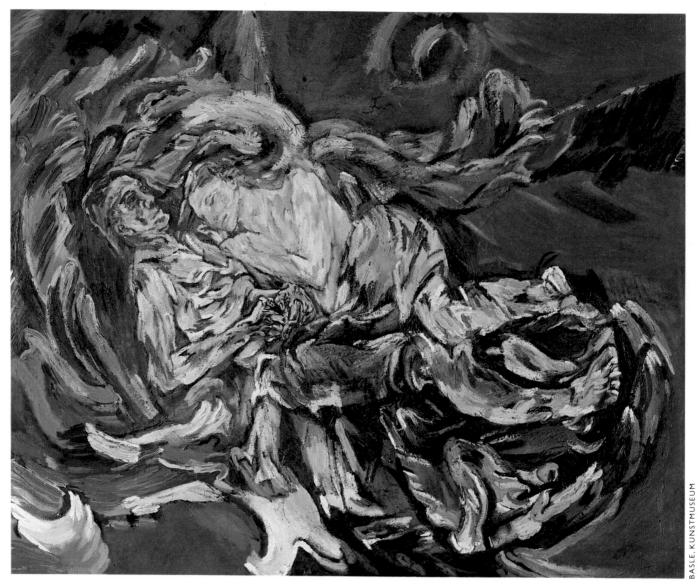

134

RICHARD CORK

# Kokoschka 1886–1980
# The Tempest 1914

At first glance, the ferocious storm surging across Kokoschka's large canvas cannot easily be distinguished from the figures it threatens to engulf. Limbs and waves both seem part of a single seismic upheaval. The breakers swirling around this couple are propelled by the same agitated brush-strokes which twist and dart over their bodies.

Like spray flying in the eyes of anyone who witnesses a gale at sea, the spume given off by such extravagantly applied paint is spectacular, but deceptive. It could well blind hasty observers to the real meaning of a picture which seems, on the surface, to be wallowing in an excess of turbulent emotion. And Kokoschka's explanation that the painting commemorates his passionate involvement with Alma Mahler only increases suspicions about his motives. After all, what could be more self-indulgent than a monumental canvas devoted to the heroic glorification of an artist's youthful love affair? The very idea creaks with melodrama, striving for an exalted significance which the reality of their relationship may not have deserved.

When Kokoschka met Alma Mahler soon after her husband's premature death in 1911, fashionable Vienna regarded it as a triumph to have an affair with a married woman or widow. Alma, renowned not only for her own beauty but also as the inspiration of a composer as brilliant as Gustav Mahler, was an exceptional prize. And Kokoshka can hardly have been unaware of the celebrity which would be attached to the man who became her lover. He won her over very quickly, although they could hardly have been more different. Kokoschka was a hotheaded twenty-five-year-old rebel, dedicated to challenging the Habsburg Empire's conservative values: in 1909 he had defiantly shaved his head to scorn the hostility of the Viennese press towards avant-garde art. Alma, by contrast, was an older woman of far greater wealth and standing in bourgeois society, who held a salon frequented by distinguished political leaders, financial magnates, men of letters, artists and scientists. It was therefore an exotic liaison, bound to provoke scandal among those on the look-out for titillation in high places.

But the epic proportions of *The Tempest* do not reflect the hollow pretensions of a young painter determined to revel in his conquest with the most inflated rhetoric imaginable. They pay tribute to a

Kokoschka, *Alma Mahler* (drawing)

genuine infatuation, and for a while these unlikely lovers were as inseparable as two energetic, independent people could ever be. Kokoschka defined something of Alma's wilful pride in a fierce drawing; but by the time this study was transposed to a painted double portrait, the stubborn set of her features had softened into the serenity of a goddess whose hair is crowned by a wreath of love.

It is a tender picture, spiritual rather than sexual, in which the couple appear to be on the brink of pledging themselves to a solemn union. The only suggestion of the harsher, often frenzied way Kokoschka's other early portraits probed the psyche of his sitters can be found in the wariness with which the lovers stare, not at each other, but sidelong towards the spectator. Even during their most private moments they were acutely conscious of being on view, and this affectionate but defensive painting does hint at the tension their notoriety had begun to create.

The gap between them in age, experience and social status gradually became a source of insecurity. Kokoschka grew jealous of Alma's wide circle of friends, her late husband's fame, and the incessant gossip surrounding her. They escaped Vienna for a while,

visiting Naples and Venice, where Kokoschka was impressed by Tintoretto's command over the kind of large-scale, outspoken figure composition he was to tackle in *The Tempest*. But later in the trip, when they travelled through the Dolomites and he painted the *Tre*

*Croci* pass, a new melancholy entered his work. The sombre sense of loneliness in this landscape mirrored Kokoschka's increasingly possessive attempts to isolate Alma. She began to resent it, and provoked a rift after their return by ignoring his instructions not to bring Mahler's death-mask to the small house they built for themselves near Vienna. Kokoschka could not bear the continuing influence of Alma's dead husband, and claims that she reacted to his anger by aborting their child in a Viennese clinic. Stunned, Kokoschka never forgave her. Their impetuous three-year relationship was nearly over.

Kokoschka, *The Tre Croci Pass*

*The Tempest* is, above all, an attempt to come to terms with this traumatic experience. Before the rift Kokoschka had painted a fresco over the fireplace in their new house as a surprise for Alma, showing them both rising Phoenix-like from the flames. But there was no comparable note of victory in the work he began to carry out after the abortion. Pursuing the idea of a wall decoration, perhaps in emulation of Tintoretto's great cycle at the Scuola di San Rocco, he made sketches for a grim crematorium mural. His most powerful drawing shows a trio of women embalming a naked corpse. The body

Kokoschka, Sketch for crematorium mural

resembles Kokoschka himself, and his defenceless pose contrasts with the aggressive actions of the women. One seems to be pinning his arms down, while her companion's hands thrust towards his neck as if to strangle him.

The violence is overt, not just a fanciful possibility. It bears out Kokoschka's own belief, dramatised several years before in his first stage play *Murderer Hope of Women*, that bewitchment by the opposite sex could easily lead to a tragic loss of identity he equated with death. The play was written before he capitulated to Alma, and the drawing which illustrates it shows Kokoschka trampling masterfully on a prostrate woman while he brandishes a dagger ready for the kill. But by the time he had begun to fall out of love with Alma, all this masculine bravado had disappeared and the sexual roles were reversed. In the crematorium sketch the women have vanquished the man, and his prostrate form was carried over into the preliminary charcoal drawing Kokoschka made for *The Tempest*.

Here his body has been transferred from a burial chamber to a bedroom, brought back to life so that he can enjoy the woman lying peacefully beside him. They look as if they are resting after making love, and their hands are clasped together in affection rather than conflict. Snug under a sheet, they betray no sign of discord. Kokoschka's use of line is unusually spare and economical, giving the limbs it defines the slender vulnerability of adolescence. But their happiness is only momentary. It merely represents the stillness before a storm, and as they drift towards the nightmarish sleep depicted in the final painting all the frictions which shattered their relationship are unleashed.

In *The Tempest* the sheet that once lay unruffled has been twisted and pushed up around their loins, so that Kokoschka's knee and foot are revealed in all their knotty ungainliness. The rest of his body has lost its former smoothed-out innocence as well. It is bony and emaciated, for Kokoschka makes his brush explore every hollow and crevice of a torso more cadaverous than the figure he had drawn in the crematorium. This is a man wasted by grief, like the *Man of Sorrows* drawn four hundred years before by Dürer, an artist Kokoschka admired greatly in his youth. Dürer's man is probably a self-portrait too, and he crosses his arms over his stomach in much the same resigned way as the figure in *The Tempest*. But Kokoschka's hands are empty : his fingers have nothing to do except pluck and dig into each other as he writhes with barely suppressed suffering. Alma's hand no longer clasps his, and a palpable distance now separates their two faces. It emphasises the difference between her placid sleep and his staring eyes, bruised and full of aching wakefulness.

This distance is accentuated even more by the stark contrast in Kokoschka's handling of their flesh tones. Where his skin is livid and furrowed with violent impasto, hers is painted with a delicacy which produces a pale sheen like mother of pearl. The upper half of her body forms the still heart of this painting, and remains calmly at odds with the unrest raging elsewhere. Alma's desirability is clear, but Kokoschka is removed from her, alone and apart. The entire composition is devoted to this tug of war between attraction and rejection. Even as the tempest flings them together into a proximity

Detail of Kokoschka and Alma Mahler, *The Tempest*

so intense that they seem strangely impervious to the fury around them, they could at any moment be flung apart by the centrifugal force of the storm. Their mutual absorption cannot last, and the extraordinary speed with which Kokoschka's brushwork changes from solidity to fluidity and back again reinforces the feeling of impermanence.

For the time being they remain precariously bound together by the hurricane encircling them. But where are they supposed to be? The sea or the land? Austria or some extraterrestrial wilderness? Kokoschka, who painted *The Tempest* in a bleak studio with black walls and only an empty barrel to serve as furniture, recalled looking away from this picture towards the window and seeing 'the pale summer night descending, the moon rising and riding over the long roof and the sea of houses'. Although no such specific setting can be found in the painting itself, the reference to a sea is revealing. For these lovers are caught up, not just in a storm imposed on them from without, but in the mental disturbance created by their own inner stresses.

This was the crucial psychological element Kokoschka wanted to unlock in all his early work, influenced by the climate of radical opinion in Vienna where the revolutionary Freud was insisting that 'true knowledge is insight into the unconscious'. Kokoschka's fascination with the role played by dream and fantasy was far more instinctive and less scientific than Freud's, but he did share the great psychologist's belief that dreams intimated the true inner life, released from mundane external reality. That is why he decided to expose his painful involvement with Alma through the metaphor of a tempest induced by sleep. Only by giving vent to his awareness of the dream-world could he approach the centre of their ailing relationship, for he had declared in 1912 that 'consciousness is the source of all things and ideas. It is a sea with visions as its only horizons'.

*The Tempest* is his most ambitious attempt to give this visionary ocean pictorial form. Many writers have speculated about the boat which is supposed to be carrying the couple, but the picture is at pains to dispense with such literal props. As a boy, Kokoschka had been powerfully impressed by the huge Baroque frescoes by artists like Maulpertsch he saw in Viennese churches. And he carried over their tumultuous rhythms, along with their ability to paint figures flying through space in defiance of all laws of gravity, into his own canvas. Just as the waves breaking underneath the moon bear an eerie resemblance to the mountain-tops he had painted at *Tre Croci*, so the lovers could be hovering above the sea rather than floating in a vessel of any kind. It is no accident that the painting has also been called *The Bride of the Wind*: these figures *are* airborne, in the sense that they inhabit a region of the mind unshackled by physical limitations.

But there is nothing at all exhilarating about this freedom from bodily constraints. Kokoschka sees himself as a man driven by forces he cannot control, and a profound feeling of doom oppresses this figure as he wrings ice-blue hands over his misfortune. Nor is he merely the victim of an over-developed romantic *Angst*. For Kokoshka was based in a Vienna newly overshadowed by the assassination of Archduke Franz Ferdinand, the heir to the Austrian throne. And he soon found himself at the centre of a far larger vortex which was to suck the world into a terrible conflict. Only a few months after this painting was completed, he heard the newsvendors shouting through a hot July morning that Austria had declared war on Serbia. So the premonition of flux and decay so powerfully expressed in *The Tempest* turned out to apply to the Habsburg Empire and the whole of western society, not simply to the inner life of one young artist.

The painting turned out to have a practical use, too. Feeling he had nothing left to lose or defend at home, Kokoschka decided to join the cavalry, and the money he got from selling *The Tempest* to a pharmacist in Hamburg was just enough to pay for his horse. He became a dragoon, but in *The Knight Errant*, the last picture he painted before his departure, the full extent of his despair was revealed. Dressed in archaic armour which only emphasises the futility of his participation in war, he now sees himself suspended

like a puppet between earth and sky. His arms flail around him in protest, but to no effect. The woman who lay beside him in *The Tempest* is now no more than a distant and unconcerned figure crouching on the seashore. He is more alone than ever, and the letters ES flaming in the sky spell out the bitterness of total dejection: 'My God, my God, why hast thou forsaken me?'

The only answer comes in the shape of a wasp lurking near those letters, and after Kokoschka went off to fight its sting was duly administered. Knocked to the ground by a severe bullet-wound in the head, he regained consciousness only to find a Russian soldier advancing on him, bayonet ready to strike. Kokoschka could have shot him first, but his survival instinct was by now so weak that he allowed the enemy to stab him through the lung. Art and life very nearly came together in a fatal conjunction, to turn the corpse-like man of *The Tempest* into a reality on the battlefield.

Although his death was announced in the Viennese papers, Kokoschka survived to enjoy a long career. But the final irony is that some vital element of tension went out of his art after he had recovered from the love-sick death-wish which *The Tempest* so recklessly exposed.

# HUNTING

From the early cave-paintings to those stiff English canvases of fox-hounds pursuing their quarry, the theme of hunting has often been painted with an air of mystique, almost of sanctity. It has rarely been just a record of killing for food or killing for sport. Hunting has been a royal sport and a sport of the gods. In Greek mythology the goddess of the hunt, Diana, was also the moon goddess, and the personification of chastity.

Titian's *Diana and Callisto,* from the middle of the sixteenth-century, is a sumptuous account of a shameful episode in Greek mythology, as recounted by the Latin poet Ovid who revelled in the sordid activities of the gods of Olympus. It is the story of the seduction by Jupiter of the nymph Callisto, and her subsequent expulsion from the company of Diana for breaking the vows of chastity.

One presumes that hunting, as hunting, meant little or nothing to Titian; and living most of his life in Venice, as he did, he may never have witnessed a hunt of any kind save a duck-shoot on the Lagoon. His younger contemporary in the Spanish Netherlands, Pieter Bruegel, possessed no such interest in classical mythology, preferring to record the events of pastoral life as he saw and experienced them. *Huntsmen in the Snow* is one of a set of paintings Bruegel undertook on the theme of the seasons of the year, arguably the first celebrations in western art of pure landscape for its own sake.

In the 1760s, when Stubbs painted what is often considered his finest work, *The Grosvenor Hunt,* hunting (at least in England) had become a rather grand pageant performed by the aristocracy, and the artist has taken the opportunity to make of this hunting scene an elaborate open-air portrait of a family group in costume – portraits not only of the Grosvenor family but of their horses and dogs too.

The theme of hunting also brought out an unexpectedly ceremonial side of the French painter Courbet a hundred years later. *The Huntsmen's Picnic* is an unusually formal painting for the champion of plain realism. Courbet was himself a keen huntsman, as many of his pictures bear witness, being hung about with slaughtered beasts, as this one is; only here the subject is not the kill but the celebration afterwards. The huntsmen preen and strut in their bright costumes, show off to their ladies and prepare for a copious open-air meal.

Only with the American Winslow Homer's *The Fox Hunt* does an actual hunt occupy the centre of the picture – or rather the threat of a hunt. And a highly dramatic picture it is, haunting, even menacing, with its focus on the solitary hungry fox being menaced by marauding crows in a white winter landscape. For once in a hunting picture man plays no part except as the unseen observer, and all suggestion of hunting being a sport is instantly removed. Here is a hunt in nature.

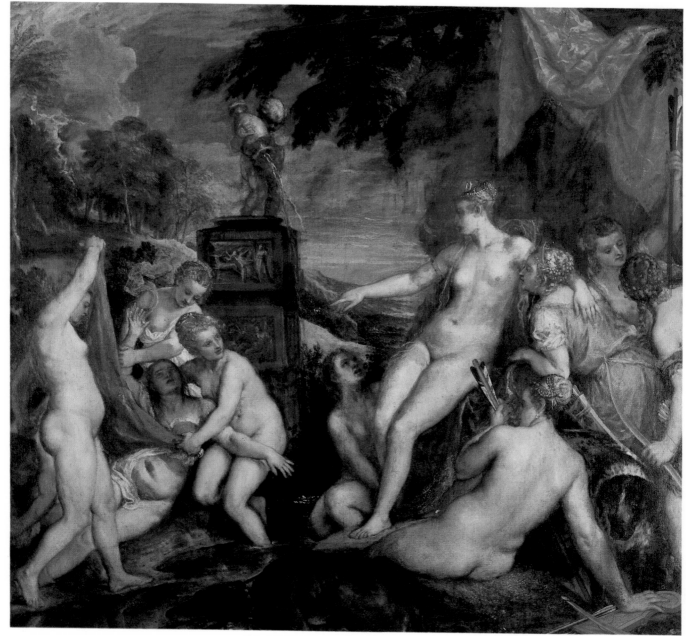

DAVID PIPER

# Titian c. 1488–1576
# Diana and Callisto 1556–9

Every picture tells a story; or anyway, certainly was in the habit of
doing so about the time Titian painted this picture, between 1556 and
1559. Every picture, of course, also works at different levels, evokes
different responses. But before I get to that, let me tell you the story
which is the invitation into the painting. This comes from that
inexhaustible anthology of picturesque incidents from the lives and
loves, the lusts and vendettas of the gods of classical antiquity,
compiled by the Roman poet Ovid in his *Metamorphoses*.

Ovid tells how Jupiter sighted Callisto, a nymph of the entourage
of the goddess Diana who was dedicated to chastity though also to
hunting. Jupiter was always both ruthless and ingenious once his
lust was aroused. In this case, though the mechanics may baffle the
modern reader, he transformed himself into a facsimile of Diana, so as
to gain the girl's trust. Which achieved, he promptly seduced her.
The wretched Callisto became pregnant. Then one fine day, Diana
with her train of attendant nymphs came to a 'gently murmuring
stream' in the summer woods.

The place delighted her and she dipped her feet in the water . . .
'Come, no one is near to see. Let's disrobe and bathe us in the
brook.'

The pregnant Callisto blushed, and tried in vain to be excused
undressing. But she was obliged to comply,

and there her shame was openly confessed. As she stood, terror-
stricken, vainly trying to hide her state, Diana cried : 'Begone, and
pollute not our sacred pool,' and so expelled her from her
company.

That is Titian's moment. On the right, the majestic figure of Diana,
supported by maidens. In her hair, her symbol, a jewel in the form of
a crescent moon. Her attendants have divested her, and relieved her
also of her other attributes, the huntress's bow, spear, arrows and
their quiver. Her dismissive arm is flung out, in judgement on
Callisto.

You might at first glance infer, legitimately I think, that the
pregnant Callisto is the rather stout figure on the extreme left, but in
fact she is the half-collapsed figure being stripped of her coverings by
her companions, and shrinking back from Diana's accusation. The

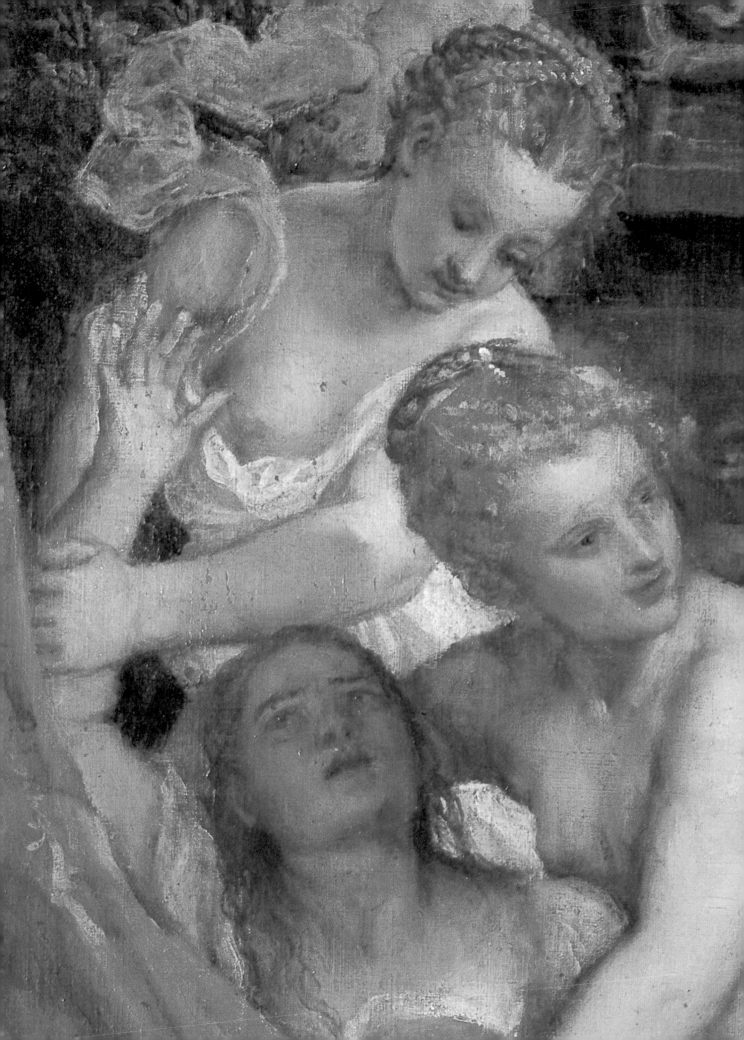

shifting, magical light of the glade has mercifully half veiled her face but only to reveal the more mercilessly her swollen belly. The story itself is not exactly a pretty one. Jupiter has done wrong to Callisto, and now Diana is making things worse. Indeed, far worse still is in store for Callisto, but Titian is not concerned here with the sequel. You may in fact wonder what he *is* concerned with.

Forgetting the story line, let us now just consider the painting, and that is not pretty either. It is just tremendous, an affair of sumptuous female flesh. It glows in the broken sun and shadow of the glade. It is a sensual man's dream of fair women in a summer landscape. From the urn held by the little statue on the fountain, water in liquid light trickles inexhaustibly. Through the two flanking groups of naked figures, through the feathery foliage of the trees, the distance opens out, blue distance, blue skies with an argosy of sunlit clouds. Golden yellow, rose, and echoing touches of rose and blue against blue.

All his life, Titian's subjects were primarily of three kinds; portraits, religious themes, and mythological or historical ones. And

*Opposite* detail of heads of Callisto and two of Diana's attendants; *below* detail of the statue on the fountain, *Diana and Callisto*

it was the mythological ones that always seem to have fired his imagination most vividly. So, very early in his career, the famous *Sacred and Profane Love* in the Borghese Gallery in Rome, as early perhaps as about 1514. The imagery is full of allusion that is now obscure, complex references, quotes from classical lore: the whole *literal* meaning has never been fully deciphered, yet it is one of the most potent, haunting images in all western art, with all the hypnotic immediacy of a dream. What are those two women doing, one clothed and one naked? And then the sarcophagus, the carved reliefs, what do they mean? But literal meaning is peripheral. This is above all in colour, in line, in mood, a lyric celebration of the human body, of woman's body, and analysis in words will not help you in the end much more than do the programme notes for Beethoven's Pastoral Symphony.

Titian, *Sacred and Profane Love*

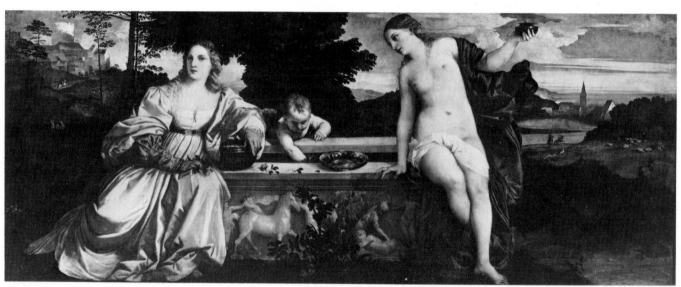

Then later for example, Titian's great *Bacchus and Ariadne* in the National Gallery in London, painted originally in 1520 to 1522 for the Duke of Ferrara. Now desire enters in: the radiant Bacchus hurtling from his chariot and a throng of attendant revellers. He seems to come out of the sky itself, with a leap worthy of Nijinsky, in pursuit of Ariadne. Here it is the male, Bacchus, who is all but naked. The startled Ariadne is turning to flight in a swirl of drapery, but the whole exultant mood of the picture announces that flight will be vain. Like the Callisto picture this too is all gold, and golden flesh, and rose and white and blue draperies. But the handling of the paint is different, much more tightly defined, sharper and harder and crisper. There is – as it were – a lot of resonant but clearly articulated brass in this exultant scherzo.

And then – it is around forty years later – Titian takes up the Diana theme. He started perhaps with *Diana and Actaeon*, now in Edinburgh together with *Callisto*. Though there is no direct link in Ovid between the two stories, other than Diana's person, Titian clearly balanced the two together as pendants in composition – and in theme: variations on the theme of gorgeous nudes bathing in a summer glade. This time it is Diana herself who is starting back in horror at the exposure of her nakedness to unauthorised eyes. They

Titian, *Bacchus and Ariadne*

Titian, *Diana and Actaeon*

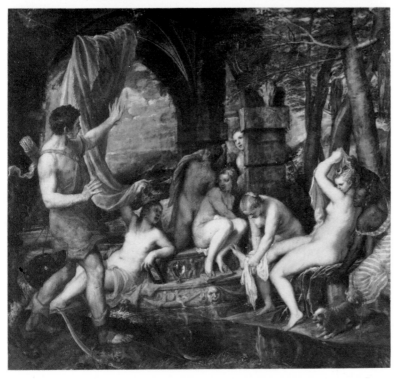

have all been surprised by the sudden arrival of Actaeon, stumbling unawares on this exotic bathing party while out hunting. As in the *Callisto*, your eye can loiter in astonishment over the painting of the nudes, the orchestration of colour, the extraordinary freedom of handling in the paint, so very different from the earlier Bacchus.

This freedom is even more striking in the sequel to the *Actaeon*, the *Death of Actaeon* now in the National Gallery in London, but here the mood has changed to sombre tragedy. As with Callisto, the outcome

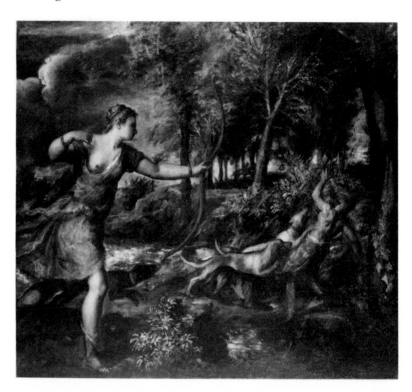

*Right* Titian, *Death of Actaeon*; *below* Titian, *The Rape of Europa*

of the story is not pretty. Diana's vengeance on Actaeon for seeing her naked (though from no fault of his own) was appalling. Here she is, shooting him with her bow. As if that were not enough, he is already half-transformed into a stag, and is being devoured alive by his own hounds. But the painting is superb, so free that the paint seems at places splashed on, or thumbed on with thumb and fingers. Titian's pupil, the younger Palma, described how the master worked in his old age. He would leave a picture unfinished for perhaps months, then get it out, scrutinising it 'as if it were his mortal enemy', says Palma. And then, adjusting it, touching with colour here and there, tuning it almost, he would use his fingers as much as his brush.

The *Death of Actaeon*, though, was not one of the set of mythological paintings that Titian painted on commission for Philip II of Spain as were the other two Diana paintings. Perhaps it jarred against the mood of the others; it may in fact be both unfinished and later than they are. In its sombreness of colour, as in its freedom of touch, it is characteristic of Titian's very latest and often pessimistic painting as in his final most profound religious meditations. The paintings that went to Philip of Spain were not at all in that dark key. Titian called them his *poesie*, his poems. There were seven of them, all now dispersed. Take the *Rape of Europa*, now in Boston.

Again, a typically improbable story line. The irrepressible Jupiter is masquerading this time as a milkwhite bull, but a playful one. He is rollicking with the unsuspecting maiden Europa on the beach, luring her for a ride on his back. Then suddenly he makes off with her into the waves. She is seen here at the moment of crisis. Europa has just realised they are out of her depth, and she cannot escape. She is, reasonably, alarmed, but the mood is far from tragic. Rather, it is ecstatic with its volleys of aerial cupids above, its marine cupid riding the great golden fish, while sea and distant hills, shore and sky

seem almost to be dissolving in veils of colour that Turner would have revelled in. One critic, though doubtless he would be classified nowadays as a male chauvinistic pig, classified the whole thing as 'hilarious'. But anyway it is essentially a huge, affirmatory celebration of sensual life, the optimistic side of the final stages of Titian's long life.

*Diana and Callisto* is equally so: even ruthlessly so, as most of them are. Callisto's subsequent fate was not easy, if not so horrendous as Actaeon's. She did in fact give birth to a son, but was then changed by Jupiter's jealous consort, Juno, into a bear, and as such was about to be killed by her own son. At that point however Jupiter, in what I suppose some might call his great mercy, snatched her and transformed her and her son into constellations in the starry heavens. But in the moment chosen here by Titian, disaster to come is swamped in the beauty of the moment, its visual splendour. All Titian's experience, his learning, his technique, come to climax in these late paintings. He has learnt, and taken what he needs, from sources other than his Venetian heritage. Thus, the little putto on the fountain is taken from a classical Roman forebear that Titian would have seen in Rome when he was there in 1545. The proportions of some of the figures – Diana for example, that elongated body with the small head – acknowledge the new fashion of younger, Mannerist, contemporaries like Parmigianino.

But it is really gratuitous to allege that Titian was 'influenced' by anyone or anything. He swept life up in his passion for it, celebrating it – celebrating above all the gift of sight even when sight, as in these Diana themes, spells disaster. And he continued to do so till the end of his days. Art historians may like to identify earlier, especially classical, prototypes for figures and motifs in his work, even for his nudes. But it is at least as probable that Titian took these nudes from the life, from the luscious and far from inhibited girls who thronged the house of his friend, the notorious poet Aretino, in Venice.

Not the least extraordinary and exhilarating feature of these late paintings, his *poesie*, is that when he was painting them, in the 1550s and early 1560s, Titian was certainly well into his seventies, very possibly into his eighties. Yet in all painting, there is no more positive, more vital, assertion of the richness of mortal life than in the work of his extreme old age.

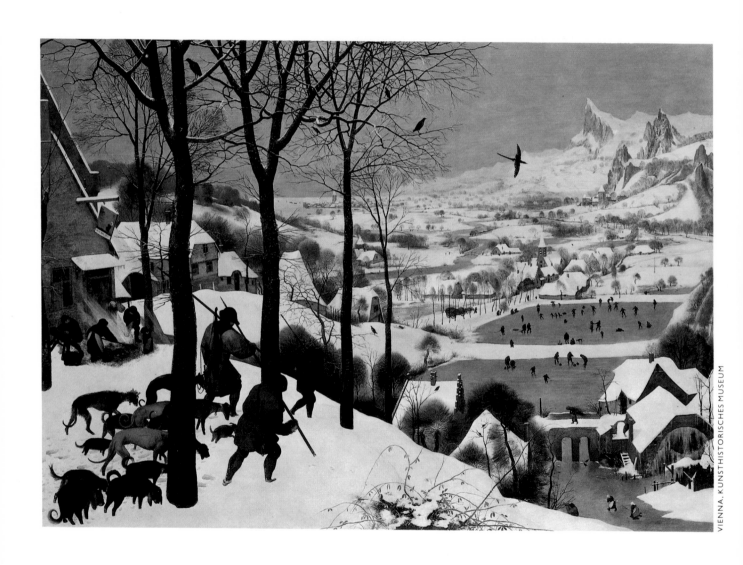

DAVID PIPER

# Pieter Bruegel c. 1527–69
# Huntsmen in the Snow 1565

A cold picture – one of the coldest ever, and one of the earliest to attempt that quality in landscape – painted by Pieter Bruegel the Elder, signed and dated 1565. (In England, Queen Elizabeth I had been just two years on the throne.) Over four hundred years old, it is continuingly one of the most actual, most immediate pictures ever painted. At first sight it could well snatch your breath as if you had just opened the door on to that huge midwinter.

You might be one of the party of huntsmen returning with their dogs as the short day is ending, stopping for a moment behind them as they come down the slope. They are hunched against the cold, maybe just tired, maybe also dejected – there is no sign of their having caught anything. The dogs droop too. They are coming to the relief of home and shelter anyway, a warmth signalled by the one warm burst of colour in the whole view, the flare of fire outside the house on the left – an inn, I suppose. The sign needs mending. If you want to know what they're doing with that outdoor blaze, they're singeing a slaughtered pig, signifying food, the stoking-up of life; signifying also – so sharp is the actuality of this picture – almost an acrid tang in the nostrils.

So the view opens up. Down the steep slope the snow-capped houses of the village straggle to the valley. A small river passes under a bridge, channelled through what seem to be two artificially shaped fish ponds: all frozen, steel blue-grey, and dotted with minute figures on the ice. Beyond, the valley opens out, sweeping round to the left threaded by the river, fields, all sheeted with snow but tufted with the leafless trees. And so away to a little town, that is as if nailed by its church spire to a spit of land sticking out in the expanse of water, estuary or lake; and even that is frozen, with minute black figures dotted on it. High on the right, the view is closed by the jagged rock walls of the far side of the valley. The sky is steely as the ice below.

This and its companion pictures are probably the first full-scale celebrations in western art of pure landscape for its own sake – a very inhabited landscape of course, but with human business inextricably involved with nature, with hills and plains, water and air, with the turning seasons. It is one of a set commissioned for a rich Antwerp citizen, one Niclaes Jonghelinck, on the theme of the Months of the

Year. Not a novel theme, but earlier examples were in miniature form, brilliant little illustrations in fifteenth-century Books of Hours, like the famous *Très Riches Heures* of the Duke of Berry. It is not quite clear whether Bruegel's set consisted of twelve or six, but six seems most likely to me for various reasons, each painting telescoping two months. Better described as the turning of the seasons perhaps rather than as the Months of the Year. The order, at any rate, is clear, though which of the five surviving paintings comes first in the sequence and which is last is open to argument. I should guess ours is last rather than first – the dead end of the year rather than its turning.

The first then would be another painting in Vienna, known as *The Gloomy Day*: here is a shift of mood into February or March weather. Some elements – naked trees, rustic village, river valley – are of the same kind as before, though in a different place. And it is after deep winter's thaw. White and black yield to softer greys, browns, greens. Frozen stillness melts into movement: waters in spate, rushing sky. The air is fresh but slightly clammy – not a crisp tingle on the skin but rather a slightly enervating restlessness of air. Mud is sticky underfoot. The December view is remarkably free from disaster – unusual in Bruegel's panoramas: indeed on that far tumultuous sea in *The Gloomy Day*, ships are in mortal trouble. But as always in Bruegel, life goes on heedless. They are pruning the willows. The nearest

*Opposite* detail of the fire in front of the inn, *Huntsmen in the Snow; below* Bruegel, *The Gloomy Day*

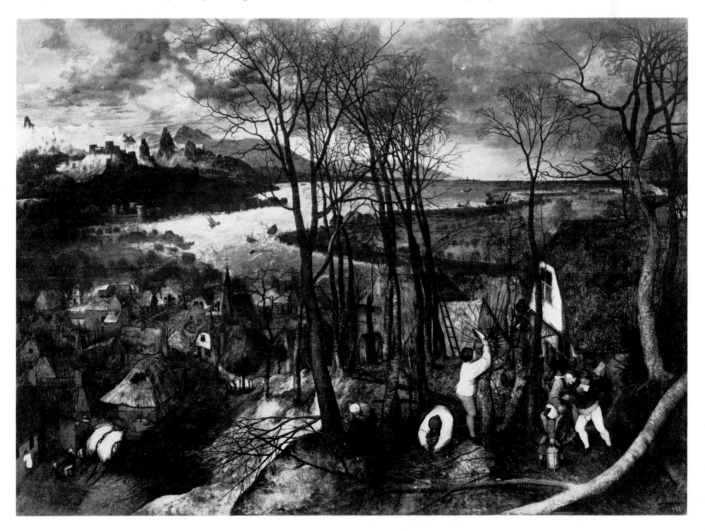

figure, on the right, the child with a lantern, has also got a paper carnival hat. Low on the left there are goings-on outside the Star tavern.

The third in the series is lost — it must have been April/May: spring. But the fourth survives, though separately, now in Prague. June/July, specifically haymaking. The world is now all yellowy-greens and browns in a sort of contented busyness. Here again are similar elements in the make-up of the landscape — a panorama of valley and sky and craggy rock and rolling hill — but now as it were subsiding into a broader, calmer rhythm in keeping with the weather, the happy harvesting of the first hay-crop.

For the fifth, you have to cross the Atlantic to New York, the Metropolitan Museum. August/September: full harvest now, abundant, rich with the yellow-to-gold of the shoulder-high corn that is falling to the scythes. Heat and toil and sweat. Dinner-break in the tree-shade, food — which is what it is all about — and drink. And temporary collapse, replete, into sleep under the glare of the heat-hazed sky. The landscape has subsided into an ample and unworried undulation. Ships lie quietly at anchor in the calm water beyond.

And so in the last of the series, back in Vienna, back to approaching winter as the seasons turn again. The men are bringing

Bruegel, *Haymaking*

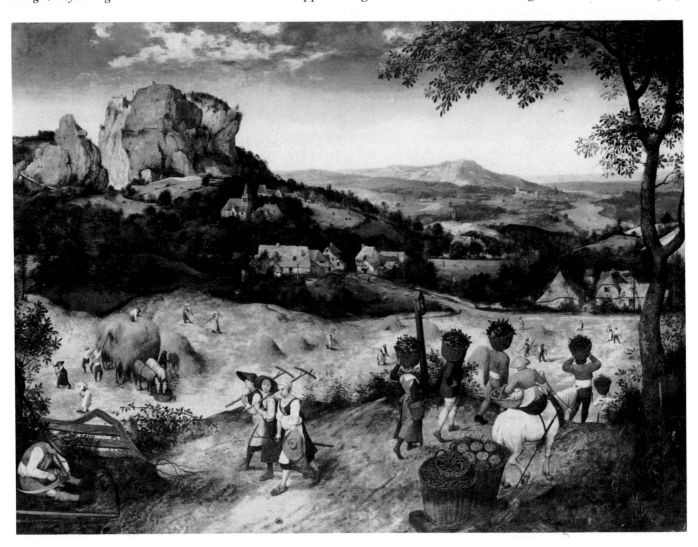

down the cattle for the winter from the upland summer pastures, threading them into the village street: October/November. The trees are stripped almost bare again. The sky is the fresh, wind-scoured blue of autumn, cloud-fringed. There is a rainbow, but the landscape, the weather, these are showing their teeth again.

The five survivors are somewhat scattered now, but they presumably once hung together, perhaps, as so often at that date, above a panelled dado, acting like an almost continuous frieze. The compositions echo one another to some extent. And as I've noted they play variations on ingredients they have in common. Although so real, so actual, they conform in fact to some artistic conventions already well established in Bruegel's time. The high viewpoint, used over a century before by the Van Eycks – Jan Van Eyck's famous *Madonna with Chancellor Rolin* in the Louvre, for example (page 74).

And then, more specifically, the estuary landscape, stretching away in mountainous landscape. You will find something similar behind even Leonardo's *Mona Lisa*, but more so in the work of rather earlier Flemish compatriots of Bruegel – Patinir for example – the bird's-eye view, the fantastic rock formations, the spreading valley. But always in Patinir the landscape is the setting for a biblical or mythological story – the *Flight into Egypt* for example has a jutting

Bruegel, *The Harvesters*

157

*Above* details of village life, *Huntsmen in the Snow*; *opposite* detail of the bird flying above the frozen pond, *Huntsmen in the Snow*

crag very similar to the snowy beak in Bruegel, but the tiny group in the foreground is of Joseph and Mary.

This could seem odd in painting by Netherlanders, inhabitants of one of the flattest landscapes in Europe: but just because of their native plains they were obsessed by mountains – especially Bruegel, who had drawn the Alps as he crossed them to and from Italy in 1552–4. For ever after he remembered – as romantic painters were to do – the haunting desolation and grandeur of the mountains.

His method of arranging these ingredients is not particularly novel. The tree, especially in his *Huntsmen in the Snow*, serves as what art-historians call the *repoussoir*, deflecting and guiding the eye into the central focus of the landscape. The landscape itself is a wide valley, with a river winding towards the horizon, and contained by the flanking hills. But look how it is all brought into unison: the dominant axis on which the composition is balanced is that emphatic diagonal from left up to right – the march of the tree trunks and the tramp of hunters and dogs down and through up to that sharp crag high in the far top corner. There are less emphatic, and more variously angled, counter diagonals from low right up to the left: the slopes of the hill, the roofs, the huntsmen's lances; the broad flow of the valley down to the water. The movement is accented by that sharp craggy beak of snowy rock high on the right, and that is why it is just at that angle, most unlikely and defying gravity, but absolutely necessary. But the most marvellous accent is elsewhere.

The sense of space in this picture is astonishing, almost dizzy, huge emptiness of air over the white world, and the final touch of genius that establishes it is that black bird there, suspended in mid flight as it planes away from its mate on the tree. That accent of black, as it were, tunes the whole vibrant scale of depth and distance. Take it away, and sense how space shrinks.

One of the most bewildering facets of Bruegel's genius is his capacity to fuse into harmony an inexhaustible profusion of minute details. Look at the figures of the skaters far below on the steely ice. Tiny black silhouettes, playing ice-hockey, curling, larking about: shapes of glee, irrepressible in vitality against the ice of the iron winter. And see how they slot into place in the whole and in relation to one another. You could make a dozen, dozens perhaps, of different but self-sufficient compositions by extracting details from this one great painting. And who but Bruegel could evoke such vivid intimations of other dimensions – even of smell, I've suggested; surely of noise – the hiss and clang of the people sporting on the ice, very clear through that absolutely still air. The slight ache even of sub-zero cold tightening around your temples.

In popular esteem this is usually seen as Bruegel's masterpiece, and most experts would agree too. It has even been suggested that it does for twentieth-century taste, in its universal appeal, what Raphael's Madonna did for nineteenth-century and earlier sensibilities. What is quite certain is that its mystery is inexhaustible.

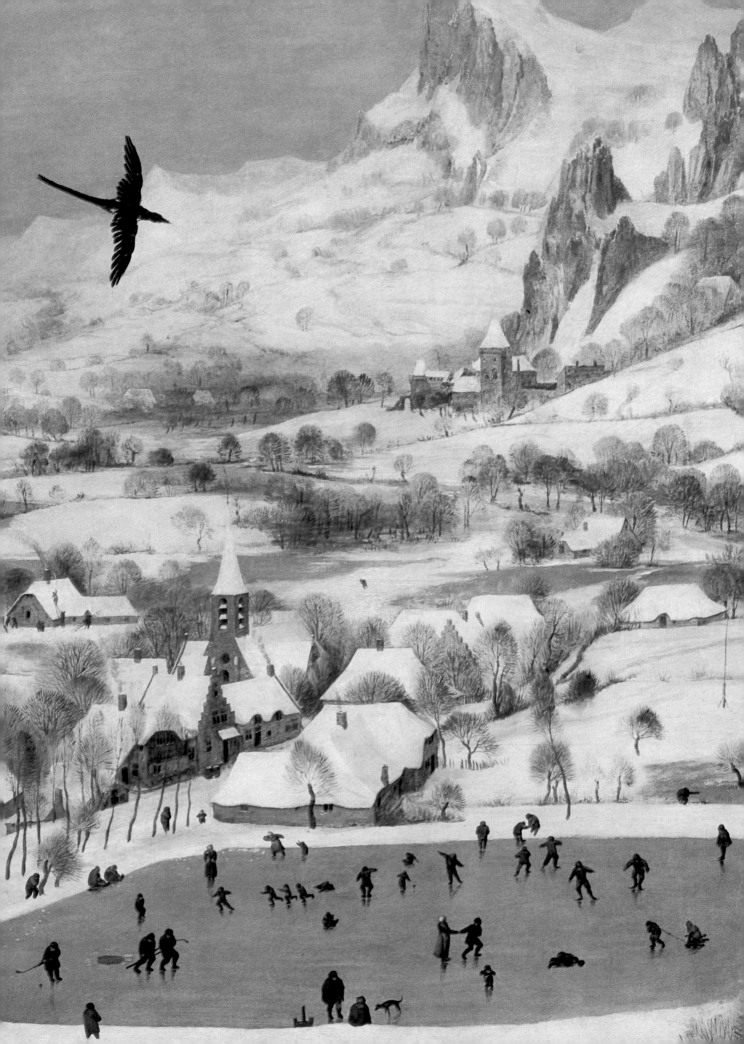

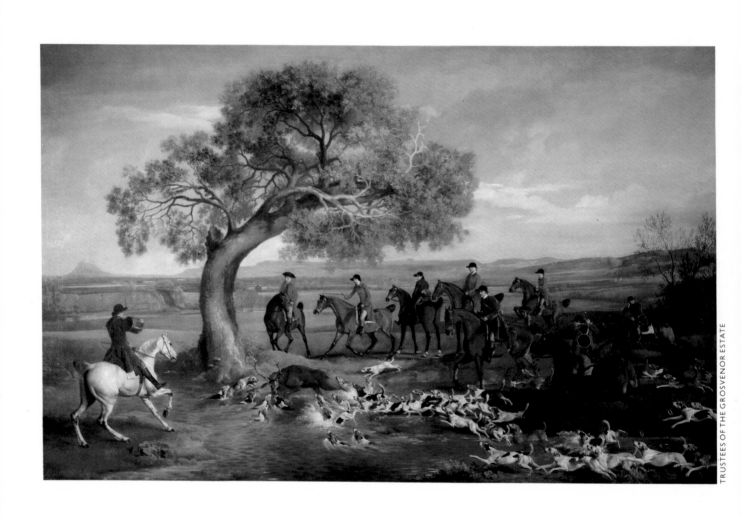

JOHN JACOB

# George Stubbs 1724–1806
# The Grosvenor Hunt 1762

If you stand where this picture was painted, the Cheshire landscape unfolds much as it did when George Stubbs came here in the early 1760s. The same prominent Beeston rock and rolling hills can be seen in the great hunting picture commissioned from him by Richard, 1st Earl Grosvenor, in 1762.

*The Grosvenor Hunt*, as the picture is known, is large; it measures eight feet long and five feet high. It seems larger than that, and Sir Alfred Munnings once described it as fifteen feet long and almost as high. Stubbs was already an established sporting artist when he painted it. Curiously, it is one of his very few hunting pictures. But as the late Basil Taylor, to whom we owe so much for re-establishing Stubbs's importance, said in his book: '. . . if one had to choose a single work by which to represent Stubbs's gifts most fully . . . the choice could well be *The Grosvenor Hunt*'. It is also one of the most complex paintings, from a painter who usually used the most deceptively simple images. It is more than a portrait of Lord Grosvenor out hunting; it is a painting *about* hunting, about the experience of hunting, the sound of the horn, the splash of the hounds, the cries of the huntsmen as they turn towards their quarry.

George Stubbs seems to have been a strong-willed, almost obstinate man, resilient in mind and body. We would probably call him a 'loner' – given to rigorous self-discipline in pursuit of his current obsession, whether it be the dissection of a horse, or the perfection of enamel painting on Josiah Wedgwood's ceramic panels. He never married but lived with his life-long common-law wife, Mary Spencer.

Stubbs was born in Dale Street, Liverpool, in 1724. He was apprenticed at the age of fifteen, but seems to have been largely self-taught as a portrait painter, practising as a young man in Wigan and Leeds. His early interest in anatomy gave him 'a vile renown' in York, where he etched the illustrations to Dr John Burton's *Essay towards a Complete New System of Midwifery*, published in 1751. (Dr Burton was the original for Dr Slop in Sterne's *Tristram Shandy*.)

Then, in 1754, he went to Rome, where he took lodgings in the Piazza di Spagna – which also contained the English Coffee House in the far corner. Richard Wilson, the Welsh landscape painter, was in Rome at that time, but the abiding effect upon Stubbs seems to have

Stubbs, *Study for a Self-Portrait*

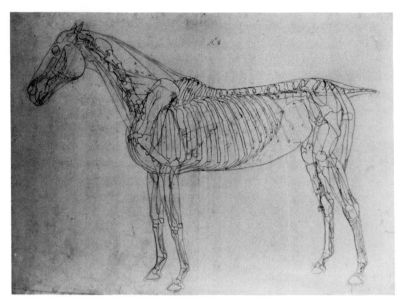

*Below* and *right* Stubbs, *The Anatomy of the Horse*; *opposite* detail the Hon. Thomas Grosvenor, *The Grosvenor Hunt*

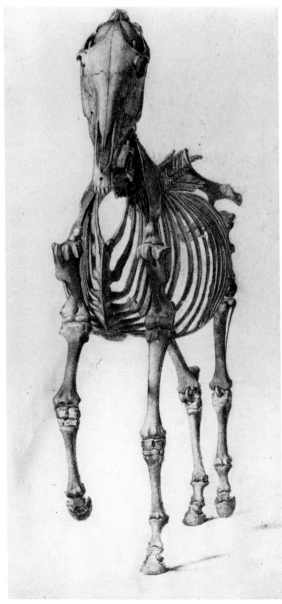

come from a slight study of ancient Roman animal sculpture, which he later used in his 'history' pictures. Stubbs returned to Liverpool, and then moved to Lincolnshire where he had patrons. There in 1758 he began those dissections and drawings for *The Anatomy of the Horse*, which was eventually to bring him fame, and in 1759 took him to London to look for an engraver and publisher.

*The Anatomy of the Horse* with its masterly plates – both a scientific and artistic achievement – was finally published in 1766. But Stubbs' arrival in London from the north could not have been at a more opportune time. He was already thirty-five, at the splendid dawn of his great powers as an artist, 'richly charged with talent and creative energy'. His arrival, like that of Robert Adam the Scottish architect, coincided with one of the greatest periods of the English country house. It was a time when the organisation of country pursuits, like hunting, became more formal; horse racing too, with the founding of the Jockey Club about 1750, began to approach more closely the conditions of the modern Turf. Never again after the Industrial Revolution was political and social power in this country to be so exclusively dependent on territorial estates.

Racehorses, like the string exercising at Goodwood, were painted by Stubbs for Charles Lennox, 3rd Duke of Richmond, seen there with his Duchess and his sister-in-law, Lady Louisa Lennox. This was one of the first works executed by Stubbs after his move south. He spent nine months at Goodwood and *Exercising* was accompanied by two others for the Duke of Richmond: *Shooting* and *Hunting*.

These early paintings still have slightly naïve characteristics in common with the sporting artists of the previous generation – Wootton, Tillemans and Seymour. But they were enough to obtain commissions from other young aristocrats, notably Earl Grosvenor and the Marquis of Rockingham. But the *Hunting* picture at Goodwood, probably painted in 1760, with its over-tall proportions, and rather awkward poses, in no way prepares us for the magnificent *Grosvenor Hunt* of two years later.

The pack and the hunt enter swiftly from the right, slowing to a turn before an old, curved oak. The hounds throw themselves in the

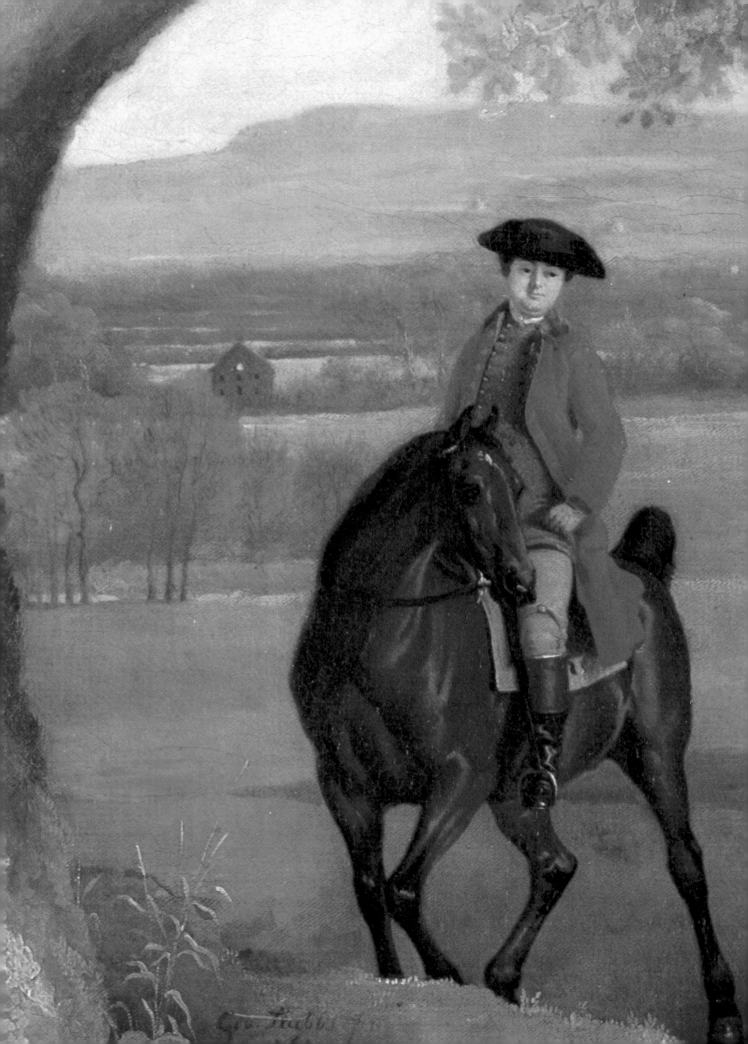

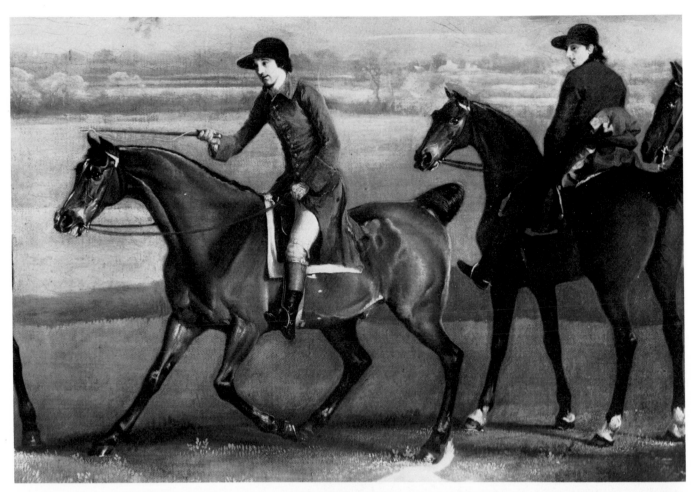

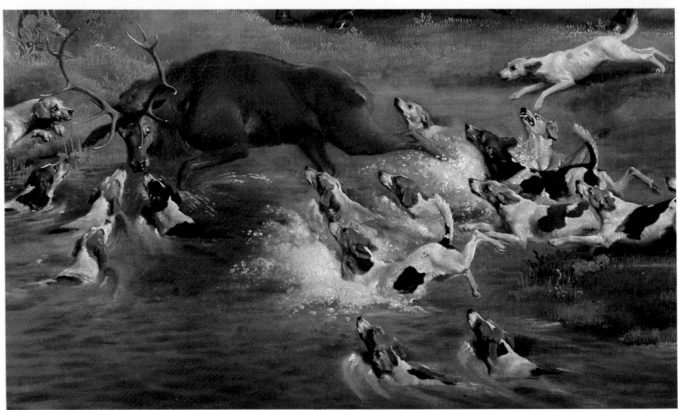

water to pursue the stag – Stubbs anticipating the findings of high-speed photography in the way in which he has painted the droplets of water. The hunt includes portaits of Lord Grosvenor's brother, the Hon. Thomas Grosvenor, his friends Sir Roger Mostyn and Mr Bell Lloyd. But just look at the way in which Stubbs focuses attention on Richard, the young Earl, huntsman, horsebreeder and patron of the arts; he is no larger or seemingly more important than the others, but he's seen in full from the side, pointing with his whip. This is the whole fulcrum of the picture and it is here at the foot of the oak that Stubbs has signed and dated the painting, 1762. Directly above on this line Stubbs has painted – a subtle point this – the sunlight reflected in a single window of a distant cottage. Now this line occurs at a point roughly two-thirds from the right hand edge of the canvas and it's in a proportion to the whole width which is known to artists as the 'golden section'.

*The Grosvenor Hunt* is one of those rare paintings which seem to use sound. Look at the huntsman riding in on the far right with his hand cupped to his ear, the whipper-in with horn over his shoulder in the foreground. One can almost hear the clatter as the jumping horse in the background touches the top bar of the gate. The sense of sound is particularly important in the splendid figure in the green coat on a grey in the left-hand corner of the painting. Not only is he larger than the other figures, but in 'stopping', with his diagonal accents, the

*Opposite above* detail of Richard the young Earl Grosvenor; *below* the stag and hounds; *right* detail of the whipper-in, *The Grosvenor Hunt*

165

headlong rush of hunt and pack, he sounds a blaring, brassy note on his horn which we can almost *hear*. Stubbs has pointed the trumpet of the horn almost directly at us. There is no escaping it; it echoes visually the horn of the huntsman on the other bank, and reaffirms the vigorous, complex, inner dynamics of the painting.

Stubbs was never again to attempt a painting so complex and so carefully constructed as his early masterpiece *The Grosvenor Hunt*. Instead he went on to paint a series of calm, serene, frieze-like paintings of mares and foals which are one of his most original contributions to the development of animal painting. This is typical of the work which Stubbs continued to exhibit throughout the 1760s

Detail of huntsman sounding the horn,
*The Grosvenor Hunt*

at the Society of Artists. One could also add that he was never to paint such a conventional picture again and, with the exception of the 'double' portait of Gimcrack, he never painted the finish on the racecourse so beloved by his successors. And there is some truth in Henry Fuseli's observation that his skill in comparative anatomy never suggested to him 'the propriety of style in forms'. Stubbs was unconventional. He had no time for the proprieties and went his own original way, neither following classical examples of antiquity nor the romantic painters' attempts to give their horses human emotions.

Stubbs was essentially a detached, realistic observer with an intuitive sense of design. Neither classic, nor romantic, nor ex-

Stubbs, *Mares and Foals*

clusively a zoological draughtsman, a sporting artist, or even a history painter, he fitted into none of the academic categories of the eighteenth century. After a period in vogue in the 1760s, he fell almost totally out of fashion in the early nineteenth century and it has been left to the twentieth century, with its lack of interest in the proprieties, but its taste for the abstract elements of design, to appreciate Stubbs once again for his true, unquenchable originality.

167

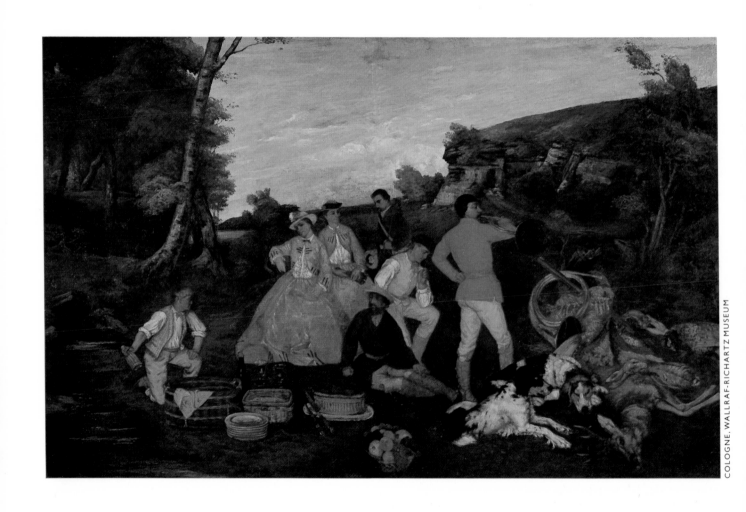

EDWIN MULLINS

# Gustave Courbet 1819–77
# The Huntsmen's Picnic 1858

A lot of French painting is about the delights of being in the open air, a curious fact considering that Frenchmen (or Parisians at least) have traditionally looked upon anything beyond Versailles as 'the desert'.

Not so the man who painted *The Huntsmen's Picnic* now in Cologne: Gustave Courbet. Courbet was a real countryman and proud of it, and this is the painting of a man proud to be a countryman. Courbet came from the Franche-Comté, near the Swiss border, where he was born in 1819, and he much enjoyed bruising the sensibilities of his Parisian friends with his country manners and his homespun opinions about art and indeed everything else. For Courbet was also a braggart, a café orator, a social rebel and a political revolutionary who ended his days miserably in self-imposed exile to escape the law. You would scarcely guess at this rebellious side of his nature here. *The Huntsmen's Picnic* is a painting about the pure pleasures of country life – of taking food and wine by a stream in late summer in the company of elegantly dressed ladies, of dressing up in bright livery to go hunting, and the unabashed pleasures of the kill.

Courbet himself was a keen huntsman, he loved food and drink (a great deal too much), he loved dressing up and he loved women: so altogether this is a picture which reflects the painter's various and vigorous appetites. It is a happy picture, and it was painted at a happy period of his life. He was staying in Germany at the time (in 1858), and he was being treated as a celebrity by wealthy German society. For them Courbet was a leading emissary from the art capital of the world – Paris; a view Courbet is sure to have encouraged, not being much given to modesty.

We know very little about the circumstances of the painting. It may have been a commission for a family portrait from one of his hosts near Frankfurt who shared Courbet's passion for hunting, and who had invited him to join a rather grand hunt. This would explain the somewhat military attire of the man blowing the horn. Two of the other men are wearing similar yellow breeches, all of which suggests membership of some exclusive hunting fraternity. The ladies, too, are anything but peasants: and their elaborate costumes complement one another as if to draw attention to the fact that they may be sisters, even twins. (If, as it has been suggested, Courbet painted the picture

169

back in France a short while after his visit to Germany, then they may be two of his own sisters, who did not accompany him abroad but whom he loved to paint. He may simply have added them, just as he may have added the rocky landscape which closely resembles the hills round his native town of Ornans.)

The suggestion here is that the ladies have joined the menfolk along with the picnic after the morning's slaughter; while the man kneeling to the left and unpacking the hamper is obviously a lackey, whose job it is to serve his masters and mistresses. Hardly the painting of a social rebel, you may say.

But although this is a picnic scene and (loosely at least) a record of an actual event in which Courbet took part, it is also an extra-ordinarily formal picture. Everyone is posing as if for one of those early, long-exposure photographs in which you had to rest on something so as not to blur the image. The lackey is posing halfway through preparing the picnic. So are the two ladies, and the man in

Detail of servant unpacking hamper,
*The Huntsmen's Picnic*

brown next to them, who looks as though he had stopped in mid-sentence. The one in yellow smoking a cheroot is even more self-consciously posed, like a statue, and so is the huntsman. Only the man seated in front looks relaxed and natural – and of course the dogs.

Courbet was labelled – often sneeringly – as a Realist, a painter who thrust life in the raw in the faces of a somewhat genteel art public; and the label Realist has struck, and has given rise to the view that Courbet was some kind of propagandist of socialism. If you believe this you have to take literally everything Courbet ever said – an unwise thing to do – but if you do believe it then you may dismiss *The Huntsmen's Picnic* as a decadent charade, and in my view turn a blind eye to the rich and sensuous nature of Courbet's art, and to his ambition to be a 'Master Painter', as he described himself. So what does Realism mean when it can result in a work as clearly artificial as this one is?

Detail of sleeping dogs, *The Huntsmen's Picnic*

First of all, it is important to understand Courbet's love of ceremony – particularly ceremonies of death. He had made his name almost ten years earlier with a colossal painting of a village burial ceremony, *Burial at Ornans* (now in the Louvre), in which the scene was from contemporary life sure enough, but it was also strictly formalised. A year later he did another large painting on the morbid theme of preparations for the laying-out of a corpse – *Toilet of the Dead*: a later hand tried to sweeten it into preparations for a wedding, none the less it is the solemn ceremonial aspect of death which

survives and gives the painting its power.

Courbet's hunting pictures, too, are ceremonies of death. In *The Quarry* Courbet himself poses like the chief mourner observing a two-minute silence in honour of the young buck he has just shot, while a fellow-huntsman blows a mournful blast as if it were the Last Post. He is rather like the liveried huntsman in the painting of the picnic. He strikes a similar formal attitude and he is presiding over another formal occasion, with all this dead meat lying at his feet. So this *is* a picnic but it is also another ceremony of death.

The label 'Realist', therefore, has to be heavily qualified. If Courbet was so concerned to paint the events of his own experience, why did he recompose those events so artificially? Was it incompetence? Surely not: the one thing no one ever accused Courbet of was lack of skill. Was it then a betrayal of the Realist cause? Many of his socialist friends thought so, and attacked him for it; and left-wing critics are still doing so. I believe these criticisms totally miss the point: Courbet rearranged his figures artificially because he wanted to endow the events of real life with the monumental gravity to be found in the Old Masters, such as the famous painting in the Louvre, then believed to be by Giorgione, now more commonly attributed to Titian: *Concert Champêtre*. Here, too, figures are posed out of doors quite artificially, playing musical instruments (though nothing as robust as Courbet's hunting-horn) and rearranged in harmony with each other and with an idyllic summer landscape.

Courbet's own landscape has more than a touch of that Venetian idyll about it and though his women are not nude, as Giorgione's

Titian/Giorgione, *Concert Champêtre*

mythological figures are, it would have been hard for Courbet to introduce nudes into a scene from contemporary life without suggesting an orgy rather than a hunting picnic. One of the snags of being a painter of contemporary life is that you are bound by contemporary social convention; even a rebel like Courbet. Elegant costume may be just as incongruous as nudity but it is more socially acceptable, and here Courbet is following the example of French

society painters a hundred years before him, such as Lancret, whose portrait of the Bourbon-Contis – another family portrait – deals with a similar contrived arrangement of figures in a summer landscape.

So if Courbet was a Realist he also took the traditional view that art was artificial: it was composed. Where he broke new ground was in taking perfectly ordinary scenes of daily life – like a picnic – and composing them in the way the Old Masters had reserved for scenes of rich society, or mythology, or history. In doing so he gave to daily

Lancret, *The Bourbon-Conti Family*

events a new dignity in painting. 'A period,' he wrote, 'that has failed to express itself through its own artists has no right to be expressed through later artists.' It was this uncompromising view of an artist's responsibility to his own times which made Courbet the most influential painter of his day: for at least the next fifty years artists would be concerned more with the present than with the past.

A further effect of this new dignity in the treatment of day-to-day themes was to give monumental figure painting a new lease of life. And with what superb panache he did it: every figure in *The Huntsmen's Picnic* is strong, bold and full of meat. Without Courbet's example it is hard to imagine Edouard Manet being able to paint his own more controversial account of a picnic only five years later, *Le Déjeuner sur l'Herbe* – controversial because Manet went back to Giorgione more literally than Courbet and set a nude lady among clothed men; and equally hard to imagine Claude Monet tackling the same theme (more discreetly and more naturally) three years later still.

A final thought: if a painter sets out to record contemporary life, as Courbet did, and as the Impressionists did who followed him, he is confronted by the contradiction that by the time he has finished the painting it is no longer strictly contemporary. It is already past. This is where the stylised nature of classical art holds the advantage: it is timeless. And I wonder if this may be a further reason why Courbet chose to compose his huntsmen and his picnickers in this statuesque and almost dreamlike way. He wanted to paint modern life as if it were already enshrined as history.

173

MILTON BROWN

# Winslow Homer 1836–1910
# The Fox Hunt 1893

Winslow Homer, the American artist, was not much given to self-praise, but right after he finished painting *The Fox Hunt* he wrote in a letter to his dealer that it was 'quite an unusual and a very beautiful picture'. It *is* an unusual and a very beautiful picture, but also a haunting one. At first sight it is somewhat enigmatic. Against a vast and bleak expanse of white snow a reddish fox is silhouetted struggling, haunches deep, through the drifts. Overhead, a flock of grey-black crows hovers ominously. In the distance, grey-green waves pound the rocky coast under a lowering sky. The scene is desolate and mysterious.

What sort of hunt is it? Not the usual fox hunt. In this forbidding winter landscape the fox is not being hunted by so-called sportsmen and women on horseback and in pretty red coats. Nor is the fox stalking the crows. In areas like Maine, where Homer lived, when snow covers the land deeply during severe winters, flocks of crows driven by starvation are known to attack animals like the fox. This, then, is the hunter hunted, the drama of natural law. As Homer grew older he became more and more obsessed with the elemental struggle for survival in its many manifestations.

Winslow Homer had begun his career as a magazine illustrator, his work covering the normal range of reportage and pleasant scenes of everyday life. It was only later, after studying art briefly, that he became involved in painting. During these earlier years his paintings were very much like his illustrations. He delighted especially in children, at school and play, wandering through the countryside, haunting the shipyards, fishing or sailing. He looked back at childhood on the farm with a certain nostalgia, recalling scenes like weaning a calf, milking cows, tending sheep or berry picking.

He had an unerring eye for a pretty girl and a pretty dress, and he painted fashionable young ladies playing croquet, promenading or swimming at the beach. Homer's world was then defined by pleasantly rural or vacation activities, a world of serenity, leisure and sensuous pleasure, very much like the world of the French Impressionists who were his contemporaries. Except that Homer's subject matter is distinctly American, less urban, certainly not as chic, more innocent, and a bit sentimental.

In the 1880s the United States as a country moved from provincial

domesticity into international involvement, and Homer's art, as did most American art, sought after a new artistic self-consciousness, profundity, and monumentality. The turning-point for Homer seems to have been the years 1881 and '82 that he spent painting in Tynemouth, England, where he was greatly impressed by the fisherfolk, and especially the women, of this coastal town: people who struggled for a living against an implacable and relentless sea, who faced the elements, met danger and death with a kind of monumental stoicism, as a fact of daily life. In response, Homer's art took on a new seriousness, muscularity and purpose. Its central theme had become the heroic drama of man against nature.

When Homer returned to the United States and settled at Prout's Neck on the coast of Maine, he continued this infatuation with the sea. He discovered the fishing fleets that worked off the Great Banks, painted the fishermen dragging their nets, shipwrecks, rescues at sea. He seems to have been haunted by the vulnerability of man in the face of the ocean's force and immensity – thus, a lone dory lost in the fog, or *The Gulf Stream*, perhaps the most notable example of the theme, in which a black man is slumped on the deck of a small sailing vessel, battered and stripped by a tornado and helplessly adrift in shark-infested waters.

Homer, *The Herring Net*

Homer, *The Fog Warning*

However, there was another, less profound and more personal subject that absorbed Homer's attention. Homer was a passionate woodsman. He loved to hunt and fish. Most of the paintings that came out of these trips were done in water-colour, rapid, brilliant sketches that caught some moment of action or observation. In these sketches Homer transforms, in a sense, the struggle for survival into the ritual of sport, toil into play, into a game in which man can symbolically face danger, defy death, and conquer nature.

Unlike the portentous and epic qualities of his late oil paintings, these water-colours are exuberant, full of light and action, revealing a world of natural splendour and delight: a doe drinking at the water's edge, a speckled trout leaping into the sunlight, a frog on a lily pad, a lone hunter emerging from a forest, or men shooting the

Homer, *The Mink Pond*

rapids in a canoe. Homer, like the Impressionists, was basically a naturalist. He painted what he saw, at the moment, and usually on the scene. He had a remarkable eye, camera-like in its accuracy and speed, constantly surprising us with revelations about the appearance of things in light and atmosphere.

The uniqueness of *The Fox Hunt* among Homer's works is that it combines his philosophic concern with the struggle for survival and the theme of the hunt. Here, as in Japanese art, and you may have noticed by now that *The Fox Hunt* has a distinctly Oriental flavour, the animals have become the carriers of symbolic meaning. But it is not only the theme which is reminiscent of Japanese art, the painting itself is very much like a Japanese screen.

*The Fox Hunt* is perhaps the most self-consciously and aesthetically conceived of all of Homer's works. It was no doubt an important picture for him. It is also the largest picture he ever painted – almost six feet long and more than three feet high. It combines in an unmatched way his naturalistic feeling about things, for weight, colour, texture, and for the total pictorial design. For instance, Homer draped a fox pelt over a barrel in the snow to study the contrast from life, as it were. He is also said to have had trouble painting the crows convincingly, and heeded the advice of a local

Detail of crows, *The Fox Hunt*

station master to come and study the crows that swarmed around his station. But the naturalism of all the elements, including the sky, the sea and the rocks, is utilised within the context of a larger decorative scheme, much in the manner of the Japanese masters.

The unusual angle of vision is Japanese, presenting the world to us in a novel and surprising way, as if it were seen not from the point of view of man, physically or psychologically, but of a creature like the fox or the crows. Japanese also is the very flatness of the picture, the high horizon, the silhouetted shapes and their dynamic relationship to the frame; as is the simplification of form and surface into bold contrasting patterns, creating a bold symbolic image. The tension of the action is reinforced by the aesthetic tension of formal relationships. Especially Japanese is the unexpected sprig of berries on the left, a startling reminder that nature is eternal, unconcerned, and poignantly beautiful.

But *un*-Japanese are the tragic overtones of the painting, the philosophic intensity and personal involvement of the artist in the theme of survival. And perhaps most of all, the insistence on physical reality, the transmission of sensuous experience that goes beyond the purely visual, the evocation of the bone-aching cold of the arctic tundra, the warmth and texture of the cornered fox, the sound of the crashing surf, and the piercing shrieks of the circling crows. Homer remains a western artist, an American painter. With all his debt to Japanese art, *The Fox Hunt* cannot be seen simply as a decoration. What we have here, if I may be permitted the pun, is a Homeric epic on the nature of existence.

# WAR

Surprisingly few great war paintings are celebrations of victory, contrary to what one might expect. Maybe this is because so few artists ever went to war, and even fewer witnessed the actual battles they were called upon to paint. Under such circumstances even warfare may seem an almost metaphysical occupation, and artists have had to reach deep into the imagination for ways of expressing it, for how to give it meaning, how to organise so chaotic an activity into a single image of action.

No series of pictures could say less about real war than Uccello's three paintings, *The Rout of San Romano,* of 1456. Whether it was actually a bloody affair or a light skirmish between mercenaries, it was certainly not like this. However, Uccello's account of the event is all we remember it by – this elaborate stage pageant in the spirit of a tournament, wonderfully choreographed and rich in ceremonial costume.

Altdorfer's *The Battle of Issus,* painted seventy years later, by comparison is conceived on the scale of a Hollywood epic. Doubtless war was never like this either, but Altdorfer's grasp of the spectacular is so convincing that he compels us to believe it was so – sweeping our imagination like a bird in flight above a forest of embattled lances.

Velazquez's *The Surrender of Breda* is a century later still, but now the handling of the subject is much closer to the formal, ceremonial manner of Uccello: indeed the palisade of lances in *The Surrender* is probably a recollection of Uccello's battle picture from Velazquez's visit to Italy. What is entirely new is how people are more important than skirmishes, more important than victory: this is a painting about humanity, about the triumph of dignity over brutishness, of Christian generosity over the spirit of revenge.

If all wars were handled as graciously then Delacroix would have had no cause to paint his *Scenes from the Massacres at Chios* in 1824, inspired by accounts of Turkish atrocities during the Greek War of Independence. This was the war in which Lord Byron perished, and it may be said that Delacroix cared more for the Byronic surge of passions in his figures than for their sufferings or the cause of the war.

This is something which could never be said of Picasso's *Guernica,* inspired by the German bombing of the ancient Basque town by the Germans during the Spanish Civil War. *Guernica* is self-evidently the outcome of shock and outrage at an incident still white-hot in the painter's mind. This is not war recollected in tranquillity in the manner of Velazquez, nor staged like the Uccello, nor laid out before us as a wonder of the world like the Altdorfer. Few war paintings of any stature are pacifist in spirit, but this is one of them.

EDWIN MULLINS

# Uccello 1396–1475
# The Rout of San Romano c. 1456

Until the invention of photography, war art was generally about anything but war, and this famous account of a battle is no exception: it is a sequence of three pictures called *The Rout of San Romano*, painted in Florence about the year 1456, and the artist, himself a Florentine, was Paolo Uccello. Alas, the three paintings are now widely separated and are in varying states of repair. They were commissioned, as far as we know, by the effective ruler of Florence at the time, Cosimo de' Medici, probably as decoration for one of the rooms in the new Medici Palace.

The battle itself had taken place some twenty years earlier, in 1432. It was not a battle which in any way altered the course of history, and but for these paintings it would certainly have been forgotten by all except the most attentive historians. However, it was a battle that mattered to Cosimo de' Medici, partly because he was a personal friend of the victorious general, but more particularly because it could be shown to represent a triumphant episode in the rivalry between Florence and the neighbouring city of Siena.

To carry out his commission Uccello would have had access to official descriptions of the event – not the same as truthful ones, of course; perhaps to eyewitnesses too. His account of the first stage of the battle is now in London, at the National Gallery. The Florentine authorities had appointed a new commander-in-chief, Niccolò da Tolentino, who with a mere twenty horsemen rode ahead of his main army – an act of irresponsible folly one would have thought – only to be surprised by the Sienese in the Arno Valley. Tolentino refused to surrender and managed to hold off the Sienese for eight hours, it was said, though in Uccello's account remarkably few enemy are in sight, barring one doomed knight, a scattering of armour and smashed weapons, and a single corpse.

The painting representing the central episode of the battle is the only one still in Florence, at the Uffizi Gallery. This is in poorer condition than the London picture, and the colours – particularly the background – have darkened almost beyond recognition. Even so, the action remains clear enough. The Florentines are gaining the upper hand, and in a charge on the Sienese lines the enemy commander is unseated from his horse, while the rest of his army is in rout.

This turn of events has been clinched by the arrival, like that of

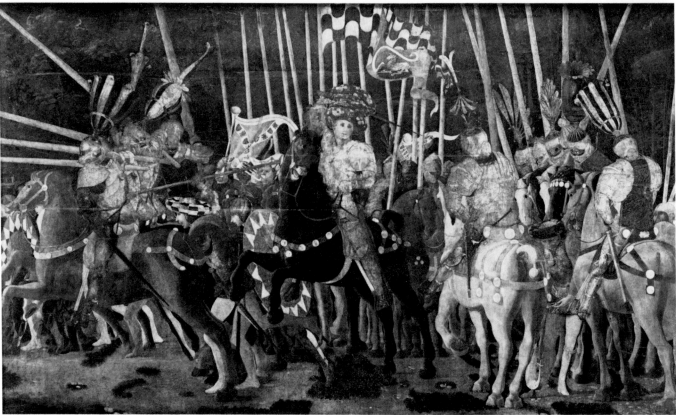

*The Rout of San Romano*, the Uffizi painting (*top*) and the Louvre painting (*above*)

Blücher at Waterloo, of the Florentine second-in-command with a subsidiary force attacking the Sienese from the rear; and it is this moment which is acknowledged in the third painting now in Paris, at the Louvre, also in a poorer state than the London picture. Like his

182

general in the first picture, the victorious leader of the counter-attack holds the centre of the stage on a prancing stallion.

It comes naturally to use the phrase 'holding the stage', because all three paintings describe not a real battle at all but a stage battle. It might be an incident re-enacted by some well-drilled regiment for an Edinburgh Tattoo. And this is precisely why these paintings are so successful: propaganda they may be, but they are superb theatre.

Uccello makes us feel we are in the front row of the audience, and nearly all the action is packed into a narrow strip of stage, delightfully coloured pink in the London picture. Any notion that serious killing may be going on is softened by a screen of oranges and roses, giving the effect more of a garden than a battlefield. This screen is neatly trimmed to follow the outline of the combatants and offset the colourful horse-trappings, the flowing banners, and the lances which look as jolly as cocktail-sticks.

Beyond the screen of flowers and fruit stretches a landscape which, again, looks more like a stage backdrop. Figures *are* engaged in fighting, if you look closely enough, though what catches the eye first is the harlequinade of coloured doublets and stockings; while the two figures galloping off into the distance look as if they are preparing for a joust, not a battle. Even the stone walls dividing up the fields suggest lists for a tournament. In the Florence picture, too, the landscape is not so much a battleground as a patchwork of little

Detail of fighting figures,
*The Rout of San Romano* (National Gallery painting)

fields where animals play and chase one another for the fun of it. Everything which in real warfare is most chaotic Uccello has organised like a choreographer. The stage is strewn with the débris of battle, but arranged as if laid out for kit inspection: helmets, shields, broken lances, even a body (one wonders how he managed to get killed).

It is the arrangement of these bits and pieces that supplies a clue to one of Uccello's overriding obsessions: the mathematical laws of perspective. Each broken lance, each shield and helmet, points towards an imaginary vanishing-point on the horizon, even though there is no actual horizon in any of these pictures.

Nowadays we take for granted an understanding of the laws of perspective; nor do we necessarily admire a painter for being able to

Detail of fallen helmets and spears,
*The Rout of San Romano* (National Gallery painting)

Uccello, *Mazzocchio headdress*, drawing

calculate that what is below the eye-line goes up and what is above the eye-line goes down; or that figures should be painted smaller if they are further away. It all seems obvious, and anyway the camera does it for us. But in fifteenth-century Florence it was a wonderful new science, and painters like Uccello were besotted with it. He would spend weeks closeted at his workbench calculating the precise angles and measurements for representing objects like a chalice, or an ornate headdress known as a *mazzocchio*; and he put these meticulous studies to good use in *The Rout of San Romano*.

Once you appreciate how carefully he has worked out the perspective of these headdresses, you also notice the same obsessive attention to perspective in the ranks of spears, a cluster of trumpets, crossbows raised in the air like birds in flight, and the brilliant fluttering banners; and of course the horses, each one resembling a study for an equestrian statue rather than a live horse – though Uccello didn't always get it right. The rearing horse in the Uffizi painting looks like one of those freaks of nature you find pickled in unpleasant museums.

Uccello's contemporaries were rather down on him for this obsession with perspective. They felt it detracted from his study of nature, of the real world. How totally they missed the genius of Uccello. The splendour of Uccello's world is precisely that it is *not* the real world. Tolentino in his inappropriate ceremonial headgear rides into battle on a white charger straight out of a land of medieval

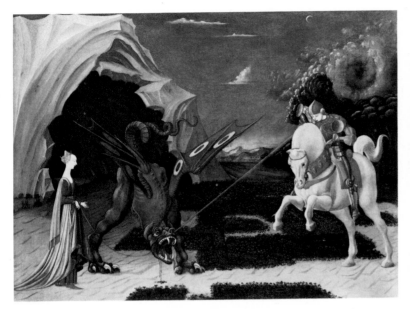

*Left* Uccello, *St George and the Dragon*; *above* detail of rearing horse, *The Rout of San Romano* (National Gallery painting)

legend. His stallion is virtually a mirror-image of another of Uccello's legendary knights, St George (the painting is also in the National Gallery), who careers out of an enchanted wood to wound the dragon led, like some pet pekinese, by a beautiful princess. Fascination with the geometry of perspective makes even the grass unlifelike.

As with *St George and the Dragon*, so with *The Rout of San Romano*. Patches of grass, débris of battle, a dead body: could there be more unlikely candidates for illustrating the laws of perspective? Now, a building in perfect perspective, or a landscape, might indeed have appeared lifelike. But these chaotic images of war: by giving them a quite artificial orderliness Uccello has created an effect the very opposite of lifelike. All this is no more true to life than a playing-card or a piece of heraldry, nor is it intended to be.

Uccello is the odd-man-out among painters of the Italian Renaissance, in that he grasped the new science of perspective and turned it on its head. It was intended to make the world look more real: in Uccello's hands it has become more unreal. And it may well be that we understand his peculiar obsession with perspective a good deal better than his contemporaries did, largely because we have so much more evidence of the subjective nature of artists' obsessions generally.

We have, after all, the potent example of Cézanne, who was a man similarly obsessed, with a mountain, which became less and less of a mountain the more he analysed it; or of the Cubists who, the more they analysed the appearance of a man, discovered less and less of a recognisable human being; or the Surrealists who, rather like Uccello, used a formal style to record an entirely personal view.

*The Rout of San Romano* is likewise, it seems to me, a personal view. It is Uccello's view of a medieval world of romance and pageantry which was already old-fashioned when he painted it. What is fascinating and unexpected is that he hit upon a way of revitalising this medieval way of seeing so modern that almost all his contemporaries misunderstood him. What they took to be analysis of nature is purely style. It is as contrived as Cubism, and in every way as unreal.

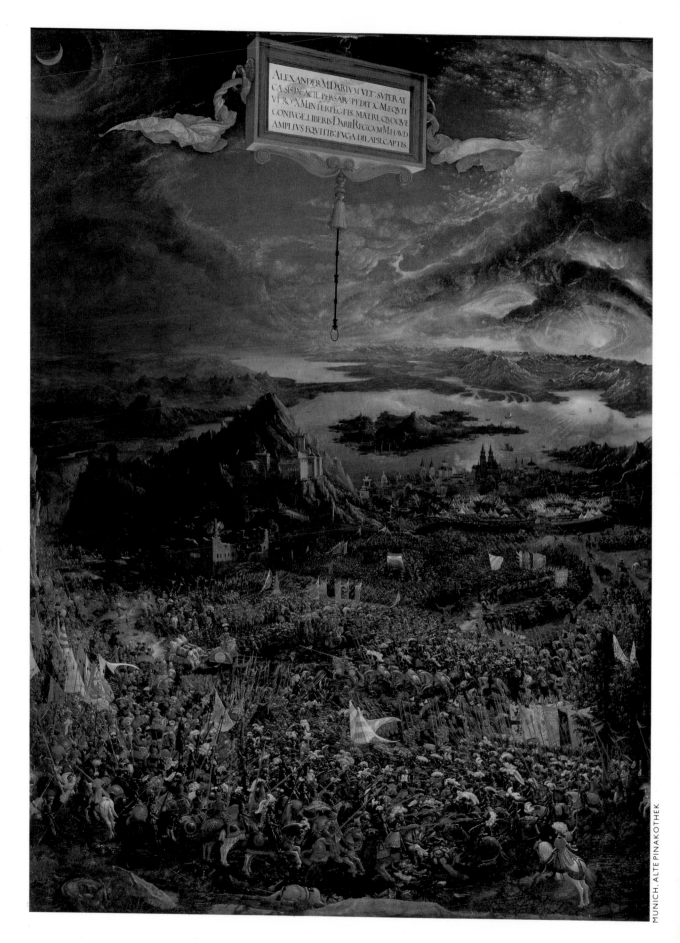

ALEXANDER M.DARIVM VICT: SVPERAT
CASSIS IN ACIE PERSAR: PEDIT: CM EQVIT
VERO X M IN TERFECTIS. MATRE QVOOVE
CONIVGE LIBERIS DARII REGIOVM M HAVD
AMPLIVS FOVITIB: FVGA DILAPSL CAPTIS.

JOHN HALE

# Altdorfer c. 1480–1538
# The Battle of Issus 1528–9

In 1528 Albrecht Altdorfer, a middle-aged, solid and prosperous citizen of Regensburg in Bavaria, was asked by his fellow city councillors to become their mayor. He said no, and the reason he gave was that he wanted to devote all his energies to finishing this picture. It shows the crushing victory over the Persians won in 333 BC by Alexander the Great, and it turned out to be his masterpiece. Four and a half centuries later, it is still the greatest vision of combat ever painted.

Altdorfer's decision to turn down the highest post his fellow-citizens could offer him was understood. He was Regensburg's outstanding painter, but this was his first commission from the city's immediate lord, Duke William IV of Bavaria. It was also an unprecedented challenge to him personally. Though nearly fifty, he had produced less than the usual quota of religious paintings for churches and no portraits. Everything about his work suggested independent means – no workshop; drawings and small paintings aimed at the congenial private collector. Who else, wanting a picture of St George, would have accepted Altdorfer's version of the subject which is now in Munich? The saint is there, just, but this is getting very near to being *Hamlet* without the Prince of Denmark. At a time when painters were told what to do, Altdorfer went his own way. And it was a private way – among the woods and hills along the Danube, and imagining the most un-ducal characters as their natural denizens: primitive, uncivilised creatures, rude or half-animal.

And now, on a wooden panel larger than any he had tackled before, he was commanded to paint a subject absolutely at the heart of the court's sophisticated interest in classical antiquity. It was, moreover, a subject charged with contemporary public relevance. At Issus, in Syria, Alexander broke the power of the Persians, barbarians who threatened to invade his homeland of Greek Macedonia. While Altdorfer was still painting in 1529, the threat of invasion by the infidel Turks culminated in their setting siege to Vienna, not so far off along the Danube. So how could he draw on the familiar scenes and private thoughts that had inspired him up to now? How avoid pedantry or propaganda?

At least to get the story right he did not have to look far. In setting the subject Duke William had probably consulted his court historian,

Altdorfer, *Leafy Wood with St George*

the classical scholar Johan Aventinus. In 1528, Aventinus came to settle in Regensburg, and he must have taken Altdorfer through the long account of the battle given by the Roman historian Quintus Curtius in his *History of Alexander*. Here was the description of the site, in the foothills sloping to the Mediterranean and the river Pinarus, of the units of cavalry and foot, of Alexander's pursuit of Darius fleeing in his chariot, and of the women of the Persian court, placed where Darius thought they would have been safest, in the middle of his army.

But to know what had happened was, as it were, only half the battle. The question remained of how to paint it. A number of conventions lay to hand. The recent battle of Pavia, fought in Italy in

Detail of Darius's chariot, *The Battle of Issus*

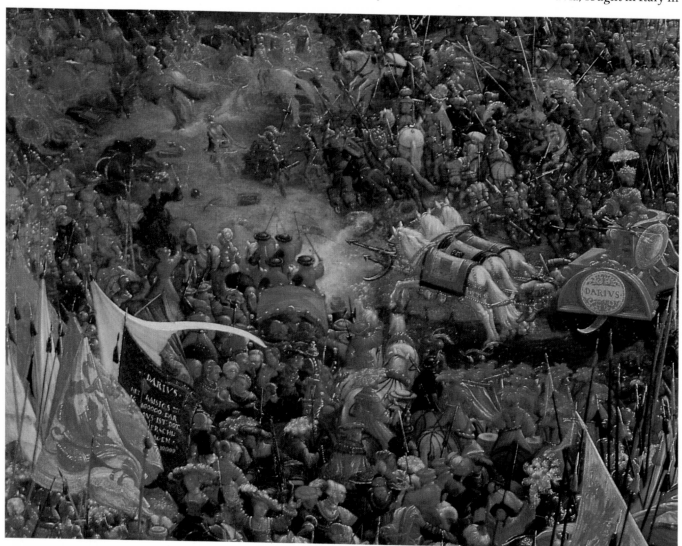

1525, had been painted in an anecdotal, quasi-documentary style, plastered with little labels to show who everyone was.

But this was journalism, a style for hacks. Art, by now thoroughly conscious of its status, required some controlling aesthetic principle.

Another treatment of the battle of Pavia, by a follower of the Flemish artist Patinir, shows one 'art' solution: to paint a landscape and then fill in the action. A second, Titian's *Battle of Cadore*, was to seize on a single episode so that warriors could be shown on a heroic

scale – and dressed as fashionably nude as possible. This was Titian's choice, almost exactly contemporary with Altdorfer's panel. Or – as in another contemporary work by Albrecht Dürer (with whom Altdorfer had worked, and who died in 1538) – the essential anonymity of modern war could be shown by reducing the whole thing to a diagram of pin-men.

Altdorfer rejected the episode and with it, necessarily, the nude. But, perhaps because his early training had been as a miniaturist, he seized on the diagram as a way of reducing war's confusion to a swirl of animated patterns; patterns of men, banners and bristling weapons so intricate and yet so firm as to have reminded a painter of our own age, Oskar Kokoschka, of a late fugue by Beethoven.

Detail of soldiers, *The Battle of Issus*

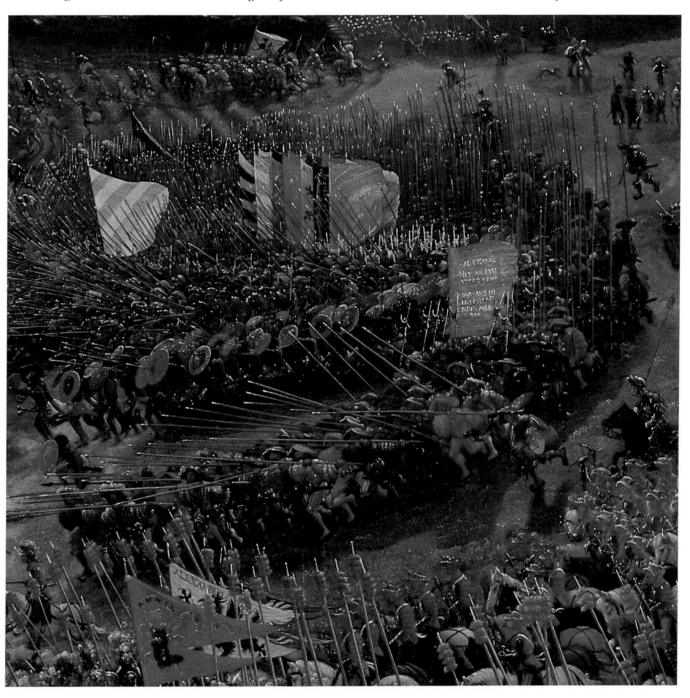

It was the solution adopted by a writer, Thomas Hardy, with whose feeling for nature and man's warmth, but littleness, Altdorfer would have sympathised. In portraying the battle of Waterloo in his huge drama *The Dynasts*, Hardy cut between naturalistic scenes on the ground to the voices of a spirit hovering in the air:

> Behold the gorgeous coming of those horse,
> Accoutred in kaleidoscopic hues
> That would persuade us war has beauty in it! –
> Discern the troopers' mien; each with the air
> Of one who is himself a tragedy:
> Red lancers, green chasseurs: behind the blue
> The red; the red before the green:
> A lingering-on, till late on Christendom,
> Of the barbaric trick to terrorise
> the foe by aspect!

Altdorfer's choice of a panoramic solution to making sense of a vast battle may have owed something to Quintus Curtius's statement that Alexander planned the action after climbing 'to the summit of a lofty mountain'. Or it may have been the vision conjured up by Alexander's pep-talk, in which he told his men that, after they had

Detail of Alexander at the head of his horsemen, *The Battle of Issus*

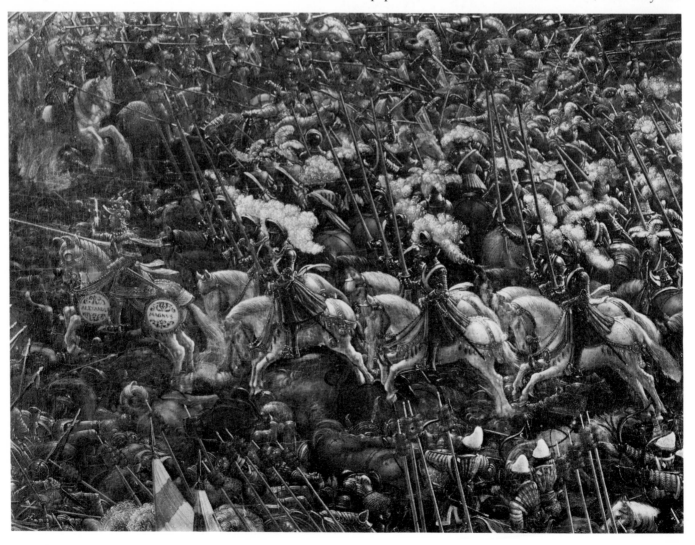

won, 'the spoils of the whole Orient were before them'. But if these were the hints, it was Altdorfer the pioneer of landscape sketching and painting who, by an extraordinary effort of will, memory and imagination, lofted his knowledge of forest, cliff and riverside into the air, and from that viewpoint produced this boundless, visionary scene where the winds rout the clouds and the sun, dying behind the mountains, smites the sea. Nature battles endlessly; must this also be true of man?

If we did not ask a question like this, we would not be looking at a masterpiece. When the Munich gallery was looted in 1800 by the French, and seventy-three of its most famous works were brought to Paris, Napoleon abstracted just one for his own. While the others went to educate and impress his subjects in the Musée Napoléon, the Altdorfer was hung in his bathroom at St Cloud. There, through the steam, he contemplated battle as the pick-lock to Empire – his mind running, as had Alexander's, on that most gorgeous of enticements, India.

For in *The Battle of Issus* near and far coexist in the even clarity of the infinitely possible. Nor is there any dreary caution dropped between then and now. Altdorfer was no stuffy antiquarian. His Greeks and Persians wear the armour and fight with the weapons of his own day – though he is tactful enough to exclude firearms. Napoleon can do what Alexander did.

But over it all, far above Alexander's viewpoint or ours, and lit by neither sun nor moon, is the inscription. What it says is derived from Quintus Curtius: 'Alexander the Great vanquishes the last Darius: slaying 100,000 foot soldiers and 10,000 horsemen of the Persians. The mother, the wife and the children of King Darius as well as 1000 fleeing horsemen in complete disarray were taken prisoner.'

But it is not just a label. Hanging in space it has something of the ominous character of the enigmatic black monolith in the film *2001*. And it veers, catching the winds, surely, of destiny. Now it describes the conflict at Issus. Soon it will record the casualties of Waterloo. It will turn over the trenches of the Somme, over Hiroshima. It still turns. We do not know, will never know, what it will record of us.

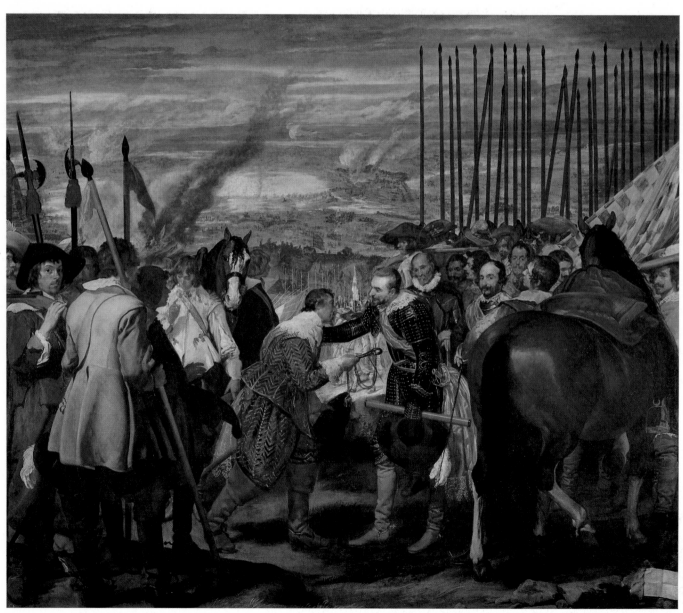

EDWIN MULLINS

# Velazquez 1599–1660
# The Surrender of Breda 1634

From the equestrian portraits by Velazquez of King Philip IV of Spain and the Count-Duke of Olivares you would be forgiven for assuming that two such splendid figures in armour had conquered half the world. In fact between them they managed to lose, if not half the world, then a good deal of it; and neither of them ever went near a battlefield. Philip IV ruled Spain from 1621 for the most disastrous forty-four years of its history; and his Prime Minister for much of that time, the Count-Duke of Olivares, was responsible for most of those disasters. But Velazquez was far too good a courtier to allow historical fact to cloud his vision of kingship and authority. He does not flatter them so much as ennoble them.

Olivares ran the country for Philip, who merely owned it; and as an exercise in propaganda and self-aggrandisement he built for his monarch a splendid new palace outside Madrid, and hung it with monumental paintings he had commissioned, each one of them glorifying a military triumph of King Philip's reign. Considering that it was a reign in which Spain was to lose Portugal, the Spanish Netherlands and a great many of her overseas colonies, this undertaking was the purest humbug: all the same it has left us one work of art which rises effortlessly above all this political flummery – this enormous battle picture, also by Velazquez, and now in the Prado Museum in Madrid, *The Surrender of Breda*.

The picture records one of the last victories gained by the Spanish armies against the Dutch in the Thirty Years' War. The city of Breda, near Antwerp, was built by the Dutch who were fighting for their independence, and was thought to be impregnable. So Spain sent her finest general to lay siege to it. He was Ambrosio Spínola, who was actually Genoese. Breda held out for the best part of a year, all supplies of food and ammunition cut off by fires, and by widespread flooding which the Spaniards caused by breaching the dams. Finally, on 2 June 1625, the Dutch were compelled to surrender. General Spínola honoured a heroic defence by treating his opponent and his army with unusual magnanimity: they were allowed to depart unmolested, and Breda was not pillaged.

Even if I had made no mention of the Spanish general's chivalry it would be obvious from this picture what it is that stirred Velazquez about the story of the surrender of Breda. It is the moment when the

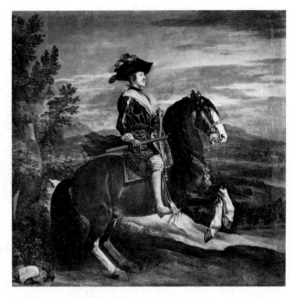

Velazquez, *Philip IV on Horseback*

193

defeated commander, Justinus de Nassau, surrenders the keys of his city to his conqueror, General Spínola; and the victor, instead of humiliating him, extends an arm in friendship towards his opponent – almost as a victorious football captain might congratulate his counterpart on a sporting match.

Velazquez painted this picture ten years after the siege. He had never seen the battle – or indeed any battle – he had never been to the Netherlands, he had never set eyes on Justinus, and Spínola – whom he did know – was now dead. So he was somewhat removed from the scene of action. What he did have access to was an etching by the French artist Jacques Callot. Callot had been no more an eyewitness than Velazquez: but like the good journalist he was he had been to the scene of the siege, studied the terrain and talked to as many people as possible who had been there. What he produced was a kind of map, with the walled city of Breda in the centre, and the deployment of the Spanish troops meticulously recorded.

In the foreground the map gives way to a pictorial scene, with officers whiling away the time at dice, others strutting about like peacocks, the victorious general surveying the scene in his flamboyant plumed hat. There is also some unsavoury ill-treatment of Dutch peasantry going on almost unnoticed, except by the artist himself, who is seated nearby pretending to take note even though he was not actually there. It is all very impersonal. To Callot there are no heroes, only victors and victims: and all rather small and distant. Callot does not want individuals to get in the way of history.

With Velazquez it is the other way round. He has used Callot for all that military stuff, which he has pushed well into the background. Our eyes sweep across the landscape, registering the smoke of battle, the flooded fields, the odd banner raised, figures gesticulating, troops on the march, and that great palisade of lances.

But having taken this in we come to the point. *The Surrender of Breda* is not a painting about battle but about generosity of spirit, about honour. In the way he has painted this quiet and civilised gathering is expressed the view that even war – perhaps especially war – is capable of ennobling a man.

What a preposterous view, you may say – that war is ennobling: do we not know better today? Then you consider the sentiments we attach in retrospect to El Alamein, to Dunkirk, to D-Day, to Remembrance Day, and the volume of old war films on television, and you begin to wonder if our view of war *has* really changed all that much – at least in retrospect. And remember *The Surrender of Breda* is about a war already ten years distant. The pain has faded: the glory survives. Far from being old-fashioned, the painting has a very familiar air of nostalgia for old victories and battles long ago.

There is another reason why this is less old-fashioned a painting than it might appear. War is not presented as a dehumanised conflict between expendable mercenaries – cannon-fodder: it is fought between men. Look at the faces of the victorious Spanish officers bunched together behind their general. And the losers, the Dutch: the way the young officer in the embroidered doublet is raising his finger to explain what is going on to his neighbour, while the man behind him places a hand on his shoulder in comradeship, or to add a

Detail of Justinus of Nassau surrendering the keys of Breda to General Spínola, *The Surrender of Breda*

Details of Dutch soldiers, *The Surrender of Breda*

comment of his own. And that gentle figure turning to look at us. These are not the faces of hatred or humiliation. This is not a picture about allies and enemies. They are just men, men we might know and love; and nothing in a year-long siege has strangled their humanity or hardened their hearts. The tension is over. On both sides they are quiet with exhaustion after a long battle. To me *The Surrender of Breda* is one of the most egalitarian pictures ever painted.

But wait. Those portraits of the two men *The Surrender of Breda* was designed to please – King Philip IV and the Count-Duke of Olivares: it would be an affrontery to our credulity, surely, to suggest that there was anything egalitarian about the way Velazquez portrayed these swaggering manikins. And of course there is not. Velazquez was also a courtier, one of the two greatest courtier-painters we have, the other being Rubens. These two figures were the

most powerful men in Spain, and they were his patrons. You can always tell when Velazquez intends to ennoble, because he sets his subject against the sky. Philip and Olivares are depicted as men of almost godlike authority, whose rank lifts them above the world of men. But with Spínola we are back on earth : he is a mere man among men, albeit a nobleman.

So, the democratic ideal and the courtly ideal run side by side in the art of Velazquez, and the one is always tinged with the other. It is how he saw himself when he came to paint his most famous picture twenty years later : *Las Meninas* (*The Ladies in Waiting*). Here is the courtier-painter proud to wear the cross of one of the highest orders in the land, that of a Knight of Santiago. What is more, he is painting a

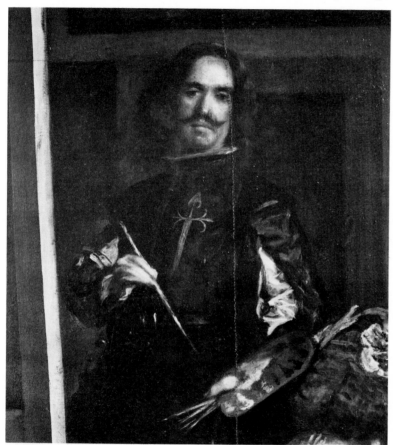

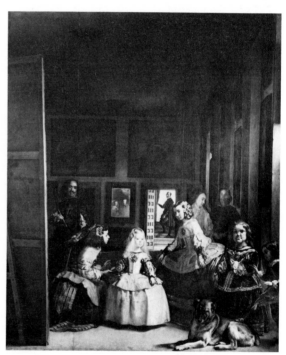

double-portrait of the King and Queen. And yet their majesties are only shadows in the mirror. Their pretty little daughter holds the stage, and even she is no more prominent than her maids, the court dwarfs or the dog. The democratic ideal shows through even in the company of kings. Velazquez saw an unforced dignity in man that was common to kings and servants, conquerors and conquered. His was a world without enemies, and his paintings never won any.

*Above* Velazquez, *Las Meninas*; *left* detail from *Las Meninas*: self-portrait of Velazquez

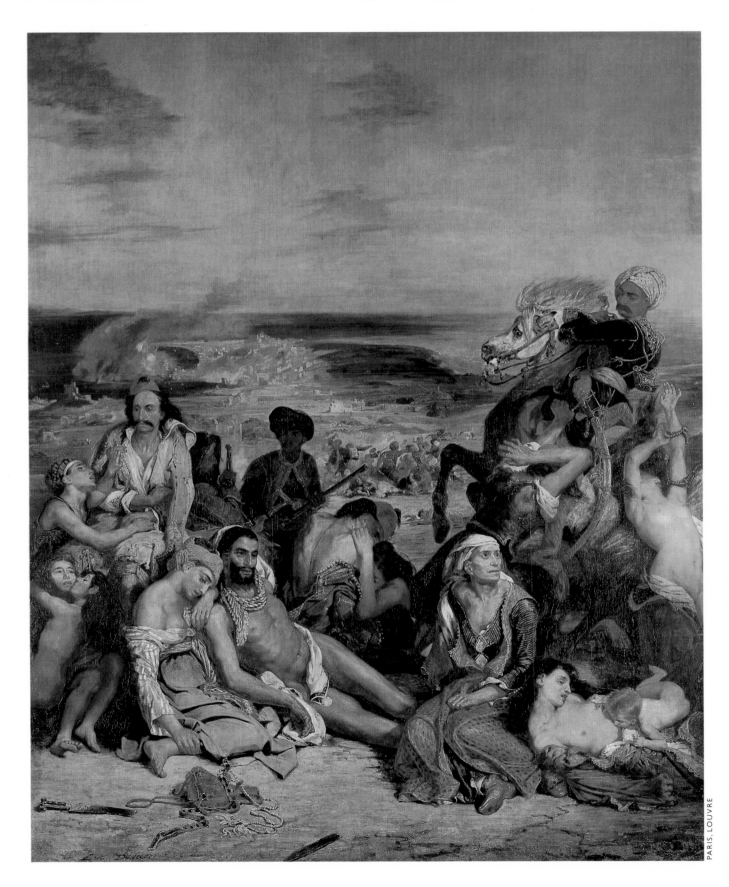

ANITA BROOKNER

# Delacroix 1798–1863
# Scenes from the Massacres at Chios 1824

Few painters go to war, and in the days before conflict became global few painters had experienced war either directly or indirectly. Their images of war may not even be very lifelike. When Eugène Delacroix exhibited his large picture of *The Massacres at Chios* in the Paris Salon of 1824, the novelist and critic Stendhal, who had been a professional soldier, complained that life on the battlefield was a bit more nervous and untidy than this. Delacroix, born in 1798, lived through rumours of war – all of Napoleon's conquests and reversals on the European mainland, in fact – but he grew to maturity in those years of peace after 1815 which many young men found dull. By 1822 war was remote. War was in Greece. The Greeks were fighting for their independence against the Turks. But Greece was a very distant country and the French for once were not involved.

In 1822 Delacroix, a nervous, elegant, and well-bred Parisian, was preoccupied with his dwindling finances and his growing reputation. He had to decide on a subject for a picture that would add to his fame in the next Paris Salon, that of 1824. Like many of his contemporaries he was a great admirer of Lord Byron, and Byron had died at Missolonghi in 1821. Rumours of war, always in the background of Delacroix's life, had been brought into sharper focus by this event.

In April 1822 twenty thousand Greek civilians were massacred by the Turks on the island of Chios, and by May 1823 Delacroix, as we read in his Journal, had decided to make this the subject of his Salon picture. He documented himself by reading the memoirs of Colonel Vouthier, a French officer serving with the Greeks, and by borrowing a few Turkish costumes from a fellow painter called Auguste. From these flimsy props and secondhand knowledge Eugène Delacroix, aged twenty-six, created perhaps the mightiest elegy for the victims of war ever to be painted.

It is not only a big picture; it has the inner coherence and cross-references of an autonomous world. Delacroix had never been outside France: he had scarcely been outside his painter's studio. His terms of reference were not European affairs but the works of other painters, in particular the war pictures of Baron Gros, who in 1804 became the most famous painter in France with his picture of *Napoleon visiting the Plague Hospital at Jaffa*. Delacroix loved this

Gros, *Napoleon Visiting the Plague Hospital at Jaffa*

painting. He loved the immense pathos of the great stricken nude, the dignity of the Arab orderlies, the doomed face of the young French doctor who has caught the contagion for which there was no cure. Delacroix remembered these attitudes when he came to paint his picture.

But one thing he discarded, as being either irrelevant or untruthful. He discarded the hero. On Delacroix's battlefield nobody wins. The Turkish enemy is given an oddly introverted gaze as if he too is stricken with some sort of problem. Another Turk is shown in

Details of *below* Turkish soldier; *opposite* the mother of the dying woman, *Massacres at Chios*

the shadows, against the light. Yet another looks like a marionette in the middle distance. This, in the mature years of the Romantic consciousness, is the new truth about war: everyone involved is a victim.

We must remember the full title: *Scenes from the Massacres at Chios*. It is an episodic work. A rigid structure of two interlocking triangles binds together a series of self-contained dramas. On the right some sort of rape is about to take place. In the foreground a dying woman gazes in despair at her hungry baby. Her mother gazes out of the picture, beyond us, as if lost to normal contact. In two separate incidents, a brother and sister embrace. A girl begs in vain

for comfort from her abstracted father. In the foreground lie a couple whose shame and grief can only be guessed at, so terrible and mysterious are they. Like the nude in Baron Gros's painting the man

Detail of wounded man and weeping girl,
*Massacres at Chios*

wears the beginnings of a baffled smile. He sheds blood. The girl lets fall a prismatic tear.

None of these people look at each other or at us. Their emotion is too deep, too personal; they are inconsolable. How extraordinary, therefore, to reflect that they are all borrowed from other paintings. They seem to have proceeded directly from the painter's heart. But painting is a learned profession, and Delacroix was a particularly learned painter. He took his rape scene from Rubens, his dying mother from Poussin's *Massacre of the Innocents*, his weeping girl from David's *Oath of the Horatii*, and, most audacious of all, his tragic father and daughter from one of the most staggeringly erotic scenes ever painted by Ingres, the *Jupiter and Thetis* in the museum at Aix.

Delacroix, Self-portrait

And the references to the *Massacre* picture in Delacroix's Journal show him to be very calculating, very much in control. He is concerned not so much with the real Greeks as with getting a certain black – 'that good black, that marvellous dirtiness' – that he remembers seeing in a Velazquez. And he is very conscious of the fact that he is out to rival the achievement of Lord Byron himself. This is what he writes: 'O smile of a dying man! Maternal glance! Embraces of despair, precious domain of painting! Silent power that seems to address itself only to the eye, and then engulfs all the faculties of the soul!'

Yet surely such controlled attitudes cannot account for the huge range and sweep of this composition, with its great vistas and its dying afternoon light. Surely these characters, whom we perceive as real families, a real community, cannot simply have been summoned from previous works of art? No, they cannot. Here we must pay tribute to that marvellous phenomenon, the Romantic imagination, which is not really imagination but a sort of heightened consciousness. 'O smile of a dying man! Maternal glance! Embraces of despair, precious domain of painting!'

The fact that we do not need to comment on the colours of this painting, or bother any more with the story that Delacroix retouched the sky after admiring a Constable, is a measure of our acceptance of Delacroix's sophistication. When we have experienced this picture we feel safe in the hands of a man of superior intelligence, one who is in command of his art and his feelings. And he is only twenty-six! Where can he go from here? He will paint all his life, neglecting love, marriage, the ordinary pleasures that make up most men's lives. And something strange will happen. It is as if Delacroix, having produced a world in *The Massacres at Chios*, will become bound by the rules of that world, a world of grief. In 1840 his attitude towards war has become intensified, as in *The Crusaders Entering Constantinople*. They are conquerors, but they are funereal. The only real life in the picture is in the paint.

The same cannot be said of the *Massacres*, completed sixteen years earlier. The painter is not yet a Stoic; war is not yet pretext for a fatalistic shrug. Here Delacroix seems to be saying that those who engage in war – whether they be right or wrong – will destroy themselves; that there is little difference between attacker and attacked. They are all victims, and what those victims suffer is never too obvious to mention. Delacroix is there to remind us – with imagination, but with a telling forcefulness – of the futility of war.

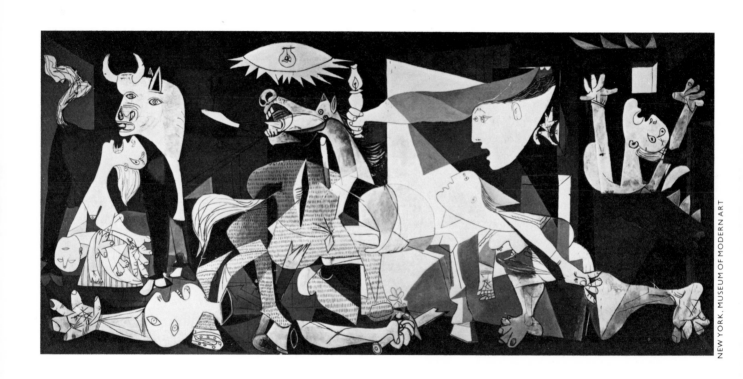

MILTON BROWN

# Picasso 1881–1973
# Guernica 1937

The *Guernica* by Pablo Picasso may be the greatest single painting of
the twentieth century. It is certainly the most famous. More than a
work of art, more than an historic document, more than a political
statement, it has become a legend, a kind of icon for our time. It came
to the Museum of Modern Art in New York shortly before the
outbreak of World War II and has remained there for safekeeping
until such time as freedom should be restored to Spain. Its home-
coming to Spain is expected in the near future. As a 'painting in
exile', a universal standard, it has grown increasingly meaningful in
the forty-odd years since its completion.

Painted originally as a protest against the ruthless bombing of a
defenceless civilian population, the *Guernica* was an anguished cry
against aggression, and it has echoed down the corridors of time,
becoming ever clearer and louder as war, violence and mass murder
have escalated, from the Spanish Civil War through World War II,
the Holocaust, Hiroshima, Korea, Vietnam, Cambodia, Laos, Africa,
the Middle East.

On 26 April 1937, according to a report in *The Times* of London,
'Guernica, the most ancient town of the Basques and the centre of
their cultural tradition was completely destroyed . . . by insurgent air
raiders. The bombardment of the town far behind the lines occupied
precisely three hours and a quarter, during which a powerful fleet of
Junkers and Heinkel bombers and Heinkel fighters did not cease
unloading on the town bombs weighing from 1000 lb. downward,
and, it is calculated, more than 3000 two-pounder aluminium
incendiary projectiles. The fighters, meanwhile, plunged low from
above the centre of the town to machine-gun those of the civilian
population who had taken refuge in the fields.'

The first photographs of ravished Guernica appeared in the
Parisian press on 28 April. On 1 May, Picasso, obviously deeply
moved by the event, began work on the mural which he had been
commissioned in January to execute for the Spanish Pavilion at the
Paris World Fair, and on which he had so far done nothing. The
*Guernica* was completed some time early in June and installed in the
Spanish Pavilion.

The impact the mural had at that time is hard to describe. Its layers
of meaning, associations, and significance were extremely complex. I

Picasso, *Guernica* studies: *top* study for the horse; *middle* and *bottom* composition studies

remember seeing it in Paris late that summer as a graduate student. The atmosphere was charged with concern over the Spanish Civil War, the surging threat of fascism. While the Western democracies were following a legalistic hands-off policy, the loyalist forces in Spain were being battered by a united fascism.

It was only a painting, and the Spanish Republic seemed doomed, but the *Guernica* was a clarion call, a shout of defiance, a scream of rage. Somehow it had the air of a positive statement, not optimistic, not a propagandist sop, but a positive statement, if not for humanity, at least for art. The greatest living artist, the standard-bearer of the avant-garde, a private, esoteric, so-called ivory-tower artist, had suddenly produced a mammoth political painting.

It is an ambiguous picture. The interpretation of the *Guernica* has by now as extensive and disputatious a literature as any medieval religious scheme or Renaissance allegory. The aesthetic baggage of a lifetime that Picasso brought to the *Guernica* was not especially designed for public communication. It may be that the news photos in themselves were so shocking, so incontrovertible, that a representational or realistic treatment, of which Picasso was certainly capable, was out of the question. On the other hand, there was no common symbolism to fall back on, except for a worn catalogue of propaganda clichés. Picasso intuitively, like a great artist, sought the universal within himself in the hope that the viewer would somehow sense the meaning.

The *Guernica* presents a scene of carnage. In the darkness, illuminated by a single electric light, a dying horse and a shattered statue lie in a tangled pile. One woman falls in flames from a burning building, while another flees in panic. A screaming woman holds a dead child in her arms. Behind her stands a bull. Another woman, holding out a lantern, surveys the scene from an open window.

The actual bombing occurred in broad daylight on a sunny day: the darkness of the painting is obviously symbolic of the deed. But why was the picture painted in black and white? Is it the black and white of the newspapers reporting the event? Are we being told the truth in black and white? Was Picasso afraid that colour would distract from or soften the bare and brutal facts? Are we indoors or outdoors? Does it really matter, since catastrophe is everywhere?

Is the woman with the classical profile, thrusting her lantern into the centre of the composition, the symbol of truth, appalled at what she reveals? What she reveals, aside from the literal aspects of death and destruction, is the symbolic drama of the bull and the horse, the imagery of the *corrida*, the bull fight; an imagery imbedded in Spanish memory, an imagery that occurs in Picasso's earliest childhood drawings and throughout his life.

Since we know Picasso's political sympathies, the wounded horse, screaming in pain, must be the helpless civilians of Guernica, the Spanish Republic ravaged by fascism; the broken statue of a warrior, perhaps a symbol of the past and of Spanish culture, is destroyed simultaneously. The bull facing the havoc, his tail flaring in rage, turns his head from the scene as if it were too terrible to behold. Everyone else turns to, looks at, or moves toward the bull, as if beseeching. The bull is no destroyer, but a protector. He is Spain,

Picasso, *Guernica* studies:
bull's head with human face

perhaps even Picasso, for he appears in an early study with a human,
classical head. And he echoes in anguish the cries of the horse and the
woman with the dead child. But he remains, with all his dignity and
courage, ultimately helpless, for this is defeat, not victory, and he
seems to be looking outward, perhaps to the rest of the world, for an
answer to the cry for help. Hope resides only in the solitary flower
emerging out of the warrior's hand and sword, and the soaring bird,
the soul of the dying horse.

Since Picasso refused to explain its symbolism, the *Guernica* must always remain ambiguous. It has been criticised for its failure to be clear, forthright and explicit in its message, as well as for its stylistic formalism. As a matter of fact Picasso was then in a Surrealist phase and returned in the *Guernica* to an earlier period of his art, Cubism. Did he feel that the complex, very personal poetic realism of the famous *Minotauromachy* etching of 1935 was inadequate to carry the passion he felt and the mural demanded? He found the answer in a simpler, bolder, expressionistic distortion, in a style brutal enough to match the horrors of reality, a style that could encompass his rage, express the inexpressible, and force the world to hear.

And even if the world does not fully understand, and the story is capable of revision, the *Guernica* will still always remain a timeless statement about the horrors of war and aggression. If the world has a conscience, it resides in this picture.

# CITIES

There are cities we see the way we do because artists have coloured them that way. To grasp the wholeness of a city, what makes it particular, its character, what it feels like to be there: such things are often easier to talk about than to visualise, and if we try to picture them the result may be a cliché, a picture-postcard. Artists do it better because they superimpose their own vision on a city, and we accept it because they have done it so convincingly. We borrow their sight.

It is questionable whether anyone would ever have seen the Spanish city of Toledo the way El Greco saw it at the end of the sixteenth-century had he not left us his *View of Toledo* — surely the most dramatic vision of a city ever painted. It is an image so unforgettable that it fixes the ancient capital of Spain in our minds forever as a place of thrilling grandeur, ghostlike and luminous under a gathering storm.

Vermeer painted his *View of Delft* some fifty years later, and here too is a city bathed in an amazing clarity of light. But with Vermeer it is a light that embalms the city in absolute stillness and silence. As in the El Greco it is high summer, and much the same conjunction of rain and summer light has appealed to both artists; only with Vermeer it is not a generalised dramatic vision of a city, it is a precise account of a particular moment in time — ten past seven in the morning.

Turner loved to paint Venice almost as much as Canaletto did, but where for Canaletto — living there — it remained the same city, Turner saw it through different eyes on each of his three visits. *Venice, the Dogana and Santa Maria della Salute* is the outcome (one of many) of his final stay there in 1840. As was his practice he actually painted it back in London from colour-sketches done on the spot, in this case several years after his return; so the painting is very much a memory of Venice, its topographical details melting into a general impression. It is Venice remembered as an almost immaterial thing, a magical shimmer of light within an enveloping haze.

The final two paintings are scenes of city life rather than views of cities. Van Gogh's *Outdoor Café at Night* is a study of the Place du Forum in the heart of Arles, and it was painted during that astonishingly prolific period in the artist's life after he arrived in Provence from Paris in 1888 — and unlike the Turner it was painted on the spot, probably in a matter of hours. Macke's *The Hat Shop* was painted in Germany shortly before the outbreak of the First World War, and it is a cameo of modern city life — a window-display of brightly-coloured hats, a woman with a red parasol gazing at them, and a pane of glass catching the light in the middle. That is all; and there could hardly be a better example of an artist creating something joyful out of almost nothing.

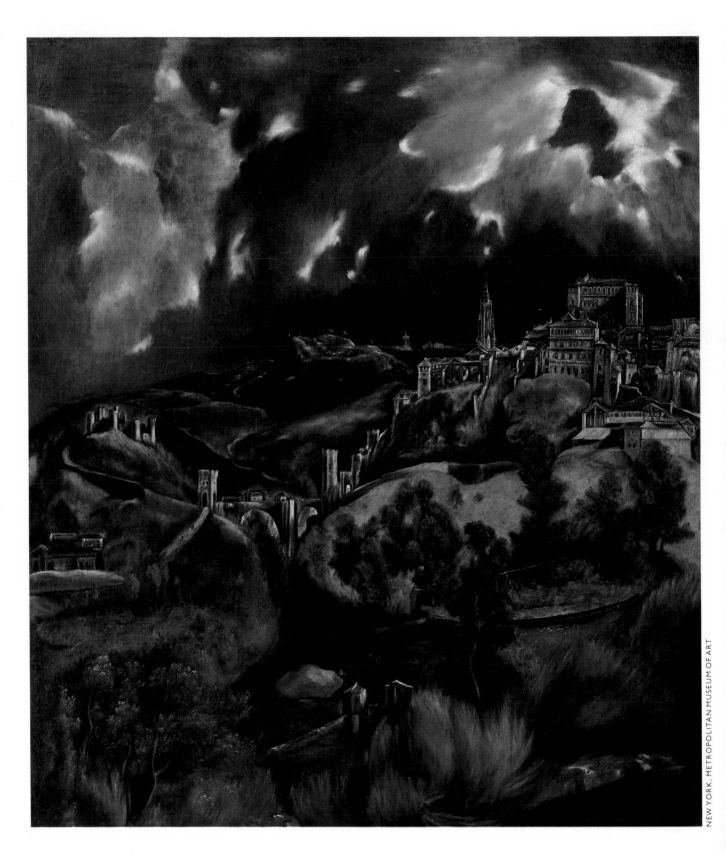

EDWIN MULLINS

# El Greco 1541–1614
# View of Toledo 1600–10

There are maybe a handful of painters, not many more, whose work is so closely identified with a particular place that we feel they almost own it, even in some way have shaped it. What they have actually done of course is to shape *our* way of seeing such places; so that when we go to Provence we see it as Cézanne, in Venice we see Canaletto, Suffolk villages we experience through the eyes of Constable, a crowded Normandy beach through the eyes of Boudin, while our image, at least, of Tahiti must be for ever Gauguin's, even though it may not be or have ever been in the least true. I don't know; I haven't been there.

But I have been to Toledo; and when I've crossed the River Tagus and looked back at that surprising Spanish city perched theatrically on its rock, the vision superimposed on what I see is this one. It's El Greco's *View of Toledo*, painted at the end of the sixteenth century or early in the seventeenth, and now in the Metropolitan Museum of Art, New York.

I have called it a vision, and this is precisely what it is: a vision of a city. You might imagine from looking at it that El Greco had glimpsed it just once in a dramatic storm and the impact of that moment had fixed it for ever in his mind. Not at all. He had lived here in Toledo more than twenty years before he came to paint it, and he seems to have done it purely for himself. Toledo was his home city, or rather the city El Greco made his home after years of wandering from his native Crete, first to Venice and then to Rome.

The scene is bathed in that dark, unnatural-looking sunlight you sometimes get when a storm is about to break. The foreground is bright and summery, a landscape of rock, water and small pastures. At first sight it looks empty of people, but it is not. There are tiny matchstick people on the road. A man on a white horse is crossing the river. Near him stand three men fishing, and behind them a cluster of figures washing clothes in the water. These could hardly be more sketchily rendered; mere tokens of humanity, no more important than ants, and quite unaware of the drama of nature being acted out over their heads.

And a terrific storm it is too, building up over the hills behind Toledo, blackening the horizon and creeping like armies of the night towards the monuments of the city lit by this unreal light like

Detail of figures on the road, *View of Toledo*

211

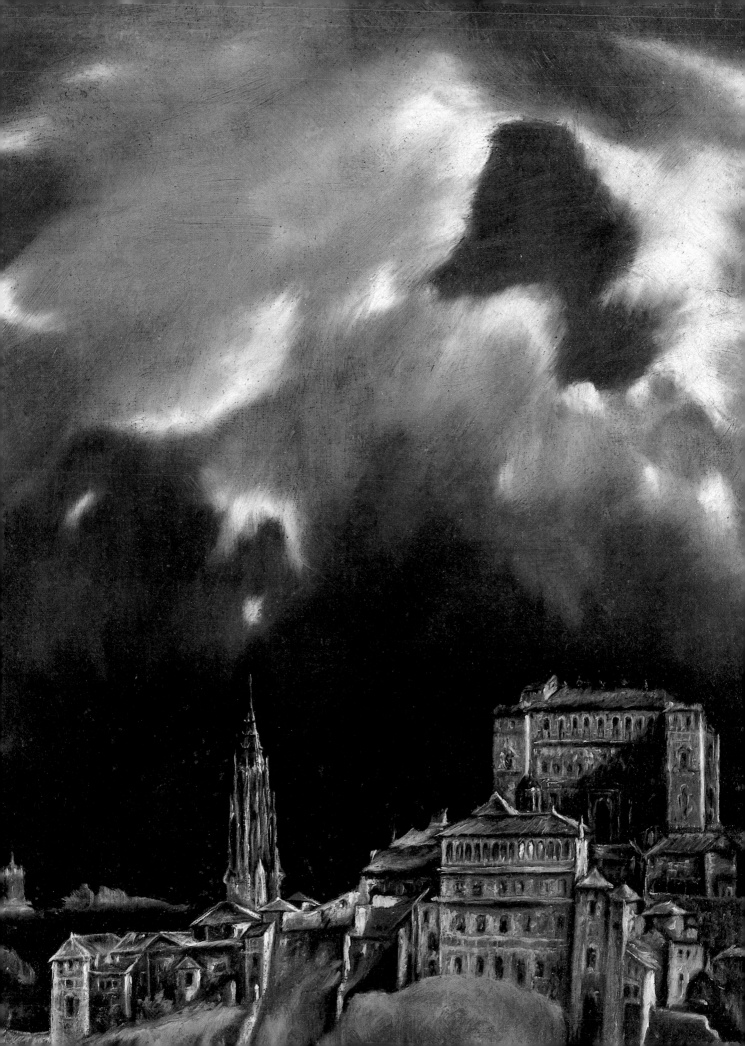

phosphorus. Toledo seems under threat from such a force of nature; it might be the ferocious storm in Shakespeare's *King Lear* (written, as it happens, just about the same time).

This feeling of a city under siege gives added meaning to the great fortress dominating the town, the Alcázar, and to the castle of San Servando outside the walls to the left of the picture. This, too, was built to protect Toledo against invasion, as was the fortified bridge over the River Tagus, the Alcántara Bridge, leading to a line of watchtowers that girdle the city.

The supernatural storm gives more significance, as well, to the Gothic spire of Toledo Cathedral thrusting into the black sky like a symbol of hope, a symbol of man's spirituality rising above earthly things. For Toledo was, and still is, the seat of the Primate of all Spain. In El Greco's time it was the hub of Spain's religious life. This was the principal reason he settled here. Money, mostly gold from the New World, was pouring into the church coffers here, making Toledo one of the wealthiest cities in Europe. Monasteries and churches were being lavishly built and lavishly decorated, and El Greco ran a highly successful local practice supplying all kinds of religious paintings to satisfy this demand. These included a *Disrobing of Christ* for the High Altar of the cathedral. It's still there. Then, an *Assumption* for the High Altar of the Church of Saint Dominic, which is now in Chicago. A *Holy Family* for the newly built Hospital Tavera, using his wife – so it's thought – as the model for the Virgin Mary. And the most famous of all El Greco's pictures in Toledo churches, the *Burial of the Count of Orgaz*, which he painted for his own parish church, Santo Tomé.

I cannot help feeling that in the *View of Toledo* El Greco was to some extent paying tribute to his own work, since so many of the buildings visible in the picture had been embellished by him. Nor do I believe it a coincidence that El Greco should choose the view of Toledo which gives fullest prominence to the Renaissance palace he himself lived in, sometimes – it was said – hiring musicians to play for him while he dined. Neither is it a coincidence, I imagine, that he brought forward from more than twenty miles distant the church tower of the neighbouring town of Illescas. Five of El Greco's paintings still hang in the accompanying Hospital of Charity here, and it was the church authorities of Illescas who at this very moment were involving the artist in an acrimonious lawsuit over payment for his work. I like to think it was not for nothing that El Greco set Illescas right in the track of God's thunder.

El Greco intended it, I am sure, to be read as 'God's thunder', and intended the *View of Toledo* to be seen as a religious painting. This may become clearer if we look at it in relation to a whole group of pictures in which El Greco included the city of Toledo. The most straightforward and topographical of these is the *View and Plan of Toledo*. This might almost be a pictorial map were it not for the allegorical figure on the left representing the River Tagus, and a further group of figures including the Virgin Mary descending from the clouds. In fact it is less topographically accurate than it seems. For instance, what about this foreground building seated on a cloud? It is actually the Hospital Tavera, for which the artist had been commissioned to paint *The Holy Family* and several other altarpieces, and he

Detail of the storm breaking over the city, *View of Toledo*

El Greco, *View and Plan of Toledo*

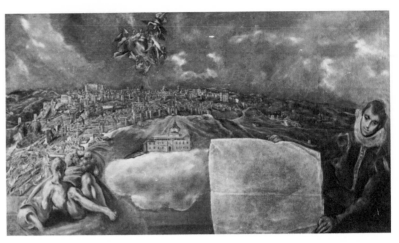

has set it on a cloud so that he might be free to turn it to face this way. The painting is half-map, half-vision.

In the painting of *St Joseph and the Infant Christ* El Greco has again made free use of the topography of Toledo, but in a different way. Now the city is standing in for, presumably, Jerusalem. And once again the storm-clouds gather like a prophecy of doom, a warning of the Crucifixion to come. Another vision.

Then there is that extraordinary painting, *Laocoön*: not a biblical painting this time, but still a painting that makes a moral point. It illustrates the story of the Trojan priest who warned against receiving the Greek gift of the Horse of Troy, and was promptly destroyed along with his sons by two serpents sent by the Goddess Minerva. This time Toledo is Troy, and the storm-clouds are a premonition of its imminent destruction.

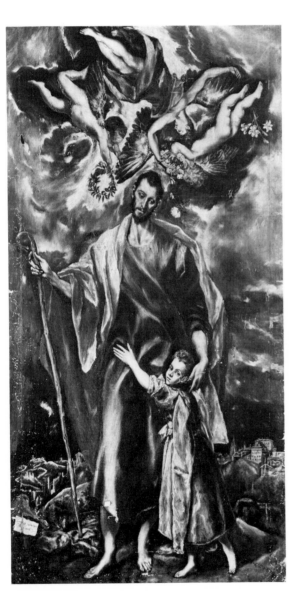

*Above* El Greco, *St Joseph and the Infant Christ;* *right* El Greco, *Laocoön*

In the *Christ on the Cross* Toledo rises in the background of the Crucifixion under a sky that is by now almost totally black. The only light is Divine Light. It shines weakly on the cathedral of Toledo and on El Greco's palace, but it shines fully on the figure of Christ and on the torn fragments of cloud which swirl in the general blackness.

In all these paintings it is the same thing: blackness is the human condition on earth: we live in the shadow of our sins. Overhead God's thunder rolls. Even Toledo, that splendid city, is not so splendid after all. The light that falls on it is only a pale reflection of the celestial light above. Toledo is doomed, like Troy, like man.

What El Greco has achieved here is something rare in art – a tragic vision of landscape. It is not so much a view of Toledo as a view of life, and a black one at that. It is a depressing picture, perhaps, since man is so puny, so insignificant: there is no warmth of love for man or for man's works. And yet – like *King Lear* – it has an unforgettable tragic grandeur: it strikes you with all the force of this tremendous storm which is about to strike the city of Toledo. It is terrible but it is also thrilling. It is superb. It sets the nerves tingling. If this is God's wrath we can only stand in awe.

El Greco, *Christ on the Cross with View of Toledo*

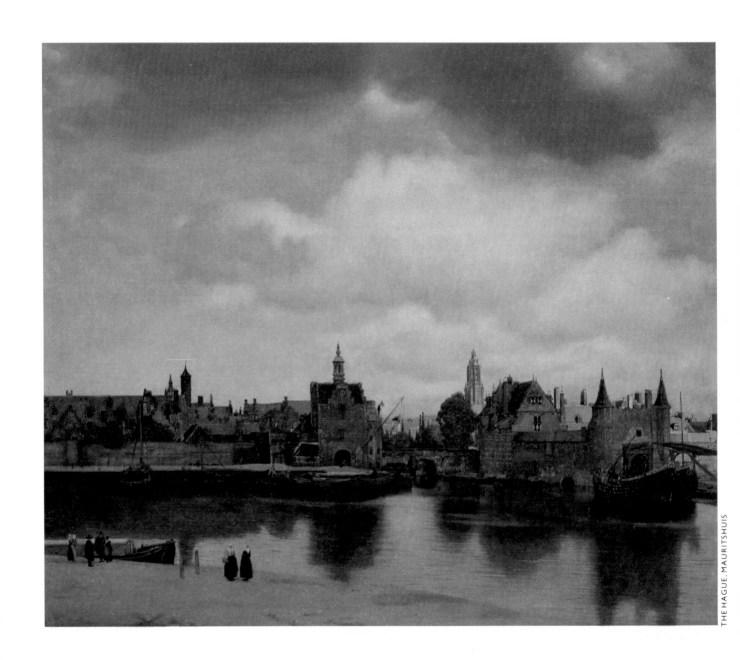

DAVID PIPER

# Vermeer 1632–75
# View of Delft c. 1660

The Mauritshuis is a great collection, and not least strong in the work of the two supreme Dutch painters of the seventeenth century, the Dutch Golden Age: Rembrandt, the painter of troubled humanity and his opposite, Vermeer – the coolest, calmest, most detached painter ever born. Vermeer lived a few miles from The Hague, in the little town of Delft, where he was born in 1632, where he spent all his not very prosperous life, and where he died in 1675. He was only forty-three.

Vermeer's *View of Delft* is a big picture by Vermeer standards, almost four feet across. It is also unusual in subject: not one of those serene, domestic interiors brimming with light and the silence of unheard music that you associate Vermeer with. From a normal viewing distance it seems very literal. Reproduced in black and white, you might think it to be a photograph of the place.

As such, as a record, you can decipher it, identify the local points of interest. From the left, the ridge of characteristic Dutch steep roofs runs above the old town wall. Red tiled roofs, scored with casement windows, and the sharp angles of gables – typical stepped gables. A couple of towers are just showing over the roofs – one of them is the Old Church, where Vermeer is now buried. Then a gateway, one of the town gates, called the Schiedam Gate, but with vivid grey-blue slates now; over a stepped gable again, with a pretty little cupola lifting clear above. In the centre stands the town wall breached by an arched opening. Through that runs a branch of a canal that floods the foreground and penetrates the interior of the town. Then to the right, tall trees, a grand, large house, very lustrous red, attached to another town gate, with battlements and twin, pointed turrets. This is the Rotterdam gate.

But all that – the full frontal of the defensive face of the town – stands in shadow. Or not exactly shadow, but rather cloud-light, not at all dead but investing the buildings with a subdued radiance: cloud-light as distinct from sunlight. And the sunlight is indeed ablaze elsewhere, shining on the middleground, the buildings lifting from within the town in clear reds and yellows. The splendid aerial tower of the New Church, where Vermeer was baptised, becomes a dominant vertical in the view.

So the town stands, a fretting strip of building between land and

sky. Water and sky, rather. That tall sky, its blue lumbered with clouds that have yet to be dripped dry, with a great grey swag across the top – where, in another kind of picture, a baroque painter of Vermeer's era might have looped up a curtain. In the foreground, the grey sheen of water is slightly troubled by the movement of air, the reflection of the town's façade slightly disturbed. And just down to the left, on the sandy bank of the water – which is the Rotterdam canal – there are people standing by a moored boat. They don't move, they just stand. Small, inexpressive as the two bollards there, yet crucial as anchors to the stability of the whole picture. The two women on the right of the group, black topped with white, answer the sunlit upright of the New Church.

Detail of two women and two bollards, *View of Delft*

It's a moment in time. A very particular time and very particular weather. The glisten, the clarity, suggests it has just rained in shower. The air is very fresh, and very early. We do not know exactly what year it was painted : about 1660 or a year or so one way or the other. But it is clearly a typically Dutch showery summer day. Trees are in full leaf. And it is ten past seven in the morning – the clock says so. Morning rather than evening because you are looking at the south flank of the town and the sun is coming from fairly low to your right, that is from the east.

Now one of the most endearing traits of the Dutch seventeenth-century painters is the pride and pleasure with which they celebrate their native landscape. Holland's hard-won independence from Spain, and the ensuing boom of its material fortunes, were only fifty years old when Vermeer painted his town of Delft, but he was already a latecomer in the greatest period of Dutch painters. In fact, though, his townscape is unique, entirely original, not only in his own work, but in contrast with the development of Dutch landscape. Town-scaping was anyway a relatively late speciality, and didn't happen before about 1650. Before that, the founding fathers of Dutch land-scape had of course painted towns, but almost always as constituent elements in their landscapes, rather than as solo portraits.

Cuyp's view of Nijmuegen of somewhere in the 1650s is typical of the way an artist would usually treat specific places. It is a highly picturesque site that attracted many painters; but they all absorbed it into their different styles, and Cuyp has adapted it here for a typical Cuyp, primarily an idyll of balmy, sunlit tranquillity.

There is one precocious forerunner to Vermeer's Delft that is rather startling, not only because it was painted forty years earlier – in 1618 – but because it anticipates so closely the general arrangement of Vermeer's painting, even to the little group in the left foreground. Esaias van de Velde, who painted a view of Zieriksee, was an extraordinary inventive and influential pioneer of the landscape school. Though it is all in brown, with a few touches of green, and as

*Left* van de Velde, *View of Zieriksee*; *below* Vermeer, *Street in Delft*

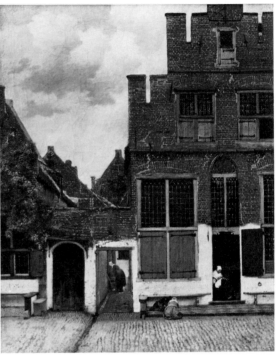

if gradually submerging in the blues of a fading dusk, it is astonishingly realistic. Yet in comparison with the Vermeer it is nevertheless rather obviously artistically contrived, more overtly stressed by the diagonals of its streaky clouds, and so on. The presence, the identity of the town, is subordinate. And, less than a foot high, it is also a miniature in comparison.

We have no idea what prompted Vermeer to paint this view of Delft. Perhaps it was a specific commission, as it is so unusual in his work. A stage towards it, though, is indicated in his little painting of a street in Delft, perhaps done a little bit earlier, and that may have been prompted by one of Pieter de Hooch's typical courtyard scenes like the one in the National Gallery dated 1658, when de Hooch was working, like Vermeer, in Delft.

The human interest, the anecdote, is crucial in de Hooch, apart from the fact that his command of line and colour lacks the ultimate subtlety of Vermeer's. In the Vermeer, all anecdotal interest is absent. The figures are anonymous, faceless, even perhaps a bit smaller in scale than other proportions would suggest they ought to be. Stillness and silence: the atmospheres are those of Vermeer's interiors, translated into the street – an outdoor interior. The observer is absolutely detached, and neither makes nor implies any comment.

So too in the *View of Delft* – the view expanded from interior, to the street, to range imperturbably over the façade of the whole town.

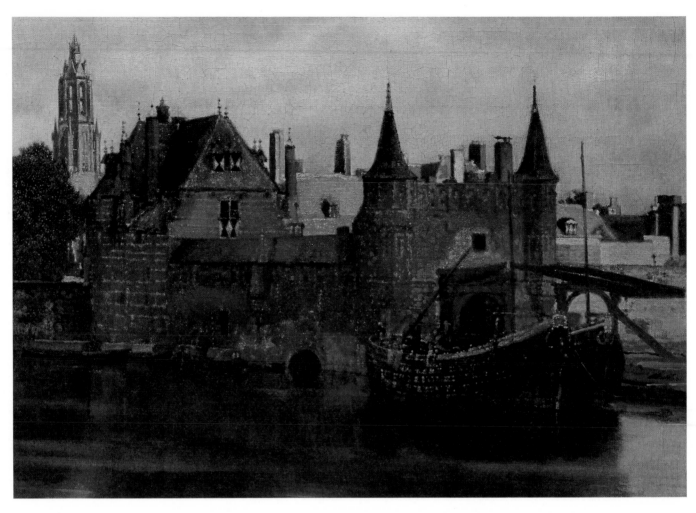

Detail of the Rotterdam gate and moored boats,
*View of Delft*

The coolness, the distancing, the unbridgeable space between image
and observer – you feel that the longer you look. It is imaged overtly
in the unbridged water between you and the town. These shadows
do not invite. All boats are moored. The technical apparatus which
helped to make absolute objectivity possible is not visible. It was
surely a form of *camera obscura* – that early form of camera still to be
found in some seaside resorts, projecting by an ingenious system of
lenses a distant image on to a flat surface, which could be a canvas,
and on which a painter could simply – to put it at its crudest – trace
his picture on the cast image. Crudely Vermeer did not do it, yet an
important factor in the overall evenness of emphasis he achieved lies
in his use of the *camera obscura*. It was no new departure. Delft was a
centre of optical research and experiments with versions of the
*camera obscura* were exciting attention in England as much as in
Holland, and in artistic as much as scientific circles.

A related experimental interest in perspective experiments is clear
in one of the few surviving works of Carel Fabritius, who died in a
catastrophic factory explosion that had wrecked much of Delft in
1654, and who is thought to have been Vermeer's master. His *View of
Delft*, showing an instrument maker in his shop, and the New Church
from another angle, was perhaps originally painted as part of a
peepshow box, like the surviving one by Samuel Hoogstraaten in the
National Gallery.

This all points to a fascination with the nature of reality, the nature of illusion, and I find it is the paradox between the intense apparent realism and the actual illusion of Vermeer's Delft that is its most mysterious and perennially haunting character. If you might think it at first glance a blow-up of a coloured photograph, you then become aware of its beautifully balanced composition, and then as you get closer, of the fact that it is not so much about the objects that light reveals but about light itself, the objects being merely the excuse for

Fabritius, *View of Delft*

giving light form. You will find hardly any sharp contouring lines in the whole thing – and, as van Gogh noted: 'When we step forward for a close-up view we can hardly believe our eyes. It is painted in colours quite different from those we saw at a distance.'

It is a painting that responds to the formal, even abstract, appetites of the twentieth century just as does Piero della Francesca, and indeed it is only about a hundred years since Vermeer, and this painting in particular, have been rediscovered. Impressionists marvelled at Vermeer. Proust thought this particular view the most beautiful painting in the world, and in a famous passage in his *Remembrance of Things Past* he bestowed a second immortality on it.

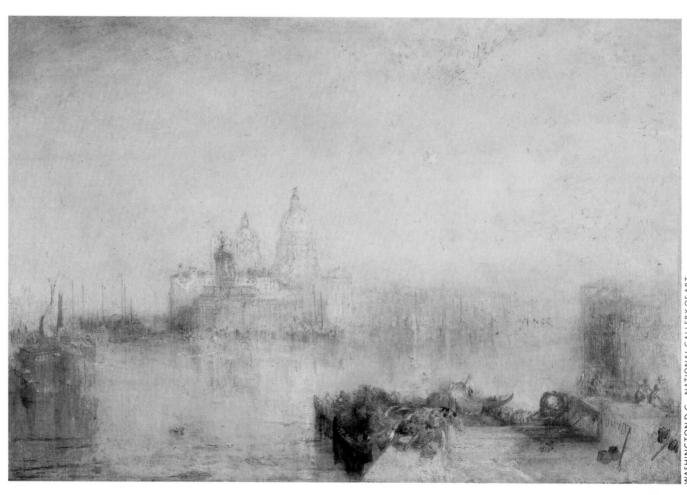

EDWIN MULLINS

# Turner 1775–1851
# The Dogana and Santa Maria della Salute 1843

In a small painting by S.W. Parrott reproduced here the short man in a tail-coat and top-hat and a fistful of brushes is England's greatest painter – J.M.W. Turner. The year is around 1846, the scene is the Royal Academy in London, and the seventy-one-year-old artist is giving the celebrated performance he put on each year on Varnishing Day as it was known, when painters applied the finishing touches to their work for the Summer Exhibition. Except that with Turner it was a great deal more than the finishing touches: often he would transform a canvas in a matter of hours.

Eccentric this may have been: an act it was certainly not. Such a performance was a key moment in Turner's creative process towards the end of his life. It was Turner working to a deadline, leaving everything to the last minute until the adrenalin was flowing like quicksilver, and then getting it down in a torrent of paint. What this performance tells us about Turner in the latter part of his life is crucial to an understanding of his work. He did not build up a painting slowly and meticulously like a piece of furniture; it emerged out of an excited dialogue, a confrontation, between the artist and the canvas. And this kind of confrontation is so much part of the grammar of modern painting that we can perceive what Turner was attempting in a way his contemporaries were not equipped to understand.

Turner showed his view of Venice, called *The Dogana and Santa Maria della Salute*, in the Royal Academy of 1843, three years earlier than the study of him by Parrott: it shows the Customs House and the celebrated white Church of Santa Maria seen from across the entrance to the Grand Canal. We do not know in what state the picture arrived at the Royal Academy, but it shows every sign of that same inspired assault that astonished all who watched Turner at work on Varnishing Day. Gouts and scumbles of rich colour have been pressed straight from the tube, or moulded with his fingers or a palette-knife. Violent excavations have been made into the paint surface with the sharp end of the brush, or with his thumb-nail which he grew like an eagle's claw for the purpose. Passages are streaked and wiped with an oily rag and heaven-knows-what-else to produce that magical haziness which the writer William Hazlitt had earlier described as 'pictures of nothing and very like'.

Parrott, *Turner on Varnishing Day*

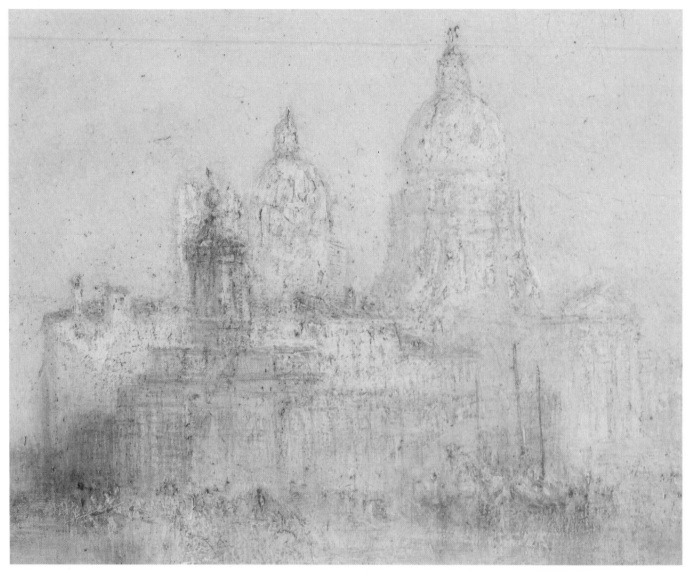

Detail of the Customs House and
the church of Santa Maria, *The Dogana and Santa
Maria della Salute*

That is exactly it. Here is not a documentary record of Venice: more a memory brought to life by this dialogue between the artist and the canvas he is working on. It has, supremely, the quality of remembered experience. It was three years since Turner had actually visited Venice; so it is not the details he recalls, only the most dominant landmarks. For the rest, vague impressions – of buildings related to water and to space, of vistas, smears of colour, the general bustle of a sea-port, the feel of the place. And to Turner above all in these last years, the impact of light! Because Turner had made an important discovery, which was that light does not always strengthen physical shapes, it can break them down; as when you look into the light. Here Turner, it seems to me, has half-closed his eyes on a memory of Venice and come up with something nobody had ever noticed before. The result – magically – is perhaps the finest view of Venice he ever painted.

The way Turner worked to bring a canvas to completion, relying on the inspiration of the moment, is matched by the way he recorded his first impressions on the spot, with colour jottings in water-colour. He filled sketchbooks with them: they are notes, memory aids,

Turner, watercolour sketches of Venice
from the sketchbooks

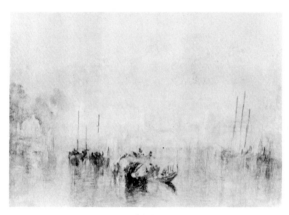

visions of Venice caught in an instant, as though the city were a coloured stain on the sea and sky, a coloured stain on paper.

There is every indication that towards the end of his life Turner gave up expecting to be understood by the art public at large. He had been famous young, a Royal Academician at twenty-six, a professor at thirty-two; he had made a fortune, and he could now go his own way – witness the fact that this view of Venice was one of the relatively few paintings in his late style which he bothered to exhibit.

This lack of understanding is itself a source of misunderstanding, because it encourages us to look at a painting like this in relation to later artists who were also misunderstood – in particular the French Impressionists. Monet, after all, also painted Venice. To me, this painting has nothing whatever to do with Impressionism, and everything to do with his own more popular work that preceded it. It is simply that Victorian taste went backwards while Turner's imagination went forwards.

It is worth considering what beckoned Turner to Italy in the first place, in 1819. The motive was precisely what beckoned every ambitious artist in the early nineteenth century. He went in search of the relics of the Golden Age of Rome and of the Renaissance, in search of the roots of our culture. Turner went to Italy to feel history in his veins, and to discover locations in which he might depict the lofty actions and ideals of mankind. This was what High Art was all about. It is no accident that in the largest picture he ever painted, *Rome and the Vatican*, Turner chose to include a study of the painter who in the eyes of the nineteenth century most perfectly expressed those lofty ideals – Raphael.

Then, on a later visit to Italy, in 1833, the focus of Turner's attention switched from Rome to Venice: from the Eternal City to what – increasingly for Turner – became the Ideal City. And again he included in the foreground of a painting entitled *The Bridge of Sighs* a tribute to one of the greatest artists of the Venetian scene, Canaletto,

Turner, *The Bridge of Sighs* (1833)

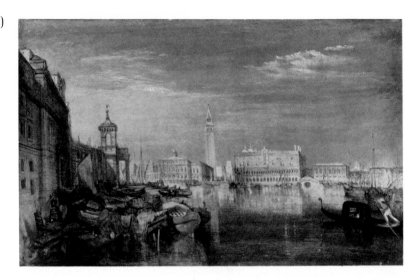

by showing the painter at work as though he were still alive and not dead already for sixty-five years. In other words Turner's love of Italy was rooted in a kind of worship. He was a pilgrim seeking strength from the two artists who represented, one, the highest ideals of Man, and the other, the highest ideals of Man's works.

Turner was actually a rather old-fashioned painter, in that he believed art should express what was sublime and heroic – the epic quality in life. Traditionally artists sought this epic quality in the great events of history and in the deeds of classical or biblical heroes, which meant that you had to know the story. I suspect this may have been what drew Turner to seek high drama in the forces of nature, which were self-evidently sublime. You did not need a story. Turner loved storms, raging seas, he loved mountain scenery, he loved grandiose architecture.

But then he took it one stage further: he grew obsessed by what he saw as the ultimate source of all this heroic energy in nature – the sun. Whether Turner really said on his deathbed 'The Sun is God' nobody quite knows, but if he did not he should have done: what he certainly did was to leave as an appropriate epitaph one of his final paintings, *The Angel standing in the Sun*.

On his third and final visit to Venice, in 1840, Turner's vision of the city changed. In that same year he painted a view of Venice from the Giudecca. Already the noble palaces and towers are softening into a white haze, and the domes of the Salute have begun to look unreal. Light itself is becoming a substance denser and more solid than brick and marble.

Three years later – the painting we started with – and Venice scarcely retains any material substance of its own at all. There is only light, materialised as paint, as colour. In other words, Venice as the most sublime creation of the sun.

I have been tempted to call Turner's vision unique. It is so personal that it is hard to imagine anyone following him. There is one other painter, though, who searched for an underlying structure and power in nature in order to express a yearning for the sublime, and that painter was Cézanne. But that is another story.

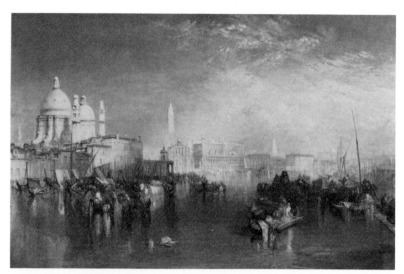

Turner, *View of Venice from the Giudecca* (1840)

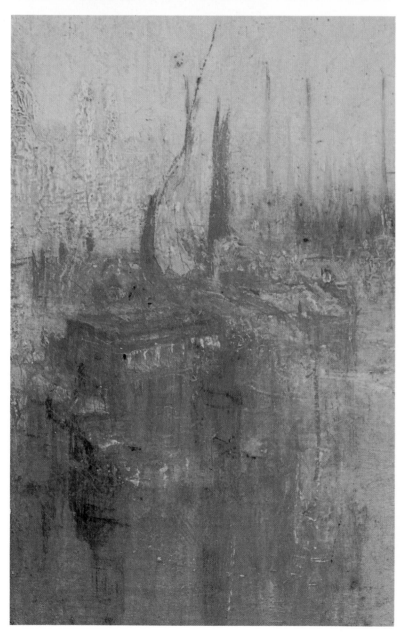

Detail of craft in the Grand Canal,
*The Dogana and Santa Maria della Salute*

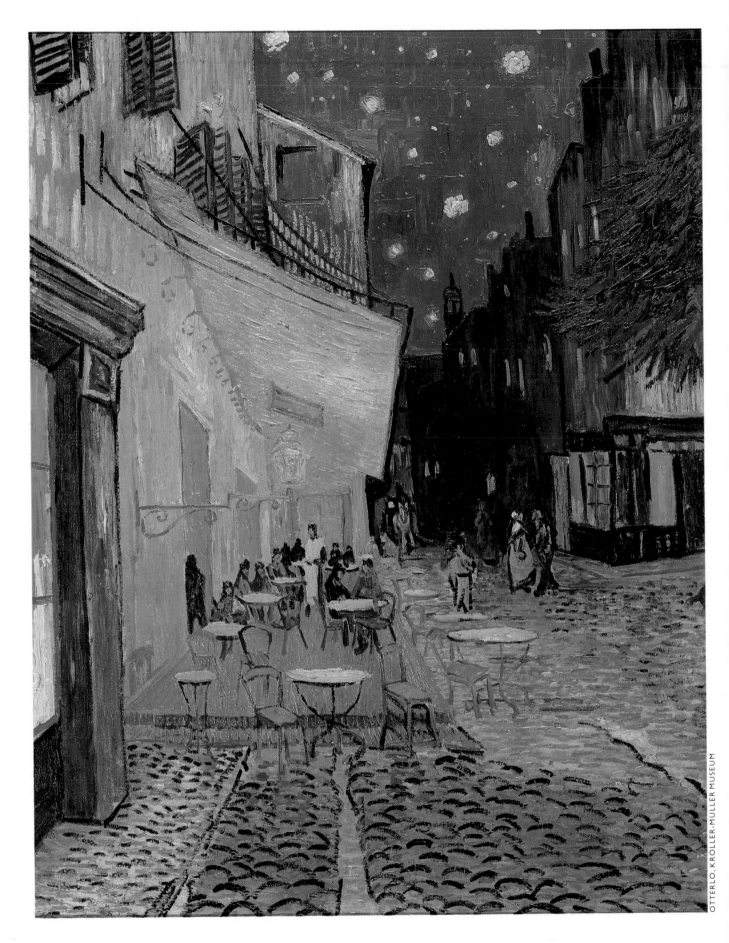

DAVID HOCKNEY

# Vincent van Gogh 1853–90
# Outdoor Café at Night 1888

It was Toulouse-Lautrec, supposedly, who told van Gogh to go to Arles, and in February 1888 he just got on the train and went there. And when he reached Arles he painted everything – in a way that I think a Frenchman would not have done, in that he painted the fields, he painted still-lifes, he painted his room where he lived, he painted things in the day and at night.

Although he wanted the sun and the light van Gogh began to be fascinated, oddly enough, by the artificial light of the little southern town at night. He described in vivid detail in his letters the colours he saw at night, how he saw things as even more colourful; and when he decided to paint this café in September of that same year, 1888, he fixed some little candles on his hat, so as to be able to see his own canvas, as he sat or stood in the little square in Arles and painted this scene.

It is quite unusual to paint night scenes. Technically they are rather hard to paint – think of the problems. A photographer will tell you how hard it is to photograph something at night; in films it often has to be done artificially, 'day for night' it's called, because otherwise how are you going to see what you are filming? *Café at Night* is based on two contrasting colours, yellow and blue, marvellously giving the effect of artificial light after dark. It is not based on the effect you would get from photographing the same scene; in fact probably in 1888 it would have been extremely difficult to get this effect at all with film as it was then.

Underneath the bright light of the lamp he makes the table-top a marvellous pale emerald green. Now, the effect of this green when combined with the yellow is to neutralise just a little bit the yellow he is using: there must be four or five different yellows and three or four different green-yellows all making up the area – very subtle, this effect he has got through colour, to use the green so that it looks lighter in tone than the yellow. The effect is stunning. it is probably intuitive – he intuitively found the colour on his palette and painted it this way. The figures in the café catch the light, and the movement of those in the street is just suggested, with the light catching them; this effect is all given by eight or nine yellows and green-yellows in the middle of the picture.

And the people walking away, or the people seated at the table, are

van Gogh, Drawings of the park at Arles

229

all done with a few brush-strokes – only four or five strokes a figure. Then the cobblestones: if you can imagine the light on cobbles, the light would be falling from above and shadows would be underneath – van Gogh finds a marvellous graphic way to do this shadow without being fussy: he just draws it with black lines, a wonderful method that you completely believe. It doesn't intrude as a graphic device, it all works as real.

He is also using a quite ingenious perspective, which is not easy to see straightaway; notice the way the lines work, with strong diagonals going all the way through the picture, and how the bottom half is based on a perfectly ordinary triangle. It is a very symmetrical perspective, but you don't notice it because it is shattered by this marvellous complex of yellow blobs in the centre. They are so vivid that they keep breaking it up. It is only after quite a long time that you can see how very symmetrical the division of the picture is.

As to how long he took to paint the picture, there are one or two clues. In particular there are very few cracks in it, or in any of van Gogh's paintings, even after a hundred years. The reason is that they were painted rapidly, in one go, as it were. Oil paintings crack if you put wet paint on top of semi-dry paint, so that it dries at different levels and at different times. There is hardly a crack in this painting at all, even where it is very thick. I am not an expert on how he worked, but I would have thought it was probably painted in two or three hours, the whole thing. There are drawings of the scene which he probably did beforehand; but he *might* have made the drawings afterwards – historians always think drawings are done before, but it is not always so.

What is quite remarkable about van Gogh, something that moves me, is that for the last eight years of his life we have more evidence of his existence than of almost any human being of the nineteenth century. He made eight hundred paintings in ten years. Eight hundred paintings is eighty paintings a year, that is nearly two paintings a week. He also made thousands of drawings and then he wrote all those letters so the twenty-four hours of his every day are probably accounted for – all accounted for. He would get up early in the morning, he would go out to paint, he would come back, eat with a few friends in the café, clean his equipment and write his letters. After he had done that there was nothing left but to go to sleep. I think very few people can account for their daily experience in that way; it is all so very vivid and in his art it has been left to us in a most vivid and generous way.

Details of *Outdoor Café at Night*

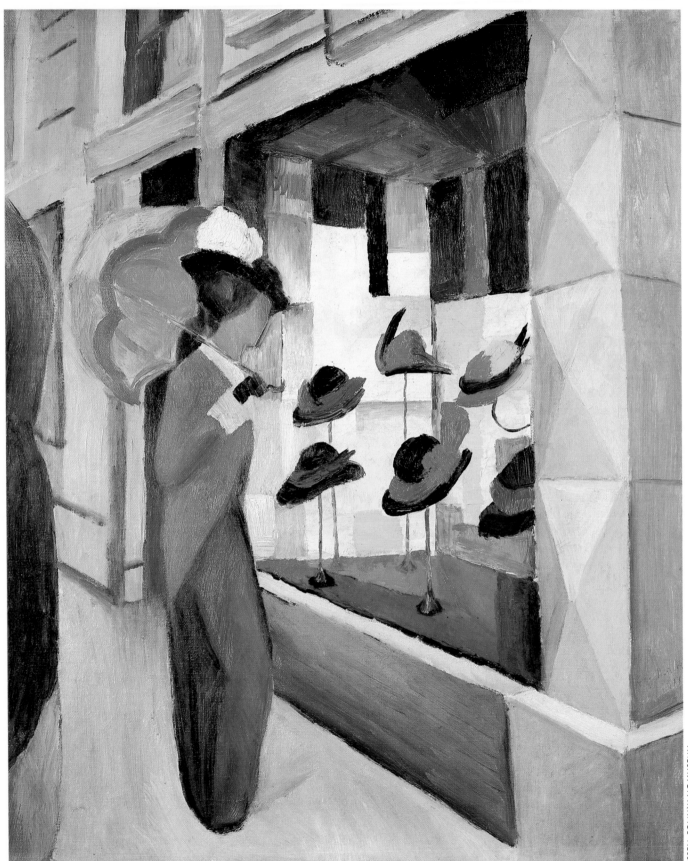

JOHN JACOB

# August Macke 1887–1914
# The Hat Shop 1914

Across the street from the Folkwang Museum in Essen is a hat shop, one of those old-fashioned shops – in this very modern city – with the hats supported in the window on poles of different length. The window is only half backed, so that an assistant can lean over and reclaim the wares from the window. At either side there are long panels of looking-glass to reflect the hats at different angles.

A woman looking in just such a hat shop is the subject of one of the most popular paintings in the Folkwang Museum. It is quite a small painting, by August Macke, one of the artists associated with the 'Blue Rider' group in Munich in the years immediately before World War I. The work of the 'Blue Rider' group is imbued with a modern spirit, and yet they shared no tangible programme, apart from an agreement to abandon realistic colour. Instead they used colour, sometimes in a quite arbitrary way, to convey strong feelings or emotions. Sometimes, as here, it can be used to produce an elegiac mood.

We tend to think of city paintings as dark, dramatic pictures of great buildings under smoky skies, dwarfing their puny inhabitants. But Macke's pictures are different: light and bright and full of colour, they seem to be a celebration of city life, in which dominant figures, like the elegant but relaxed woman here, move in idyllic surroundings.

Macke is hardly a well-known artist. His paintings were proscribed as 'degenerate art' under Hitler, and one of the largest collections of his work was destroyed by fire in Bonn in 1945. He was born in 1887, the son of a civil engineer and building contractor who was often close to bankruptcy. He had no fewer than five elder sisters, and looked to his mother – who took in lodgers – very much as the saviour of the family's fortunes. In 1899 one of Macke's school friends, Hans Tuar, was run over by a horse-drawn tram, and lost both legs. Macke visited him every day and started drawing to amuse his friend. After that he never ceased drawing.

The family moved to Bonn, and there the young Macke at the age of sixteen fell in love with Elizabeth Koehler. Elizabeth was the niece of the wealthy Bernard Koehler, who became Macke's patron and, through him, a great collector of German Expressionist art. Macke visited Paris with Koehler in 1908, and the following year –

immediately after completing his army training – married his niece Elizabeth and settled in Bonn.

In January 1910 Macke met Franz Marc, the painter of animals whose works, like the *Blue Horse*, he had already seen in Munich. The two became firm friends, and Marc introduced Macke to Wassily Kandinsky and other artists of the New Artists' Federation in Munich. Macke was briefly influenced by Kandinsky, but his work was at this time a curious mixture of French Cubism, Italian Futurism and German colour. Only the lyricism was his own, as in the delightful painting of *Two Young Girls*, painted in 1912, where the monumental forms of the two girls, with all their simple affection and innocence, are posed against the confused, bustling life of the city.

In this same year, 1912, Macke, this time accompanied by Marc, returned to Paris and met Robert Delaunay for the first time. Delaunay's window pictures, his paintings of the Eiffel Tower and the colour theories he called 'Orphism', had a profound influence upon Macke. The effect of Delaunay's 'windows' is apparent in the first of Macke's shop window paintings, *Large Shop Window*, of 1912. It was to become one of Macke's favourite themes – a woman looking into a fashionable shop window, with all the possibilities this gave for exploring the angular reflections and splinters of light derived from the Frenchman's art. There is also a curious painting of the

*Top* Marc *The Blue Horse; below left* Macke *Two Girls; below right* Delaunay *Window on the Town*

Cathedral at Freiburg, which shows Macke's fascination in the similar, diamond facets of the stonework, echoed in the segments of the woman's umbrella, and the lattice ironwork of the tower.

But the *Hat Shop* is Macke's masterpiece, painted in the momentous year of 1914. It combines a typically 'Blue Rider' feeling for poetry and symbolism, within a formal arrangement. It is structurally much more powerful than the earlier treatments of the theme – simpler, and not so dependent on the shattered perspective of Delaunay. The colour effects are masterly: the long slab of blue-grey makes the greens and reds in the shop window look even more brilliant, and the vertical reflections in the mirror glass provide a counterpoint to the tilt of the hats in the window. The painting has a strong but subdued emotional atmosphere.

Macke is here painting a poetic mood – a painting akin to the poetry of the 'Blue Rider' Group, or the music of Schoenberg. In his letters to his wife, Macke had commented on the curious affinity he found between music and painting: 'That which makes music so mysteriously enchanting also works for painting, but it takes supernatural strength to co-ordinate colours like notes.'

Here in this picture we can see him doing it confidently and successfully – the red coat and brown skirt of the woman contrasts with the yellow parasol so that it almost hurts. The reflected light in

Macke *Large Shop Window*

235

the shop window explodes with an energy that is now not that of Delaunay, but of Macke. In the last few years before World War I, Macke became his own man, arriving at a highly personalised vision of the life of his time.

There was to be one final development. In April 1914 he set out with Louis Moillet and Paul Klee on the famous trip to Tunisia. The water-colours which both Macke and Klee brought back are staggering in the intensity of their colour. On his return, Macke threw himself into his painting with a burst of activity that was unusual even for him. His last painting was entitled *Farewell*, and shows women and children standing by while men sign their mobilisation papers.

Macke, *Farewell*

By August, Macke was drafted to the Western Front. On 26 September 1914 he was killed near Perthes, in Champagne. Franz Marc wrote in his obituary: 'It was Macke who produced lighter and brighter colours than any of us; as light and bright as he was himself.'

# TOUCH

The moment of physical touch between two human beings may be swallowed in the passing of time and the crowding of events, but occasionally a work of art halts time at this electric moment, allowing us to reflect on it and to feel its impact and its meaning.

All these five paintings are about a kind of loving. The earliest, *Christ heals a Man Blind from Birth,* is a small panel that was once part of an enormous altarpiece painted almost seven hundred years ago by Duccio for the cathedral in Siena. The painting depicts a miracle and shows, in fact, two stages of it, the touching of the blind man's eyes by Christ's fingers, and the astonishing moment of his being able to see for the first time.

Tintoretto's *Ariadne, Bacchus and Venus* was painted in Venice during the 1570s, and its source is that favourite quarry for painters of classical mythology, the writings of the Latin author Ovid. Ostensibly it is an account of a wedding, with Venus as intermediary; in fact, since the painting was designed to hang in the Ducal Palace in the room where visiting ambassadors awaited their audience with the Doge, the painter has obligingly turned it into a piece of lightly-disguised political propaganda.

Painted about seventy years later, de la Tour's *The Dream of St Joseph* contains no such overtones. As with the Duccio the picture describes a kind of miracle – the appearance of an angel to the sleeping Joseph to inform him that his wife Mary is to give birth to the son of God – and the poignancy of this moment in the New Testament is conveyed by the gentlest touch of the angel's fingers on the old man's wrist.

The Rembrandt was painted some twenty years later still. He never painted a more intimate study of a human relationship than the so-called *The Jewish Bride* – 'so-called' because no one is sure who these two figures are and what may be the precise significance of the bridegroom's gesture. Perhaps it has a biblical reference. But does one need to know? In that simple physical gesture lies a perfect expression of the spirituality of love. Merely to gaze at it resolves the enigma. And maybe the same can be said of a twentieth-century masterpiece for which, also, no precise explanation exists, Picasso's *La Vie,* painted in 1903/4 during the artist's Blue Period. Couples touch, huddle together, exude a tender melancholy verging on despair. The meaning is obscure, the mood is clear: it is one of Picasso's most moving elegies for the tragic experience of young love.

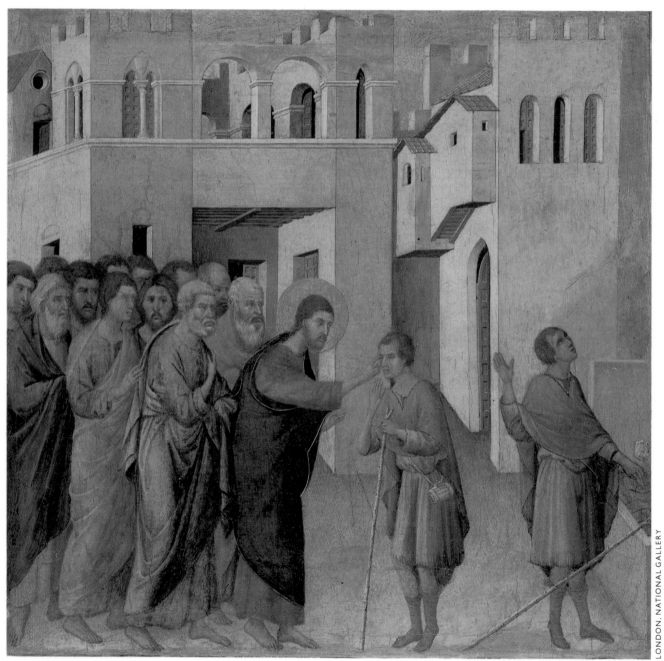

238

ALISTAIR SMITH

# Duccio 1257–1317
# The Blind Man 1308–10

On a summer's day in 1311 a large painting was carried from an
artist's studio through the winding streets of a hill town in central
Italy, on its way to be installed as the main altarpiece in the cathedral.
As it proceeded slowly on its way, it was accompanied by the town
dignitaries, both lay people and divines. Many of them carried
candles; music was played; the church bells rang. It was a day of
great celebration. The town was Siena, which today is rather quiet,
even provincial. Yet in the fourteenth century its population was a
vast 100,000. In wealth, and often in war, it challenged Florence
which lies a mere sixty miles to the north. It could command the best
painters of the day – and afford them.

When Duccio di Buoninsegna was employed by the cathedral he
was one of Italy's two most important painters – equalled, perhaps,
only by Giotto. His undivided attention for the almost three years it
took to complete the altarpiece cost the Sienese authorities 3000 gold
florins – a colossal sum. But then it was a colossal painting. Fifteen
feet across, it showed on one side an image of The Virgin and Child in
Majesty. From this the painting took its name – *La Maestà* – which
coincidentally expresses something of its scale and ambition. The
reverse of the panel was covered with upwards of forty scenes. Here
Duccio painted incidents from the life of Christ.

Like many great paintings, this one has been tampered with. As
early as 1505 it was moved from the high altar and deposited
elsewhere in the cathedral, until 1771 when it was literally cut to
pieces, the major change being the separation of the front from the
back. One part was mounted on the altar of the Holy Sacrament, the
other on an altar dedicated to S. Ansano. In fact it was only in the
1950s that the two were mounted once more back to back and
displayed in the Cathedral Museum – a process that took longer than
its original creation. In the intervening period several small panels
were separated from the main part and three of them found their way
here to the National Gallery in London. These I find especially
moving – partly because of the pathetic contrast between their
smallness and the immense panorama of the main part of the
altarpiece. It is as if they are children strayed far from home.

I think too that one of them can claim to be the most personal
painting of all those which went to make up the ensemble. Its subject

*Right, above and below* Duccio, *The Maestà*
(reconstruction by Professor John White); *left, above*
Duccio *The Annunciation*; *left below The*
*Transfiguration* (both originally from *The Maestà*)

is the two senses on which the art of painting depends, and on which Duccio himself relied for his livelihood: sight, which gains the painter his perception of life, and touch, by which means he translates his vision on to canvas – or in this case on to a wooden panel. To each painter the eyes are a source of both pride and anxiety, and his hand is as precious as his eyes.

The ninth chapter of the Gospel according to Saint John has, therefore, a special significance to all visual artists.

> As he went on his way Jesus saw a man blind from his birth.... His disciples put the question, 'Rabbi, who sinned, this man or his parents? Why was he born blind?' 'It is not that this man or his parents sinned,' Jesus answered; 'he was born blind that God's power might be displayed in curing him....' With these words he spat on the ground and made a paste with the spittle; he spread it on the man's eyes ... and said to him: 'Go and wash in the pool of Siloam.' The man went away and washed; and when he returned he could see.

Duccio shows the miracle taking place on the right. The man washes at something which resembles more a horse trough than a holy pool – and looks up to see the sky for the first time.

To emphasise the authenticity of the narrative, Duccio has placed the two different episodes practically side-by-side – they can *both* be observed by the apostles, who therefore act as witnesses. Their intent scrutiny is in poignant contrast to the blind lids, and to the rolling uncontrol of the newly-sighted. One of them looks out, as we look in. He might be saying, 'You can see it just as well as I.'

The sky which fills these eyes, opened for the first time, is not as one would expect to see it either in Duccio's Italy or in Jerusalem. It is gold rather than blue – symbolic rather than realistic – and it reminds us that this small painting is redolent of meaning. Its simple narrative is in itself symbolic. Physical blindness is a reference to spiritual blindness, and its cure a simile for illumination of the soul. The story is, quite literally, about 'seeing the light'.

Duccio has made the experience of sight good. The town shines as if freshly laundered, or rather freshly bathed in sunlight. Its delicate colour, the crispness of its focus, the purity and harmony of its construction – these are as much the product of perfect vision as they are a source of pleasure for it.

The deficiencies of its perspective remind us that Duccio and his contemporaries did not possess perfect mathematical accuracy. Another century or more had to pass before these were available to all. In Duccio's day there were no sleight-of-hand short cuts to art; his skills were thought impossible to come by through reason and hard work, but were rather thought to be endowed at birth – in short, his vision, both physical and mental, was God-given. Which is exactly what this scene represents, and why it is of particular importance for an artist. One might almost wonder if the head of the blind man might be modelled on an artist whom Duccio knew. The substances used by Christ to perform the miracle – remember 'he spat on the ground and made a paste with the spittle' – these very substances, earth and water, are exactly those which provide the

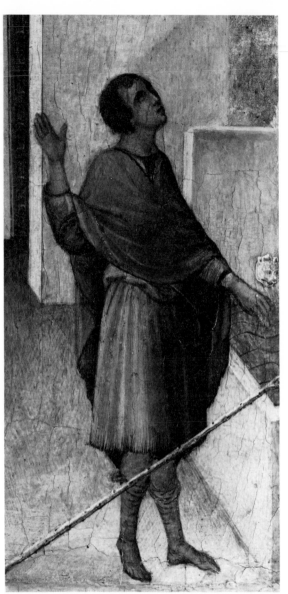

Details from *The Blind Man*:
*opposite* Christ's touch; *above* the blind man sees

basis of the painter's materials.

So there is every reason to think that this scene received very special attention from Duccio. Certainly his art seems almost to be heightened here; austerity and elegance more completely united than ever. There is great art in the way Duccio convinces us of the beggar's poverty, yet clothes him in a cloak of refined curves – and invents the subtlest colouring for him – a warm grey set off by pink; his stockings in a pale green complementary. Christ is, of course, given richer colours than the others. Emphasised by them, he becomes the dynamic centre of the picture. His gesture, simple though it may be, has multiple associations. It is a benediction extended to bless the eyes. It resembles the movement which closes the eyes of the dead; yet it is all the more effective through this comparison, since it opens the eyes to life.

Significantly, although Christ is said to have spread paste on the man's lids, Duccio has made it necessary for him to do little more than point with his index finger. He clearly wanted to emphasise that the essence of the miracle is the body of Christ, and that its magic is transmitted through a mere fingertip. The simple means used to effect the cure is rendered perfectly by Duccio's understated style. No histrionics, no excessive display of emotion. The emphasis is upon clarity and authenticity. The truth is made to appear good by its display in such harmonic colour, whose very preciousness – for the gold and the blue of Christ's robe were extremely costly – is a parallel for the uniqueness of the occasion.

As the gospel narrative insists, 'Since the world began was it not heard that any man opened the eyes of one that was born blind.' And if that is a miracle, then I feel the painting is too. To quote the blind man himself: 'Why herein is a marvellous thing.'

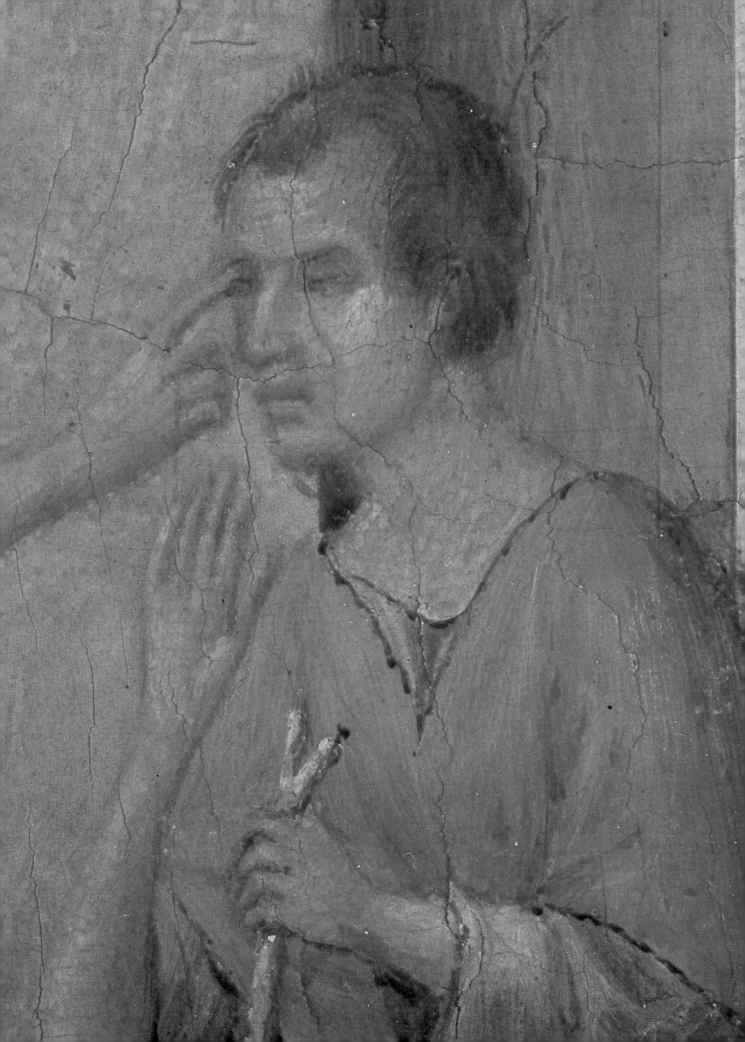

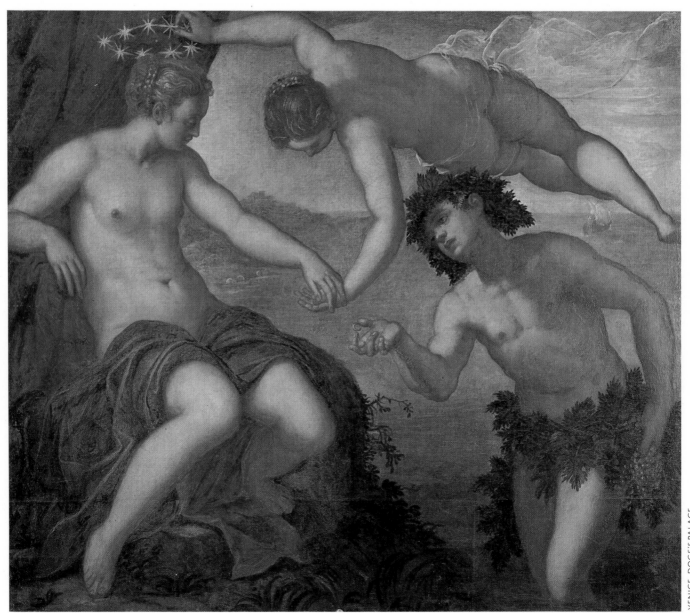

ALISTAIR SMITH

# Tintoretto 1518–94

## Ariadne, Bacchus and Venus late 1570s

We are used to visual images which have a very definite purpose. Some are no more than documentary passport photographs and the like, but many are deliberately persuasive. They set out to convince us that one politician deserves our vote more than another. They suggest that we buy a particular washing powder. This type of imagery, basically propagandist, is so much part of our daily lives that it is impossible to tell how it affects us – although large manufacturers (and governments) would very much like to know.

Many of the paintings and sculptures we now describe as 'works of art' were originally conceived as propaganda. This may come as a surprise, since their aesthetic interest now outweighs their original purpose. This painting, made in the late 1570s by Jacopo Tintoretto, is a particularly interesting case.

It is a lush subject. A young man is offering a wedding ring to one of those women who populate Venetian Renaissance paintings (perhaps 'fill' would be a better word): magnificent, rather awesome creatures. She seems reluctant to accept it, although her costume hardly suggests timidity: perhaps she finds his approach rather bourgeois. Her hand is being manoeuvred into a receptive gesture by another nude, a flying female who crowns the bride with a circlet of stars.

One would have thought that the intimate theme and its sensuous treatment would have made the painting suitable for a bedroom, or at least for a private apartment of some sort. But no, it hangs in the Ducal Palace, Venice, in the Sala dell' Anticollegio – the room where ambassadors would wait before being admitted to the presence of the Doge. We would hardly expect any twentieth-century equivalent to be so sumptuous. In fact it was moved into this room only in 1716 – about 150 years after its creation – having been originally conceived as part of a larger decoration with a particular political point.

The story really begins with a disaster – one of those fires which make art historians sigh to this day. It wiped out many pictures in the palace, including Titian's famous *Battle of Cadore*. Nevertheless it gave the opportunity for a decoration which would promote a particular self-image, all the more necessary since the Venetian Republic's territory and power were waning by the minute. The Doge, Girolamo Priuli, and his committee evolved a scheme intended

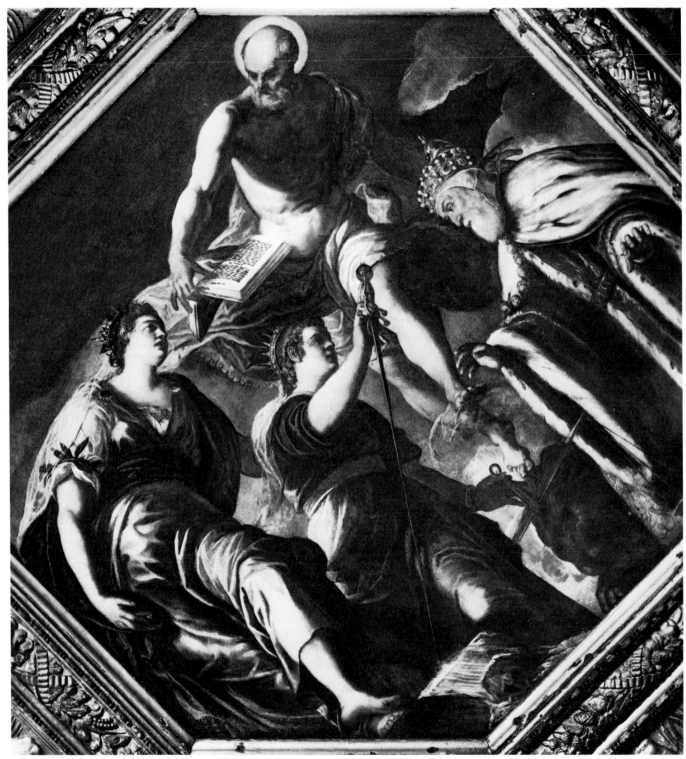

Tintoretto, *Doge Priuli Receives the Sword of Justice*, ceiling painting in the Sala Quadrata

not only to honour Venice, but to swell his personal repute. The scheme has all the bombast of insecurity. Priuli had himself painted smack in the centre of the Sala Quadrata. Accompanied by his patron, St Jerome, he is presented to two ladies. They represent Justice and Abundance, two virtues which any Doge needed – in addition to Jerome's Christian wisdom, and the strength of the lion. The ceiling bears Priuli's coat-of-arms and paintings exemplifying the same four virtues. Four children represent the cycle of time: Spring, Summer,

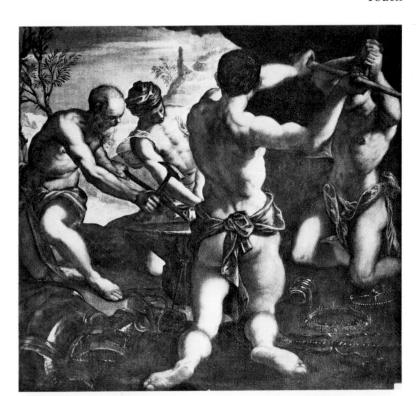

Tintoretto, *The Forge of Vulcan*, in the Sala dell'Anticollegio

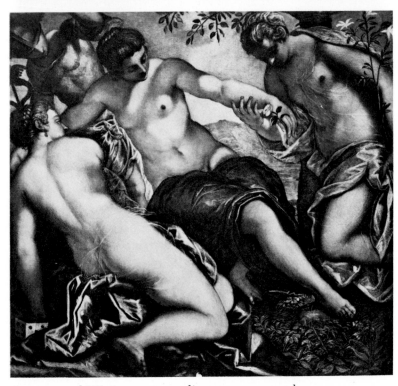

Tintoretto, *Mercury and the Three Graces*, in the Sala dell'Anticollegio

Autumn and Winter, never-ending, ever-renewed.

Priuli and his committee saw the decoration as being completed by four canvases by Tintoretto, and in November 1578 they authorised that 217 ducats be paid for them. These are the pictures now in the Anticollegio. Their symbolism is diverse, but each one represents a union which produces good. Vulcan is united with the Cyclops. Together they produce armour – symbolic of Venetian military strength. Each of the paintings contains a similar allegory. Wisdom

unites with Peace, and repulses War with ease. Love and Beauty are backed by Wisdom too – and they overcome Chance.

Only one of the paintings transcends the allegorical form, as if this were the only subject which appealed to the artist. It allowed him to display his command of the nude. Although Tintoretto hardly set foot outside Venice he amassed a collection of engravings and bronze statuettes which taught him a great deal about central Italian artists like Michelangelo. In fact it was said that he aimed to unite in his work the 'design of Michelangelo with the colouring of Titian'. He would study his lay figures from every angle, and in every type of light. This allowed him to hit on foreshortenings which exceed all previous Venetian attempts in complexity and drama. In this painting we find him making use of his Venetian artistic inheritance, glorying in his ability to paint the 'delicate body'. This term was used by his contemporaries to describe not just women but 'men of class'.

The story comes from Ovid, but it is given a rather free interpretation. A girl, Ariadne, has been abandoned by her lover, Theseus, whose ship is seen disappearing over the horizon. Peculiarly, Venetian painters seldom bothered with the black sail of the legend. She is discovered by Bacchus, here characterised by a superabundance of vineleaves as well as a large bunch of grapes. It is Venus, the agent of erotic love, who brings them together. Ovid tells that Bacchus married Ariadne, promising her that her crown would become a perpetual constellation in the sky after her death.

Contemporary accounts of the painting stress the Venetian connection. Ariadne is to be thought of as Venice herself – indeed she sits next to the sea – made rich by heavenly grace, crowned with the diadem of freedom, and destined to reign for ever. Bacchus symbolises the fruits of the earth which Venice can command from her colonies because of her sea power.

Tintoretto translates into sensuous form the nucleus of Venetian ideology – the superstitions that the Republic had a magic relationship with the sea. Every year on Ascension Day a ceremonial marriage takes place when the Doge officiates at the wedding of Venice to the Adriatic. It is a splendid occasion. In his composition Tintoretto takes the opposite point of view, stripping off costumes as well as ceremony, and lending his scene the intimacy of a private moment. Bacchus is more of a love-lorn youth than a god; his eyes appeal for her to receive his ring. Ariadne's eyes are lowered in an expression as close to modesty as her costume will allow – a flash of wit that would not have been lost on the spectator. Both are controlled by love.

In their original position, under the Priuli ceiling, the allegorical meaning of such a painting would have been explicit. In its later position here, its glamour and wit come to the fore – the blond flesh bathed in permanent, warm sunlight; the hesitant young suitor; his delicate gesture. Remember that in this room ambassadors queued to make proposals to Venice.

The painting's ultimate quality is plain to see. It may have a political message, but its emphasis on love, pleasure and amusement is perhaps a truer and better advertisement for Venice than any statement of sea power and military strength.

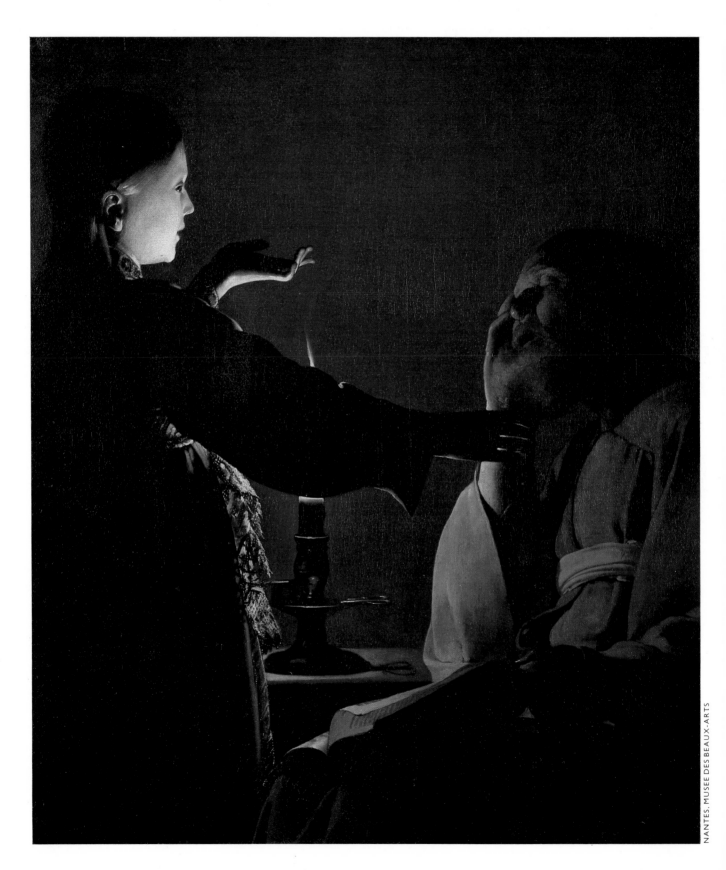

EDWIN MULLINS

# Georges de la Tour 1593–1652
# The Dream of St Joseph c. 1640

In the French city of Nantes on the edge of Brittany the local art gallery houses a collection of remarkable paintings given to the city by one of Napoleon's diplomats in 1810. Among the gems of the Nantes Museum is a group of pictures by the seventeenth-century French artist Georges de la Tour, whose works are particularly rare. The three here are *The Denial of St Peter*, *The Blind Hurdy-Gurdy Player* and this picture, which is generally known as *The Dream of St Joseph*.

Curiously, when these pictures were given to the city of Nantes Georges de la Tour was not even known to have existed, and how three of his paintings came to be in the same collection remains an intriguing but unsolved mystery. It was not until World War I that de la Tour's identity began to emerge. Gradually since that time, more and more pictures have been found to be by him – there are now thirty-eight: one was identified by a French prisoner-of-war in Germany, another at Hampton Court, another quite recently in a museum store-room in the North of England. It is an extraordinary detective story, and what is particularly remarkable about it is that he is such a major artist, responsible for some of the most moving pictures ever painted.

*The Dream of St Joseph* is actually signed, G. de la Tour; dimly but quite distinct. A signature nobody apparently bothered to read properly for centuries, or else they attributed the picture to various minor painters who happened to have the name de la Tour. And almost as many interpretations have been given to the picture as attributions.

An old man has been reading a book by candlelight and has fallen asleep. A child – a beautiful child – has approached, and is touching him on the wrist to wake him up. His eyes are just beginning to open, and so is his mouth, as if he is muttering something incoherent.

It is not clear what the child is telling him, though the radiant expression suggests it must be good news. An elegant hand is beckoning, perhaps offering something. Maybe the child is simply saying 'Wake up Grandpa, it's supper-time.' And on this level the picture works perfectly well. So-called *genre* pictures of homely domestic scenes were fashionable in seventeenth-century France. But the picture is so intense, a point of focus for such powerful

De la Tour, *Christ with Joseph in the Carpenter's Shop*

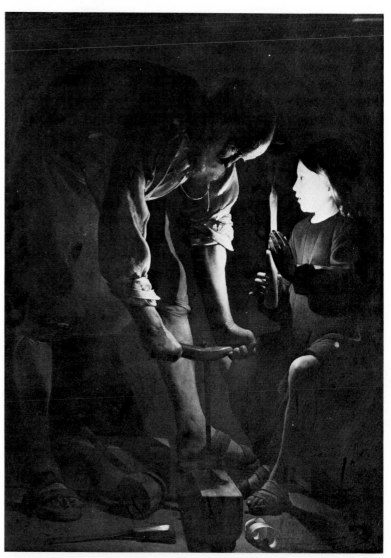

De la Tour, *The Adoration of the Shepherds*

feelings, that a mere call to supper seems less than adequate.

What identifies the scene is the existence in Paris of another painting also identified as by de la Tour, in which the artist has apparently used the same two models. There can be no doubt about the subject of the painting – *Christ with Joseph in the Carpenter's Shop*. What is more, also in Paris there is yet another de la Tour which is obviously *The Adoration of the Shepherds*. Again, it would seem, the same old man is St Joseph.

So, we can be pretty sure that the old man in the Nantes painting is St Joseph. And if he is asleep and dreaming as he appears to be, the only dream of Joseph that fits the mood of joy and solemnity is surely the appearance to him of an angel announcing that his wife Mary will bear the Son of God, from Matthew's Gospel. Remember, Matthew has just described how Joseph wanted to 'put her away', he says, for carrying a child that is not his. It is joyful news, then, to a deeply unhappy man.

With de la Tour, as with his contemporary Rembrandt, the distinction between religious and secular painting is unclear – deliberately so. We are supposed to read this picture on two levels, and to feel that one meaning enhances the other. So this is an angel but it is also a much-loved child, very likely de la Tour's own child: we know he had many. Maybe it is through our own experience of parenthood that the picture reaches us; just as our experience of that special grandparent/grandchild relationship helps give the picture its particular tenderness.

The magic of this painting lies in the way de la Tour has treated his theme. For instance, both figures, the angel and St Joseph, have their mouths open as though they are speaking. Obviously in a picture you cannot hear what people are saying, but sometimes you can imagine, or lip-read: you *know* what they are saying. Here you cannot, because he has chosen a moment of silence – silence either before or just after speech.

All the poignancy of this relationship is expressed in a single action, the gesture of touching. The faintest thread of light seems to carry the angel's message along the arm and fingers, to Joseph's wrist, hand, and his face cupped in it, to his brain; so that in his dream he will look across the candle and see that other hand, more strongly lit, gesturing him to rise and go to his wife, Mary. The entire picture is a mime of gestures and facial expressions, conducted in a darkened room – like a darkened stage – lit by a single candle, half-hidden.

The shielded candle is a favourite motif of de la Tour. Instead of the eye focusing on the naked flame, it is led to whatever the flame emphasises. The candle is an inquisitor in the dark. (It is a dramatic device he took from the Italian master Caravaggio, though in no other respect are they alike.) Light floods the face of the angel, who of course *is* light: the truth. And by the same symbolism Joseph is only parly lit. In his dream he is being led from ignorance towards the truth.

I keep returning to this bewitching hand. How elegant and delicate it is, and yet the longer you look at it the less it seems to be flesh and blood, but a gesture made with light and shadow. The hand is a kind

Detail of Joseph's head, *The Adoration of the Shepherds*

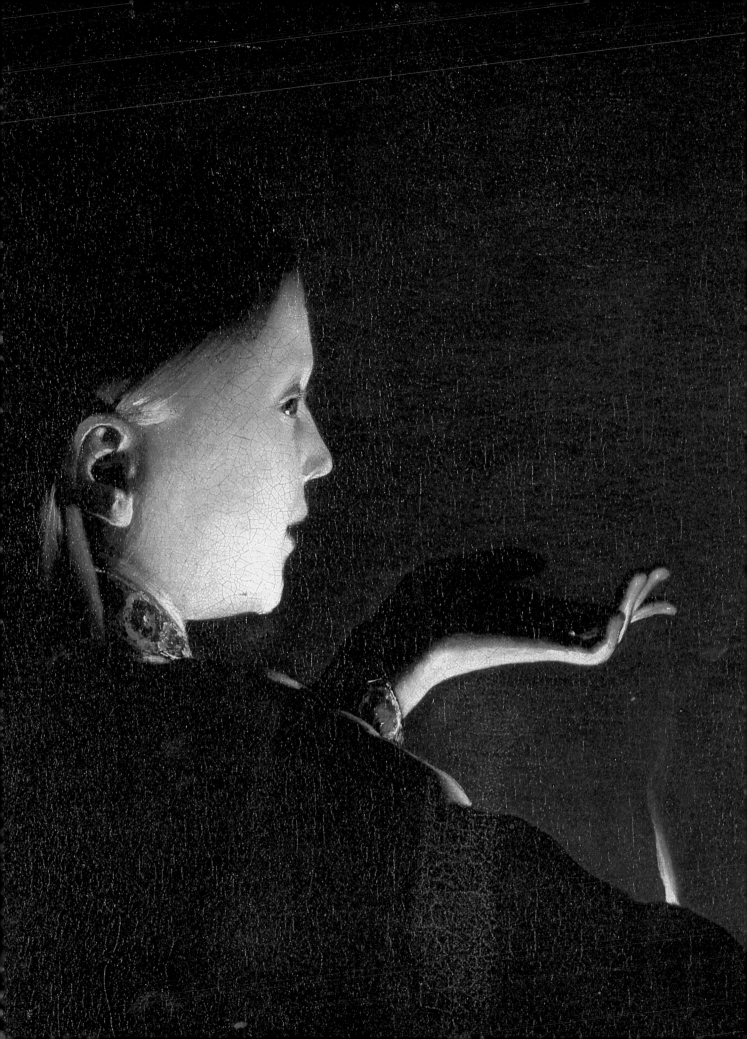

of object brought to life by the candle, just as the angel's scarf has come to life in a cascade of golden drops such as Vermeer was to paint some twenty years later. So too has the book Joseph has been reading: it is soaked in light like a stained-glass window. Even the candle-snuffer glitters, its shadow on the table as substantial as the object itself. And this rich golden sleeve of Joseph, it might have been carved in alabaster. And the splash of red band against the burnt sienna tunic: such a rich sense of the texture and colour of objects.

An ordinary painter of still-life makes objects look real, and that is all. A great still-life painter understands the relationship between objects and the people who use them. A man who holds a book, or a child a candle, in a painting becomes as much an object as the thing he holds; while the object comes to life as an extension of him. This is another facet of de la Tour's magic. He does not give us a snapshot, a chance incident frozen in time. He employs light extremely carefully to harmonise every detail as though each were an instrument in an orchestra.

I wonder why it has taken the present age to discover de la Tour. Maybe it is only the age of electricity that can be fully aware of the intimacy of candlelight: when everything was lit by candles or lamps no one thought about it. It is also, I believe, that the art of the twentieth century has led us to respect what a painting feels like rather than what it stands for, and to respond therefore to the resonance of very simple statements – like a picture about touch.

*Opposite* Detail of the Angel, *The Dream of St. Joseph*

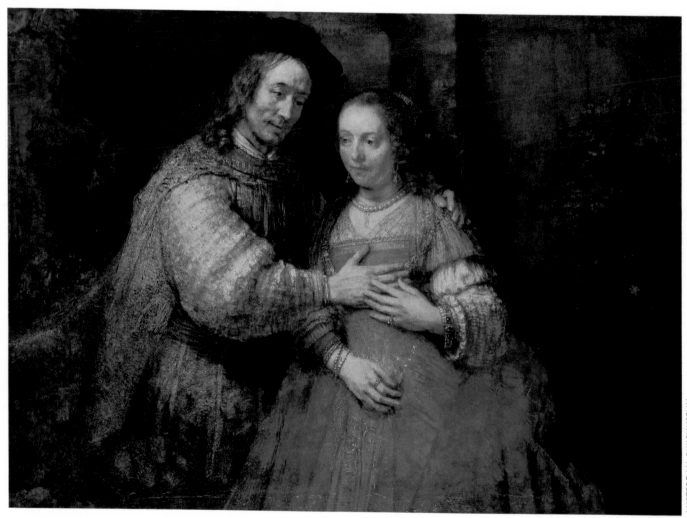

DAVID PIPER

# Rembrandt 1606–69

# The Jewish Bride (The Loving Couple) 1666

It is Rembrandt's late paintings, from the last decade of his life in the 1660s, that seem more and more to haunt our late twentieth-century imagination. They probably did not appeal all that much to more polished taste in Holland at the time. That texture, that troubled surface of worked and worried paint, that often unfinished look. The enigma, the mystery – all this now fascinates us. As the Impressionists were later to warn their public, so Rembrandt warned his not to get too close. 'The smell of paint might make you sick,' he said, no doubt ironically. This painting is one of the most magical of all. Officially known now I think as *The Loving Couple*, but better known as *The Jewish Bride*, in fact, it has also been called the greatest painting in the world, and in some moods I would go along with that.

Yet it is very simple, in essence. So simple, as you can see: a loving couple indeed. A man and a woman. 'Embracing' is how they are described. But that is too vague a word, and though not ungentle, it is almost too gross a term for this encounter.

When you see *The Jewish Bride* in the flesh, you find the paint alight, even if it is not precisely bright. The light does seem to be within the paint. There is a kindling of colour, a radiance that modulates right through the background, and becomes almost ablaze in the luminous reds of the woman's skirt, the olive green of the man's sleeve running liquid gold.

The focus of interest is concentrated in a rough circle just to the left of the centre of the painting. The two faces, the sleeve, the dress and, above all almost, those three hands so eloquently deployed on the woman's body. Yet they are not particularly elegant or well bred or delicate hands. The girl's hands, her right one anyway, the lower one, seems almost clumsy. His right hand rests on her breast, very lightly. The finger tips of her left hand just touch his hand, and *that* gesture is precisely as delicate yet as elemental as any gesture of human emotion that any painter has ever painted. You may hear people sigh in front of this picture.

A bridal couple: it seems fairly obvious, yet in the nineteenth century at one point they were described as a father decorating his daughter, a bride to be, with a necklace. It was probably darkened then with old varnish, but even so! If you look at the faces, they are young people, unflattered, not particularly handsome in any

257

fashionable sense, but young even if, as I guess, he is a bit older than she, which would be quite normal. Their expression is of love, giving and receiving, a tranquillity of complete confidence, in which melancholy and the most serene joy are inextricable. They don't look at each other. They don't need to. As even in the closest love, they know they are apart while they know they are together, and in this painting for ever, as long as the paint holds, they are together.

Together in a mysterious world of glowing colour. On a terrace possibly. There is a flowering shrub, a little ghostly, on the right – that may or may not be symbolic. And though he is obviously not her father, the man is indeed decking her with jewels, a gold necklace. Her jewels are extraordinary. Those great lustrous globules at her neck. Pearls – can they be real? Did they have artificial ones then? She has rich ear-rings, rings on her fingers, bracelets. And so even if you are not expert in seventeenth-century costume, you realise the costume, the costumes of both of them, are not everyday but verge on fancy dress, on the fantastic. There is an exotic, even an oriental flavour. The light catches the rich texture of the cloths as if they were gold. Or perhaps more specifically there is a biblical reference.

Detail of the couple, *The Jewish Bride*

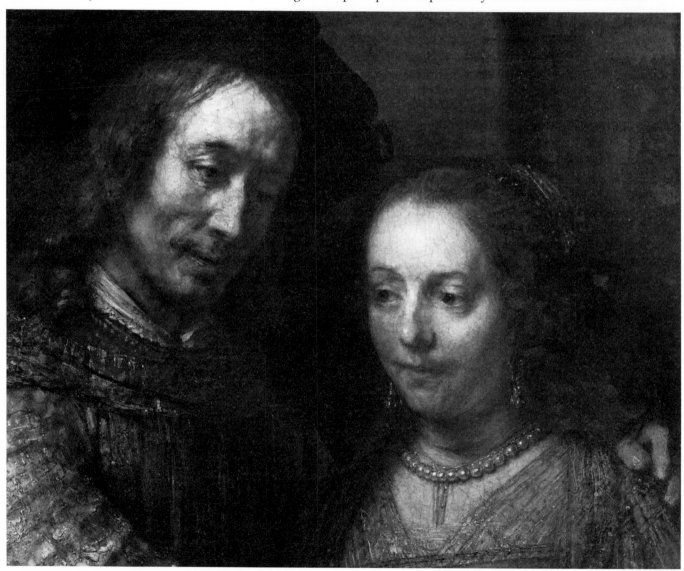

And what *are* they doing? For that matter, *who* are they? You have only to look at their faces to know they are real people, drawn from the life. They may indeed be just a young couple whose names we no longer know, who commissioned Rembrandt to paint their portrait at the time of their marriage: a wedding portrait transposed into a heightened key not only by the genius of Rembrandt's paint, but by being dressed up as Rembrandt loved to do with his sitters (not excluding himself) all his life long.

On the other hand, they could be models posing for a subject picture commissioned by another client. Various biblical subjects have been suggested: Ruth and Boaz, but no hint of alien corn here; Tobias and Sarah from the Apocalypse, one of Rembrandt's favourite sources; Esther and Ahasuerus; or Isaac and Rebecca – the greatest of recent Rembrandt scholars, Horst Gerson, used to call it firmly Isaac and Rebecca.

In the Vatican at Rome, in the apartments called the Logge, one of the decorations designed by Raphael is of Isaac and Rebecca. There the two are locked in closer embrace, but with Abimelech spying on them from above. They are seated, on a bench, with a fountain

Raphael, *Isaac, Rebecca and Abimelech*

playing, and an X-ray of *The Jewish Bride* has shown that Rembrandt's first idea was to have his couple seated rather than standing, or almost floating, as they are now.

There is further a Rembrandt drawing that is related, and it can be plausibly interpreted as an intermediate stage between *The Jewish Bride* and a half- or subconscious memory of Raphael's design, perhaps via an engraving of it. In the drawing Rembrandt seems to be searching, almost groping, in that exploratory scribbling that indicates the hands, groping towards the final perfect definition that he was to achieve in the painting. Abimelech has almost vanished already, a wild squiggle floating above the couple, while the fountain (on the right) seems well on the way to its metamorphosis into a flowering shrub.

But there are other candidates still: Jacob and Rachel. There's a strong iconographical tradition of their embrace going right back to

259

Hugo van der Goes, *Jacob and Rachel*, drawing

*The Tetrarchs* from San Marco, Venice (porphyry);
*opposite* detail, *The Jewish Bride*

the fifteenth century, as in a beautiful drawing by Hugo van der Goes at Christ Church, Oxford. You find it recurring again in a rather dull prosaic version in a painting by a contemporary of Rembrandt's, called Dirck Saatvoort. And then again the basic theme, of lovers embracing, seems to have Venetian echoes, as Kenneth Clark has underlined. It is a theme that persists from the famous group of the Four Tetrarchs at San Marco in Venice, that some date as early as AD 300. That is taken up in the dreamy idylls and those of his followers. And the format of Rembrandt's painting, those frontal three-quarter lengths, and of course the radiance of colour, recalls Venice.

But none of that begins to explain Rembrandt's achievement. It was a common enough convention, even amongst the smoothest of society portrait painters, to dress their sitters in mythological or pastoral gear, as gods or goddesses, shepherds or swains or Roman heroes, so flattering the sitter by equating them with heroes or divinities. Rembrandt almost does it the other way round: flattering fictional gods or mythical heroes or biblical characters by revealing them as real human beings.

The painting is a celebration of young love. The wonder of innocent sensuality has never been more touchingly conveyed. Touchingly, by that gesture, his hand on her breast, her fingers resting light as a butterfly on his hand. There is this combination of certainty and diffidence, of shyness and absolute awareness, a revelation shot through with awe. No other painter has ever managed so to evoke the spiritual within the physical. Rembrandt breaks the body down, and then in the coarse medium of ground pigments in oil, with brush and palette knife, with the blunt end of the brush, with fingers and thumb if need be, re-creates it, building it like a coloured lantern with the spirit alight in human flesh. By portraying the individual so faithfully, Rembrandt transcends individuality. After van Gogh saw this painting for the first time, he wrote of a 'glimpse of a superhuman infinite'. Neither will you find a better image for that vow in the marriage service: 'for better or for worse'.

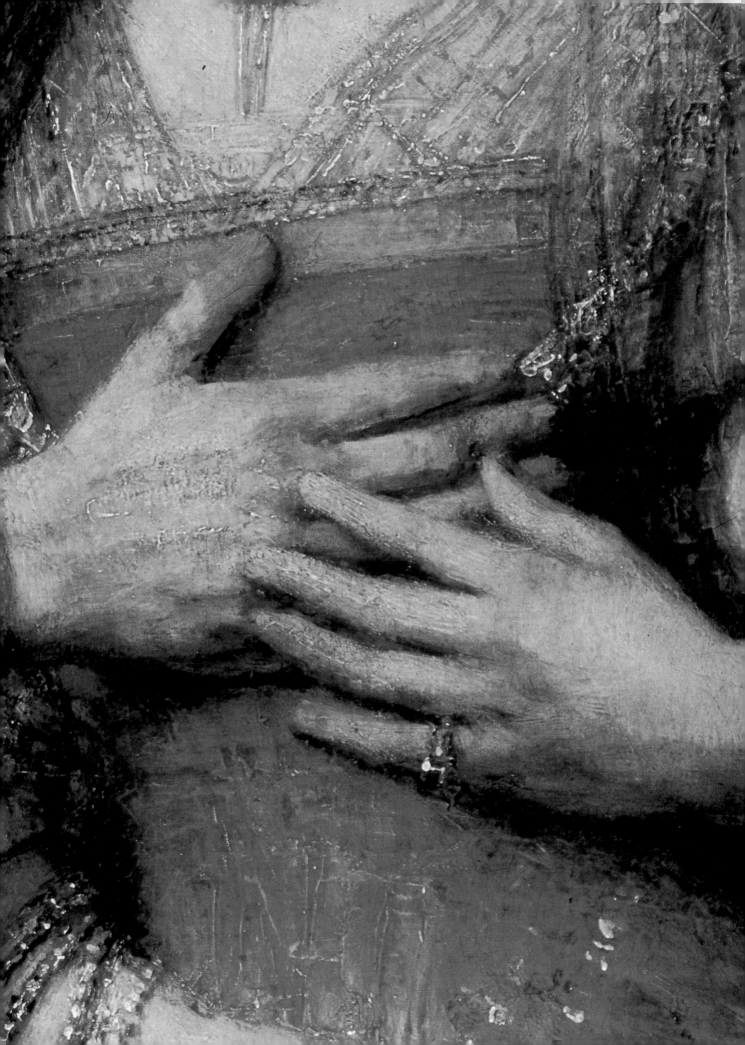

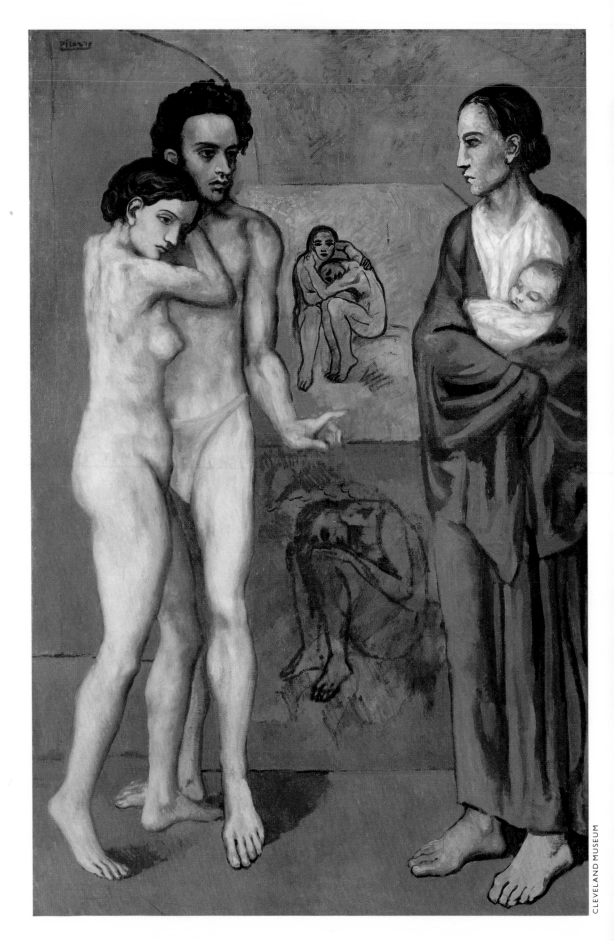

MILTON BROWN

# Picasso 1881–1973

# La Vie 1903–4

*La Vie* is a story picture; it is also a problem picture, and a rather cryptic one at that. Perhaps it is even indecipherable.

You may be struck at first that it is not in any of the by now recognisable avant-garde, modernist, somewhat abstract styles we have come to associate with Picasso, and which, of course, have raised entirely different problems of interpretation. *La Vie* is in fact a very early painting, done in 1903–4, in many ways the most consummate and ambitious work of Picasso's so-called Blue Period, which began in late 1901 and which is the first of the identifiable personal styles of his long and illustrious career.

Picasso's very earliest manner, preceding the Blue Period, was derivative, borrowing from Daumier, Steinlen and Toulouse-Lautrec. When he came to Paris for the first time as a precocious youngster, he was already painting subjects like *Le Moulin de la Galette*, urban genre scenes that had become quite common among late nineteenth-century artists: a mixture of Bohemian and pro-letarian life in the streets, parks, cafés, and other places of public or private entertainment, all of it seen with high-pitched vitality, mordant wit, or rather obvious pathos. It was a realistic, tough, sometimes bawdy secular art, responsive to *fin-de-siècle* social consciousness.

However, within a short time, late in 1901, Picasso's style changed dramatically, though not entirely without forewarning. It shifted from the secular to the spiritual, from the erotic to the ascetic, from the real to the symbolic, from the contemporary to the timeless. His strident colour gave way to a monochromatic blue, evoking a mood of doom and gloom. Picasso had become, somewhat belatedly, a Symbolist, his style a mannered asceticism, its roots deep in medieval Spanish art, but especially in the art of El Greco.

From describing the gregarious activities of urban life, Picasso turned to the lonely and resigned melancholy of the dispossessed, the derelicts, the homeless, the blind. The single or paired figures are largely stripped of identity, existing in timeless space. They are not so much representations of people suffering poverty, hunger and alienation, as symbols of those conditions. They are removed from reality and transformed into elegantly emaciated beings, spiri-tualised images of human misery, bordering at times on sentimental

Sketches for *La Vie*

morbidity. The transcendent anguish of *The Old Guitarist* has a close affinity with the religious ecstasy of an El Greco saint.

Picasso may have been translating his own struggles, his abject poverty, his uncertainty, his awareness of the alienation of the artist, into symbolic and artistic terms. It was a very serious, harsh and pessimistic art, as only that of a very young man could be. That it was also somewhat self-pitying indicates how young he was.

*La Vie* was painted toward the end of the Blue Period and is in many ways the culmination of that phase, before he moved on to the more lyrical and self-consciously aesthetic Rose Period, which evolved about 1905. *La Vie* is more complex and programmatic than the usual, almost simplistic images of the Blue Period, clearly an allegorical painting, and a very personal one.

From its title it is obviously a philosophic comment on life and, from even cursory observation, on the relation between the sexes and, perhaps, on love. The scene includes a nude couple, the woman seeking protection in the embrace of the man, who looks and points, in a rather mannered gesture, toward a clothed woman holding a child. In the background are two pictures of figures in tragic poses. The upper is of two nudes (incidentally, of indeterminate sex) embracing each other despairingly, and the lower, of a single nude bent over in the grip of some unnamed sorrow. The inference is strong that this is an artist's studio, though, as in all Blue Period paintings, paraphernalia and environment are eliminated. In preliminary studies one of the pictures is shown on an easel. It is possible to infer also that the man is the artist, though it has been suggested that the two nude figures are models. However, in a similar study, the man's head is recognisably a portrait of Picasso himself.

Who are the women, and what is the man's relationship to them? Are the women the artist's model and his wife and child? Are they embodiments of sacred and profane love? Or are they the same person at different stages in time? The enigma remains.

But, then, Symbolist artists were not interested in answers, only questions. Philosophical paintings of this sort were quite common. Gauguin's great canvas, *Where do we come from, What are we, Where are we going?*, painted in 1898, comes immediately to mind, for Picasso at that time was evidently influenced by Gauguin, who had just died in 1903. Perhaps even more pertinent is Edvard Munch's *Dance of Life* of 1899, with its essentially pessimistic view of the relation of the sexes, echoed in Picasso's own ambivalent attitudes toward women.

Picasso offers no help toward deciphering his intentions and feelings in *La Vie*. Besides stripping the scene of environmental clues, he presents two figures nude, and the woman with the child as wearing a curiously undatable garment, certainly not contemporary, but (like others of the Blue Period) reminiscent of the Madonna in medieval and Renaissance religious painting.

Disconcerting also are the unfocused gazes. The nude woman looks blankly outward and deeply into herself. The man points at the clothed woman, but seems to be looking beyond her. And she in turn looks sternly, even accusingly, but also not directly at the nude couple. Perhaps they are not to be seen as people in a situation from

Preparatory drawings for *La Vie*

life, but as symbols in a philosophical proposition. Or is the painting an example of that Symbolist reticence toward precision in meaning, allowing the relevant elements to be read personally and variously? There is no question, however, that life is fraught. Tragedy lies heavy over all.

Picasso returns in *La Vie* to an earlier incident in his life which apparently continued to haunt him. When he first came to Paris in October 1900 it was with his very close friend, Carlos Casagemas, a painter and poet who shared a studio with him on the Boulevard de Clichy. Unfortunately Casagemas fell in love with disastrous consequences and, deep in depression, attempted suicide. In an effort to help, Picasso went home with him around Christmas, but to no avail.

*Above* sketch for *The Death of Casagemas*; *below* *Death of Casagemas*

Casagemas returned to Paris by himself, tried unsuccessfully to shoot the woman and then killed himself. Picasso learned of the tragedy while still in Spain, and on his return to Paris in 1901 became so involved in the episode that he began a series of posthumous portraits and studies, culminating in the large *Burial of Casagemas*. One might imagine that this would have assuaged the memory or exorcised any guilt he may have felt about the incident. But then, in 1903, back in Barcelona, in the same studio he had once shared with Casagemas, the memory of his dead friend returned to haunt him. The head of the man in *La Vie* is that of Casagemas, although earlier studies for the painting indicate that Picasso had intended it to be himself.

267

It would seem that Picasso identified his own tortuous relation-ships with women with the Casagemas affair, though there was no similarity. At that time, at least, Picasso saw the relationship of the sexes as an irreconcilable dilemma and love as a tragic experience. *La Vie* is the youthful masterpiece of a great artist, overwrought, turgid, not entirely convincing, yet stated with such passion and conviction that one cannot forget it.

# BATHING

Throughout much of the history of western painting stories from the Bible and from classical literature have supplied a pretext for displaying the naked female form: indeed anyone acquainted with the Bible and with Greek myths only through art might conclude that women did little else but bathe and lie around nude. Susanna, Bathsheba, the goddess Diana: they have acquired a fame through painting which they would not have known if legend had left them clothed. And European painting would have been greatly the poorer if it had.

The Venetian tradition of the nude is unsurpassed in richness and sophistication, and it is represented here by one of its last practitioners in the early eighteenth-century, Sebastiano Ricci. His *Bathsheba Bathing* is typical of that tradition above all in the grace and decorum of the picture – qualities that manage to transcend the disreputable story as reported in the Book of Samuel, and ensure that she remains, for all her nakedness, inviolable.

This classical and biblical pretext remained in force right into the nineteenth century, when motifs taken more directly from contemporary life began increasingly to find their way into painting. In his *Turkish Bath* Ingres introduced fresh material that was certainly contemporary – at least in the artist's imagination: he fused an exotic harem scene with the classical theme of bathers which had been his preoccupation for more than fifty years.

Perhaps the first major artist to omit all reference to that classical tradition was Degas later in the nineteenth-century. His *Woman in the Tub* is one of a marvellous series he painted of women at their toilet. They are represented in purely domestic terms; they bathe simply in order to wash their bodies, not to disport themselves for the delight of painter or patron.

Yet the classical tradition survived the naturalism of nineteenth-century Impressionism: it even acquired a fresh lease of life. Cézanne's *Baigneuses*, painted at the turn of the century, represents a new kind of classicism in which the ideal of beauty no longer resides in the perfection of individual form – far from it! – but in the architectural harmony these bathing figures create as a group. Matisse, in his *Bathers by a River* of 1916/17, is concerned even less with perfection of individual form: there is virtually no interest in women as women, whether idealised or domesticated. They are impersonal monuments in a landscape simplified as severely as the artist dared without actually losing touch with life.

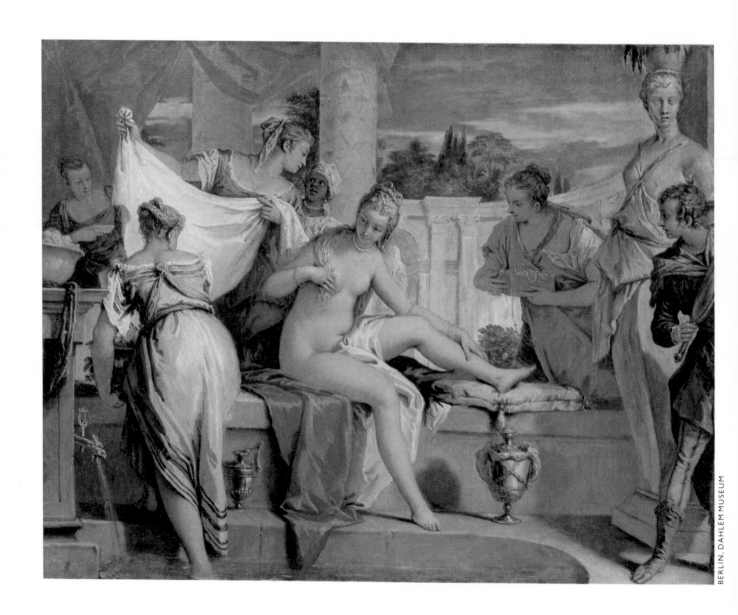

270

JOHN HALE

# Sebastiano Ricci 1659–1734
# Bathsheba Bathing c. 1720

Of all the ancestors of Christ, King Solomon, divinely inspired, wise and wealthy, is the most impressive. He built the temple sacred alike to Jews and members of the Masonic Order. The biblical Book of Proverbs was ascribed to him. Jesus himself told how the Queen of Sheba 'came from the utmost parts of the earth to hear the wisdom of Solomon', and referred to his riches in the Sermon on the Mount: 'Consider the lilies of the field . . . even Solomon in all his glory was not arrayed like one of these.' Yet instead of portraying this supremely Establishment figure, painters have preferred to look at his mother.

Forgetting the Bible for a moment, what is Ricci showing us in this painting of about 1720? A young woman, pleasingly past the skinniness of absolute youth, has had a bath and is facing the delicious task of deciding what to wear and what will best go with it. Clearly she is rich, with deferential maids and with space enough to enjoy the seclusion of a pillared bathing kiosk within an enclosed garden.

The whole scene radiates a sense of leisure, luxury and sophisticated decorum: just the qualities appreciated by Ricci's aristocratic patrons, whether the English Lord Burlington or the German Emperor Joseph. And its colour glows in the warm, late-afternoon light of that marvellous Indian summer of the Renaissance, when painters looked back for their models – this was once catalogued as a Veronese – but with an airiness and a fragile verve that anticipated a new style, the Rococo.

It is so prettily assured, so ravishingly unimportant that it seems almost vulgar to ask, 'Is there more here than meets the eye?' Yet this is Bathsheba, a figure potent in the imagination of artists from the illuminators of medieval manuscripts to Picasso; the protagonist in one of the most dramatic of all Biblical *causes célèbres*. And Ricci, who painted for altars as well as boudoirs, who designed sets for theatres clamorous with moral issues, and whose own temperament twice involved flight from the death penalty for sexual offences (one involving an attempt to poison a pregnant mistress), was well aware of it. The story of Bathsheba had a moral twist to it – and he brings in a youth carrying that well-known symbol of vanity, a mirror. It also has a scandalous narrative interest – so, on the other side, he

271

introduces a messenger carrying a letter. We are bidden to think as well as look.

David, the slayer of Goliath, has become King of Israel. His army is off fighting the Ammonites. His harem bores him. Time hangs heavily in Jerusalem. One evening he climbs to the roof of his palace and looking out, he sees a woman bathing. He is captivated. Who is she? Bathsheba, he is told; married, but her husband, Uriah, is away with the army. David sends a messenger from a king to a woman wondering what to wear on an empty evening. She comes, sleeps with him, tells him later on she is pregnant. David panics. He summons Uriah on the pretence that he needs news of the army, but really so that he will make love to his wife: a bit of fudging of dates and all will be well. But Uriah is a man of principle. He spends the night on the ground outside the palace. And when David asks why, he most inconveniently replies: 'The ark, and Israel, and Judah, abide in tents, and my lord Joab [David's general] and the servants of my lord are encamped in the open field; shall I then go into mine house, to eat and drink, and to lie with my wife?' Baffled, David sends him back with a letter to Joab. Send an assault party against the city of the Ammonites, he wrote, and 'set ye Uriah in the forefront of the hottest battle, and retire ye from him, that he may be smitten, and die.' Joab obeyed, and Uriah was killed under the walls. So Bathsheba was free to become David's wife.

The breathtaking cynicism of this story is then qualified: it comes, after all, from the pages not of Balzac but the Bible. Reprimanded by God through the prophet Nathan, David repents, pays for his sin with the death of his and Bathsheba's bastard, and goes on to father on her the sage and potent Solomon.

It could be read, then, as an anticipation of the Catholic doctrine of confession: contrition for sin, penance, forgiveness. Or, at a more commonplace level, as demonstrating the corrupting power of female sexuality even when glimpsed – as in another painting by Ricci – from afar, almost entirely in the imagination.

Or, given the habit of seeing episodes in the Old Testament as foreshadowing the New, it could be read as Christ (David) seeking out in love the Church (Bathsheba) which would ensure the transmission of his teaching to posterity. There is something of this in Veronese's own, very serious treatment of the subject in the Musée des Beaux-Arts, Lyon. The bathing element here is played down to a dribble on a finger-tip. The main emphasis is on David's messenger, no furtive girl go-between but a man of prophet-like dignity. Will she forsake, not a mere husband, but the paganism symbolised by the male nude on the fountain? If she does (and she will) she becomes not just David's concubine but Ecclesia, the Church, the Bride of Christ.

The pillars, the classical enclosed garden, the weight of the composition lying on the left: Ricci must have known this painting by the artist he most revered. But lighter in mind and touch, he preferred anecdote to narrative, an uncovered body to a veiled doctrine. So did Rembrandt, who died when Ricci was still a boy. But in a picture by which all other representations of the Bathsheba story must be measured – his *Bathsheba* in the Louvre – Rembrandt chose a different moment. She has taken the letter from the messenger. Save

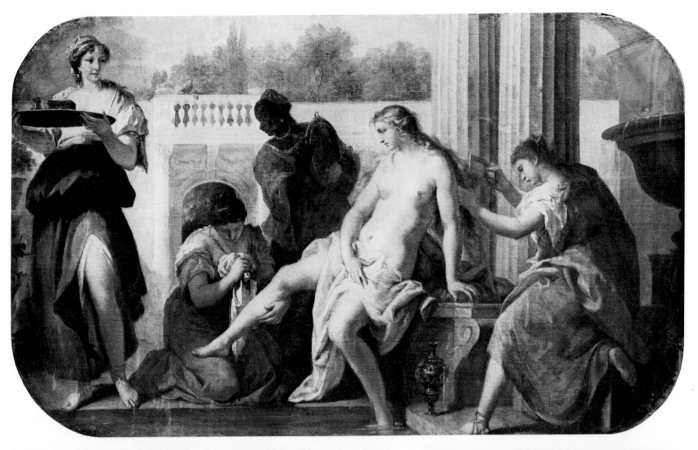

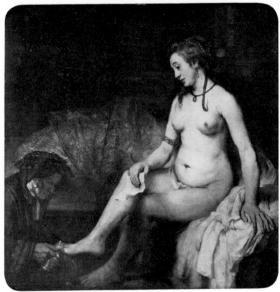

*Top* Ricci, *Bathsheba*;
*left* Veronese, *Bathsheba and David's Messenger*;
*above* Rembrandt, *Bathsheba*

for one crone-like attendant she is alone. She knows, because
Rembrandt knew, because everyone then knew, what her decision
could entail: a treacherous death for her own husband, a choice to
join the blood line that would lead to the Virgin's husband, Joseph.

And she ponders, played upon by the light of so many centuries of knowledge and interpretation that it is Rembrandt's humane triumph that he can compel us to sympathise with, indeed wait for her choice.

We can see just how familiar the story was, how the barest of references could call it to mind, from another Dutch painting, *Bathsheba with David's letter*, this time by Jan Steen, who died when Ricci was twenty. A handsome young bourgeoise has let an old woman into her bedroom and has taken a letter from her. Apparently yet another illicit love affair is going to get under way in the Calvinist society of Delft or The Hague. Beautifully painted it is, all the same, a fairly trivial *genre* scene, with perhaps a nod towards some routine proverb of the love-laughs-at-locksmiths variety. But because we know the story we pause long enough to read the address on the letter. Sure enough it is inscribed 'To the beautiful Bathsheba', and now we see why the building glimpsed through the open doors is so un-Dutch: it is the palace where King David waits for an answer.

Looking again at Ricci's painting, which contains so few clues to the bather's identity that it was once labelled '*Toilette of Venus*', we can explain another aspect of its effect on us. His patron wanted a naked lady to look at. But convention demanded that nudes should not be shown for their own sake; there had to be some mythological or biblical justification. And this is why, for all the charm of her expression, the grace and softness of her breasts and belly and legs, she is not, and the painter does not try to make her, an object of desire. Ricci may have been a Don Juan, his patron a lecher, but Bathsheba, though so near and so exposed, cannot be raped by sexual fantasies, she is safe within the sacred resonance of her story.

*Opposite* detail of attendants, *Bathsheba Bathing*

275

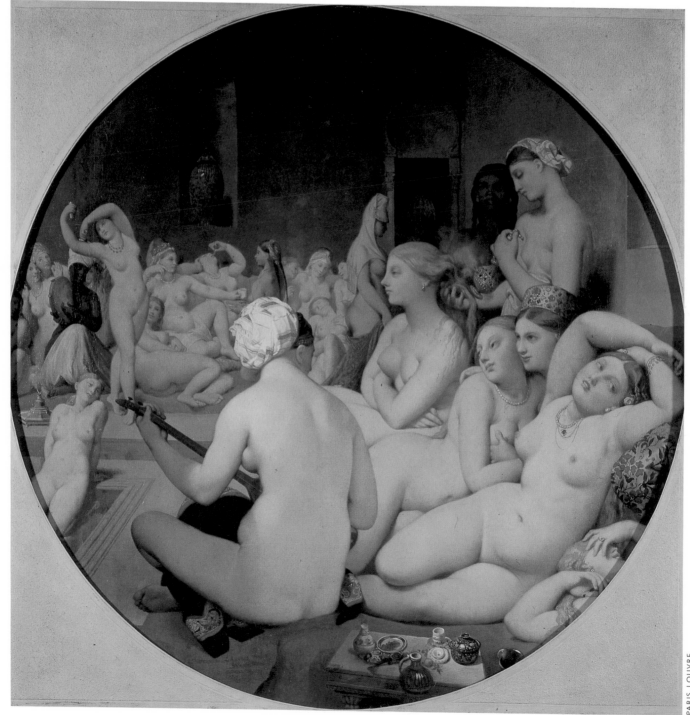

# Ingres 1780–1867

# The Turkish Bath 1862

A shameless picture. A picture capable of embarrassing even the most fervent admirers of the great establishment figure who painted it, in 1862: Jean Auguste Dominique Ingres, Professor at the Ecole des Beaux-Arts, member of the Institut de France, Senator, and Grand Cross of the Legion of Honour.

This notable person had his fantasies, like the rest of us. But more important than that, he loved women, and sexual fantasies are not always based on love. His whole work is informed by a serious appreciation, a *considered* appreciation, of a woman's looks, her moods, her elegance, her sophistication, and her accessibility.

As befits the last great representative of the academic tradition of painting in France, Ingres had an authoritarian type of character – this is apparent in the sort of advice he gave to his pupils, who were numerous. When he wanted them to stop looking at the early Florentine masters and concentrate on Raphael, he pronounced, 'Those gentlemen are in Florence, and I am in Rome. You understand, Messieurs, I am in Rome.' People were terrified of him. The more sophisticated of his contemporaries, like his great rival Delacroix, laughed at his pomposity. Delacroix rather spitefully considered Ingres to be dimwitted and called his painting 'the complete expression of an incomplete intelligence'.

This is wrong. Pompous Ingres may have been; awe-inspiring he probably was; bossy perhaps; but above all very, very clever. It was the sort of cleverness that takes in everything at a glance and then patiently works it out in terms of composition. For example, his painting of Mme Panckouke (in the Louvre) shows a wit: you can see it in the quirkiness of the lines and attitudes. Mme Marcotte (also in the Louvre) is a hypochondriac: you can see it in the stuffiness of her colours, and the elaborate and exhausting contours of her dress and hair.

So the painter is a man who loves women, who is clever with them, who is also serious and important. He is one more thing. He is innocent. He is totally respectable. Then how, at the very respectable age of eighty-two, did he come to paint so shameless a picture as *The Turkish Bath*?

Naturally, some critics have said that at that age to fantasise in this way was about the only thing he could do. But this doesn't cover it.

*Top* Ingres, *Portrait of Mme Panckouke;*
*above* Ingres, *Portrait of Mme Marcotte de Sainte Marie*

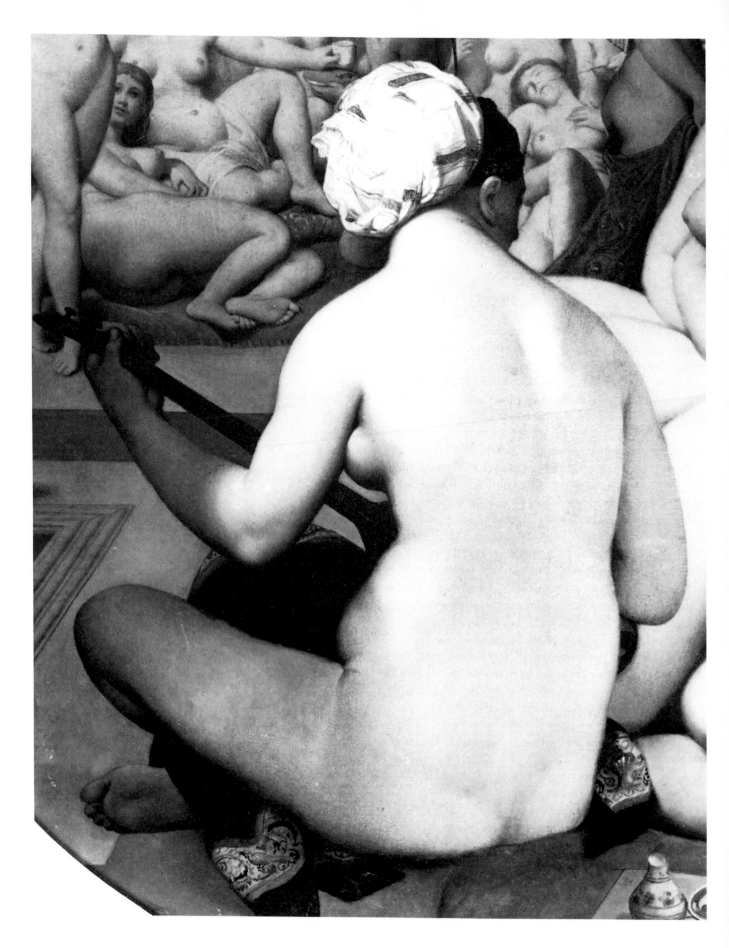

To have such appetites is a considerable attribute at any age. And in any case this is only one part of the story. The respectable side of the painting – its alibi, so to speak – is the fact that it has to do with the bathing figure, or *baigneuse*, which is not only a staple theme in European painting but a preoccupation with Ingres himself.

His first treatment of this theme, the *Valpinçon Baigneuse*, dates from 1808, more than fifty years earlier, and you can see that Ingres was so satisfied with his formulation of the figure that he retained it and restated it as an element in *The Turkish Bath*.

Onto the theme of the bather is grafted another theme – that of the harem. Like many men in the nineteenth century Ingres was fascinated by the idea of women just hanging around, in separate quarters, until needed. One of the few books he is known to have read was a translation of Lady Mary Wortley Montagu's account of her visit to the women's baths in Adrianople in 1717. And this is exactly what Ingres has painted: a group of women bathing in preparation for some erotic ritual.

Appropriately enough, it is a dense and steamy group of figures and one is very much aware of damp flesh. There is not much water to be seen: the bath is drained and even the perfume spray seems empty. The figures merge in what seems a timeless afternoon interlude. Few stand out. It is a very silent picture. There is dancing; there is conversation; but these details do not break the heavy brooding atmosphere. There are signs that the aged painter is tiring. Features tend to slide around the face. The little red and blue still life in the foreground is shaky and does not stand on anything. Above all,

*Opposite* detail of the *baigneuse*-figure; *left* detail of still-life, *The Turkish Bath*; *above* Ingres, *Valpinçon Baigneuse*

the most prominent figure, on the right, which is painted from a model, does not merge with the others. She of course is the most shameless element in the composition. There might have been another: the truncated lady in what would have been the corner if the picture were still square as originally planned. Ingres sacrificed her when he rounded off the canvas, in 1863.

This dense group of unrelated nudes gives out something more dreamy than a sense of erotic exhaustion or anticipation. The painter is aware that love is a serious business, and that even thoughts about it may tend to the melancholy. Many of these heads are very grave. They do not titillate. Some have the mistiness of uncertain perspective. Only the two foreground figures are seen in sharp focus, and they represent the two polarities of innocence and experience. The *baigneuse* figure, with her back to us, is as inviolable in 1862 as she was in the first painting of 1808. And the fully frontal nude, the *odalisque* figure, is unnervingly frank and straightforward.

What the painter so singularly lacks is a sense of time. At eighty-two, one would think, he should paint something more appropriate. The fact that he chooses to paint this particular subject is either shocking or heartening, depending of your point of view. His characters have not grown old along with him. The poet and critic Baudelaire, who was to die in early middle age in 1867, the same year in which Ingres died at eighty-seven, was aghast at this seemingly permanent youth and appetite, but wrote perceptively of the painter's sensuality, describing it as 'robust and nourishing as love in the days of the ancients'. This is a talent given to a few and not one we care to consider much these days.

And yet there is a poignancy here. We return to the little still life: those tiny cups and saucers, like a doll's tea-set, tell us that the painter's concentration is now only intermittent. Little patches of cushion and headdress, unabsorbed red and blue, are a half-hearted attempt to arrest the tendency to uniformity of colouring – even the different types of skin on the various figures are scarcely distinguished from one another.

The women's bath is a scene of mystery to the painter and it is a mystery which he intends to investigate. The ultimate outcome of all the preparations has no mystery for him at all – only erotic appreciation. But his sense of the ritual, of the closed world of women without men, is as sharp and as tantalising as ever. Maybe he feels that the ritual is a hidden one. Maybe that accounts for his hazy visualisation of the scene. For we must remember that he is very, very clever. And although the picture was acquired by the Turkish ambassador to Paris, who loved spicy subject matter, to Ingres it was anything but that. He has preferred rather to present the truth as he himself saw it: as a grave and dreamy preparation for the most serious of activities.

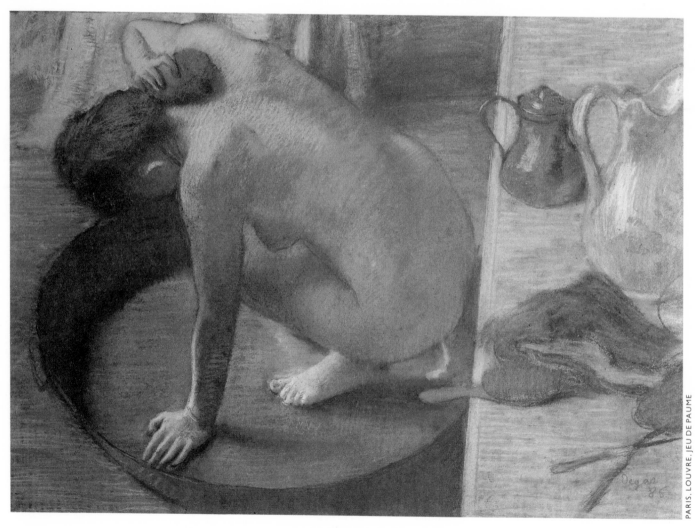

ALISTAIR SMITH

# Degas 1834–1917
# Woman in the Tub 1886

'The human animal, self-absorbed. . . . My women are simple, honest folk, concerned only with their physique. Here's one washing.'

She crouches in the shallow zinc bath, holding herself steady with one hand and sponging herself with the other. It is a chilly, uncomfortable way of washing. It lacks the luxury of the bath tub – *and* its hygiene. But then, needs must.

Another day. Coffee-pot, water-jug, scissors. Hair-brush at the ready. And her hair-piece flung down – lying on the dresser, half alive. It is an everyday scene. But it is not allowed to remain so. Every Monday morning has its magic. The girl becomes an unconscious model for the sunlight. Her hand, foot, slowly her whole body, glow like creamy marble. Her hair glints bronze and tempts the word 'Titianesque'.

The clutter is not so careless after all. The two jugs, more seductively curvaceous than their owner, trace out a graceful *art nouveau* rhythm. Brown and cream contrast and harmonise; rich and pure. The man who discovered this treasure amidst banality interjected his name in a blue of discreet contrast: *Degas*, and the date '86.

'Why did I never marry? Well I always feared that my wife might look at one of my pictures and say "Mm, that's pretty.". . . There's love and there's painting. And we've only got one heart.'

Nothing in life excited Degas more than paintings. When he wasn't himself working, most likely he would be scouring the Parisian dealers trying to exchange one of his own pictures for a Delacroix, or arranging the purchase of a Corot. On one occasion he bought not one picture by Ingres, but two – which practically cleaned him out. 'I will die in the poorhouse,' he is supposed to have said, 'but I want to give them to my homeland; and then go and look at them and think how noble I've been.' Pictures from Degas's collection are now on the walls of the Louvre and I think that he would be happy to know that some of his own works hang upstairs in the same gallery.

Degas loved the Louvre. His parents took him there on Sundays when he was small, and, while his brother played slides on the polished floors, he used to examine the paintings. For him it was a place of excitement and confrontation. Some of its paintings he copied in homage. For instance a *Crucifixion* by Andrea Mantegna, the fifteenth-century Italian master, and a pair of Venetian dandies,

first painted by Gentile Bellini. Here in the Louvre he developed a great love of the art of the past – and he was always ready to point to the deficiencies of some of the moderns when compared with the older masters. Renoir, he described as 'a cat playing with balls of coloured wool'.

It was this acid, witty tongue which kept the world at bay. Because of it, Degas' friends were few. His cynicism veiled a natural reserve, which insulated him even more effectively from women than men. Perhaps his only close female friend was Mary Cassatt, an American of French descent whom he coached in drawing. They would promenade along the galleries of the Louvre. Degas was enchanted by 'Mlle Cassat' (as he called her) and for the first time he found himself forced to admire a female person: 'I can hardly believe that a woman can paint so well. . . . This is the best painting of the nineteenth century . . . the Infant Christ with his English nanny.'

Degas, nevertheless, seemed incapable of developing a relationship of real intimacy even with a woman who shared his love of painting. Although she worked regularly in his studio, there were times when they were estranged for months. And his words about her betray the distance of formality: 'this distinguished person, by whose friendship I am honoured.' The images he created around her, her umbrella and their study of art, show her as a public person in a public place – and chaperoned. Degas peeps at her from behind a column like a stranger.

The constituent missing from Degas' personal life came to form a major part of his professional life. According to what one might call Freud's law, it is only to be expected that an artist who lived without a female partner should make a special study of the female nude. Degas drew it again and again – and again. Were it not clear that he was obsessional first and foremost about creating images, one might suspect a sexual obsession – for he studied the nude from every angle, in every pose, in all different lights, making literally hundreds of studies.

What is most noticeable is his refusal to idealise his model in the conventional way. He does not convert her into a Venus; he does not paint her by a stream and call the result *La Source*. The only water his women know is in a jug or bath tub. Their natural habitat is not the hillsides of ancient Greece but the bedrooms of Montmartre.

Degas rejoiced in their unclassical qualities – the pertness, the upturned noses that would have made Ingres wince. And instead of arranging them in carefully balanced poses, based on the sculptures of the Louvre, he caught then unawares, whether nude or clothed, as if in a snapshot – yawning, scratching, at their most ungainly – in poses which display mindless unconsciousness; rapt concentration; the void, almost dream state that comes with being alone and doing something so banal as to be completely automatic. The artist who was a stranger to women captured this soul-baring intimacy as no husband could.

'It's the human animal busy with herself. Up to now the nude was always shown in poses which presuppose an observer. My women are simple folk, and honest; concerned only with their physique. *En voilà une autre.* Here's another one, washing her feet. It's as if you

Degas, *La Repasseuse* (*Woman Ironing*)

Degas, *Woman with Hat*

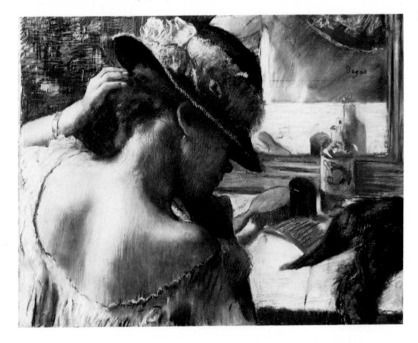

were looking through the key-hole.' The most amazing thing, of course, is that at the time he made all these studies Degas could actually see very little through a key-hole. From as early as the 1870s the light had started to pain his eyes. His condition gradually worsened. At times he was in depair at the prospect of eventual blindness; at others he battled bravely against his impaired sight. The extent of his vision varied from time to time, but from the 1880s onward it seems that he was at the very least prey to a large dark spot in the centre of his visual field. It required the utmost concentration

to draw what he could see around the periphery of this blot.

To counteract his increasing blindness Degas worked in techniques other than oil. Eventually, in his last years he had to rely on touch alone, and created a series of small wax figures; some were cast in bronze after his death. Between the early paintings and the late sculptures come vast numbers of works in pastel, a technique which achieves its results much quicker than oil. It is as if he wished to complete as much work as possible in case the dark came suddenly. Degas developed the pastel technique to virtuoso heights, working for the most part in delicate parallel lines or hatchings, the movement of the chalk recalling a prolonged gentle stroking. The chalks lent themselves to the subject – the soft, diffuse light of an interior and the inclines of the female body.

Degas' approaching blindness completed his rift with society, and with the real life of Paris. Forced to retreat more and more into the world of art, he worshipped the quotidian scene all the more – so much so that there was little need for him to idealise it. Anyone can close his eyes and visualise an ideal. It was just this type of blindness that Degas rejected, and he dedicated his life to recording, as quickly as he could, the essence of modern life and modern woman – anonymous, matter-of-fact, dulled by monotony. 'If I had been painting some years ago, I would have done Susannah in the bath: now it's girls in a tub.'

Degas, however, transformed his girls, infusing his banal subject with an order and harmony foreign to it. The hardened girls of Montmartre take on a certain rhythm, slipping often into poses which have a classic grace and stillness, calm and purity. In these works, Degas achieved, as much as anywhere in his *oeuvre*, the aim which he craved, 'Le mouvement des Grecs'.

Degas lived on to the age of seventy-three, dying in 1917. In his last years he was a shambling, tragic figure, seldom seen in the streets which he had loved so much – he himself seeing nothing of them. Many of his paintings and drawings he kept by him. There is something pathetic about the thought of an old man hoarding drawings of young girls which he could not see, but which he did not want to show to anyone else. Like love-letters from someone long dead.

*Opposite* detail of the model's back, *Woman in the Tub*

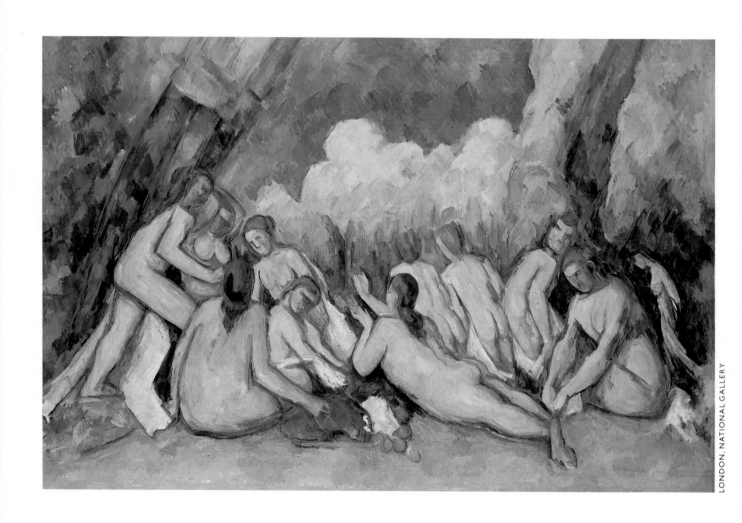

ANITA BROOKNER

# Cézanne 1839–1906
# The Bathers c. 1900

I sometimes feel that Cézanne belongs more to the art historians than to the general public and I think I can understand why this should be so. He is in so many ways the total painter, one who seeks the solution to absolutely everything in terms of visualising a subject and translating it into paint on canvas : life, if you like, conceived as a series of pictorial motifs. For this reason it is not always easy to enjoy him and one's reactions can sometimes go deeper than this. In 1978 there was in Paris an exhibition of the late works – of which this is one – and many of the people who saw it reported a feeling of oppression, even of distress. This feeling coincided with the times when Cézanne failed to meet his own mark, and was forced, again and again, to start from the beginning.

This picture of bathers is just such an exercise and it represents experience on many levels. It was painted around 1900, and it forms part of a series of attempts to depict nude figures in a landscape, in a manner, as Cézanne said, that would be as durable as the art of museums. To understand this ambition one must remember that Cézanne began his long painting career in the 1860s, the years that saw the evolution of Impressionism. To the Impressionist painters, the visual information of the passing moment could be applied, with wit and logic, to the themes that had preoccupied painters since the Renaissance.

When Manet paints *Le Déjeuner sur l'Herbe*, very few people need to know that he is modernising a subject made famous by Giorgione. When Renoir paints his *Baigneuses*, one's sense of pleasure is so great that the painter's own classicising ambitions at this date are quite irrelevant. But when Cézanne paints *Bathers* there is no such sense of release ; very much the opposite. There is tension, and sadness and mystery : the mystery of the painter's task and also the mystery of a style which will, within a few years, remove itself from common experience.

'Life is frightening,' Cézanne used to say. If we care to, we can see in this picture just how frightening he found it. These are not real women ; they are abstracts, pictorial motifs, subject without content. They look aloof and gloomy and disengaged, yet they form quite a collection. It is the vision of a recluse or a hermit. That is one level of experience. The next may consist of trying to make animate figures

Renoir, *Les Baigneuses* (*The Bathers*)

inanimate, so that they will conform more readily to the painting's architecture. This is a huge undertaking, for life is not so durable as the art of museums, and that perhaps is why it is so frightening. When painting a still life, Cézanne frequently used artificial flowers: they lasted longer. And when he painted men playing cards, he eliminated the mobility of their features by giving them faces that are literally masks.

So Cézanne is dealing with nothing less than imponderables such as desire and time. And he is trying to cancel both. In fact by 1900 he has almost put such urgent preoccupations behind him. His life consists of painting concepts of nature which now exist inside his head. And because it is usually impossible completely to objectify one's inner experience, he must paint several versions of the same subject, with increasing despair; hence the anxiety that hovers round his late works. There are many card-players, many bathers, and many pictures of the mountain that overlooks his home, Aix-en-Provence: Montagne Sainte-Victoire.

Cézanne, *The Bathers c.* 1890

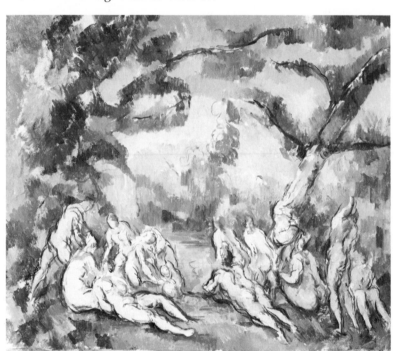

Cézanne, *The Bathers c.* 1895–1900

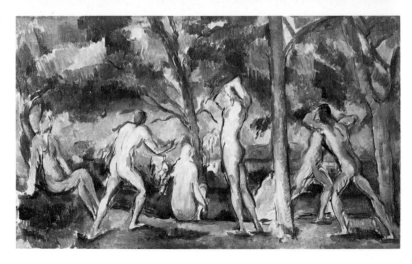

Cézanne, *Seven Bathers c.* 1900

Cézanne, *The Large bathers* (Philadelphia version)

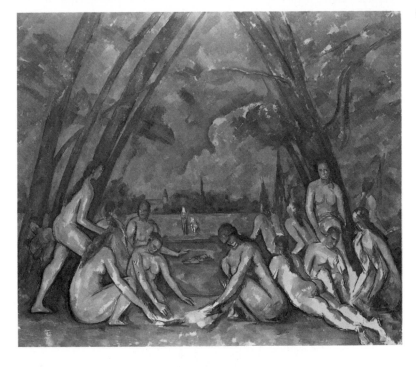

All these pictures involve an element of distortion. The bathers, in the Philadelphia version of the theme, are rammed into a pyramidal scheme that might even be an echo of the mountain. The National Gallery picture, which is slightly later, still tends in that direction. The structure is more interesting than its components, for Cézanne is not trying to reproduce life; he speaks of art as a harmony parallel to nature. And this subject, which must have started as a fantasy of Mediterranean paganism, has ended up as a statement of detachment, if not of calm.

Above all, one is aware of this strange and haunting picture as an effort of will, an effort to impose will on the random and haphazard

structures of the natural world. This corresponds to a need for certainty that nature cannot give. Throughout the nineteenth century painters submitted to nature as mystics do to God. Cézanne finally decided that this would not do. Here he has imposed on nature a structure as rigid as that taught in any academy: a pyramidal composition and a central vanishing point. He is attempting nothing less than that synthesis which we all crave, especially when time is running out.

I think he failed. I think the attempt to provide solutions to intractable problems is doomed to failure. Cézanne's friend Emile Zola was sure that he had failed, but Zola was operating from a basis of moral indignation which many people still feel when they look at modern art. But failure, unless it is habitual, is so interesting.

And failure at this level of effort is absolutely fascinating. That is why this is such a great picture. One does not care too much what came uppermost in Cézanne's mind: professional conscience or terminal anxiety. They are both here. The peculiar integrity of Cézanne is that he did not evade these problems. From the subversive and probably life-giving chaos of fantasy, he has brought forth pictorial logic: a strange, sad, and yet utterly authoritative version which is there to remind us of the painter's desire to make life permanent.

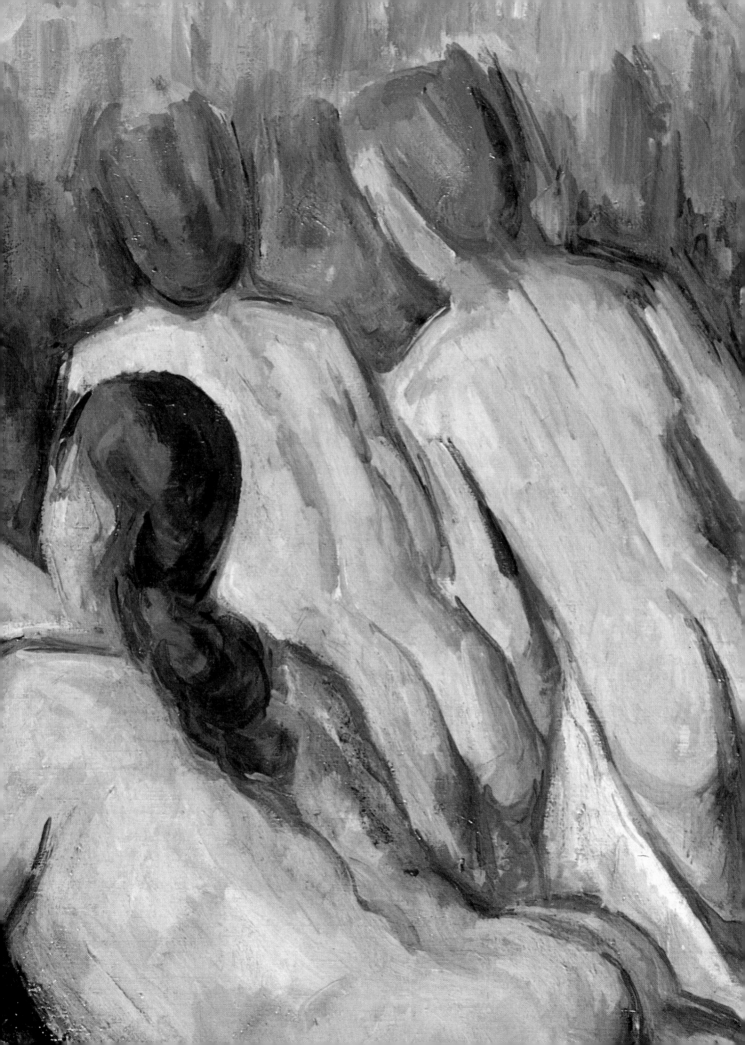

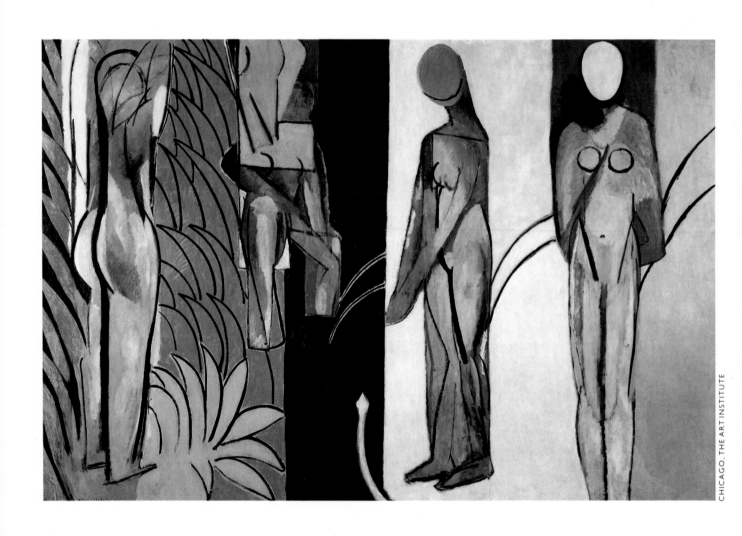

294

EDWIN MULLINS

# Matisse 1869–1954
# Bathers by the River 1916–17

If there is one painter round whom the art of our century turns, I believe it is Matisse. His career – over sixty years of it – illuminates so many of the struggles and preoccupations with which modern painters have been concerned. He was in on the birth of the modern movement at the beginning of this century, and a quarter of a century after his death he is still the standard by whom a great many painters measure their own achievement – abstract and figurative alike. Matisse is one of those key figures, like Freud or Marx or Einstein, to whom we constantly find ourselves referring when we try to define what makes our own time different from earlier ones.

You may say after such a fanfare that any painting would look small; but not, I think, this one in the Art Institute of Chicago, *Bathers by the River*. It is a massive rough-hewn slab of a picture: Matisse at his most monumental, some would say at his least attractive, certainly at his least seductive. I doubt if you would guess from this picture that Matisse was one of the foremost modern draughtsmen of the human figure. It is simply that in this instance clean, crisp drawing is not what he is after.

Four figures of bathers are arranged like crude statues against a few slabs of colour in which only the green foliage on the left actually describes an image in nature; and even here it is the repeated pattern of the leaves that is more important to Matisse, it would seem, than their descriptive role as plants growing by a river-bank. They set up a swaying rhythm which is picked up by the strange shapes looping between the figures – alternative limbs are they? – so that a kind of dance is being performed around the figures, who themselves remain absolutely still.

They are also still because they are really no more than *ideas* for figures, just as the black strip down the centre is nothing more than the idea of a river. Matisse has wanted to give us an idea of naked figures in a landscape – which is a traditional theme in painting – by making us see them first as colours and shapes on a flat canvas, rather than as a trick window on to a real world. So they have no faces, no human expressions at all.

This was the sort of problem Matisse tried to solve all his life: how to make a flat, impersonal decoration but keep it alive. It was 1916–17 when he painted *Bathers by the River*, still quite early in his career;

but even earlier, in 1908, he had made a statement which strikes me as highly relevant to this picture. Matisse said, 'When an artist stands back to think, he must be aware that his painting is artificial, but when he is painting he must believe that he is copying nature.'

That in a nutshell, I think, is what Matisse is about. Painting *has* to be something artificial: it is not a copy of life. At the same time it is rooted in what he sees around him. And this, I believe, explains why Matisse never 'went abstract' as so many of his contemporaries did, and as so many disciples of Matisse have done – in particular recent American painters like Mark Rothko, Barnett Newman and Ellsworth Kelly. In a picture like this one, Matisse seems to be teetering on the edge of abstraction, but he stops short because there is always in Matisse this crucial bond between himself and the world he perceives.

And this bond, this bond with life, becomes very much clearer if we look at how the painting evolved. Some years earlier Matisse had worked out a huge decorative scheme for a three-storey house. On the ground floor he envisaged – as he put it – something demanding an effort, but also giving a feeling of relaxation. This became *Dance*, and it was installed in the house of his Russian patron Sergei Shchukin. So was *Music*, for the first floor, 'the heart of the house', he wrote. The third decoration he never carried out, but he did sketch it in miniature. This was to be for the top floor, or working-studio, where – Matisse said – all peace and people are lost in dreams. This small water-colour was the seed which over the next six years grew into the giant composition of bathers now in Chicago.

Obviously the idea altered enormously in that time: Matisse had originally been thinking of something much more realistic, a pagan romp echoing back to the nudes of Manet and Renoir, and more specially to those rich feasts of flesh served up by Courbet in the mid-nineteenth century. But in those six years between the original sketch and the finished painting a great deal happened. In Moscow, visiting Shchukin, Matisse discovered Russian icons. He was bowled over by their monumental gravity and their symbolic employment of colour – gold for heaven, blue for the Madonna's robe, and so on.

Soon afterwards Matisse made another discovery outside the boundaries of European painting: he came across Persian art – miniature painting – and Moslem art generally. He travelled to Munich specially to view a great exhibition of Islamic art mounted there in 1910. Now, a great deal of Islamic art is non-figurative since the Koran forbids the portrayal of living forms – at least in a religious context. As a result the creativity of Islamic artists has for centuries been channelled into abstract designs. Matisse was fascinated, and he began to travel to North Africa to experience Islam for himself. The impact on him of all these influences was enormous. He organised what he saw in quite a new way, simplifying colours and simplifying the shapes of people and plants, discovering echoes between the outlines of figures, buildings and – in one case – melons on a stall. Matisse was searching for a kind of synthesis which would enable him to express the human scene as an overall rhythmic decoration.

*Bathers by the River* belongs in its final state to the period of the large North African paintings – but with one more new element

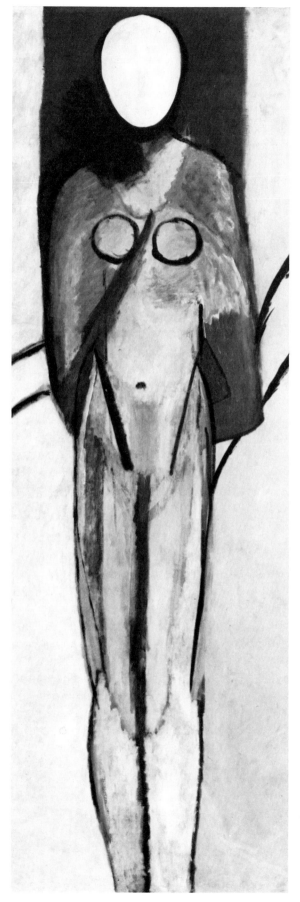

*Left* detail of *Bathers by a River*;
*above* Matisse, *Zulma*

Bathing

which he seems to be struggling to incorporate as well, and that is Cubism. Picasso's revolutionary distortions of the human form in paint like the *Demoiselles d'Avignon* were not all that relevant to Matisse's own search, but Cubism was an explosion which affected all painting in these years, and there are signs in this picture that Matisse was striving to come to terms with it. Cubism is – among other things – about alternative angles and viewpoints, and the two left-hand figures here seem to suggest that he is experimenting with such an idea.

There is a note of experiment running through this picture. It is not a 'finished' painting in the traditional sense. What we are looking

Details of three bathers, *Bathers by a River*

at is a work in progress spanning many years, during which the artist's ideas have been constantly evolving until there has come a point when he effectively says: 'This is as far as I want to take it.' After all, we are dealing with a period of such colossal change and revaluation in art that every painter was in a sense a pioneer without a map. What Matisse has chosen to do here is to leave the false trails and the true ones side by side, because he is still not quite sure which is which.

So, when did Matisse come up with a clear answer? Everyone has his own reply to that question. I think he found it right at the end of his life, when he was partially bedridden and unable to paint in the conventional manner. What he could do was to use scissors and cut shapes from coloured paper. As he said, he found himself 'drawing with scissors'. And of course if you draw with scissors, one cut and that is it. You may discard hundreds: I'm sure Matisse did. We cannot tell. False trails are eliminated, so that the result looks deceptively easy.

Matisse, *The Parakeet and the Mermaid*

As a result these cut-outs are, to me at least, the most joyous creations in all twentieth-century art. Simplicity, colour, form, vitality: he got them all together in the end. These are the consummation of that bond with life which gives the work of Matisse its sap, its blood, its terrific optimism. *Bathers by the River* is a precursor of those final triumphant pictures. Sombre and clumsy it may be, but it has the unmistakable throb of a life-force, and this is where Matisse is a very great artist indeed.

# OUTDOOR LIFE

Man's vision of life out of doors has rather depended upon his status: to the rich man the open air has meant pleasure, to the poor man labour. Since art has generally been for the enjoyment of the well-to-do a high proportion of paintings of open-air life dwell on man's amusements, whether formal, social, sporting or courting. It would be easy to decide from a study of western art that the countryside existed chiefly for the purposes of man's pleasure – at least until the nineteenth-century – with just a little farm-work being done for decorative purposes in the precincts of noble castles as represented in mediaeval manuscripts.

The earliest painting here is not actually European but Chinese, *Clear Weather in the Valley*, long believed to be by a celebrated artist of the tenth-century, Tung Yuan, but now thought to be by someone else quite unknown two hundred years later. The difference scarcely matters: the picture is one of the most delightful of Chinese painted scrolls on which the artist, whoever he was, has described a panorama of mountains, forest and sea in terms of a journey which we are invited to make as we unroll the scroll.

Dutch painting is often the exception to generalisations about the nature of painting, because it is relatively classless. In Dutch paintings of outdoor life, like Avercamp's *Winter Scene,* work is included among the bustling activities of a Dutch village in winter – even so, only in the margins. This is a portrait of a community at play, and few artists have handled the theme so deftly.

More than two hundred years after Avercamp the American artist Thomas Eakins also tackled the theme of open-air play. But instead of looking at a community Eakins has singled out individuals engaged in his own favourite pastime, rowing. *Max Schmitt in a Single Scull* belongs to a series of paintings the artist made of men rowing on the Schuylkill River outside Philadelphia, and it is contemporary (1871) with some of the earliest studies of rivers – summer afternoons on the river – which French artists were painting in the new technique of Impressionism. Renoir's *The Luncheon of the Boating Party* is among the most sumptuous of these, one of the happiest pictures ever painted. The subject is a feast in the open air, and the picture is itself a feast.

Seurat painted *A Sunday Afternoon on the Island of La Grande Jatte* only a few years after Renoir's *Boating Party,* and his theme is also a weekend gathering on the banks of the Seine in summer. But what a very different picture. Where everything in the Renoir is fresh and intuitive, the Seurat – which took him two years – represents a systematic disciplining of the Impressionist approach by a scientific arrangement of tiny coloured dots. The fleeting moment so beloved by the Impressionists has become fixed and timeless.

PENELOPE MASON

# Chinese, 12th century
## Clear Weather in the Valley

Viewing a Chinese handscroll is a little like taking a long train ride. One boards at a familiar station and, taking a seat next to the window, watches as a succession of scenes slide by. City gives way to country. Rivers flash by. Occasionally one catches a glimpse of the ocean or people, tiny specks in the distance, going about their daily business. At the end of the journey one emerges several hours older but with one's store of visual images greatly enriched. Fortunately, the act of viewing a handscroll does not involve the noise and dirt of travel or the fatigue. Instead one feels not only enriched but refreshed.

As with any journey, preparations must be made. The table on which the scroll is to be placed must be covered with a clean cloth, preferably felt or lint-free paper to prevent any damage to the painting. Taking a seat in front of the table we pick up the rolled

303

scroll and examine its rich brocade cover. Next, the silk cord that holds the roll together must be unwound and anchored so it does not interfere with our viewing. Then, unrolling with the left hand and rerolling with the right, we open the scroll.

One of the first things we see is an inscription written in bold, black letters on the white brocade. 'The true brush of Pei Yuan', the name most frequently used by the tenth-century Chinese painter Tung Yuan. Our journey through *Clear Weather in the Valley* has begun.

Descending a steep, tree-covered slope we come upon a swiftly flowing stream, its water tumbling over large boulders with a soft splashing sound like the rattling of pieces of jade. The narrow gorge through which the stream has flowed is filled with mist. Next we cross a grove of trees and come upon a simple thatch-roofed house, encircled by a mud wall. Its doors are open, and inside we can see some of its furnishings. Approaching the gate is an elderly gentleman carrying a walking stick and behind him a young servant. The boy is clutching a long box which contains a *chin* – a stringed instrument. Both figures are walking purposefully and we are too far away to hail them, but, pausing to watch them, we catch sight in the distance of a Buddhist Temple nestling in a valley between two mountain ranges.

Detail of thatched house approached by two figures, *Clear Weather in the Valley*

304

Even as we gaze at the graceful, curved roofs of the buildings, they seem to disappear amid the mists creeping into the valley.

Our journey continues over the rocky ground. Ahead we catch a glimpse of water and, following a path along its edge, travellers – a man with a wide-brimmed hat, riding on a donkey, and behind him two men carrying poles across their shoulders with bundles tied to the ends. The two on foot are striding quickly to catch the man ahead, but the path is uneven and they are having to extend their free arms to balance themselves as they walk. Some distance away is a boat pulled up to shore. Perhaps the travellers have just crossed the river and are making their way to an unknown destination in the mountains. To the left, the tall peaks diminish to low hills and finally the land becomes a narrow peninsula jutting into the wide expanse of the river. Standing at the very tip are a traveller on a donkey and his servant carrying luggage on a pole. A third man gestures excitedly toward the ferry boat which has left the opposite shore and is slowly making its way toward them. Far in the distance are low hills, barely visible through the mists. We cross the river and land on the other shore where under the boughs of a tall tree a wine shop, its cloth flapping in the breeze, invites us to stop for a little refreshment.

The painting ends abruptly at this point. Clearly it has been

Details of *above* two figures at the water's edge hurrying to catch man on donkey; *below* peninsula jutting out into river, with mounted man and two servants; *left* the ferry boat and the wine shop on the opposite bank, *Clear Weather in the Valley.*

cropped, because a line of writing in the upper left and two seals below it can barely be distinguished. Perhaps the artist concluded the painting with a small village which would have provided a counterpoint to the isolation of the scholarly gentleman dwelling at the foot of the mountains.

A journey such as this is a movement forward in time, but a Chinese painting often has another dimension, that of looking backward in time. This scroll is at least seven hundred years old. It has been owned and appreciated by numerous art lovers, some of whom placed their seals on the painting as a mark of the pleasure they received from possessing such a fine work. In addition, the scroll has been studied over the years by connoisseurs who have given written opinions on it, and some of these have now been mounted to the left

of the painting. The most notable commentator is the scholar-painter Tung Ch'i-ch'ang, who studied the painting in 1633.

As we look at the scroll today we cannot help but be aware of the many people who have unrolled and studied it, just as we are doing now. A western painting seldom carries its history on its back as a Chinese painting does. We may know who commissioned a particular western work. We may even know the names of some of its owners and what various people have thought of it, but this knowledge is external to the work itself. Nothing in the viewing process calls it to mind. A Chinese painting, on the other hand, almost always announces something of its history.

Unfortunately, since human beings are fallible and even the best of connoisseurs have been known to make mistakes, the history proclaimed for a painting by later viewers is not always correct. Such is the case with this painting. For centuries, on the basis of Tung Ch'i-ch'ang's inscription, it has been attributed to Tung Yuan, an artist active in the tenth century. Little is known about Tung Yuan, aside from the fact that he served the Southern T'ang court as Assistant Keeper of the Northern Park. However, several centuries later when scholar-painters were searching for a new inspiration for their work, they saw in Tung's painting a loftiness of spirit, a fidelity to nature and a quality of naivety, of the antique, which appealed to them. Quickly Tung was elevated to the position of a patriarch of the *literati* movement. Small wonder that Tung Ch'i-ch'ang, one of the foremost scholar-painters of the seventeenth century, should have attributed this accomplished landscape scroll to his revered predecessor. However, today scholars believe it to be the work of an unknown painter active during the Chin Dynasty in north China two hundred years later.

Another concern of our artist is fidelity to the character of the landscape he is depicting. The mountains at the beginning of the scroll are tall and forbidding, composed of numerous layers of slaty, sharply undercut forms. The ground is rocky and difficult to

Detail of mountains, *Clear Weather in the Valley*

traverse. The atmosphere of the painting, in spite of the mists which creep into the deep gorges, is sharp and clear. All these elements are characteristic of north China, particularly the region around the ancient capital of Ta-t'ung, and appear in other paintings of the period.

But the greatest insight into the mind of this artist comes through his handling of his subject-matter. True he gives us a succession of images from the countryside he knows so well, but among those, several linger in the memory: the gentleman bent with age returning home with his *chin*, the travellers, mere specks in the landscape, hurrying on their way and finally, separated from the scholar by a broad expanse of water – a cleansing distance – the wine shop. Our artist is demonstrating to us the pleasures of reclusion, of devotion to a simple life and to the pursuit of knowledge. By causing us to journey through forests, past rushing streams, beneath steep mountains, he recreates for us the environment in which the scholar has chosen to live and allows us to experience the spiritual refreshment this man must have derived from the world around him.

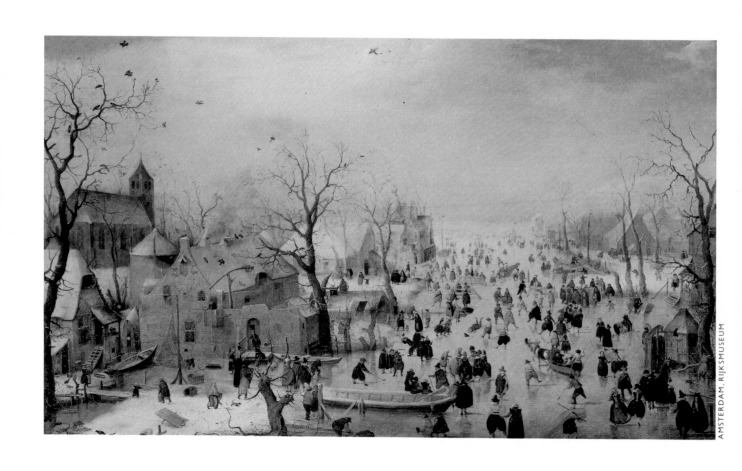

EDWIN MULLINS

# Avercamp 1585–1634
# Winter Scene c. 1630

There is something instantly recognisable about a lot of Dutch painting. Much of it seems to conform to certain archetypes, so that we find ourselves referring to a 'typical' Dutch picture in a way that is quite impossible with French or even English painting. The outdoor winter scene is among the most popular of these archetypes, and this painting by Hendrik Avercamp is probably the best-known example, and justly so.

The prevalence of these archetypes in Dutch painting must have some direct connection with the fact that Holland is such a man-made country, much of it reclaimed from the sea. Dutch art invariably seems to be about the relationship between man and his man-made world, and Dutch artists – particularly those of the seventeenth century – have been outstandingly good at identifying that relationship. Dutch art is forever trying to answer the questions: 'Who are we, and what is this land we have dragged from the sea?'.

There are people who find paintings like this Avercamp trivial and interchangeable. Certainly there are many others like it: in fact Avercamp never painted anything else but winter scenes – it makes one wonder what he did in summer. But this is a particularly fine example, and the longer I look at it the more I enjoy it. He worked in the country town of Kampen, close to the Zuider Zee – which I imagine lies in the misty distance of this painting, beyond the warehouses and local castle where the ice-yachts skid among the skaters. The whole world and its wife has taken to the ice. It must be Sunday. Avercamp has given us a portrait of a society at play.

There is a group of figures playing ice-golf. (The Dutch word was 'kolf', which is said to be where our word 'golf' comes from.) Here and there couples are skating hand-in-hand, an elderly couple precariously, a younger pair convivially, while another has come to grief. Those who have already been at the ale take advantage of a convenient tree.

The frozen canal is also the place for the Sunday morning gossip after church: and the church itself is a mere stone's throw away. There is also work to be done: reeds to be cut, a bird-trap to be set, a hole to be cut in the ice to draw water for the ale-house, which is all of twenty yards from a rotting carcass, and all of ten yards from the outdoor lavatory. This is an upturned boat for some; a ditch for

others. Seventeenth-century Holland cannot have been the most comfortable of places in midwinter, or the healthiest, even in a prosperous small town where no one appears ill-dressed except a solitary beggar. He has picked out the grandest group.

This is a harmonious society, and a relaxed society. It seems unlikely that a feudal tyrant inhabits the castle or that a voice of doom bellows from the pulpit of the church. The picture has an air of quiet celebration, as if something had happened. And, as we know, something had. Holland had recently thrown off a double yoke – Spanish rule and the Roman Catholic Church. You might suppose that puritan Calvinism was a heavier yoke to bear than either, but not yet. These people are self-evidently free, uninhibited and prosperous.

We know them well, these self-made, self-contented Dutchmen: they look us straight in the eye from the portraits of Frans Hals, successful men of the world pretending to be nothing but what they are. Men with nothing to hide, happy to go down to posterity with a glass in their hand. Avercamp puts these men in their social context. His portraits are of communities, not individuals: though when celebrities did come to Kampen he recorded them; as in 1626 when

Details of town life: *opposite above* centre background, and *below* left foreground, *above* beggar and affluent townsfolk, *Winter Scene*

*Top* detail of figures in a sleigh, *Winter Scene*;
*above* Avercamp, *Nobility on a Sleigh*, drawing

the exiled King of Bohemia paid a visit with his family, including his wife, masked against the cold. (She was the sister of Charles I of England.)

It is probably the same visiting nobility on a sleigh, in a drawing now at Windsor in The Royal Library. Avercamp must have used this drawing when he came to paint his large *Winter Scene*, altering the figures and the sleigh, though keeping the pose of the skater. Other drawings done on the spot he seems to have used, too. Also at Windsor is a study of ice golf, which suggests three scenes in our picture.

So maybe this picture is not quite the true-to-life record it first seems, but a complicated jigsaw-puzzle pieced together from fragments of sketches made at different times and possibly different places. In its own way this is an idealised view of a society at play. All the figures are deployed across the landscape rather like those little transfer-figures which children stick on a card to make a battle scene or a football game.

And it is not only the arrangement of figures that is carefully contrived. So are the colours in which they are painted. Avercamp is

a marvellous colourist: his sparing use of red, for instance – just the occasional red figure to break the monotony of black and brown. And the mellow rose-red of the local brewery, which glows so warm you can almost feel the fire burning within. Even more sparingly he uses another primary colour – blue: a long skirt here, breeches there, a pair of identical bonnets, and the delicate blue shutters of the big house adjoining the castle, with its blue onion-dome almost lost in the haze that is heavy with snow to come. It all brings a touch of magic to a mundane scene. A touch of fairyland.

In Calvinist Holland there were no paintings designed for churches. Paintings like this one were for private houses; an enormous number of private houses. People in seventeenth-century Holland seem to have bought pictures just as they bought furniture, without thinking of them as works of art in the self-conscious way we do. This is perhaps the only moment in history when original paintings have been genuinely popular. Dutch art is about people, for people. It is in no way an élitist art: not for a ruling court or an aristocracy; and not of course for the Church.

Yet this kind of popular painting comes out of a tradition that was

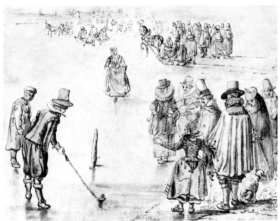

*Top* detail of ice golf, *Winter Scene*; *above* Avercamp, *Ice Golf*, drawing

313

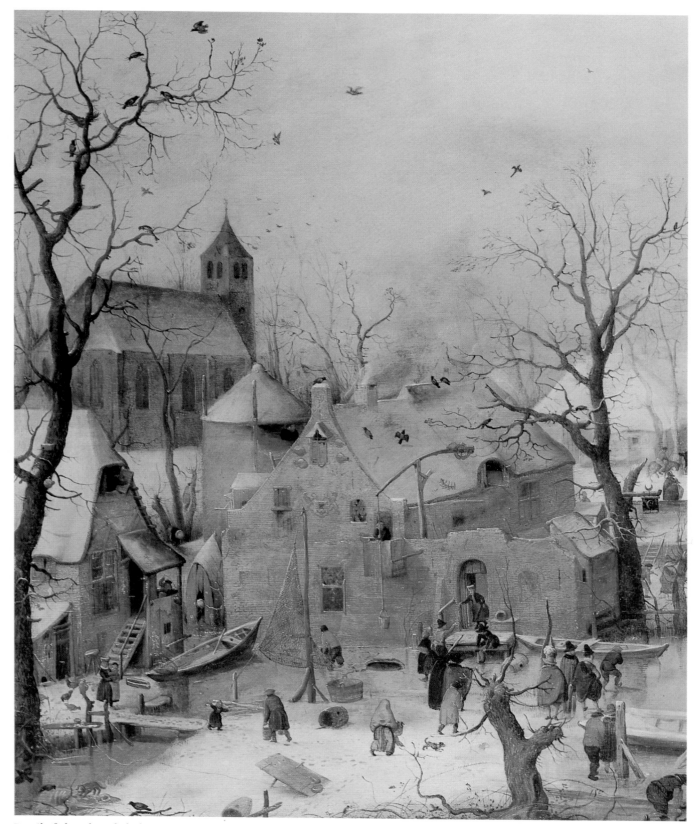

Detail of church and ale-house, *Winter Scene*

in fact deeply religious. It is worth comparing the Avercamp with a winter scene painted a little over fifty years earlier in Catholic South Netherlands, in Flanders. The artist is Pieter Bruegel. The people are poorer than Avercamp's middle-class merchants; otherwise it is the same kind of picture. But only rather so, because this is not simply an old man leading a woman on a donkey. He is Joseph, she is the Virgin Mary, and this is meant to be Bethlehem. So, the origins of these village scenes lie in pictures which depict Bible scenes. They were popular because they illustrated the popular faith, and because they set that faith within the context of ordinary life.

They were not only straightforward Bible stories either. Bruegel's painting called *The Blue Cloak* is another peasant village scene, but what a village! All hell has broken loose. The painting is an illustration of local proverbs designed to bring home to us the follies of mankind – helplessness, stupidity and greed. Only by divine forgiveness can we be saved.

And the artist who stands behind Bruegel, fifty years earlier still, offers an even more terrifying vision of the evils of mankind: Hieronymus Bosch. Critics stuffed with Freud have had a field-day with Bosch; not surprisingly. Bosch regards everything to do with the human body as deliciously evil. All pleasures reek of sin. I confess to finding him a spiritually stifling artist; everything is either temptation or punishment. He is still dark and medieval in spirit, and he makes me understand why the optimism of the Renaissance had to come – the liberation of man's mind from the tyranny of superstition.

By Avercamp's time the Renaissance had come, and so had the Reformation. Spanish Catholicism and Spanish rule had been swept away, along with all that stifling sense of sin which had denied man the right to walk on earth and enjoy himself with his head held high. And this is exactly what all the people in this painting are doing: they are walking on earth – or in this case on ice – with their heads held high. Here is a society that has come out of the darkness and is determined to make the most of it.

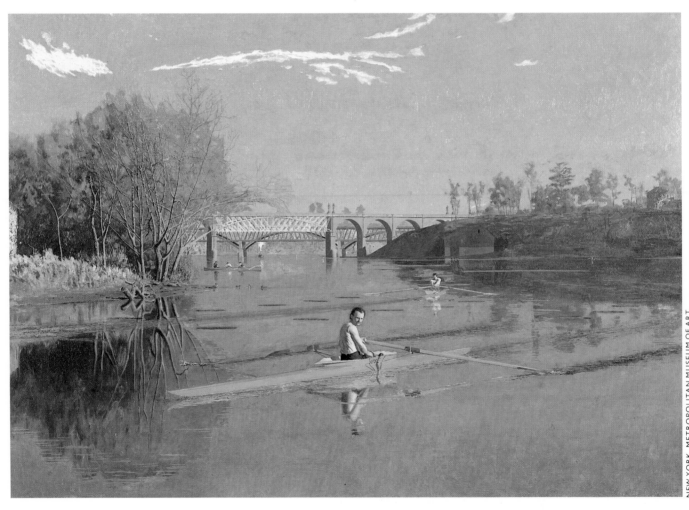

# Thomas Eakins 1844–1916

## Max Schmitt in a Single Scull 1871

There is an oft-repeated truism in art history that art imitates art. This is not a derogation, but a reminder that art has a very persistent past and that all artists grow up in, and accept, some tradition or consciously seek another. Occasionally a work of art may strike us as startlingly fresh, unlike anything we have ever known before, as if the artist has revealed something to us for the first time.

To me, at least, such a rare work is the *Max Schmitt in a Single Scull* by the American painter Thomas Eakins. It is not a revolutionary vision, it is not a picture that influenced the course of art such as Manet's *Déjeuner sur l'herbe* or Picasso's *Demoiselles d'Avignon*. As a matter of fact, considering that Eakins was in Paris when Impressionism was emergent, it is aesthetically rather retarded in its meticulous handling of minute detail, in what is essentially a *plein air* painting. It is the conception of the scene – the subject, the landscape, even the retarded style – that offers us the shock of newness, of revelation.

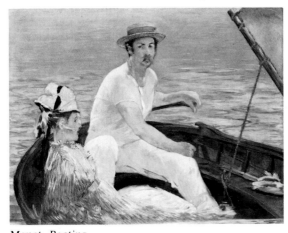

Manet, *Boating*

Thomas Eakins came back to Philadelphia in 1870 after almost four years abroad, most of it spent at the Ecole des Beaux Arts being schooled as an academic painter. But instead of settling down to paint romantic literary themes, for which he was trained by Jean-Léon Gérôme, one of the leading French academicians, his earliest efforts were scenes of everyday life, very local and personal subjects, pictures of his immediate family at home, and a series of outdoor pictures – sculling on the Schuylkill River, sailing and hunting.

Beginning in late 1870, and over the next four years, Eakins painted a series of unusual rowing pictures. The *Max Schmitt*, the best known and finest of these, done in 1871, is first of all a sporting picture and in the nineteenth century the sporting picture was a popular rather than a high art form. But a good deal of American art still had strong popular roots. Also, Eakins's attitude to sports and his own participation was much more active than that of, for instance, the Impressionists who were his contemporaries. Manet, Monet, Degas and Renoir painted scenes of horse-racing and boating, but usually from the viewpoint of the spectator or, at most, as a leisurely activity. Eakins sees such scenes close up and as a participant. He was an active sportsman and he knew many of the oarsmen who belonged to the boating clubs along the river, among them the Biglen brothers,

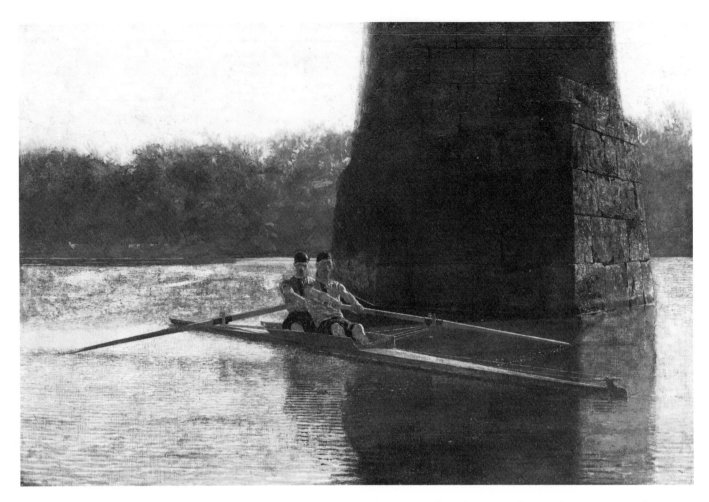

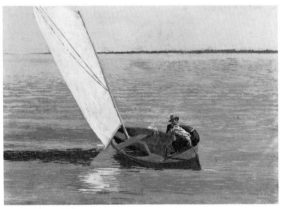

*Top* Eakins, *The Pair-Oared Shell*;
*above* Eakins, *Sailing*

professional rowers, whom he painted several times. Max Schmitt, an old and close friend from high-school years, was a champion oarsman who turns up in several other of Eakins's rowing pictures. In this painting Max is in the foreground scull and Eakins is the oarsman in the receding boat to the right with the Eakins signature on the stern.

Despite the importance of the subject the *Max Schmitt* can be seen simply as a landscape; but here also there is something arrestingly different about the picture. It does not recall other landscapes in the history of art. A prosaic scene, very particular in detail, it is almost as if it had been photographed, and it probably was by Eakins himself. Many aspects of the picture appear photographic; perhaps the very nature of reality as it is presented here is photographic.

The conception of this landscape is a far cry from the sublimity of such romantic painters as William Turner or, within the American tradition itself, Thomas Cole and the Hudson River School. Nor has it the bucolic charm of the French Barbizon School of painting. In its 'pleinairism' and anti-romanticism it is closer to the informality of the Impressionists. However, Eakins differs from them not only in technique but in his attitude towards light. In effect the Impressionists saw the world in terms of light, as if light were the basic element transforming all matter into itself, which they then transposed into paint. For Eakins light was an ambience, not a dissolving medium. Matter, which exists within that ambience, is defined discreetly and with precision.

The Eakins landscape is, then, not a unified and generalised entity, but an accumulation of disparate elements, all of which have their own character. The brilliantly clear blue sky. The quite eccentric cloud formation that one would hardly expect to see again. The carefully observed clump of willow trees at the water's edge, with its counterpoint of linear precision in the trunks and branches and the delicate haze of indefinable foliage. The mechanical filigree of the ironwork in contrast to the measured cadence of the masonry arches of the distant bridges – a sharp note of modernity in a pastoral setting. The dark mass of the shadowed hill cutting like a spear into the picture, certainly a photographic image. And the moving elements on the river that, like markers, measure the space for us as it recedes toward the horizon – Max resting on his oars, Eakins rowing off to the right bank, the two-oared red boat before the bridge, and the steamboat with its puff of white smoke in the distance. And everything mirrored in the glassy surface of the water.

All of these separate entities have coalesced by chance to create an unforgettable moment that becomes a memory of a hot, clear, autumnal day on the Schuylkill River. One is reminded of the Wordsworthian definition of poetry as emotion recollected in tranquillity. The scene, like a memory, is frozen in time, as if caught in an eternal stillness by the click of a camera shutter. That sense of stillness is reinforced by the limpid sky, wisp-like clouds, the mirror-smooth water. There is little air and scarcely any movement. Max, riveting the composition in the very centre of the canvas, pauses as his scull glides soundlessly through the water, trailing three parallel wakes. Eakins, moving off in the distance, breaks the surface with

Detail of the bridge, *Max Schmitt in a Single Scull*

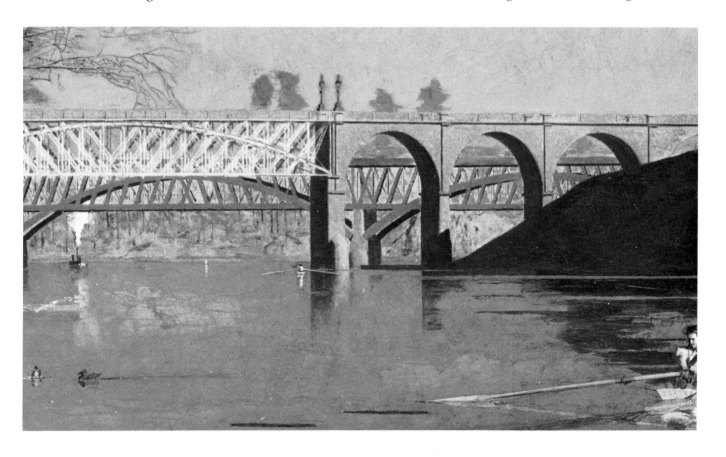

the wake of his scull and the regular puddles of the dipping oars. In the stillness one can almost hear the lap of Max's scull *Josie*, or perhaps the click of Eakins's oarlocks, or a distant shout carrying across the water.

This lyrical, poetic quality recalls the earlier school of American landscape painting, of about mid-century, identified as 'luminism', for the *Max Schmitt* can be seen as a somewhat belated example of that style. Without going into great detail, luminism has been described as emphasising light, air, and atmosphere, the light having a palpable existence, clear and within a light and narrow tonal range, not at all like the bright Mediterranean sun and pure colour range of the Impressionists. This luminist light has been described rather frequently as specifically American. The overriding mood of luminist paintings is stillness – few figures, generally motionless, the landscape dominated by placid water, the painting by smoothness of surface. The artist remains unobtrusive. Compositionally, luminist landscapes tend to emphasise horizontality, implying perhaps a certain geographic expansiveness.

In addition, many observers have noted an indefinable mystery in these pictures, which may in effect be the cumulative impact of all these lyrically poetic elements. The *Max Schmitt* lacks the mystical, quasi-religious overtones ascribed to some luminist paintings in which light is sensed as a divine emanation. Eakins was too coolly scientific for that, but his light is nonetheless equally palpable. His poetry, without mystification, is a song to the wonder and beauty of the most mundane of things and the most usual of moments.

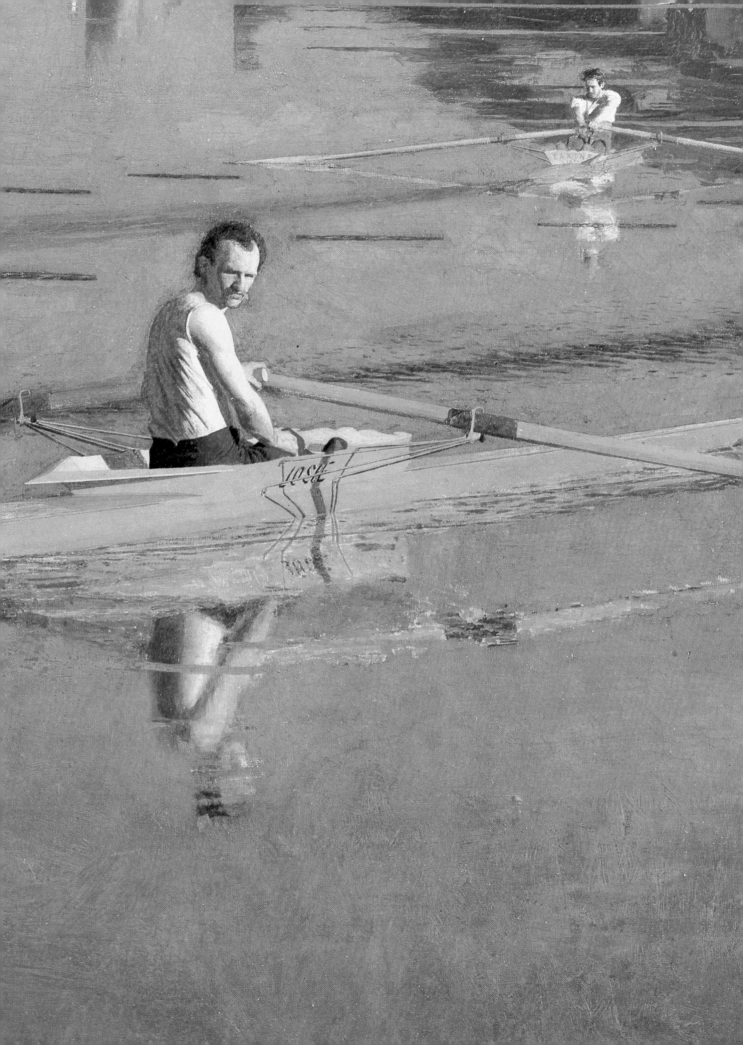

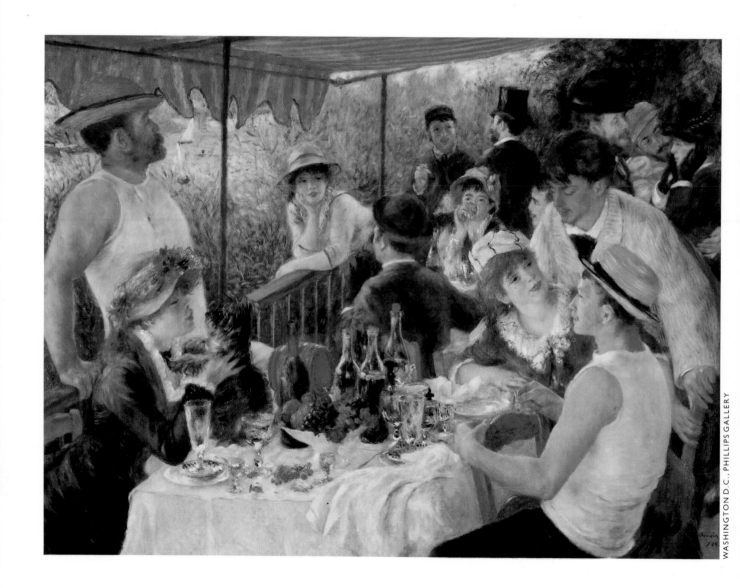

MILTON BROWN

# Renoir 1841–1919

# Le Déjeuner des Canotiers (Luncheon of the Boating Party) 1880

Among my favourite paintings is Auguste Renoir's *Déjeuner des Canotiers*, or, as its title is translated at the Phillips Gallery in Washington where it now happily hangs, *The Luncheon of the Boating Party*. By any name it is a totally delicious picture. Everything about it is ravishingly sensuous. This is the kind of picture that one hardly needs to talk about. One can lose oneself just as completely in the beauty of the day and the occasion depicted as in the sumptuous quality of the painting itself. Renoir has here achieved an ultimate concordance between the joy of living and the act of creation, between the experience of physical pleasure and its expression in paint.

In 1880, when Renoir painted the *Luncheon Party*, he was at the height of his powers. His Impressionist technique had reached an incomparably fluent opulence, which was in some ways a reflection of his own state at the time. The Impressionists were finally achieving some success. Renoir had patrons, his work was selling, he was surrounded by congenial companions – many of whom are immortalised in this canvas – and his work shows the largeness and confidence of maturity.

It was during this period that Renoir painted some of his most engaging and impressive pictures, pictures of healthy, joyous holiday activities in and around Paris: dancing in the park, boating on the Seine, eating, drinking and merrymaking. The people are all young and beautiful, and the sun speckles them with gold. This is in essence the Impressionist view of life, relaxed, serene, untroubled: a group of happy friends enjoying lunch in the warm summer light in the open air along the Seine. Actually the scene is at Père Fournaise, a small hotel and restaurant on the Ile de Chatou, a suburb of Paris, which Renoir and his friends frequented. One could hardly guess from the painting at the poverty of the surrounding working-class neighbourhood where Renoir's mother lived, or its industrial smoke and squalor that his fellow Impressionist Raffaelli had recorded. Renoir chose the sunny side of life. Of all the Impressionist painters he was the most dedicated to the search for the pleasurable.

And one can accept the painting simply as a delight of the senses. Even probing will not reveal profound depths of meaning, though it may enrich our understanding and appreciation. The repast, the

meal, the feast as a subject in art has an unusually ancient history, going back as far as the earliest of Egyptian tombs, where the central theme was the ritual offering of a meal for the deceased. And as a ritual theme it has come down through the ages in many cultures, including, of course, the Christian 'Last Supper'. It also had its secular counterpart, even in ancient times, in the depiction of less formal gatherings such as symposia which appear on classical Greek drinking-vessels. The secularisation of a religious feast in Veronese's *Marriage at Cana* has many points in common with Renoir's *Déjeuner*.

Renoir knew the Veronese very well, since it is one of the great treasures of the Louvre. As a matter of fact, he considered it a miracle of art; it was for him the greatest of all masterpieces. The Veronese is a painting of overwhelming sensuous range and brilliance. The religious theme is all but lost in a display of secular splendour and

Veronese, *The Marriage at Cana*

painterly virtuosity. It is no wonder that a similar, though later, feast by Veronese brought him before the Inquisition for blasphemy. And it is no wonder that Renoir admired exactly that concern with sensory delight in the physical world. Like Veronese, Renoir delighted in the senses – all the senses. One is reminded of the ribald revelries in such Dutch painters as Jan Steen, where the rowdy feast is often symbolic of the Five Senses. Renoir's feast is of course non-symbolic, but a physical evocation of those senses.

The whole scene is obviously absorbed at first through sight. A burst of brilliantly sparkling colours in profligate harmonies, an

orchestration of jewel-like touches presents a group of Renoir's friends – a Bohemian mix of *bons vivants*, affluent gentlemen interested in the arts, artists, actresses and models (we can identify all of them) – relaxing after lunch on the verandah of the Fournaise restaurant. The big, burly man on the left, in the straw boating hat and sleeveless shirt, is Père Alphonse Fournaise, the proprietor, who seems to be viewing the scene with satisfaction. The party has broken up into smaller groups in animated conversation. The table, in some disorder, is covered with the remnants of the repast. The memory of the long meal and the taste of food and drink seems to pervade the scene. It is embodied in the bowl of succulent fruit in the foreground, in the partly-emptied wine bottles and glasses, and in Angèle, one of Renoir's favourite models, in the centre of the picture toward the rear, who is still drinking her wine.

Detail of Angèle, *Déjeuner des Canotiers*

*Opposite* detail of the glasses, *Déjeuner des Canotiers*

In this very animated interplay of figures one has not only a sense of social intercourse in the complex pattern of who is looking at whom, but of sound, the hum of voices and laughter. The very pretty girl in the left foreground is cooing at her little dog. In the background to the right, Renoir's close friend Paul Lhote, who posed for many Renoir paintings of this period, leans forward toward the young actress Jeanne Samary and, with his arm around her waist, whispers something, perhaps amorous, to her. She raises her hands to her ears in mock dismay, as if not to hear the scandalous proposal. Lestringuez, another of Renoir's cronies, joins in the amusement.

Of all the senses transmitted perhaps the strongest is that of touch. There is a palpable textural quality to so much of the painting, beginning with the pigment itself, that it seems even to dominate the colour. One can almost feel the warmth and softness of the skin, the lightness of the hair, the nap of the cloth, the crispness of the straw hats. The bottles and glasses sparkle in the light, the lush fruit invites

Detail of Paul Lhote, Jeanne Samary and Lestringuez, *Déjeuner des Canotiers*

the touch. There is a patently erotic character in the cumulative sensuousness of the painting, for it is a kind of paean to the senses, to all the beautiful young women Renoir could never resist, to his gay and charming friends, to living and loving, to the physical world itself in all its happy manifestations.

The painting is really a kind of declaration of his new-found love for the delicious Aline Charigot in the perky flowered straw hat, who eventually became Mme Renoir. Here she cuddles her little dog, quite obviously attracting the attention of the roguish young canotier who straddles his chair: Gustave Caillebotte, painter, devoted friend and patron of Renoir. He on the other hand seems to be the focus of the lovely young actress Ellen Andrée, who is in turn attracting the solicitous attention of the handsome young man in the jacket.

A sense of wellbeing permeates the entire painting, a feeling of surfeit, a surfeit of sun, air, food, wine; the implication that everyone is young, beautiful and happy – and will remain so. The genius of Renoir has captured it forever, the memory of another more pleasant time.

*Below* detail of Aline Charigot;
*opposite* detail of Ellen Andrée, Gustave Caillebotte and young man, *Déjeuner des Canotiers*

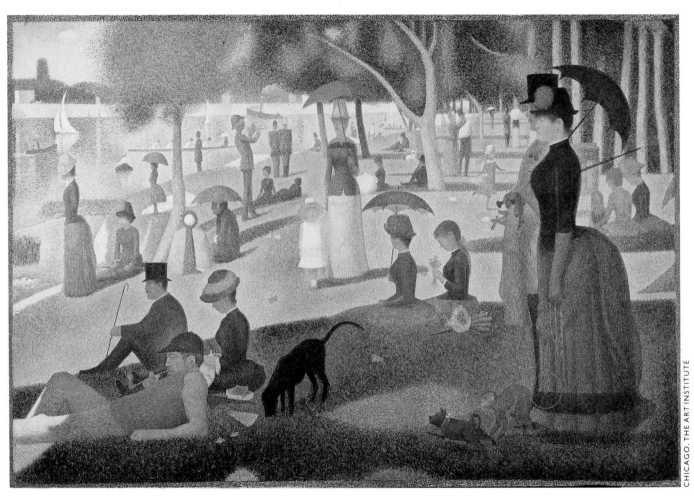

# Seurat 1859–91

# A Sunday Afternoon on the Island of La Grande Jatte 1884–6

Georges Seurat was twenty-five when he painted *A Sunday Afternoon on the Island of La Grande Jatte*. He died at the age of thirty-two and left only seven major large paintings. Yet after the exhibition of *La Grande Jatte* at the eighth and last Impressionist Exhibition in 1886 he was already the recognised leader of a new generation of French painters who had become dissatisfied with Impressionism.

Even some of the Impressionists, such as Pissarro, Renoir, and Cézanne, had become disaffected, troubled by what was called 'Monet's disease', by the growing awareness of the limitations of the 'mindless eye', by the undeviating naturalism of the moment.

Seurat set out to transform Impressionism through what he thought of as science, the science of optics and composition. It really does not matter how valid the so-called 'law of simultaneous contrasts' in colour or the golden section in composition are, but what effect they had on the work of art itself. This is not the first occurrence of this paradox in the history of art. Paolo Uccello, for instance, thought his greatest contribution to art was the theory of perspective as demonstrated in *The Rout of San Romano* (page 180). We accept his involvement with perspective as a particular obsession of his time, but we admire the painting today for its brilliant decorative pattern. Similarly, we no longer judge Cubism on the legitimacy of its connection with the Einsteinian concept of the fourth dimension. *La Grande Jatte* stands on its own today, not as a scientific demonstration nor even as a landmark in the history of art – though it may be both – but as a work of art.

When *La Grande Jatte* was first shown, it was greeted with abuse and derision from sophisticates as well as the public. Why? Because of its size? It is ten feet long and almost seven high. Perhaps because of the incongruity of so large a surface covered with small dots. Or was it because this new group of artists, consisting of Seurat, Signac, Pissarro and his eldest son Lucien, variously called Neo-Impressionists, Pointillists, Divisionists, or in derision Confettists or Lentilists, were hung together in one room and people found it impossible to tell the works apart?

The painting describes a typical Impressionist subject – a sunny Sunday afternoon in a park thronged with people. The Ile de la Grande Jatte was a popular public gathering place, about a mile long,

in the Seine on the northwest edge of Paris on the way to Neuilly. Set in an area of warehouses, small factories and low-cost housing, it did not attract the *haut monde*. With its restaurants, cafés, dance halls and a few stretches of greenery, it was a favourite haunt of boaters, anglers, soldiers on leave, and cocottes. On weekends it offered a very lively scene.

Seurat began *La Grande Jatte*, his second large painting, in 1884. Two years earlier his discovery of Impressionism had a profound effect on his artistic direction, turning him away from the academic training he had received at the Ecole des Beaux-Arts, where he had studied under a pupil of the great classicist, Ingres. The impact of Impressionism was visible in his first major work, *Une Baignade*, which was exhibited at the first show of the *Indépendants* in 1884, where he met Signac, an admirer of Monet. Signac got Seurat to

Seurat, *Une Baignade*

eliminate earth colours from his palette, and Seurat got Signac interested in his scientific theory of 'chromo-luminarism', which, without going into detail, is painting not by mixing pigments on the palette, but by juxtaposing touches of set colours on the canvas and permitting the eye, as it were, to mix them.

In essence, this is what the Impressionists had already done, but intuitively and on the spot. Seurat proposed a scientific method of recording visual phenomena. He made preliminary colour sketches much in the manner of the Impressionists, but then combined and painstakingly worked out the details according to formula in his

studio. The result was a composition of almost classical order and a surface of almost mechanical regularity. A fanatically methodical workman, Seurat was at La Grande Jatte every morning for more than six months doing oil sketches from nature, and then working on the painting in his studio in the afternoons and evenings. It took him two years to complete the picture.

The very process of work, the premises of his scientific theories, his profound aesthetic intentions – for Seurat conceived himself as an artistic revolutionary and seer – coalesced to produce a painting of monumental power. But perhaps it was all the result of that peculiar genius and sensibility inherent in Seurat as a person. For there is something strange and unexplainable about this picture.

Is it because Seurat has tried to transform Impressionism into its opposite? All the variety and accident of nature which Impressionism

Seurat, preliminary oil sketch for *La Grande Jatte*

had raised to the level of art is here congealed into a formal, if not classical, structure. The world of the ordinary is seen as a universal geometry of ordered verticals and horizontals, regular and controlled curves, and a measured planar recession into depth. The fleeting moment, at the very centre of the Impressionist aesthetic, is frozen forever in time. The little girl will never catch her butterfly, nor will the little dog with the blue ribbon get to romp with his new-found friend. The infinite forms of action are reduced to the diagrammatic and hieratic, to front, rear and profile views. And so the strolling woman and child move toward us with the inexorability of fate.

Rather than being intuitive and fluent, the composition is studied and molecular, perhaps in part because it is composed entirely of dots. Not really dots, but discreet touches of colour, criss-crossing in the grass, horizontal in the water, and following the contours in the figures. Small dots were probably added later to increase the luminosity and definition of some forms. In any case, as a synthesis of a series of separate studies, the painting remains a composite. It seems almost as if figures are magnetically attracted to form into distinct vignettes, echoing each other throughout the canvas, yet within these groups each figure seems curiously isolated by the precision of definition, and psychologically alienated by introspection. The boater in the left foreground, immutable as an ancient river god, though formally tied to his neighbours, is embalmed in his own thoughts.

The methodical dotting also results in a spatial paradox. In conjunction with the silhouetted shapes it creates a tapestry-like surface flatness. But then the same fanatical rendering of each form back into the distance achieves a remarkable sense of depth. Instead of the Impressionist, intuitively perceived relation of forms in space, Seurat has returned to the Renaissance device of measured intervals to define it.

Although *La Grande Jatte* was patently worked out in scrupulous detail, it harbours a number of unexplained or ambiguous situations, both formal and psychological. What are the three figures on the extreme right watching? And if shadows are being cast from left to right, what has caused the shadow in which they are seated? But stranger than any of these puzzles is the contradiction that Seurat sets up between the specificity of subject and the generality of treatment. It is best exemplified in the dominant pair, the elaborately gowned cocotte with parasol and ringtailed monkey and her immaculately turned out and affluent bourgeois escort, a somewhat eccentric couple to say the least. But they are handled straight-faced, with all the formal dignity of noble personages right off an Egyptian relief.

Seurat, crayon studies for *La Grande Jatte*: *below* seated woman; *right* three women

334

Seurat, crayon studies for *La Grande Jatte*: *left* seated woman; *below* monkey

Add the man blowing a horn and the two women fishing, and one is led to question the rationality of the picture as a whole.

Examined closely, everything in it becomes ambiguous. In a very curious way reality itself becomes unreal. Science becomes poetry.

Seurat, studies for *La Grande Jatte*: *above* figures at the water's edge; *right* woman fishing

The Grande Jatte becomes the Elysian Fields. The painting has become much more than a landmark in the history of art; it is an artistic masterpiece.

# The Contributors

Anita Brookner is Reader in the History of Art at the University of London and Lecturer at the Courtauld Institute. She is a specialist in eighteenth- and nineteenth-century French Art, and her book on David was published in 1980.

Milton Brown is Resident Professor of Art History at the City University, New York. Formerly Chairman of the Art Department at Brooklyn College and Executive Officer of the Ph.D. programme in art history, CUNY, he is author of various books on American Art, in which he is a specialist.

Sir Hugh Casson has been since 1976 President of the Royal Academy, and was until 1975 Professor of Environmental Design at the Royal College of Art. From 1948–51 he was Director of Architecture for the Festival of Britain. He is a frequent broadcaster and prolific author.

Richard Cork is Art Critic of the *Evening Standard* and former editor of *Studio International*. An expert on twentieth-century painting and author of the standard work on Vorticism, he is a frequent broadcaster.

David Hockney, painter, draughtsman and theatrical designer has also edited and illustrated a selection of Cavafy's poems.

John R. Hale, Professor of Italian at University College, London, since 1969, is a former Chairman of the Trustees of the National Gallery. He has published a number of books including *Machiavelli and the Italian Renaissance, Renaissance Europe* (edited) and most recently *Florence and the Medici*.

John Jacob is Curator of The Iveagh Bequest, Kenwood, Marble Hill House, Twickenham, and Ranger's House, Blackheath. He was formerly Deputy Director of the Walker Art Gallery, Liverpool. He combines an interest in modern art with the study of paintings and furniture in the English Country House.

The Contributors

Penelope Mason is Associate Professor at Florida State University. She has published a book and several articles on the *Yamato-e* tradition of Japanese painting, and is currently writing a history of Japanese Art.

George Melly, polymath and jazz musician, also has a deep interest in surrealist art, of which he is a collector.

Edwin Mullins, novelist, art critic, journalist and broadcaster, has written regularly on art for several national newspapers since 1962, and has been a frequent presenter of arts programmes on radio and television for fifteen years. His non-fiction publications include *The Pilgrimage to Santiago* and a monograph on Georges Braque.

David Piper has been Director of the Ashmolean Museum, Oxford, since 1973 and was formerly Director and Marlay Curator of the Fitzwilliam Museum, Cambridge. Author of several books, he is currently editing a major Encyclopaedia of Art.

Robert Rosenblum is currently Professor of Fine Arts at New York University. Formerly Slade Professor of Fine Art at Oxford, he has also taught at Columbia, Yale, Princeton and the University of Michigan. His books include *Cubism and Twentieth-Century Art* (1960), *Ingres* (1967), *Frank Stella* (1971) and most recently *Modern Painting and the Northern Romantic Tradition: Friedrich to Rothko* (1975).

Alistair Smith is Keeper (Exhibitions and Education) at the National Gallery, London, where he is responsible for paintings of the fifteenth-century Italian School, the Early Netherlandish School and the German School. He was formerly a curator of the Whitworth Art Gallery in Manchester and Lecturer in the History of Art at Manchester University. He has published on subjects ranging from Mantegna to Whistler, and is currently engaged on a book on *Art in Literature*.

# Index of Painters and Paintings

Italic figures refer to page numbers of illustrations

339

# Picture Acknowledgements

Page 12 National Gallery, London; 14 (middle) Uffizi Gallery, Florence (photo Alinari); 15 (left) Kaiser Friedrichs Museum, Berlin; 18 Norton Simon Foundation, Pasadena; 21 (right) Church of Mary Magdalen, Seville (photo Mas); 22 Metropolitan Museum of Art, New York (Fletcher Fund); 23 Seville Museum (photo Mas); 24 Musées Royaux des Beaux-Arts, Brussels; 25 Museum of Modern Art, New York (Lillie P. Bliss Bequest); 26 Musée D'Art Moderne, Paris (photo Giraudon); 29 Private Collection; 30 Peggy Guggenheim Collection, Venice; 32 Private Collection; 35 (top) Eglise St Pierre, Louvain (photo Giraudon), (bottom) Private Collection; 36 Museum of Modern Art, New York (Mrs Simon Guggenheim fund); 38 Museum of Modern Art, New York; 39 Museum of Modern Art, New York; 42 National Gallery, London; 48 National Gallery, London; 49 National Gallery, London; 50 Kunsthistorisches Museum, Vienna; 53 National Gallery of Art, Washington (Widener Collection); 54 Metropolitan Museum of Art, New York (Michael Friedsam Collection); 56 Art Institute, Chicago; 58 (top) Minneapolis Institute of Arts (William Hood Dunwoody Fund), (bottom) Louvre, Paris (photo Giraudon); 59 (top) London Courtauld Institute of Art, (bottom) Albright Knox Art Gallery, Buffalo (A. Conger Goodyear Collection); 60 Stadtischen Galerie, Munich; 63 Stadtischen Galerie, Munich; 64 Stadtischen Galerie, Munich; 65 Stadtischen Galerie, Munich; 66 National Gallery of Art, Washington (Ailsa Mellon Bruce Fund); 67 Stadtischen Galerie, Munich; 68 Metropolitan Museum of Art, New York (George A. Heard Fund); 70 Smithsonian Institution, Washington; 72 Museum of Modern Art, New York; 74 Louvre, Paris (photo Giraudon); 79 Staatliche Museum, Berlin; 80 Pinacoteca, Borgo San Sepolcro (photo Scala); 81 Pinacoteca, Borgo San Sepolcro (photo Alinari); 84 San Rocco, Venice (photo Alinari); 85 (top) San Apollonia, Florence (photo Alinari), (bottom) Musée des Beaux-Arts, Tours; 88 Uffizi, Florence (photo Scala); 90 Uffizi, Florence (photo Alinari); 92 (bottom) National Gallery, London; 96 Louvre, Paris (photo Giraudon); 99 (top) Louvre, Paris (photo Giraudon), (bottom) Versailles (photo Giraudon); 102 Norton Simon Museum, Pasadena; 106 National Gallery, London; 108 (left) Prado, Madrid (photo Mas); 110 Courtesy of the Smithsonian Institution, Freer Gallery, Washington DC; 112 Yamato Bunkakan, Nara-Shi; 113 Kunaicho, Imperial Palace, Tokyo; 116 Cleveland Museum, Ohio; 117 Philadelphia Museum of Art (John H. McFadden Collection); 118 National Gallery, London; 119 (top) Tate Gallery, London, (bottom) National Gallery, London; 122 Detroit Museum of Art; 126 Courtesy of the Smithsonian Institution, Freer Gallery of Art, Washington DC; 127 (left) Smithsonian Institution, Freer Gallery of Art, Washington DC, (right) Tate Gallery, London; 128 Baltimore Museum of Art; 130 Museum of Modern Art, New York (Lillie P. Bliss Collection); 131 Courtauld Institute Art Gallery, London; 132 (top) Cleveland Museum of Art, (Leonard C. Hanna, Jr. Collection), (bottom) Kunstmuseum, Basle; 134 Kunstmuseum Basle; 136 Courtauld Institute, London; 137 Courtauld Institute, London; 144 Duke of Sutherland Collection (on loan to the National Gallery of Scotland, Edinburgh); 148 Borghese Gallery, Rome (photo Alinari); 149 (top) National Gallery, London, (bottom) National Gallery of Scotland, Edinburgh; 150 (top) National Gallery, London; (bottom) Isabella Stewart Gardner Museum; 152 Kunsthistorisches Museum, Vienna; 155 Kunsthistorisches Museum, Vienna; 156 Narodni Galerie, Prague; 157 Metropolitan Museum of Art, New York (Rogers Fund); 160 Trustees of the Grosvenor Estate; 161 Mr and Mrs Mellon Collection; 162–6 Photographic Records Ltd; 167 The Grosvenor Estate (Photographic Records Ltd); 168 Wallraf-Richart Museum, Cologne; 172 Louvre, Paris (photo Giraudon); 173 Courtauld Institute Gallery; 174 Pennsylvania Academy of Fine Arts, Philadelphia; 176 (top) The Art Institute of Chicago (Mr and Mrs Martin Ryerson); 177 Fogg Art Museum (Grenville C. Winthrop Bequest); 180 National Gallery, London; 182 (top) Uffizi Gallery, Florence, (bottom) Louvre, Paris; 184 Mannelli Collection; 185 National Gallery, London; 186 Alte Pinakothek, Munich; 187 Alte Pinakothek, Munich; 192 Prado, Madrid; 193 Prado, Madrid; 197 Prado, Madrid; 198 Louvre, Paris; 199 Louvre, Paris (photo Giraudon); 203 Louvre, Paris (photo Giraudon); 204 Museum of Modern Art, New York; 206–7 Museum of Modern Art, New York; 210 Metropolitan Museum of Art, New York; 214 (top) Fundaciones Vega-Inclan, Madrid; (left) Museo de S. Vicente, Toledo (photo MAS), (right) National Gallery of Art, Washington (Samuel H. Kress Collection); 215 Cincinnati Art Museum; 216 Mauritshuis, The Hague; 219 (left) Staatliche Museum, Berlin, (right) Rijksmuseum, Amsterdam;

221 National Gallery, London; 222 National Gallery of Art, Washington; 223 Dept. of Fine Arts, University of Reading; 226 Tate Gallery, London; 227 (top) Victoria and Albert Museum, London; 228 Kroller-Muller Museum, Otterlo; 229 Stedelijk Museum, Amsterdam; 232 Folkwang Museum, Essen; 238 National Gallery, London; 240 (left) National Gallery, London, (right) reproduced from *Duccio* by John White, (Thames & Hudson 1979) by courtesy of the author and publisher; 244–7 Ducal Palace, Venice (photos Alinari); 250 Musée des Beaux-Arts, Nantes; 252 Louvre, Paris (photos Giraudon); 256 Rijksmuseum, Amsterdam; 259 Vatican, Rome (photo Alinari); 260 (top) Christ Church, Oxford, (bottom) photo Alinari; 262 Cleveland Museum of Art; 267 (bottom) photo Giraudon; 270 Dahlem Museum, Berlin; 273 (top) Szépmüveszeti Museum, Budapest, (left) Musée des Beaux-Arts, Lyons, (right) Louvre, Paris (photo Giraudon); 276 Louvre, Paris; 277 Louvre, Paris (photos Giraudon); 279 (top) Louvre, Paris (photo Giraudon); 282 Louvre, Paris; 285 (top) Louvre, Paris (photo Giraudon), (bottom) Kunsthalle, Hamburg; 288 National Gallery, London; 289 Philadelphia Museum of Art (Mr & Mrs Carroll S. Tyson Collection); 290 (top) Art Institute of Chicago, (bottom) Baltimore Museum of Art; 291 (top) Galerie Beyeler, Basle, (bottom) Philadelphia Museum of Art (W. P. Wilstach Collection); 294 Art Institute of Chicago (Worcester Collection); 297 Statens Musem für Kunst, Copenhagen; 300 Stedelijk Museum, Amsterdam; 302–3 Museum of Fine Arts, Boston; 308 Rijksmuseum, Amsterdam; 312 (bottom) Royal Library, Windsor; 313 (bottom) Royal Library, Windsor; 315 Musée des Beaux-Arts, Brussels; 316 Metropolitan Museum of Art, New York; 317 Metropolitan Museum of Art, New York (Bequest of Mrs H. O. Havemeyer); 318 (top) Philadelphia Museum of Art (Thomas Eakins Collection), (bottom) Philadelphia Museum of Art (Alex Simpson Jr Collection); 322 Phillips Collection, Washington; 325 Louvre, Paris (photo Giraudon); 330 Art Institute of Chicago; 332 National Gallery, London; 333 Metropolitan Museum of Art, New York (Bequest of Samuel A. Lewisohn); 334 (left) Philadelphia Museum of Art (Louis E. Stein Collection), (right) Smith College Museum of Art, Massachusetts; 335 Museum of Modern Art, New York (Abby Aldrich Rockefeller Bequest).